**TIMELESS**

*For my dad, who was present during the initial stages of this book, but who was unable to see its completion. With his timeless style, chic and a touch eccentric, he cultivated the main thread of this project and supported me throughout its writing, in an ethereal haze of cold tobacco mixed with Equipage cologne.*

**HAYLEY EDWARDS-DUJARDIN**

# TIME LESS

## A fashion anthology

ILLUSTRATIONS BY
TIMOTHY DURAND AND THE SHELF STUDIO

*Hardie Grant*
NORTH AMERICA

**WHAT YOU WEAR HAS MEANING**

Our clothes are an inevitable second skin. They connect us to the rest of the world. They protect, embellish, and reassure. They can also reveal, transform, or camouflage. Our clothes expose our deepest secrets; they also display who we are socially, politically, culturally, and economically. That is where clothes become fashion. A phenomenon. An industry. A norm. An authority.

Yet, we know very little about our clothes. We have forgotten their history. Fashion is contradictory in that it is both short-lived and long-lasting. There are timeless garments, and there are enduring legends from runways and haute couture houses. Each one gives insight into a creator's imagination and reveals our desire for dreams, but also for rules.

Telling the story of these pieces, whether they are trivialized or fantasized about, means following the thread of fashion history — a history of men and women, of popular culture, of frivolity and depth. It also means restoring their value in an era when fashion is considered negligible. By exalting fashion and image, we exalt individuals.

# WARDROBE

78 ESSENTIALS

P. 9

---

# DESIGNS

60 ICONS

P. 191

---

# STYLES

22 LOOKS

P. 301

---

# PORTRAITS

52 DESIGNERS

P. 349

PART 1

# WARDROBE

### 78 ESSENTIALS

| | | |
|---|---|---|
| White T-shirt ............... p. 10 | Tang jacket ................. p. 65 | Aviator jacket ............. p. 122 |
| Ballet flats ................... p. 14 | Bowtie .......................... p. 68 | Bomber jacket ........... p. 123 |
| Cardigan ...................... p. 15 | Shorts ........................... p. 69 | Duffle coat ................. p. 126 |
| Breton shirt ................. p. 16 | One-piece bathing suit ..... p. 72 | Peacoat ....................... p. 127 |
| Dr. Martens ................. p. 20 | Bikini ............................ p. 73 | Espadrille ................... p. 130 |
| Turtleneck ................... p. 21 | Puffer jacket ............... p. 76 | Platform shoes .......... p. 131 |
| Polo .............................. p. 24 | Waist bag .................... p. 77 | Boubou ....................... p. 134 |
| Yellow boots ................ p. 28 | Prairie dress ................ p. 80 | Qamis .......................... p. 135 |
| Lumberjack shirt ......... p. 29 | Straw hat ..................... p. 81 | Jeans ............................ p. 136 |
| Geta .............................. p. 32 | Qipao ........................... p. 84 | Sweatpants ................. p. 144 |
| Sarong .......................... p. 33 | Chore jacket ................ p. 85 | Kimono ........................ p. 148 |
| Bucket hat ................... p. 36 | Samue .......................... p. 86 | Overcoat ..................... p. 152 |
| Flip-flops ..................... p. 37 | Cap ............................... p. 87 | Fedora ......................... p. 153 |
| Bandana ...................... p. 38 | Sneakers ...................... p. 92 | Sweater ....................... p. 156 |
| Tweed jacket .............. p. 42 | Pumps .......................... p. 96 | Miniskirt ...................... p. 160 |
| Boots ............................ p. 43 | Bra ................................ p. 98 | Turban ......................... p. 161 |
| Caftan .......................... p. 46 | Panties ......................... p. 99 | Barbour ....................... p. 164 |
| Overalls ....................... p. 47 | Tank top ...................... p. 102 | Beanie .......................... p. 165 |
| Birkenstocks ............... p. 50 | Men's briefs ................ p. 103 | White button-up ........ p. 166 |
| Backpack ..................... p. 51 | Little black dress ........ p. 106 | Jean shirt .................... p. 170 |
| Khakis .......................... p. 54 | Djellaba ....................... p. 110 | Trench coat ................ p. 171 |
| Sweatshirt ................... p. 55 | Kufi ............................... p. 111 | Moccasins ................... p. 174 |
| Sari ............................... p. 56 | Dashiki ......................... p. 114 | Kilt ................................ p. 178 |
| Military jacket ............ p. 60 | Biker jacket ................. p. 115 | Huipil ........................... p. 179 |
| Desert boots ............... p. 61 | Guayabera ................... p. 118 | Necktie ........................ p. 182 |
| Jean jacket .................. p. 64 | Beret ............................. p. 119 | Modern suit ................ p. 186 |

# WHITE T-SHIRT
## BLANK CANVAS

| | |
|---|---|
| FACES OF | MARLON BRANDO, JEAN SEBERG |
| PODIUM | JIL SANDER, VIVIENNE WESTWOOD, DIOR |

At first, the white T-shirt is a humble undershirt – comfortable, practical, and universal. In the second half of the 20th century, it becomes the paragon of fashion essentials. Ordinary and exceptional at the same time, it carries a variety of signifiers that underlie the many contradictions of the fashion industry.

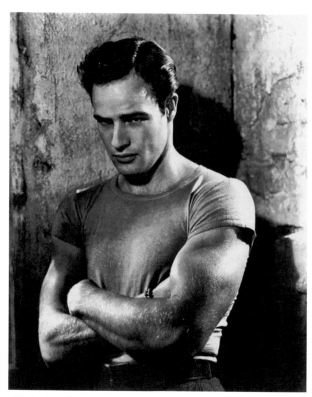

↑ Marlon Brando, in *A Streetcar Named Desire*, 1951

> « I'VE ALWAYS THOUGHT OF THE T-SHIRT AS THE ALPHA AND OMEGA OF THE FASHION ALPHABET. »
> GIORGIO ARMANI

### THE SHAPE OF A T

T-shaped undergarments have existed since the Middle Ages. Simple, sturdy, and pragmatic, they protect the body from the roughness of certain materials, while also preventing sebum from soiling outer garments. Gradually replaced by the chemise, or shift, the undershirt reappears in the 19th century, bolstered by new hygienic considerations.

### WAR HEROES

The modern T-shirt takes shape in 1898. The U.S. Army integrates the undershirt into their uniform, and it becomes their hallmark – sometimes even worn with nothing on top during missions to hot countries. It comes to life during World War II when it contributes to a triumphant iconography: soldiers flaunt their form-fitting T-shirts in a virile aesthetic of sensual ambivalence.

### FORM-FITTING GARMENT

Hollywood embraces this ambiguity. On the silver screen, Marlon Brando flaunts a tight white T-shirt that accentuates his muscles. The revolutionaries of May 1968 in France make it their own. Bold, rebellious women and well-behaved college students wear it too. Feminists put it on without a bra, and the gay community adopts it as an erotic ally.

### LITERARY ORIGINS

The first written mention of the term « T-shirt » is attributed to F. Scott Fitzgerald. In his 1920 novel This Side of Paradise, it appears in the description of the contents of a suitcase. In the 1950s, in France, the derivative « tee-shirt » appears.

### TEXTILE POLLUTION

The white T-shirt becomes a must-have for everyone, everywhere – to the planet's detriment. It is luxurious when ruinously expensive and commonplace when sold in bulk at a bargain. It has a place in every aspect of the fashion vocabulary, including its shortcomings, since it also embodies fashion's environmental abuses.

### SPREAD THE WORD

T-shirts with printed text and images appear in the 1940s, when soldiers in the U.S. Army wear them to announce their corps or division. Graphic T-shirts become popular in the general public thanks to a politician in 1948. Soon after, Walt Disney releases promotional T-shirts. Shirts with personal messages and words of protest appear in the 1960s, followed later by shirts affixed with luxury logos.

## SPREAD THE WORD

### 1871
**ICONIC BRAND**
Fruit of the Loom is founded.

### 1898
**FAVORED BY SOLDIERS**
During the Spanish-American war, the U.S. Army adopts the white undershirt.

### 1901
**OFFICIAL SUPPLIER**
Hanes is established and they supply T-shirts to the U.S. Army.

### 1920
**FROM PRACTICAL TO PRESTIGE**
In his novel, *This Side of Paradise*, Francis Scott Fitzgerald implements the term « T-shirt ».

### 1939
**GOODIES**
The first promotional T-shirt is created for the release of *The Wizard of Oz*.

### 1942
**FIRST PRINTED T-SHIRT**
A soldier wearing a T-shirt adorned with the details of his role in the U.S. Army appears on the cover of *Life* magazine.

### 1948
**POLITICAL T-SHIRT**
Thomas Dewey runs for U.S. president and creates T-shirts with the slogan « Dew-it with Dewey ».

### 1951
**SEX SYMBOL**
Marlon Brando drives crowds wild with his form-fitting T-shirt in *A Streetcar Named Desire*.

### 1960
**SILVER SCREEN**
In *Breathless*, Jean Seberg strolls down the Champs-Élysées wearing a « New York Herald Tribune » T-shirt.

### 1977
**ICONIC MODEL**
« I Love New York » is created.

### 1984
**PRINTED MANIFESTO**
British designer Katharine Hamnett meets Margaret Thatcher while wearing her protest T-shirt: « 58% Don't Want Pershing ».

### 2017
**TAKING SIDES**
Dior launches T-shirts that say: « We Should All Be Feminists », inspired by the words of Chimamanda Ngozi Adichie.

← **The Ramones,** Santa Monica, 1976

↑ **Crewneck T-shirt,** Velva Sheen

# BALLET FLATS
## FROM STAGE TO CITY

FACES OF ......... BRIGITTE BARDOT, AUDREY HEPBURN, KATE MOSS

PODIUM ......... VALENTINO, CHRISTIAN DIOR, MIU MIU

In the 20th century, dancer Marie-Anne de Cupis de Camargo removes the small, constraining heels that adorn her dance shoes. Her new footwear is lighter and more practical, offering a new vision of femininity: romantic, modern, and deceptively innocent.

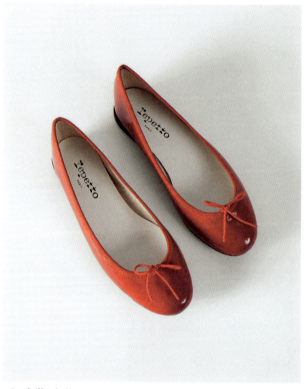

↑ Cendrillon ballerinas, Repetto

« IF THE SHOE HURTS, GIVE IT AWAY. »

CLAIRE MCCARDELL

### THE INFLUENCE OF DANCE

In the early 19th century, dancers wear flexible, flat shoes. They are continuously improved upon to support the dancers' posture and technical movements. Salvatore Capezio opens a New York workshop specializing in this art form. In the streets, women wear romantic, ballet-slipper-inspired flat shoes with straps that wrap around the ankles.

### FROM STAGE TO STREET

Jacob Bloch emigrates to Sydney in 1932 and opens a dance shoe workshop. He calls his slippers « ballerines. » But it's in the U.S. that the style expands beyond the ballet studio. Minimalist design pioneer Claire McCardell develops the clean, elegant, and comfortable style that ballet flats are prized for.

### POSTWAR APPEAL

McCardell collaborates with Salvatore Capezio in 1944, when he designs flats tailored to her prêt-à-porter collection. In the 1950s, the newly fashionable ballet flat is popular with young women who prefer its more reserved, slightly tomboyish style to the outrageously dressy look of the 1950s. Audrey Hepburn wears Salvatore Ferragamo's version.

### LUXURY BALLET FLATS

In 1960, Fiamma Ferragamo takes over the luxurious and inventive shoe brand with which her father, Salvatore, conquered the international elite. In 1978, she creates a ballet flat model with a small square heel and a grosgrain bow on top: the Vara. The perpetually reinvented best-seller is a Ferragamo classic.

### PARISIAN ICON

In France, Brigitte Bardot draws attention to the Cendrillon ballerinas, created for her by Rose Repetto in 1956. The French New Wave takes over the look, and the shoe becomes synonymous with a certain Parisian style – cheeky and falsely modest. Today, the ballet flat retains that identity, blending audacity with romanticism and sensuality.

### AMERICANA

American fashion pioneer Claire McCardell adapts to the constraints of WWII by imagining a woman's wardrobe composed of functional, simple, and accessible pieces that favor natural fabrics. Since city shoes are restricted, but not dance shoes, McCardell launches the trend of wearing ballet flats around town, heralding the arrival of a simple and polyvalent contemporary silhouette for active women that will define the identity of American fashion and influence designers such as Calvin Klein and Ralph Lauren.

# CARDIGAN
## URBAN LEGEND

**FACES OF** .......... KURT COBAIN, EDIE SEDGWICK, HARRY STYLES

**PODIUM** .......... CHRISTOPHER KANE, PRADA, JACQUEMUS

The cardigan is elegant and relaxed, comfortable and proper, all at the same time. This variability surely has something to do with its origins, both aristocratic and functional. The cardigan flourishes in the 19$^{th}$ century, though it likely originates in the clothing worn by fishermen in the 17$^{th}$ century.

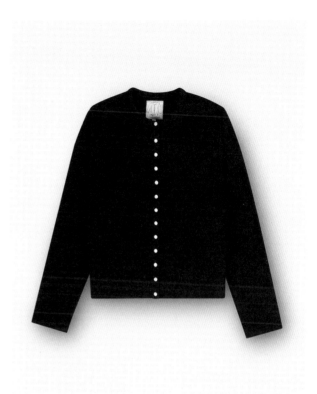

↑ Le Classique Snap Cardigan, agnès b.

### WAR MYTHOLOGY

Its posterity is established in 1854 at the Battle of Balaklava in Ukraine during the Crimean War. Instead of the traditional military uniform, James Thomas Brudenell, the Earl of Cardigan, wears a collarless wool waistcoat, which is warmer and more suitable. A myth is constructed around his false military exploits.

### FRENCH STYLE

In 1979, Agnès Troublé, known for her brand agnès b., grows tired of her sweatshirts and decides to cut one up the middle and add snaps. It is the prototype of the fleece snap cardigan, the brand's endlessly revisited signature.

### COMMERCIAL SUCCESS

Tailors capitalize on the myth to sell the sweater, naming it after the Earl. Warm and soft, it becomes increasingly popular, especially among English aristocratic men.

### ACTIVE ELITE

With the development of luxury sportswear in the 1920s, expanded by designers like Lucien Lelong and Jean Patou, the cardigan is associated with recreational sports. It enters women's closets when Gabrielle Chanel incorporates it into an elegant day ensemble, the jersey suit (p. 203). In the 1930s and 1940s, it becomes more commonplace in women's wardrobes, especially among American students, while for men, it remains exclusive to the elite.

### UNANIMOUS

In the 1950s, it's everywhere: from preppy Ivy League students (p. 334) to the intellectuals of the Saint-Germain-des-Prés neighborhood in Paris by way of twinset-wearing pin-ups and bohemian beatniks. The lesbian community turns it into a symbol of their sexual identity, while on TV, it's associated with quiet patriarchal conservatism. Cool and serious at the same time, it also becomes quirky and grunge (p. 338) when Kurt Cobain wears a shabby, oversized cardigan for an iconic performance on MTV.

### CONFUSION

The cardigan can occasionally be misunderstood. In France, the cardigan is often called a « gilet », which is actually either a piece of outerwear or (more often) a short sleeveless vest worn with three-piece suits. A cardigan is specifically a knit sweater, buttoned up the front.

### GRUNGE FOREVER

In 2019, the olive-green cardigan Kurt Cobain wore during his 1993 MTV *Unplugged* performance sells at auction for 334,000 dollars.

# BRETON SHIRT
## BEYOND THE SEA

**FACES OF** .......... ANDY WARHOL, PICASSO, GABRIELLE CHANEL

**PODIUM** .......... BALMAIN, JEAN-PAUL GAULTIER, JACQUEMUS

Until the 19th century, French sailors wear their own clothes aboard ships (officers wear a standard-issue uniform). In 1858, a ministerial decree establishes a uniform for crews that distinguishes their silhouette: a sailor collar, fisherman's smock, sailor pants, a peacoat, and a striped knit shirt.

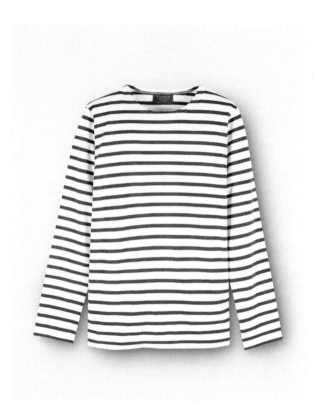

↑ Historic Breton shirt, Le Minor

« THIS STRIPED SAILOR'S JERSEY HAD THE POWER OF A LEOPARD'S SKIN. OR MAYBE IT WAS THE ANIMAL ITSELF, HIDING THERE, WRAPPED UP IN ITSELF [...]. »

JEAN GENET

### MARINIÈRE
In 20th century France, the liberated elite strut around coastal towns wearing the blue and white striped cotton-knit sailor shirt. According to the 1858 decree, the sleeves must be shorter than the smock – they only cover three-quarters of the arm. The stripes reduce the use of expensive indigo to just a few lines.

### WIND IN THEIR SAILS
Beginning in the late 18th century, children's clothing borrows from marine style. During the Belle Époque period in France, with the development of coastal tourism and leisure activities, women appropriate the shapes and patterns of the sailor's uniform, embracing the adventure, liberty, and sensuality represented by the sailors. In the 20th century, to wear nautical references is to claim a form of independence.

**SAILOR STRIPES IN NUMBERS**

**1858:** A ministerial decree defines the look of the striped knit top.

**21 white stripes:** 20 millimeters wide for the torso and 15 millimeters wide for the sleeves.

**20 or 21 blue stripes:** 10 millimeters wide for the torso and 14 or 15 millimeters wide for the sleeves.

### BOHEMIAN CHIC
In the 1920s, the Breton sailor top grows in popularity. The Japanese artist Foujita wears it in Bohemian Paris, followed by Pablo Picasso and Andy Warhol. As for Coco Chanel, she draws on the look of the fisherman's smock when she designs her jerseys, and she wears a Breton shirt with pants in 1930.

### ONSCREEN CHARM
After the war, the Breton shirt is seen in French New Wave films, worn by Jean Seberg and Brigitte Bardot.

### IN THE FLESH
Sporty when worn by liberated women, it is carnal when worn by men, fed by homoerotic fantasies in works such as *Death in Venice* by Thomas Mann and *Querelle of Brest* by Jean Genet.

**NICE AND WARM**

In 1850, Léon Legallais founds a woolen mill in Saint James, France. By the end of the 19th century, the mill is creating long wool sweaters. The tops are called « chandail de marin » (sailor sweater), after the mariners nicknamed « marchands d'ail » (garlic merchants) who wear them. The French Navy becomes their principal client: the sweater is striped for the crew and solid for the officers.

# DECORATING THE BODY

## A HISTORY OF PATTERNS

Already in prehistoric times, men and women decorate the textiles they wear by intertwining tinted threads or by printing patterns with the help of stencils or pieces of engraved wood. Indian printing techniques develop primarily in the East until Europeans, wishing to imitate the textiles imported from Asia, create the first Western fabric printing workshops in the 17th century.

POLKA DOTS

STRIPES

GINGHAM

TARTAN

HOUNDSTOOTH

ZEBRA

LEOPARD

CAMOUFLAGE

LIBERTY

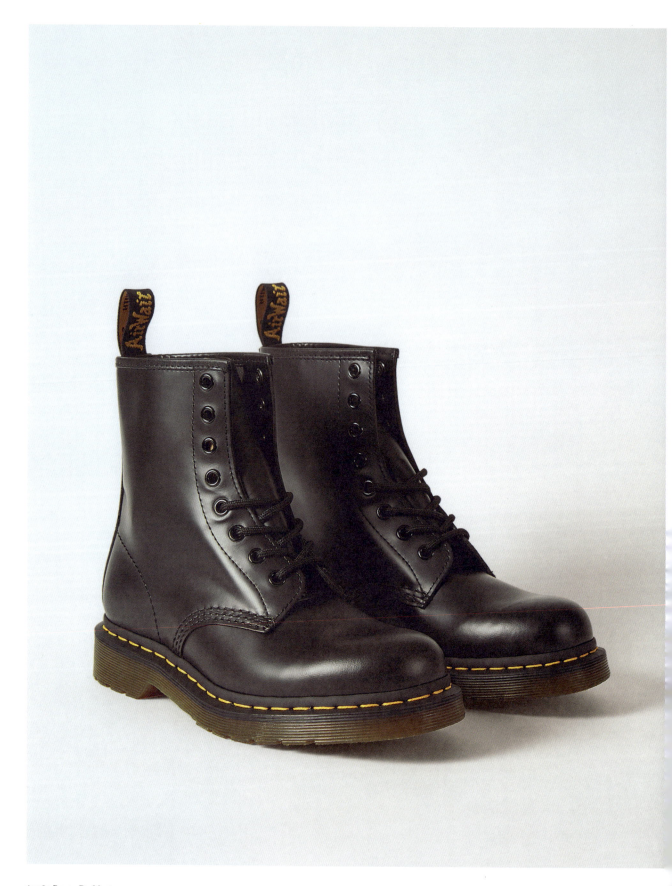

↑ 1460 Boots, Dr. Martens → British Punk, UK, 1982

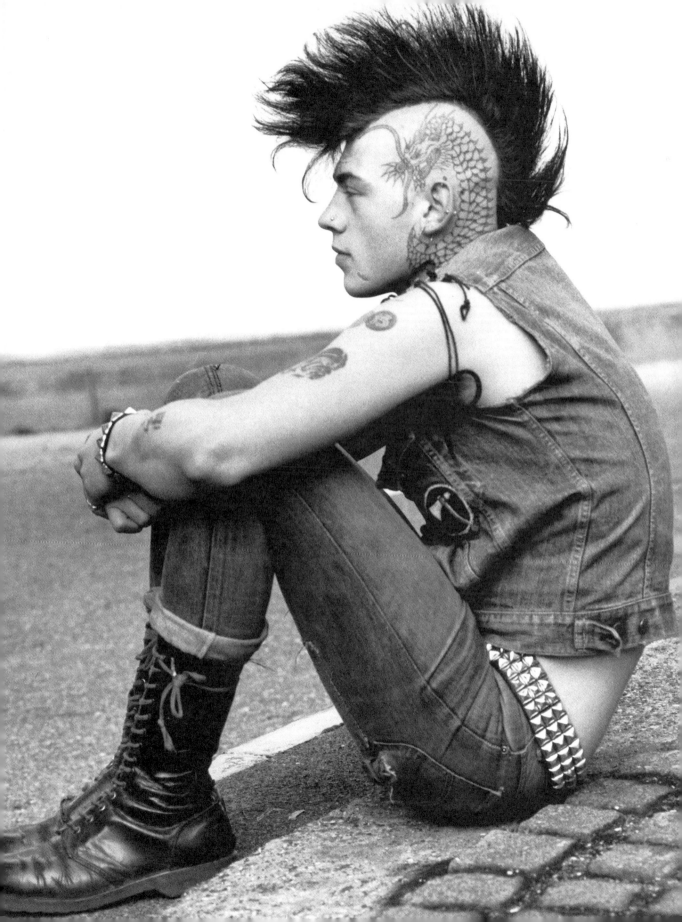

# DR. MARTENS
## AGAINST THE GRAIN

FACES OF ......... PETE TOWNSHEND, DREW BARRYMORE

PODIUM ......... PERRY ELLIS, JEAN-PAUL GAULTIER

Around 1946, the German doctor Klaus Märtens teams up with engineer Herbert Funck and invents « Doc Martens » with air-cushioned orthopedic soles. Dr. Martens' bouncy soles provide relief from the discomfort of men's military boots and women's wooden shoes.

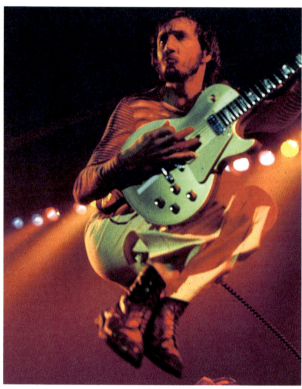

↑ Pete Townshend, guitarist for The Who, 1975

« THEIR TOUGHNESS AND FLEXIBILITY MADE THEM PERFECT FOR THE ATHLETIC ROUTINES I PERFORMED ON STAGE. I LITERALLY STARTED TO FLY. »

PETE TOWNSHEND, THE WHO

### WORKING ON YOUR FEET
The R. Griggs Company obtains the exclusive license to produce the soles in England. They create boots with a rounded toe in durable leather, with yellow stitching and a grooved sole. « Airwair with bouncing soles » is written on the heel loop. They become the Dr. Martens 1460 boot, an homage to their creator and their creation date: April 1, 1960. Inexpensive and functional, they entice laborers, London Underground agents...

### LETHAL WEAPON
... and counterculture movements. In the mid-1960s, English skinheads adopt the boots because their popularity with workers aligns with their ideology and because they are imposing – they add centimeters of height. Once they've found their crowd, sales explode.

### FROM PUNK...
In the 1970s, the boots are a central element of punk style (p. 328). Punks appreciate their quasi-menacing military aesthetic. Unisex, they personify nonconformity, rage, and the ferocity of punk music.

### ALL THE RAGE
Skinheads, successors of the mod movement, come from working-class East London and English industrial towns. They favor ska and rocksteady music developed by the Jamaican rude boys. In the late 1970s, part of the movement, violent from the beginning, turns to fascism and extremism, an identity that is still associated with punk today.

### ... TO GRUNGE
In the U.S., most of the alternative music trends of the 1980s, inspired by punks, adopt the boots, as does the grunge movement in the 1990s. Worn with laces untied and the tongue folded down with nonchalance, they give rebellious youth its own vocabulary.

### NEVER-ENDING STORY
The ostentatious early 2000s renounce Dr. Martens, but the boots resurface in the 2010s and become cult. Deconstructivism is revived and even more brutal. While luxury brands offer expensive versions, younger buyers return to an authentic and affordable model.

### GANGS
Dr. Martens' image suffers from their close association with the skinhead movement. They are often used to represent violence and fascism within sartorial symbolism. Stanley Kubrick even put them on his disturbing and ultraviolent characters, Alex DeLarge and his « droogs », in the 1971 film A Clockwork Orange.

# TURTLENECK
## ONE FOR ALL

| FACES OF | STEVE JOBS, ANDY WARHOL, HALSTON |
|---|---|
| PODIUM | GUCCI, MAX MARA, YVES SAINT LAURENT |

When the turtleneck appears at the end of the 19th century, it is favored by athletes and sailors for its thermal and practical qualities, just like cardigans and sweaters before it.

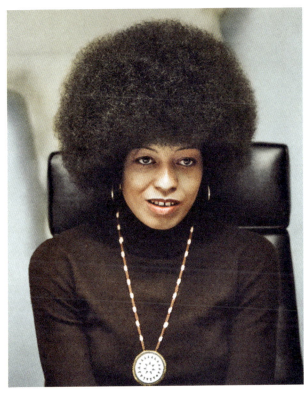

↑ Angela Davis, 1974

### HIGH COLLAR

During the Renaissance, high collars proliferate. Covering the neck is a way to protect it, to conceal it, or to accentuate nobility– those in power flaunt whimsical and extravagant ruffle collars. Though women's throats are revealed beginning in the 17th century, men appreciate the elegance of scarves and ascots. With the arrival of the turtleneck at the end of the 19th century, the high collar leaves behind its aristocratic associations and becomes synonymous with functionality.

### PROVOCATIVE KNITS

After Lana Turner wears a form-fitting sweater in the film *They Won't Forget* in 1937, the objectifying term « sweater girl » is created to highlight her sex appeal. The term proliferates during the 1950s with the appearance of conical bras. Exploiting exaggerated femininity, the decade features pin-ups with tight sweaters and falsely modest turtlenecks.

### SPORTY COLLAR

As styles change, necklines are more or less revealing, but men tend to cover their chests more than women. The turtleneck appears at the end of the 20th century. The naval sector and athletes, especially polo players, adopt the top for its functionality.

### MISCHIEVOUS AND SEXY

In the 1920s, liberated from constraints and conservatisms, it becomes daily wear. It is assimilated by the roguish jet set and by certain feminists for its androgynous aesthetic. In the 1950s, it's no longer worn in the same way. A synonym of nonchalant masculinity for men, it highlights the shape of the conical bra worn by women.

### UNISEX AND POLYVALENT

The 1960s soften these stereotypes. Unisex, graphic, and minimalist, it is versatile and particularly polyvalent: intellectual for the philosophers of Saint-Germain-des-Prés in Paris, futuristic for the Space Age obsessed (p. 266), cool for the mods of London (p. 304), and militant for the Black Panthers (p. 340). It's the ally of modern women, explorers like Jacques Cousteau, and disco designers like Halston (p. 219).

### SCHIZOPHRENIC TURTLENECK?

Multifaceted, it adapts to all demands. In the 1970s, it is everywhere, rendered utterly banal, and it even enters into the rigid world of work: men are authorized to abandon their button-ups (p. 166) and ties (p. 182). Feminists also adopt it because it reveals the body's curves, and also covers them generously. It's an essential staple: it becomes invisible while it provides space to express individuality.

### BRANDING

While visiting Sony's offices in Japan in the 1980s, Steve Jobs notices the pure lines of the Issey Miyake-designed clothing worn by the employees. He orders black turtlenecks from the designer for his own employees, giving Apple a versatile and identifiable signature style that lies somewhere between the erasure of the self behind the brand and a perfectly marketed personal image.

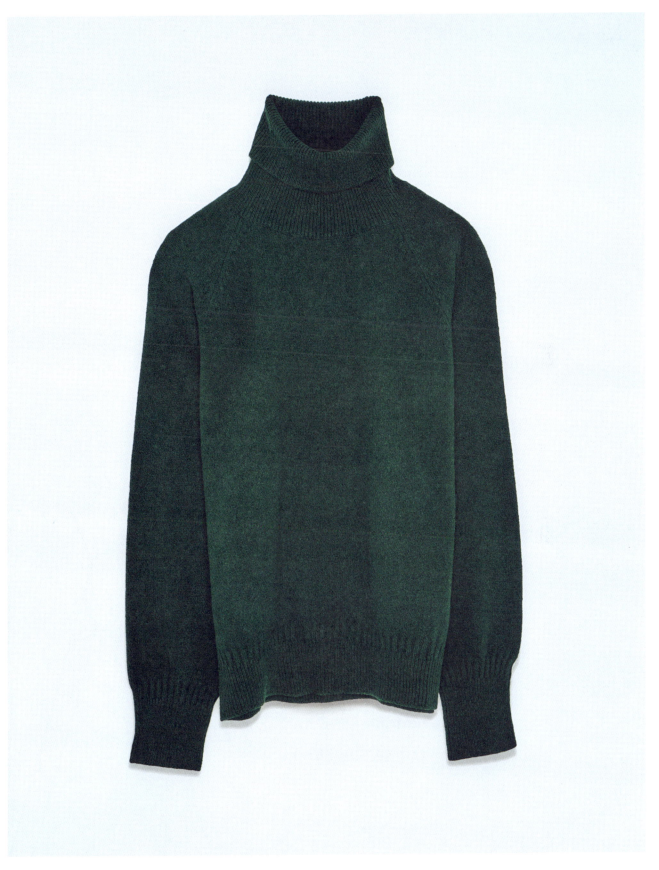

← Michael Douglas *wearing a turtleneck and a suede jacket*

↑ **Cashmere turtleneck,** Tricot

# POLO
## ATHLETIC LOGO

FACES OF ......... PAUL NEWMAN, AMY WINEHOUSE

PODIUM ......... MARNI, FENDI, PRADA

It isn't until the 1920s that the polo becomes the shirt we know today: a short-sleeved knit top with a collar and a shortened placket. Before that, the polo is a comfortable shirt born in India on the playing fields of the British colonists.

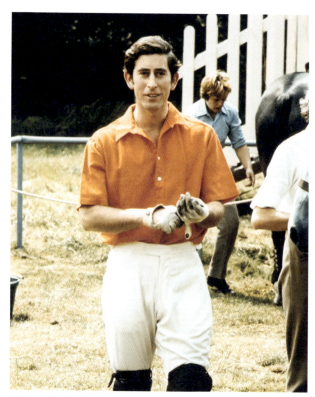

↑ **Prince Charles** *during a polo match at Windsor Great Park*

« INVENTOR! IF I HAD TO PUT A PROFESSION ON MY BUSINESS CARD, THAT IS WHAT I WOULD WRITE. I HAVE INVENTED MY WHOLE LIFE. »

RENÉ LACOSTE

### GIDDY-UP
In the 19th century, British soldiers stationed in India play polo wearing a comfortable cotton shirt with a button-down collar. At the end of the century, the American brand Brooks Brothers brings the shirt to the masses and creates an essential American style.

### BAD REPUTATION
In the 1970s, the Fred Perry polo suffers from its appropriation by extremist groups such as skinheads and neo-Nazis who wear the M12 model with striped edges. The neo-fascist Proud Boys select the black polo with double yellow stripes on the tips. Fred Perry stops selling the latter in the U.S. and Canada to distance the brand from the association.

### THE CROCODILE
For the 1926 US Open, the French tennis player René Lacoste asks a tailor for jerseys with soft collars and short sleeves that he wouldn't need to roll up. Some are in wool, and others in more breathable cotton pique. His friend Robert George dreams up a logo in homage to his nickname, the « Crocodile », which he has embroidered on his blazer.

### COLORFUL POLOS
The other players admire his polo shirts, and in 1933, Lacoste partners with knitwear manufacturer André Gillier to sell to a larger market. In the 1950s, the brand diversifies its color range, and the polo becomes characteristic of the privileged class, who seek to remain elegant even in casual wear.

### LAURELS, CROCODILES AND HORSES
Fred Perry, a British tennis player with working-class roots, introduces the shirt to the masses. In 1952, he creates his own polo, featuring a laurel wreath meant to establish his legitimacy in sophisticated circles. Later, in the 1970s, skinheads and London mods adopt the brand, reversing its bourgeois symbolism. French rappers of the 1980s choose the Lacoste polo, and in the 1990s, American hip-hop (p. 316) chooses the Ralph Lauren version.

### CHIC
When Ralph Lauren releases his polo in 1972, he creates a link between tennis and polo – his logo represents a polo player on a horse. The logo also connects his garment with elitist values.

## CLAY COURT

### 19TH CENTURY
**ATHLETIC EQUIPMENT**
Polo develops in India, and its players wear button-down shirts.

### 1926
**ON THE COURTS**
During the US Open, René Lacoste wears the first athletic polo: the Lacoste tennis shirt.

### 1927
**ICONIC LOGO**
The Lacoste crocodile logo is born.

### 1933
**A SUCCESS STORY**
René Lacoste commercializes his polo.

### 1952
**ICONIC LOGO**
Fred Perry launches his laurel-embroidered polo.

### 1955
**THE SILVER SCREEN**
Sidney Poitier wears a Fred Perry polo in the film *Blackboard Jungle*.

### 1972
**QUINTESSENTIAL MODEL**
Ralph Lauren creates his polo shirt. The now famous logo of a player on a horse is a nod to his Polo line, launched five years earlier.

### 1988
**ORGANIZED CRIME**
The Lo-Life movement is born. Devoted to the Ralph Lauren brand, the group organizes raids of New York department stores where they steal the brand's clothes.

### 2016
**IDEOLOGICAL EXPLOITATION**
For the neo-fascist group Proud Boys, wearing the black and yellow Fred Perry polo serves to combat multiculturalism.

### 2017
**SILVER SCREEN**
Timothée Chalamet wears a Lacoste polo in the film *Call Me By Your Name*.

### 2020
**POLITICAL DECISION**
Fred Perry halts sales of the black polo with yellow tips in the U.S. and Canada.

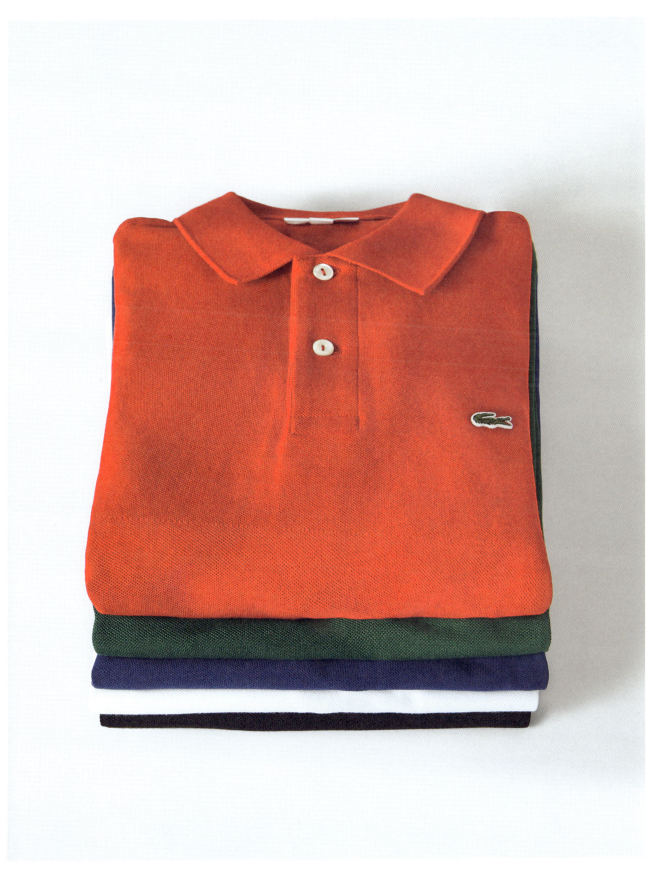

← René Lacoste, *North London Hard Courts Championships,* **London**, April 13, 1929

↑ **Original L.12.12 Polo**, Lacoste

# YELLOW BOOTS
## SURPRISE CUSTOMERS

| FACES OF | RIHANNA, JAY Z, JENNIFER LOPEZ |
| --- | --- |
| PODIUM | MOSCHINO, MOWALOLA, CELINE |

In 1952, Nathan Swartz buys shares in an American shoe company, and it soon becomes his own. Living in a region where nature is imposing and the climate is unpredictable, he knows it is primordial to create practical shoes adapted to the fiercest elements.

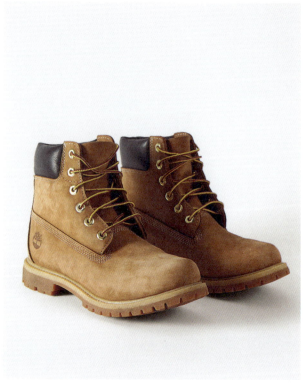

↑ 6-Inch Waterproof Boot, Timberland

### THINK « WATERPROOF »
Swartz innovates by replacing the seams between the sole and the leather upper with injection molding. In 1973, his son Sidney designs a pair of waterproof yellow suede boots lined in leather, with rubber lug soles. Designed for men, the model is called Timberland. It appeals to laborers and those who need suitable shoes for outdoor life.

### IMITATION TIMBERLAND
In 2002, the upscale shoe brand Manolo Blahnik releases the Oklamod, an adaptation of the Yellow Boot with a high heel. Famous women of R&B, led by Jennifer Lopez and Beyoncé, wear them in their videos. The universal success proves that the work shoe has a place in the luxury market.

### SUCCESS IS IMMINENT
In 1978, the Swartz family brand is renamed Timberland, and the shoe model, the Yellow Boot. During the 1980s, the company leans into fashion trends, exporting its designs to Europe, beginning with Italy, and eventually opening boutiques. In the 1990s, the Yellow Boot seduces the followers of an influential musical genre, and everything changes.

### CONTROVERSIAL BRAND AMBASSADORS
Between the great outdoors and pop culture, there is only one step. It takes place in the streets of New York, where drug dealers wear Timberland boots while conducting business. Having thus penetrated the counterculture, the Yellow Boot is rapidly worn and celebrated by rappers. The brand, preferring to be associated with the traditional working man, isn't happy about this commercial boost. But it's difficult to ignore a phenomenon that triples sales.

### EXPLICIT
The name « Timberland » comes from timber, which references lumber, but also what a lumberjack shouts to warn of a falling tree. It's crystal clear who the brand is targeting!

### « IN MY LEATHER AND MY TIMBS LIKE IT'S 1998. »
DRAKE

### MULTICULTURAL
The fans imitate their idols, and even women are wearing the boots. Timberland can't ignore that beyond the logger and white working-class culture, it's the Black American community that assures the brand's success.

# LUMBERJACK SHIRT
## FROM FOREST TO STAGE

| FACES OF | KURT COBAIN, GWEN STEFANI, AXL ROSE |
| --- | --- |
| PODIUM | DRIES VAN NOTEN, BOTTEGA VENETA |

Fabrics with a check pattern have been part of textile history since the 16th century. Scotland is known for its tartan patterns, and India for its striped cotton, known as madras. In the U.S., a wool flannel inspired by Scottish tartans represents local taste.

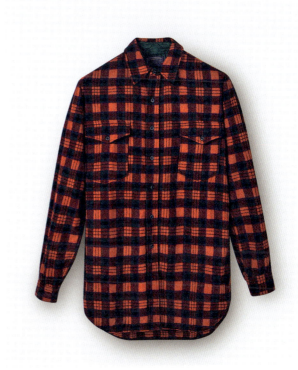

↑ Vintage wool shirt, Pendleton

« RATHER BE DEAD THAN COOL. »

KURT COBAIN

### WOODSMEN
In 1850, Woolrich Woolen Mills creates the Buffalo Check: a plaid flannel shirt inspired by the tartans of 18th-century Scottish workers. By the end of the century, Woolrich offers shirts in various patterns and colors popular with outdoorsmen.

### WORKING CLASS
After the Second World War, the shirt transgresses social barriers. Worn by family men on the weekend, it is popularized as leisurewear. With the rise of hippie culture (p. 326) at the end of the 1960s, it embodies a proletarian, utopian ideal of collective living. During the next decade, the gay community of San Francisco adopts it, affirming its heightened virility.

### GRUNGE TRADEMARK
The 1990s are the golden age of the flannel shirt. As the grunge music movement (p. 338) develops, a style associated with its sound is born: jeans (p. 136), worn-out sneakers (p. 92), baggy T-shirts (p. 10), and flannels - all gleaned from local thrift stores.

### SQUARE DEAL
Grunge fashion is practical for young people on tight budgets who initially buy second-hand clothes out of necessity, but the identifiable collective uniform gains popularity. Tied around the waist or open over an old T-shirt, the plaid flannel becomes unisex and forges the look.

### ANTI-FASHION
Clothing brands absorb grunge fashion. Worn-out thrift-store shirts become immaculate, and trendy pieces sell worldwide. Some designers try it and fail, like Marc Jacobs at Perry Ellis. Grunge is born of deprivation; the world of high fashion has nothing to do with it.

### LOCAL COLOR
The first traces of madras fabric, made with banana fibers, were discovered in the 16th century in Chennai, in South India. In the eighteenth century, it becomes popular throughout Europe and the colonies, exported by the English as a light cotton fabric with colorful checks. Often associated with the Antilles, the fabric arrives there in the 19th century with the Indian labor force after the abolition of slavery.

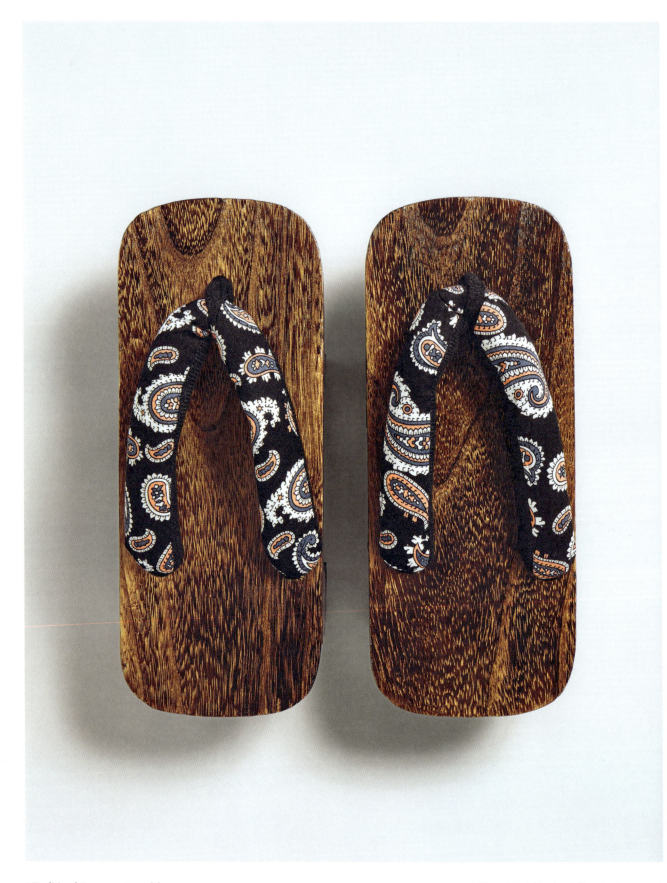

↑ Traditional Japanese geta sandals → Kinosaki neighborhood, Toyooka, Japan, 2022

# GETA
## THE SYMPHONY OF WOODEN SOLES

FACES OF ......... KANSAI YAMAMOTO, SAYOKO YAMAGUCHI
PODIUM ......... PRADA, CHRISTIAN DIOR, KENZO

The first geta appear in Japan thanks to Chinese influence. Derived from the wooden sandals of antiquity, they develop in the Middle Ages. Elitist and common at the same time, the height of geta sandals elevates the wearer for both symbolic and practical reasons.

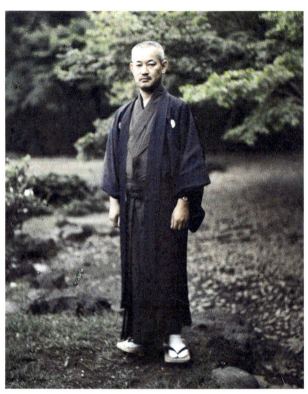

↑ A man in the gardens of the Asaka family residence, Japan, 1926-1927, *Albert-Kahn Museum collection*

### « I LOVE THE TAP, TAP, TAP OF WOODEN SOLES. »
MAURICE CHEVALIER

**SOCIAL LADDER**
The elevated wooden sandals are worn by the elite, by geishas, and by fish merchants in feudal Japan. The upper classes are dominant and elegant in very high, lacquered models, while geishas keep their onerous kimonos (p. 148) from sweeping the ground, and fish merchants avoid the debris at their feet.

**STEP TO THE BEAT**
The Japanese let the back of their feet stick out slightly from the geta in the search for balance so they don't tip forward over the teeth of their sandals. The rhythmic sound of the wood tapping against the floor highlights the orderly gait the shoes create. It's an effective way of standing out!

**SOLES WITH TEETH**
Geta sandals consist of a wooden platform resting on one or several (usually two) teeth, called ha, and a fabric strap, sometimes created from kimono scraps, placed between the big toe and the second. These elevated sandals are often worn with an informal cotton kimono called yukata. They can also be worn with tabi socks.

**FAR EAST**
Japanese designer Hanae Mori presents her first prêt-a-porter collection in New York in 1965, sharing her culture with the world. She creates a link between Japanese tradition and Western style while flattering the bohemian-chic tastes of the American elite. In 1977, she becomes the first woman to join the Chambre Syndicale de la Couture in Paris.

**BLENDING GENRES**
Today, they are primarily a relic of the past. Yet, many people are revisiting the shoes, mixing them with European-style outfits. The fashion industry, having brought platform shoes (p. 131) back into style in the 1970s, is not unfamiliar with the absorption of old into new. Poetic and rustic, geta sandals influence without dominating.

**CULT OBJECT**
Martin Margiela presents his first Tabi boot in the Spring/Summer 1989 collection. He takes inspiration from Japanese jika-tabi footwear, a hybrid between shoes and socks, with the big toe separated from the others. The tabi boots become a staple of the brand, endlessly revisited. They defy traditional aesthetic principles of shoes and mock Western ideas of beauty.

# SARONG
## ONE SKIRT FOR ALL

FACES OF — DOROTHY LAMOUR, YOHJI YAMAMOTO
PODIUM — JEAN-PAUL GAULTIER, MICHAEL KORS

In the West, pants may be the imperative garment for men, but in many cultures, they are not. In South Asia, on the African continent, and on most Pacific Islands, it is common for men to wear a piece of fabric knotted around the waist like a skirt.

↑ Traditional Indian cotton sarongs

**DISOBEDIENT**

In 2021, in Myanmar (Burma), the sarong becomes a weapon of resistance against the junta. Feminists suspend their traditional wrap, the htamein, on laundry lines or electrical wires. Why? In local culture, walking under a woman's garment worn below the waist brings bad luck to men and their virility. The soldiers don't take the risk.

**COVER THE BODY**

The sarong, an English term derived from the Malay and Indonesian word « sarung », which means « to cover », is originally a garment worn by Malaysian sailors. It may have been introduced to Asia by Indian Muslims, although versions have existed on the continent since antiquity. Both formal and ordinary, it takes on a variety of symbolic meanings and multiple uses, depending on the culture. In Indonesia, it's an everyday, unisex garment.

**TO EACH THEIR SARONG**

Made of cotton or silk, with colorful patterns and prints obtained using traditional ikat or batik printing techniques, it ties firmly around the waist, sometimes under the arms for women, forming a tube secured around the lower part of the body, all the way to the ankles.

**FETISHIZING THE EXOTIC**

In the 1930s, Hollywood creates an exotic fantasy, emphasizing actresses' sensuality and an iconography of otherness. The earliest example is Dorothy Lamour, with her hips draped in fabric that exposes her legs in *The Jungle Princess*. The sarong is reinterpreted and redefined according to Western criteria to the point where it becomes the English word for a wrap worn on the beach.

**TIME TO GET DRESSED**

Beyond the fantasy, it remains a traditional object that suggests the alliance of genders – the sarong is both masculine and feminine. It expresses the artisan's skill but also exalts the simple fact of dressing, of taking the time to feel, fold, knot, and honor that which covers the body.

**ON THE SAND**

Tahiti develops its version of the sarong, the paréo (meaning wrap, derived from the local term « pāreu »). Initially, the term only designated the wrap-around cloth worn by women, with men wearing the maro. But today, the word is used for all wraps on the island.

**GLOBE-TROTTER**

Sarongs around the world
**Saudi Arabia :** *fouta*
**Sri Lanka :** *saram*
**Somalia :** *macawis*
**Malaysia :** *kain*
**Philippines :** *malong*
**South Africa :** *kikoi*
**Brazil :** *kanga*
**India :** *lungi*
**Cambodia :** *sampot*
**Hawaii :** *kikepa*

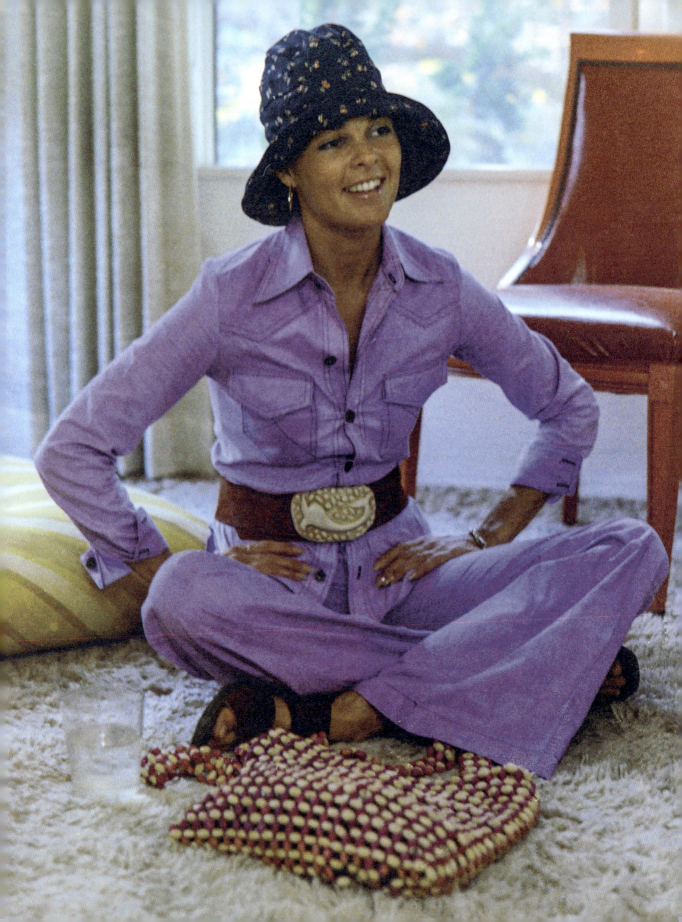

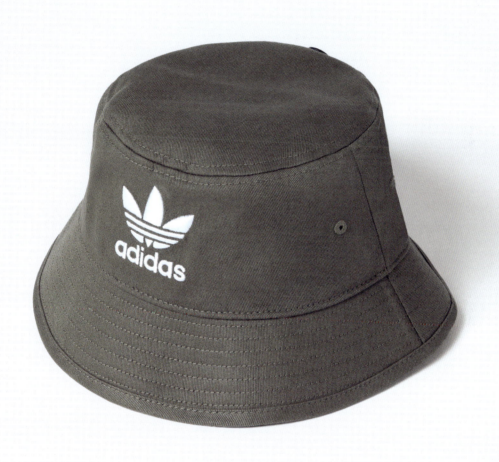

← Ali MacGraw, 1972

↑ Adicolor Trefoil bucket hat, Adidas

# BUCKET HAT
## SYMBOLIC AND ORDINARY

| | |
|---|---|
| FACES OF | RUN-DMC, JANET JACKSON, LAUREN HUTTON |
| PODIUM | FENDI, PRADA, VALENTINO |

The bucket hat is said to derive from the headwear of Irish fishermen and farmers in the late 19th century. It is practical, light, waterproof, and protects from the sun thanks to its wide brim. Most importantly, it can fit in a pocket – a detail that appeals to the U.S. Army.

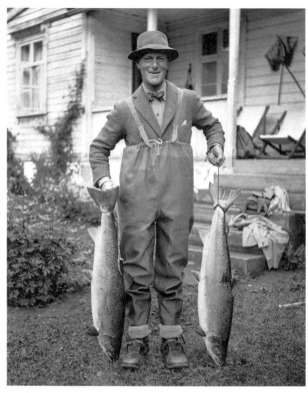

↑ Fisherman, United States, 1930

« THE BEST WAY TO PUT ON A BUCKET HAT IS ALMOST TO SLAP IT ON YOUR HEAD AND NOT LOOK IN THE MIRROR. »

STEPHEN JONES, BRITISH MILLINER

### A PLACE IN THE SUN
During WWII, the U.S. Army introduces the bucket hat to protect its troops from the sun. The Vietnam War popularizes the more rigid boonie hat, subsequently prized by those who bargain hunt in military surplus stores.

### IDENTITY ACCESSORY
Beyond its functional usage, it carries cultural and sometimes political symbolism. Starting in the 1940s in Israel, the tembel hat, of Turkish origin, becomes the emblem of the first settlers advocating a socialist and agrarian ideology. In South Africa, pantsula dancers in Johannesburg townships wear the ispoti.

### ECONOMY CLASS
Bucket hats express nonchalance and rebellion for young or nonconformist Americans, like writer Hunter S. Thompson. Meanwhile, U.S. TV promotes a silly, folksy archetype with the character of Gilligan in the 1960s sitcom *Gilligan's Island*. The bucket hat also conjures the tourist, the middle class, the Tour de France… It represents both the rebels and the masses.

### ROBERT…
The hat is called a bob in French (and occasionally in English), and legend has it that a man named Robert invented the first bob in 1924, with the nickname of its creator becoming forever associated with the hat.

### THE PULSE OF HIP-HOP
In the late 1970s, as an ally of the hip-hop movement (p. 316), it gains in popularity with young people who discover it thanks to the rappers of Run-DMC and Sugarhill Gang. Women who wear it project nonchalance. Now that kitsch and low-brow fashion are more popular than ever before, the bucket hat can reconcile its two identities: both corny and cool at the same time.

### … OR ROBERTS
Others claim bob comes from the nickname the French gave U.S. soldiers during WWII: the « Roberts ». As a nod, their wide-brimmed hats become known as bobs.

# FLIP-FLOPS
## WALK LIKE AN EGYPTIAN

| FACES OF | GISÈLE BÜNDCHEN, JENNIFER ANISTON, BRAD PITT |
|---|---|
| PODIUM | MARNI, ISABEL MARANT, JACQUEMUS |

The sandals are adopted as early as prehistory for their simplicity and functionality. Originally constructed with natural materials, by the 20th century, they are all-synthetic, and are an essential element of leisure society.

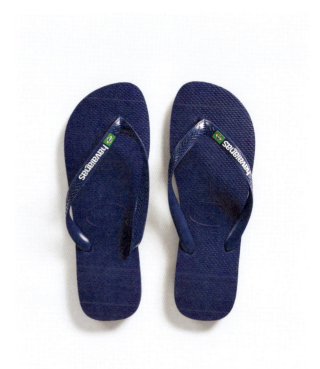

↑ Brazil Logo Flip-Flops, Havaianas

« I AM PHYSICALLY ALLERGIC TO FLIP-FLOPS. »

KARL LAGERFELD

### WHAT COULD BE SIMPLER?
Flip-flops (or thongs, as they used to be called) are age-old basics: a flat sole and a strap that attaches between two toes. Unsuitable for the cold and considered primitive, they are abandoned as modernizing society favors more elaborate shoes with fuller coverage, especially in Europe.

### A JAPANESE FLIP-FLOP
Neoprene thongs, likely inspired by Zoris and Getas (p. 32), are industrialized in 1940s Osaka thanks to synthetic rubber developed during the war. The Japanese swim team wears them in the 1956 Melbourne Olympics, inspiring other athletes to do the same.

### THE CALL OF THE BEACH
In the 1960s, as wardrobes become simpler, flip-flops invade American beaches. In 1962, Scotsman Robert Fraser decides to create his own rubber version after observing a Japanese pair in Hawaii. Living in Brazil at the time, he establishes the brand Havaianas (« Hawaiian » in Portuguese), which becomes the standard footwear of local culture, falling somewhere between cliché and authenticity, sandy beaches and nonchalance. In the 1990s, the Brazilian flip-flops circulate globally, thanks to a marketing campaign, the 1998 World Cup, and the popularity of Brazilian models. As a fashion accessory, they are playful, universal, and symbolic of travel and leisure.

### CULTURAL CONTRADICTIONS
Their symbolism is varied. Whether everyday shoes, an occasional pleasure linked to vacation, or tokens of humility when worn by spiritual and religious figures, they stretch between jubilance and banality on one hand and exoticism and cultural appropriation on the other.

### NICKNAME
During the Vietnam War, U.S. soldiers notice the strappy sandals worn by Vietnamese rice farmers. The soldiers nickname them thongs (a thong is a strip of leather or hide used to fasten something).

# BANDANA
## A SMALL SQUARE WITH A BIG STORY

| FACES OF | TUPAC, MADONNA, AXL ROSE |
| PODIUM | LOEWE, SACAI, CHILDREN OF DISCORDANCE |

Indians have created colorful scarves decorated with hand-printed patterns since antiquity. In Sanskrit, the prefix *bandh* means « to tie », and the bandana is all about ties that bind. The English and the Dutch export these textiles under the name bandana in the 17th century.

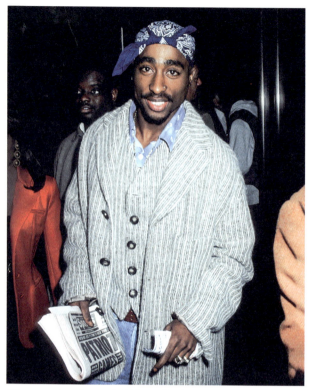

↑ Tupac, *on the red carpet for* I Like It Like That, New York, 1994

### « BETWEEN TIMELESSNESS, AUTHENTICITY AND MODERNITY. »
CALVIN KLEIN

**MELTING POT**

In the 19th century, Europeans become fond of printed Indian shawls when Napoleon's men bring them back home in memory of their expeditions to Egypt. Meanwhile the English industrialize and popularize paisley, of Iranian origin, on squares of cotton that are dyed Turkey red and that mimic Indian scarves. A bandana with multicultural influences takes shape.

**THE GREAT WEST**

In 1775, the English prohibit textile printing in the American colonies. In protest, Martha Washington has a linen bandana made in the image of her husband, George Washington. The first American bandana establishes a symbol of political dissent that will continually be brought back to life. Further West, inspired by Spanish peasants and the scarves of German immigrants, American cowboys use them to protect themselves from dust and sun.

**MASCULINE PROPAGANDA...**

Hollywood cowboys of the 1920s and 1930s transform the bandana into the archetype of a slightly rebellious masculinity.

**... FEMININE PROPAGANDA**

Patriotic service gives it a new purpose in WWII: to protect the hair of women replacing men in the factories, including feminist symbol Rosie the Riveter.

**ICONIC BANDANA**

**Shape:** square

**Dimensions:** 20-22 inches per side (50-55cm)

**Colors:** 3 colors, including black and white

**Pattern:** paisley

**SENSE OF BELONGING**

A symbol of identity, it participates in the erotic language of the gay community in the 1970s. Its colors and positioning express preferences and practices. Later, it accompanies rockers, as well as rappers inspired by gangs. A signifier of affiliation, occasionally bourgeois, often dissenting, it is imbued with political meaning. It protects, masks, and exalts rebels in protest all around the world.

# TIE ME UP

## A CODED HISTORY

① 

**A BANDANA AROUND THE NECK**

*In the original version, like the cowboys who raised it over their mouths.*

② 

**STILL AROUND THE NECK**

*But this time in a more classic and universal style.*

③ 

**KNOTTED AT THE BACK OF THE HEAD**

*For a look inspired by the hippies and rockers of the 1980s.*

④ 

**À LA TUPAC**

*Wrapped around the forehead – it's the rapper who brought the style, popular in gangs, to the mainstream.*

⑤ 

**KNOTTED UNDER THE CHIN**

*And why not wear a bandana as a headscarf?*

⑥ 

**AROUND THE KNEE**

*The choice of rockers is inspired by hard rock traditions.*

⑦ 

**IN THE BACK POCKET**

*In the gay community, especially in the 1970s, flagging (or the hanky code) indicated interest and preferences in sexual practices.*

⑧ 

**TIED AROUND THE WRIST**

*Also inspired by rock traditions, it's a sign of recognition of the wives and girlfriends of gang members.*

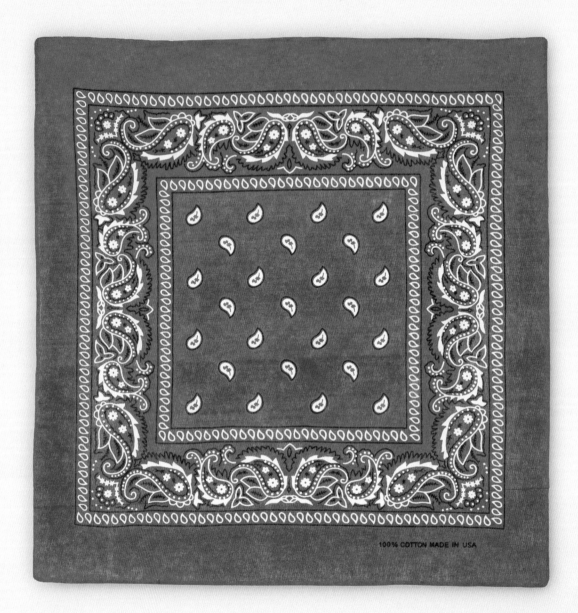

↑ Traditional paisley bandana

→ Vultee Aircraft Factory worker, Nashville, Tennessee, *photo by Alfred T. Palmer*, 1943

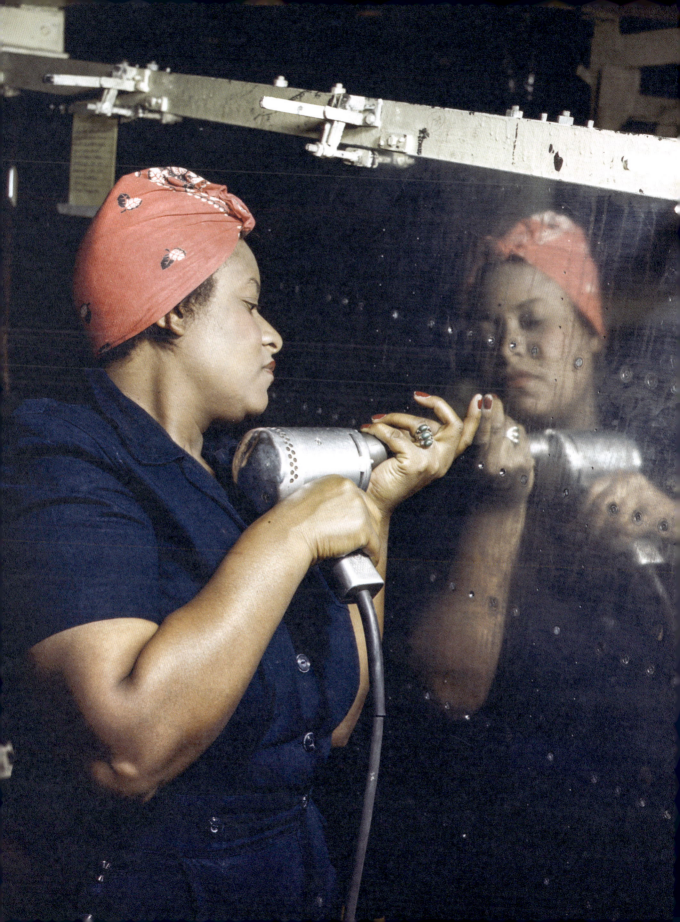

# TWEED JACKET
## ACCESSIBLE ARISTOCRACY

| FACES OF | PRINCE CHARLES, DAVID BECKHAM |
| PODIUM | MIU MIU, RALPH LAUREN, VIVIENNE WESTWOOD |

In the 18th century, Irish and Scottish peasants need suitable clothing. The *tweel* (Scottish for « twill ») is born: a thick woven wool with diagonal ribs. At the end of the 1820s, an English merchant misinterprets his supplier's handwriting and renames the fabric « tweed ».

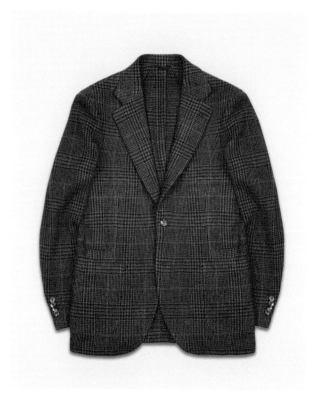

↑ Prince of Wales Check Tweed Blazer, Drake's

### PERSONALIZED TWEED
As interest in outdoor activities develops, the upper classes adopt the robust and warm tweed to hunt and fish. Aiming to stand out, many landowners wear a distinctive tweed, like a tartan. Tweed also adopts vegetal and earthlike shades and is worn as camouflage.

### FULL SPEED AHEAD
It moves beyond the countryside and into recreational sports like golf and tennis, extending into the middle class and leaving behind the confines of the aristocratic world. Even more revolutionary, the English adopt it for biking.

### FAMILIES OF TWEED

**Donegal tweed :** from Ireland, rustic and sporty

**Saxony tweed :** softer and more lightweight

**Cheviot tweed :** after the sheep of the same name; thicker

**Shetland tweed :** soft and fine

**Sporting tweed :** used as camouflage for hunting

### GENTLEMAN FARMER
At the turn of the century, the rustic charm of the tweed jacket captivates the upper and middle classes. It becomes a staple of men's wardrobes, even if rarely worn in town. King Edward VII makes it the pinnacle of chic.

### LADIES' SUIT
Gabrielle Chanel introduces it into high fashion. In the 1920s, her lover, the Duke of Westminster, invites her to his Scottish estate, and she borrows his tweed jackets to go hunting with him. True to form, the designer draws inspiration from the masculine garment when she designs her iconic 1950s suit (p. 203).

### WILD SIDE
In the 1960s, tweed takes on a darker image, and then in the 1980s, the punk designer Vivienne Westwood pays homage to it (p. 294). But it isn't until the 2010s, with TV series like *Downton Abbey* and *Peaky Blinders*, that it seduces a new generation passionate about pop culture.

### BEST OF THE BEST
Woven wool labeled Harris Tweed is the most prestigious of tweeds. Crafted on a small rocky island in Scotland, it is legally protected from imitation and subject to strict fabrication rules. It is recognizable by its logo in the shape of an orb. In 1987, Vivienne Westwood creates a Harris Tweed collection in tribute to the fabric.

# BOOTS
## SEVEN LEAGUES

| FACES OF | JULIA ROBERTS, BEYONCÉ, MICK JAGGER |
|---|---|
| PODIUM | BALENCIAGA, CHANEL, BALMAIN |

The first soft leather boots appear in antiquity in the harsh climates of the Asian continent. In the Middle Ages, boot-like shoes become popular. For men, they are helpful for hunting, fieldwork, and military life. For women, the velvet versions are a sign of prestige.

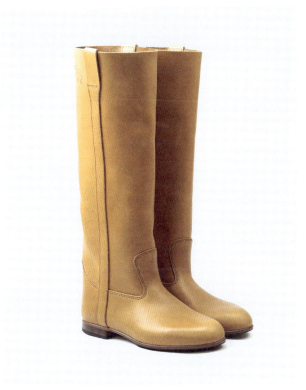

↑ High Ella Boots, La Botte Gardiane

« I PREFER A GOOD PAIR OF BOOTS TO SHAKESPEARE. »

LEO TOLSTOY

### MUSKETEER STYLE
Boots, sometimes thigh-high, become popular in the 16th century, especially among men. Protective and imposing, they confer an aura of virility and power to those who wear them; even civilians can feel like warriors. In the 17th century, the look becomes equestrian, and men wear their pants tucked into leather boots.

### COWBOY BOOTS
The American Civil War develops boots' popularity. At the end of the 19th century, companies create their first models, and the cowboy boot is born. It has a thick angled heel and a pointed toe and is sometimes decoratively engraved. With the popularity of westerns and the rodeo in the 1930s and 1940s, cowboy boots become everyday wear.

### MILITARY ACCESSORY
When Louis XIV dictates French aristocratic style, boots are left behind in favor of high-heeled shoes. Now reserved for fighting wars or riding horses, their military association offers boots a moment of glory. The boot is cavalry, Prussian, or esquire. Its form distinguishes military ranks. It's the shoe of conquest: Napoleon turns it into a uniform.

### AMONG THE WOMEN
The industrial revolution boasts a different victory, that of money. Boots are replaced by shoes that match the dark suits of the urban bourgeois aesthetic. In the second half of the 19th century, women also adopt the boot. Alluring, sensual, and flirtatious, their high-heeled boots are lace-up, evoking the corset.

### GOLDEN AGE
The 1960s revive boots as a fashionable accessory. They become ankle boots among men, especially in England, where Chelsea boots are the mod footwear of choice. Women opt for an androgynous look with boyish flat boots. In the 1970s, boot styles signal an era of liberated bodies and minds. Hotpants and miniskirts are worn with tall, sometimes platform, boots.

### FROM PADDOCK TO PAVEMENT
Boots are appreciated by horse riders and soldiers beginning in the Middle Ages because they protect their clothing and their shins from friction. In the 19th century, leather riding boots are standardized: most often black, recognizable by their straight cut and asymmetrical boot top. They stand out as a marker of elite recreational activities. In the early 1970s, as a nod to its unique link to the equestrian world, Hermès turns the riding boot into a high-fashion accessory with a clasp that evokes the Kelly bag.

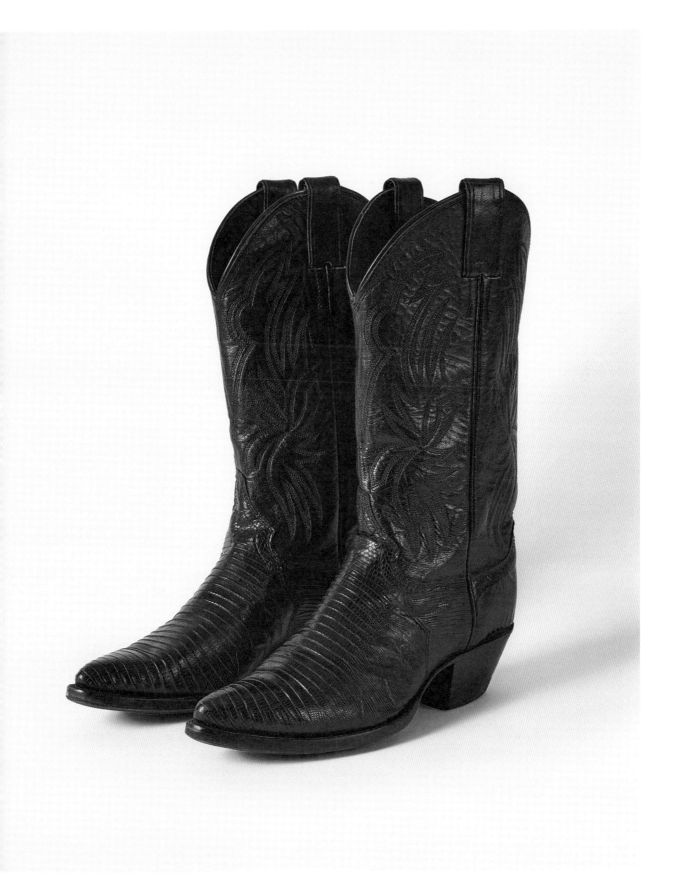

← George Bush, *Air Force Two*, 1985

↑ Vintage cowboy boots

# CAFTAN
### EVENING DRESS

**FACES OF** ........... ELIZABETH TAYLOR, LEILA SHENNA, TALITHA GETTY

**PODIUM** ........... ELIE SAAB, VALENTINO, NAEEM KHAN

The caftan appears in 8th-century Persia, probably influenced by the prehistoric tunics of the Far East. Today, we are familiar with the feminine Moroccan version, though it was originally a long robe worn by men.

↑ *Hepburn long Caftan*, Norya Ayron

**GREAT MEN**

A diplomatic gift in the Ottoman Empire, it travels from court to court, often adopted by Venetian aristocrats who appreciate the embroideries and shimmering silks. This long, collarless tunic with long, loose sleeves (sometimes sleeveless) is open at the front and adorned with cords and trimmings that define the wearer's status. Some versions intersect slightly at the hips, evoking equestrian styles of Asia Minor.

**FETISHIZED ORIENT**

Paul Poiret, influenced by the Ballets Russes in the 1910s, particularly their performance of *Scheherazade*, introduces many traditional ethnic designs that are closer to theatrical costumes than items of clothing. His controversial creations contradict the conventions of women's fashion and exemplify the European tendency to appropriate « exotic » clothing.

**EXOTICISM IN FASHION**

In the 18th century, under Louis XV, French aristocrats are captivated by faraway lands and folklore. In the privacy of their homes, women wear reinterpretations of caftans that reflect growing exoticist trends that continue into the 19th century.

**LUCKY CHARM**

The Moroccan ceremonial caftan is worn with a *mdama* (belt) in the form of a turtle, meant to protect from *aïn* (envious eyes) and bring happiness.

**CONQUERING WOMEN**

The expansion of Islam and the Ottoman Empire standardizes the caftan in North Africa. The Moroccan caftan is born thanks to Moorish artisans, experts in textile art and embroidery, who migrate to Morocco. Entering women's wardrobes in the 18th century, it becomes popular in the 19th century as an indoor garment for wealthy city-dwellers, who wear richly adorned velvet versions.

**HAUTE CULTURE**

The new generation abandons the caftan in everyday life, and it becomes a ceremonial garment, endlessly revisited. At the end of the French Protectorate in 1956, many Moroccan women designers, like Zhor Sebti and Tamy Tazi, establish a local haute couture that modernizes Moroccan heritage and artisanry, bringing it back into style.

**BOHEMIAN BECOMES CHIC**

In the 1960s, hippie culture brings a bohemian aesthetic that borrows from cultures around the world. European celebrities and free spirits wear tunics and caftans inspired by Arab traditions. Western designers like Ossie Clark, Yves Saint Laurent, and Halston appropriate the style, offering luxury versions that are flowy, opulent, and colorful.

# OVERALLS
## HARD AT WORK

FACES OF ............ KATHARINE HEPBURN, COLUCHE, WILL SMITH
PODIUM ............ VETEMENTS, JEREMY SCOTT, ISABEL MARANT

Although we associate overalls (or dungarees) with the carefree days of childhood, their origins are much more laborious. Embodying opposite extremes, they are the comfort clothing of children's play and the workwear of the Industrial Revolution's assembly lines, where they participate in human exploitation.

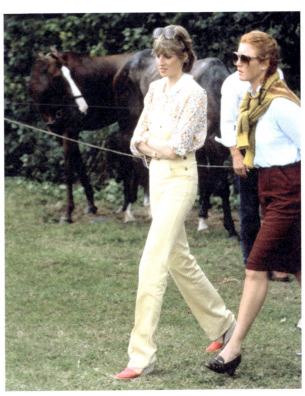

↑ Lady Diana Spencer, *Cowdray Park Polo Club, Midhurst*, 1981

### FROM CARPENTER PANTS TO A BIB AND STRAPS

In France in 1844, Louis Lafont devises a pair of pants for his carpenter father-in-law; they are relaxed in the leg, slightly tapered at the ankle, and have a pocket at the waist for easy access to tools. In 1896, his grandson, Adolphe, establishes the workwear brand Lafont. He introduces his grandfather's model after adding a bib with straps, thus giving rise to cotton overalls. He calls them « *cotte à bretelles* » (bib pants).

### WHAT A MESS

Overalls are originally worn over workers' clothes. The French word « *salopette* » references the term « *salope* », which means grimy or dirty. The overalls protect the clothing underneath from becoming sloppy.

### MODERN TIMES

Across the Atlantic, Levi Strauss (p. 136) creates his first denim overalls. They are the garment of choice for laborers, miners, and especially sharecroppers. Overalls are the incarnation of mechanical or manual labor. They characterize images of the Great Depression and symbolize assembly line work, exemplified by Charlie Chaplin in *Modern Times*.

### ROOM FOR WOMEN

In the 1930s, they are revisited as a fashion statement. During World War II, as women replace men in the factories, overalls become their uniform. After the war, the number of models multiplies, and in 1960, children appropriate overalls as the ideal partner for messy play.

« BUT HIS SERVICE WAS TO ART, NOT TO CHURCH OR COUNTRY. HIS BEADS, DUNGAREES, AND SHEEPSKIN VEST REPRESENTED NOT THE COSTUME, BUT AN EXPRESSION OF FREEDOM. »

PATTI SMITH, *JUST KIDS*

### NO ONE ESCAPES

They are sporty and unisex, glamorous in nightclubs, impertinent in magazines, and radical when they express social dissent. Multifaceted and fluid, they express an asserted and embraced point of view.

### REBRANDED

When Lafont overalls arrive in the U.S., they are called « elephant » overalls because of the way Americans pronounce the name on the label: A. Lafont.

### RECOGNIZABLE

In 1974, the French comedian Coluche wears overalls as his stage costume. The wink to the world of labor is incontestable. He chooses a blue Lafont model with white stripes, which becomes so quintessential to his image that when Guillaume Werle erects a sculpture in his honor in Montrouge, France, in 2011, only his overalls are represented.

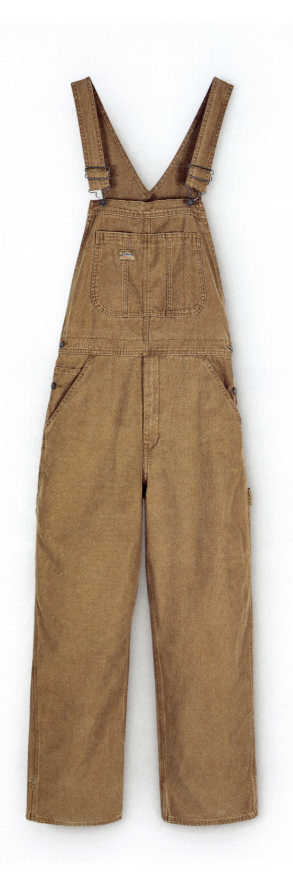

Al Pacino on the set of *Serpico*, 1973

↑ **Classic Duck Canvas Overalls**, Dickies

# BIRKENSTOCKS
## UGLY DUCKLING

| FACES OF | KATE MOSS, GRACE CODDINGTON, RICK OWENS |
|---|---|
| PODIUM | NARCISO RODRIGUEZ, CELINE, DIOR |

At the end of the 19th century, Konrad Birkenstock develops orthopedic soles, bucking the trend of industrialized and symmetrical footwear. In 1963, his grandson launches the first one-strap model: the Madrid. These early designs are marketed as medical.

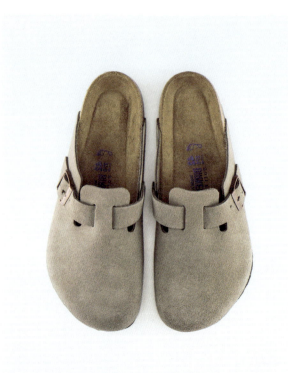

↑ Boston Suede, Birkenstock

### FLOWER POWER
Circumstances favor the success of these sandals – they appeal to hippies (p. 326) who need comfortable and durable shoes as they travel the world. Even more critical to their success, Birkenstock aims for an ecological and local approach to fabrication.

### ELEGANCE IS OBSOLETE
European protesters, particularly the revolutionaries of May 1968 in France, wear them as symbols of nonconformity, mocking the elegance that France prides itself on. Meanwhile, they arrive in the U.S. and are appreciated by those who want to stand apart from the mainstream. The simple orthopedic soles come to represent the rejection of social and stylistic norms.

### A RENAISSANCE
Their bohemian popularity doesn't protect Birkenstocks from earning a reputation as unflattering and inelegant shoes. But in the 1990s, minimalism and shapes borrowed from sportswear are in style. Birkenstocks are seen on the runways, and Kate Moss wears them for *The Face*. They become cool, and the brand widens its range of models.

### REDEFINING BEAUTY
The fashion house rides the wave of new attention with multiple trendy collaborations, and a new clientele is established. The 2010s are all about comfort, and young buyers set the tone (p. 312). Balenciaga reinterprets Crocs in a luxury version, and Celine creates fur-lined sandals. Wearing Birkenstocks shifts from tacky to transgressive and ultimately becomes highly desirable.

---

**COLLAB CHIC**

**2003 :** Robin Williams, Cindy Crawford and Whoopi Goldberg
**2018 :** Rick Owens
**2019 :** Valentino
**2019 :** Il Pellicano (iconic Italian luxury hotel)
**2020 :** Proenza Schouler
**2021 :** Jil Sander

---

« BASICALLY, BIRKENSTOCKS ARE LIKE JEANS, FUNCTIONAL AND SEXY. MAYBE BIRKENSTOCKS ARE EVEN THE SEXIEST SHOES EVER. »

RICK OWENS

---

**NEW FOOTING**

Proof that ugly has become alluring, the luxury group LVMH acquires the Birkenstock brand in February 2021. The Group's flagship brand, Dior, unveils new models in the Fall/Winter 2022 menswear collection.

# BACKPACK
## CARRY YOUR BAGGAGE

| FACES OF | ANDY WARHOL, MARIAH CAREY |
|---|---|
| PODIUM | RICK OWENS, GUCCI, PRADA |

Humans have been transporting things since prehistory. While domesticated animals shoulder some of the load, humans carry objects, food, and children on their backs with the help of wicker baskets, textile wraps, or frames made of wood. Beginning in the 19th century, soldiers and laborers use a clever vessel: the haversack.

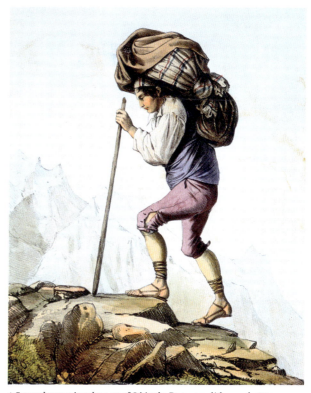

↑ Smuggler passing the port of Oô in the Pyrenees, *lithograph*, 1834

### TO EACH THEIR BAG
With the ensuing development of numerous backpack brands, backpacks become lighter and more practical. Initially utilitarian, they also evolve into a social accessory. In the 1980s and 1990s, students wear colorful backpacks to identify themselves to a group: the rebellious only need one strap, the reasonable wear it high on the back, and the audacious let it hang very low.

### FROM SCHOOLYARD TO CATWALK
The functional and juvenile backpack matures and becomes a luxury item. Miuccia Prada (p. 208) is the first to grasp its potential. She joins the family group of the same name in 1977, and in 1984, she revives the brand when she designs a resistant nylon backpack featuring the Prada logo. It attracts young buyers and becomes a best seller.

### ADVENTURE IS ADVENTURE
In the 20th century, with its greater emphasis on recreation, many people take up hiking and see themselves as adventurers or mountaineers. In 1909, Norwegian inventor Ole Ferdinand Bergan patents a canvas backpack with a curved metal frame and leather straps. In France, Lafuma develops models with a more modern feel in the 1930s.

#### HIKER
In 1991, archaeologists discover the mummy of a prehistoric man who lived in the Alps between Austria and Italy between 3400 and 3100 BC. They also find the remains of a bag made of an organic material, animal skin, or textile bound to a wooden frame. This is believed to be the first backpack.

### MODEL STUDENTS
In 1967, American designer Asher « Dick » Kelty invents the first zippered nylon backpack with an internal frame. It appeals to American university students, tired of carrying their books with a strap. The outdoor equipment brand JanSport is the first to pick up on the potential of this new clientele and sets up a shop at the University of Washington bookstore.

#### FROM UTILITY TO LUXURY
In 1935, Wallace Hume Carothers invents nylon, and it becomes the synthetic, industrial replacement for silk, particularly in stockings. Prada launches its backpack in 1984, its menswear collections around 1990, and its Prada Sport line in 1998, turning nylon into a signature of the brand and a prominent feature of the luxury sportswear aesthetic.

↑ Little America Backpack, Herschel

→ Rock-climbing, *Baff National Park*, Alberta, Canada, 195

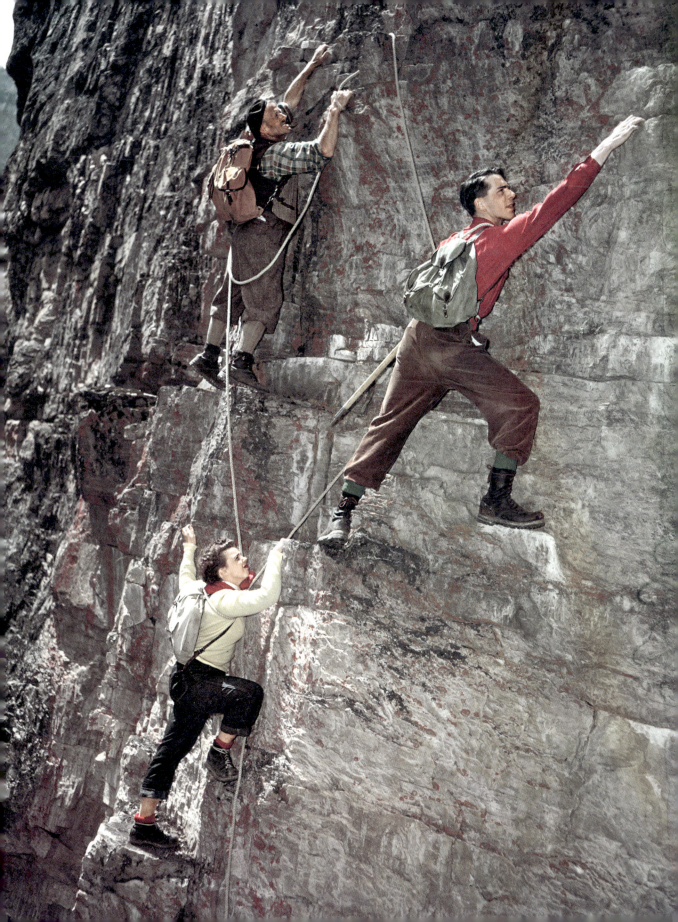

# KHAKIS
## ALL-PURPOSE

FACES OF .......... PAUL NEWMAN, JOHN KENNEDY, DUSTIN HOFFMAN

PODIUM .......... NARCISO RODRIGUEZ, CELINE, DIOR

Khaki pants first appear in the 1840s, when Lieutenant-General Sir Harry Burnett Lumsden, stationed in the Punjab region during the British Empire's expansion into India, Pakistan and Bangladesh, notices how unsuitable the British Army uniform is.

↑ Khakis, Doursoux Military Surplus

### « KEROUAC WORE KHAKIS. »

GAP, 1993

### INDIAN PYJAMAS

Gone are the red wool jackets, too warm and easy to spot on secret missions. Lumsden is inspired by an ochre cotton outfit worn in the Punjab region, which he tints with a dye from palm trees. Named khaki (« dusty » in Urdu, the language spoken in Pakistan and Northern India), it becomes the British Army's official uniform in 1885.

### KHAKI TO CHINO

Khaki becomes the official military shade, and khakis become chinos during the 1898 Spanish-American War. American soldiers based in the Philippines replace their wool uniforms with cotton. Because the light-colored, straight-leg pants they brought back from the Philippines were produced in China, they are pejoratively referred to as chinos (Spanish slang for « Chinese »).

### ADVENTUROUS INVADERS

At the turn of the twentieth century, khakis make their mark in the context of exploration, always in a colonialist climate, particularly in Africa, where they accompany Westerners on hunting expeditions. They are the idealized uniform of the adventurous traveler, like the characters in Karen Blixen's 1937 novel *Out of Africa*.

### IVY LEAGUE

In the Second World War, khakis are part of the official military uniform. They enter civilian life in the 1950s; relaxed and lightweight, they are worn by the rebellious youth of Jack Kerouac's Beat Generation. Following the G.I. Bill, a 1944 law designed to finance the studies of military veterans, the rugged pants enter the university. Sensible and casual, khakis fit right into Ivy League style (p. 334).

### FRIDAY WEAR

Ivy style becomes preppy in the 1970s when Ralph Lauren embraces this relaxed, elegant American aesthetic. In the 1990s, khakis replace stiff suits in American offices. They are accommodating and versatile, and brands like Gap and Dockers establish them as a symbol of the era's minimalism.

### TOP OF THE LIST

In 1986, Levi Strauss & Co. launches the brand Dockers. During this materialistic and conservative decade, the American man sports khaki pants as the polished garment of his time off from work. Dockers is first in line for « Casual Fridays » in the 1990s, which encourages office workers to drop the suit jacket on Fridays – or even every day of the week. The brand is so closely associated with khaki pants that khakis are sometimes simply called « dockers ».

# SWEATSHIRT
## BREAKING A SWEAT

FACES OF ......... JENNIFER BEALE, SYLVESTER STALLONE, LADY DI
PODIUM ............... ASHISH, VETEMENTS, ANTONIO MARRAS

American athletics and the U.S. military share the genesis of two iconic contemporary wardrobe pieces - both combining comfort and practicality. In the 1920s, recreational sports grow in popularity, and the sweatshirt develops as the successor of the T-shaped undershirt.

↑ Varsity sweatshirt

« I CAME OUT HERE WITH ONE SUIT AND EVERYBODY SAID I LOOKED LIKE BUM. TWENTY YEARS LATER MARLON BRANDO CAME OUT WITH ONLY A SWEATSHIRT AND THE TOWN DROOLED OVER HIM. THAT SHOWS HOW MUCH HOLLYWOOD HAS PROGRESSED. »

HUMPHREY BOGART

### WOOL IS OVER
American student Benjamin Russell Jr. notes that it's uncomfortable to play football in a warm, rough wool sweater (p. 156). With his father, who heads a company that makes cotton underwear, he comes up with a loose-fitting, collarless top made of the same material. In 1930, the sweatshirt is born, and with it, the family business: Russell Athletic.

### PROCLAIMING YOUR LOVE
The sweatshirt becomes a staple in universities and in the U.S. Army. Champion Athletic Apparel offers flocked versions, turning it into a sign of belonging. After the war, flocked sweatshirts leave the athletic field when high school and college student athletes decide to offer them to their girlfriends as a narcissistic token of love. It becomes a status symbol.

### BY THE SWEAT OF YOUR BROW
The sweatshirt gets its name from the cotton fleece's capacity to absorb sweat. It is for this reason that the historic model features a V-shaped seam on the front of the collar: the triangle is designed to collect perspiration from the neck. It also prevents the collar from becoming deformed if it is pulled by another player during the match.

### HOODIES
From the 1960s onwards, pop culture intensifies the celebrity of athletes, and the popularity of the sweatshirt intensifies as well—especially the hooded version created by Champion in 1934. Initially used by street artists to conceal themselves from the police, it is part of a cultural movement in the 1970s with the emergence of hip-hop (p. 316). It becomes iconic in 1976 with the release of the film *Rocky*.

### GENERAL PUBLIC
When hip-hop enters the mainstream, becoming a massive cultural and economic phenomenon, brands like Calvin Klein, Ralph Lauren, and Tommy Hilfiger embrace the sweatshirt. The 1990s turn it into an essential of the teenage wardrobe, and Normcore (p. 312) transforms it into the archetype of under-the-radar style.

### THE HOOD OF DISCORD
The hoodie is often negatively judged. In 2005, an English shopping mall bans them from being worn. In 2012, it makes headlines when George Zimmerman kills Black American Trayvon Benjamin Martin. This racially motivated crime leads to the « Million Hoodie March » in New York, a demonstration for all young people stigmatized because of their skin color and their sweatshirts.

# SARI
## SYMBOLIC AND ORDINARY

| FACES OF | DEEPIKA PADUKONE, PRIYANKA CHOPRA |
| --- | --- |
| PODIUM | MALINI RAMANI, YSL, MANISH ARORA |

« Sari », which denotes an Indian draped garment rooted in antiquity, comes from the Sanskrit word *sattika*, meaning « woman's garment ». The Mughal Empire (aided later by British modesty) establishes the sari's appearance as we know it today.

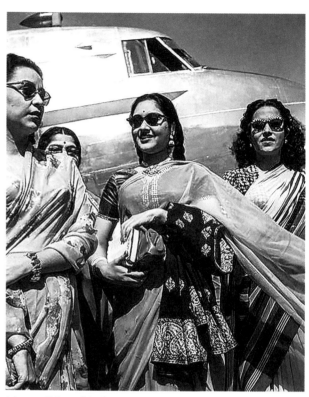

↑ Actress Vyjayanthimala, International Film Festival, Delhi, 1952

### DRAPED BODIES

In ancient times, in all civilizations, clothes are worn draped – from the Roman toga to the kalasiris worn by Egyptian women. The Asian continent is no exception: the sari is a strip of fabric, 5 to 9 meters long, that women wrap around themselves. There are more than a hundred ways to drape it – the most traditional being the « Nivi » style – often without pins or clips. Its shapes, colors, and patterns reveal the geographical, social, and cultural origins of those who wear it.

### HIDE THAT SKIN…

The original sari reveals the skin of the upper body and the ankles. But under the domination of the Victorian era's moralizing and prudish British Empire, a bodice and petticoat are added, and the sari is lengthened.

### EVERYDAY GARMENT

Even if today, on the Indian subcontinent, as in many other countries, Western-style influences what young people wear, the sari is not restricted to its role as a symbol of tradition or folklore. It is adaptable. Traditionally made of silk, linen, or cotton, it is now available in synthetic textiles.

#### FROM MODEST TO FREE

The « Nivi » is developed by Jnanadanandini Devi, a Bengali social reformer who finds the traditional sari immodest. In 1864, she is inspired by Parsi women wearing their saris with a bodice and petticoat. The diffusion of images of women wearing this type of sari during demonstrations in favor of Indian independence popularizes the sari in the early 20th century.

### PERSONAL AND PUBLIC LEGACY

Revisited by designers but passed down from woman to woman, it is, above all, a guardian of ancestral memory. Functional, sentimental, and dazzling when worn for grand occasions, it participates in constructing personal identity and collective pride.

#### THE WAR OF THE ROSES

In 2006, Sambat Pal founds the Indian feminist organization Gulabi Gang (Gulabi means « pink » in Hindi). The group aims to protect women from violence and oppression. Its members, all women, wear a distinctive pink sari and wield a *lathi* (a stick used in traditional Indian combat).

# SOFTLY DRAPED

## STEP BY STEP

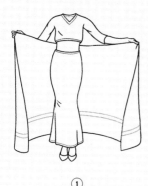

① Ensure the sari's embroideries are on the outside.

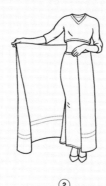

② Bring in one side of the sari and hold it in place by sliding it into the petticoat.

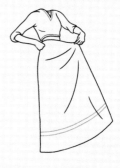

③ Wrap the sari tightly around the lower part of the body, leaving a glimpse of the feet and ankles.

④ The most difficult part is creating the pleats.

⑤ Pinch the fabric between the thumb and the index to create 5 to 7 straight, even pleats.

⑥ The pleats should be snugly tucked into the petticoat. Use a safety pin.

⑦ Gather the remaining fabric and drape it around the hips, holding it firmly with one hand.

⑧ Bring the fabric over the shoulder. This part is called the « pallu ». The style varies as desired.

⑨ The pallu can be discreetly pinned to the bodice to fix it in place, or folded in 7 or 8 vertical pleats.

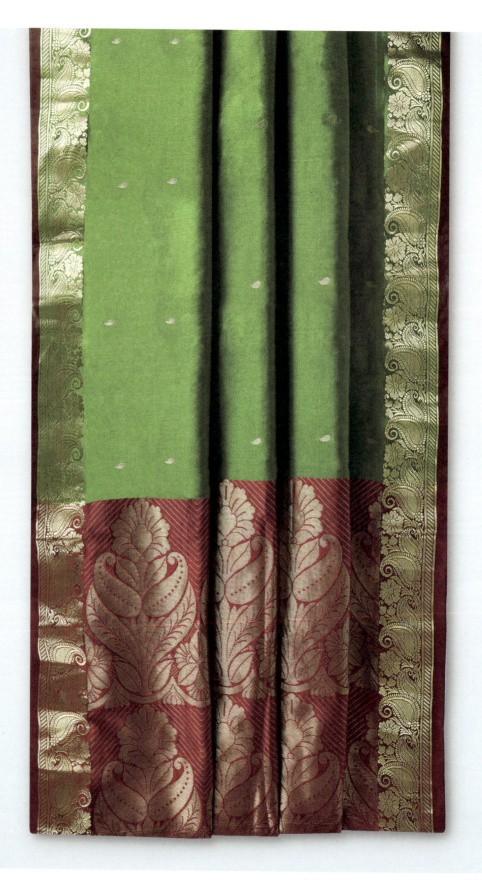

↑ Traditional Indian sari, India Silk

→ Arshi sari, Row Mango

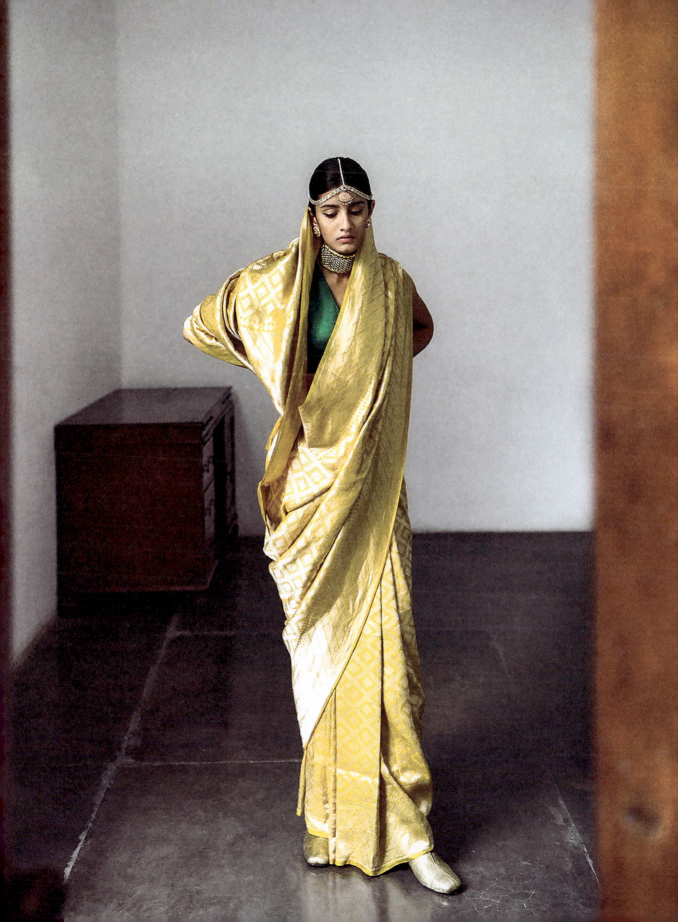

# MILITARY JACKET
## PRO OR ANTI WAR

| | |
|---|---|
| FACES OF | JIMI HENDRIX, ROBERT DE NIRO, JOHN LENNON |
| PODIUM | MAISON MARGIELA, SACAI, BALMAIN |

Fashion and war are two partners whose dialogue is surprisingly persistent. In the 20th century, armies become more professional, and their wardrobe penetrates the civilian world, sometimes in a countercultural context. After the Second World War, military surplus proliferates, and a new style emerges.

**JUNGLE JACKETS**

The cotton khaki jackets are some of the most popular surplus items. Developed in WWII, after the conflict of 1914 revealed the discomfort of the military uniforms inherited from the 19th century, the jackets reinforce the identity of the U.S. Army. The M43, M51, M65, and other jungle jacket models stand out in the military landscape.

**APOCALYPSE NOW**

Swinging London revives military coats with braided frog fasteners inspired by the Hungarian Hussars of the 18th century, as demonstrated by the album cover of the Beatles' *Sgt. Pepper's Lonely Hearts Club Band*. But in the U.S., it's the jungle jacket that proliferates. Reclaimed by hippies (p. 326) as an anti-war symbol, the jackets also leave their mark on Hollywood pop culture, appearing in iconic films that treat the Vietnam War, like *Apocalypse Now* and *M\*A\*S\*H*.

**FORBIDDEN TO FORBID**

Integrated into civilian wardrobes, the military jacket is adopted by rebels and protestors, even taking part in the May 1968 demonstrations in France. Stripped of its aggressive functions, it nonetheless exhibits a fighting spirit that appeals to the feminists who also wear it.

More traditional personalities, such as Ivy League students (p. 334) and even Woody Allen, try it for its relaxed chic.

**TEEN SPIRIT**

It isn't until the 1990s that it shakes off those associations. It becomes grunge (p. 338), and teenagers adopt it. In the 2000s, it is recuperated by the fashion industry.

### MOVIE STAR

1970 : *M\*A\*S\*H*
1976 : *Taxi Driver*
1977 : *Annie Hall*
1979 : *Apocalypse Now*
1986 : *Platoon*
1987 : *Full Metal Jacket*
2021 : *Don't Look Up*

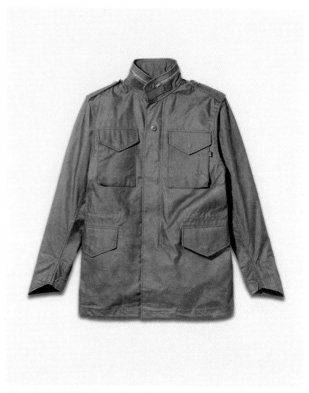

↑ Veste M-65 Field Jacket, Alpha Industries

### « YOU TALKIN' TO ME ? YOU TALKIN' TO ME ? YOU TALKIN' TO ME? »

ROBERT DE NIRO IN *TAXI DRIVER*

**DEVIATION**

I Was Lord Kitchener's Valet, a vintage shop founded in 1965 on Portobello Road in London, sells the first surplus items from the British Army. Musicians pour in: Eric Clapton, Mick Jagger, the Beatles, and Jimi Hendrix, whose military jacket with golden frog fasteners mocks the aggressive masculinity rejected by his generation.

# DESERT BOOTS
## AROUND THE WORLD

| FACES OF | WU-TANG CLAN, STEVE MCQUEEN, NAS |
| --- | --- |
| PODIUM | PAUL SMITH, ALEXANDER WANG, BOTTEGA VENETA |

In 1828, Cyrus Clark diversifies his tannery production and creates slippers from sheepskin scraps. A century later, his successor designs a soft leather ankle boot inspired by traditional South African shoes, which will anchor the reputation and identity of the family company.

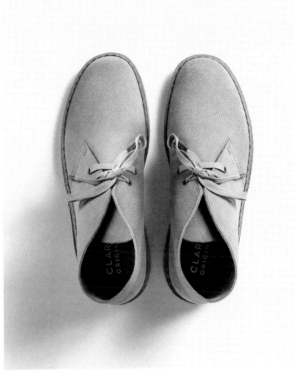

↑ Desert boots, Clark's

### TRENDSETTER
It is said that the Duke of Windsor created the trend of wearing *chukka* boots in town during his visit to the U.S. in 1924.

### DESERT SHOES
In the 18th century in Sub-Saharan Africa, early colonists discover comfortable rawhide ankle boots with gum, crepe, or leather soles. Perfect for walking in the desert, they are adopted by visiting foreigners. During the Second World War, Nathan Clark serves England in North Africa, and while searching in the souks, he notices ankle-high shoes adapted from South African vellies.

### CHUKKAS
Knowing he has discovered a successful shoe model, he presents leather ankle boots with a rounded toe and a crepe rubber sole at a trade show in Chicago in 1950: desert boots. In Europe, they appeal to postwar youth, and in Canada, the Army. They resemble chukka boots but have a sturdier leather sole, inspired by the boots worn by polo players and made popular in 1920 by the Duke of Windsor.

### CULT STATUS
George Harrison wears a pair of desert boots on the *Abbey Road* album cover.

### COOL OR RUDE ?
The American Beat Generation embraces the desert boot, especially the sand-colored model, worn with jeans and a plaid shirt. It's the uniform of nonchalance. Steve McQueen wears them, as do the mods (p. 304) in England and the rude boys in the streets of Jamaica. The Jamaican police use the boots to identify the rude boys among dance hall crowds.

### ALTERNATIVE
In 1967, Clark designs the more robust and geometrical Wallabees, which become the most successful model in Jamaica. The country's cultural influence is growing in the 1990s, and American hip-hop borrows its emblems: the boots are worn by the Wu-Tang Clan. Meanwhile, in the U.K., Richard Ashcroft wears them in his video *Bittersweet Symphony*.

### ENGLISH STAMP OF APPROVAL
As heirs to 1960s pop, English musicians of the 1990s, like Oasis, endorse desert boots, thus endorsing their history – a history of colonialism and adaptation.

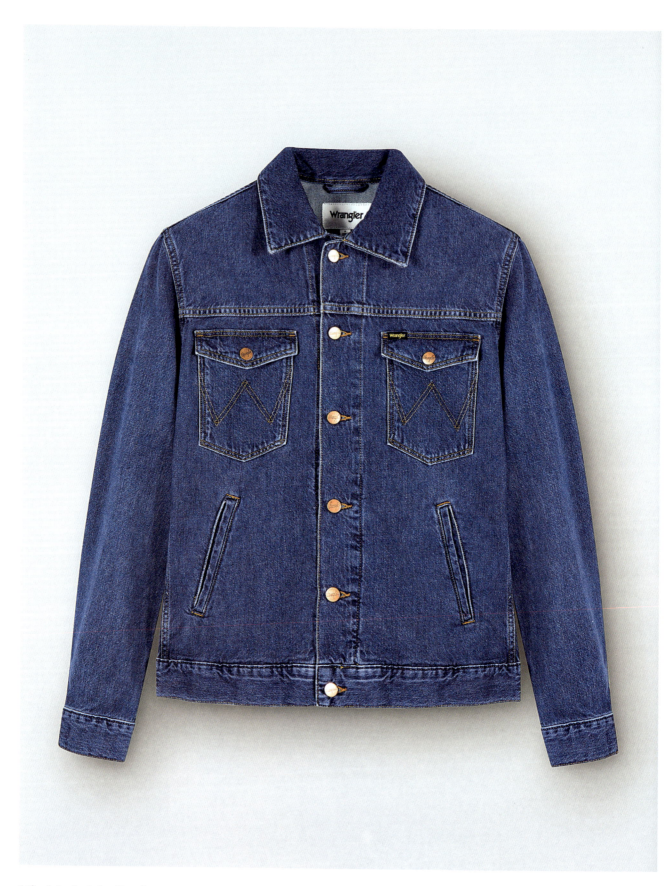

↑ Classic Denim Jacket, Wrangler

→ Marilyn Monroe on set, Nevada, 1960

# JEAN JACKET
## A JACKET FOR EVERYONE

| FACES OF | MARYLIN MONROE, JOHN LENNON |
| PODIUM | CELINE, BALMAIN, BALENCIAGA |

The jean jacket doesn't exist without the development of indigo dye. Denim begins with the color blue, which, when associated with sturdy fabric, is intrinsically linked with work across the globe. This particular blue garment becomes a fashion essential in the 20th century.

↑ Serge Gainsbourg, Jane Birkin, and Kate Barry, Paris, 1969

« THE WORLD IS BLUE, AND BLUE WILL ALWYS BE THE COLOR OF THE SECOND HALF OF THIS CENTURY, THAT WHICH COVERS EVERYONE WITH A UNIQUE SHADE. »

CHRISTIAN LACROIX

### CHORE JACKET
In the 19th century, Japanese firefighters wore a traditional short wool coat, sometimes dyed indigo blue, dating from the Edo period: the *hanten*. At the same time, the *bleu de travail* (p. 85), an indigo cotton or linen jacket, appears in France. In 1880, Levi's creates the Triple Pleat Blouse Jacket for miners and railroad workers. Made of thick denim fabric, it shares its aesthetic with Levi's jeans (p. 136).

### NICE AND WARM
Around 1943, Levi's launches its first lined models. Then, in the 1960s, they popularize jackets with sheepskin lining, commonly known as « sherpas, » suitable for residents of cold and remote regions of the United States.

### TRUCKER JACKET
The brand diversifies its line of denim jackets in the first half of the 20th century. Still, it's the 1967 Type III model, nicknamed the Trucker Jacket, that defines the style of the contemporary jean jacket: cinched at the waist, with two high pockets. In the movies, the jacket is seen on the cowboys of the 1930s, the rebels of the 1950s, and even on Marilyn Monroe, but it's not until the hippie movement (p. 326) that it really takes to the streets.

### MAKE LOVE NOT WAR
By adopting the jean jacket, hippies subvert its image. It becomes an emblem of the stereotypes and contestations of American culture, and a medium for slogans and messages.

### REBELS, ALL
It becomes associated with countercultural movements represented in movies and especially in music. It's seen on French rockers, punks in the 1970s, and teenage idols in the 1980s. It appears in hip-hop, grunge, and techno (see Styles, p. 301 and following). Revolutionary, essential, and adaptable, instead of taking sides, it binds them together.

### STREET STYLE
The jean jacket becomes universal, thanks to accessibility and broader visibility. The inventor of streetwear is the often-forgotten Black American designer, Willi Smith, who founds WilliWear in 1976. A pioneer, he establishes a brand composed of comfortable essentials that are practical and affordable. Fascinated by the myth of the cowboy, Willi Smith is one of the first designers to make denim a staple fabric and to anticipate hip-hop style (p. 316).

# TANG JACKET
## MISNOMER

FACES OF ......... YOHJI YAMAMOTO, JACK LANG, BEATLES

PODIUM ......... HUISHAN ZGHANG, GIORGIO ARMANI, YVES SAINT LAURENT

The Tang jacket, or *Tangzhuang*, has Manchu origins. Initially, it is worn as a riding coat (magua) over a long robe. It transforms from a symbolic cultural costume to a marker of class when the Manchus invade China and establish the Qing Dynasty in the 17th century.

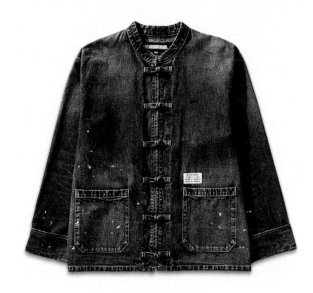

↑ Tang Denim KF Jacket, Neighborhood

### FROG FASTENERS
The Tang jacket (no link with the Tang dynasty) gains in popularity during the 19th century in China, first among soldiers. Its frog fasteners, inspired by closures worn by the peoples of the Caucasus, have developed in China since the Jin Dynasty in the 12th century. They are a marker of the Chinese clothing aesthetic.

### WHY TANG ?
The name likely comes from big foreign cities where Chinese neighborhoods are named after China's most famous and prosperous dynasty. The traditional costume would be so-called for the same reason.

### MANDARIN COLLAR
The jacket – characterized by its high straight collar, open at the center (the Mandarin collar), its buttons (*pan*), its flat pockets, and wide sleeves – is one of the essential elements of a Chinese wardrobe in the early 1900s. But after the war, it is supplanted by the « Mao » jacket (or Zhongshan suit) imposed by the communist regime. Derived from the military uniform, it is unisex, button-up, and has a turn-down collar. The Tang suit, exhibited in Hollywood kung-fu movies of the 1970s and 1980s, manages nonetheless to reestablish itself in the Chinese wardrobe.

> « MAO POSES FOR *ELLE*. AND THE CHINESE JACKET, SOMEWHERE BETWEEN CHORE JACKET AND ANTI-BOURGEOUS UNIFORM, BECOMES THE CHIC ATTIRE OF DISSENT. »
>
> ELLE, 1975

### ALLEGORICAL CONNOTATIONS

**Black :** associated with the water element, corresponds to daily usage.

**Red :** linked to the fire element, symbol of luck and joy, is worn for grand occasions like celebrating the New Year.

**Yellow :** associated with the earth element, long reserved for emperors, represents wisdom.

**White :** linked to the metal element, represents purity and mourning.

### TANG OR HANFU SUIT?
China is divided: some prefer the popular and practical suit, while others choose a typically Chinese garment introduced during the Han Dynasty. The high-fashion world picks the Tang jacket; it is reinterpreted on the catwalks, particularly by the Japanese designer Yohji Yamamoto (p. 308).

### POLITICAL OBJECT
In 1929, the Chinese Nationalist Party adopts the Zhongshan. It becomes the nation's uniform until the middle of the 1970s, erasing differences and eliminating vanity. In the 1960s, intellectuals, particularly in France, turn it into a revolutionary anti-bourgeois fashion statement. Revisited by the designer Gilbert Feruch, it becomes frivolous and loses its military and totalitarian connotation.

- Couple at the Metropolitan Opera, New York, 1943

↑ Satin Classic Bowtie, Tom Ford

# BOWTIE
## CAUSE AND EFFECT

FACES OF ·········· FRED ASTAIRE, MARLENE DIETRICH, ALBER ELBAZ

PODIUM ·········· SAINT LAURENT, RALPH LAUREN, THOM BROWNE

The history of the bowtie grows from the same origin as that of the necktie: men's penchant for tying foulards around the neck. Jabots and cravats adorn 17th- and 18th-century aristocrats; some believe the bowtie appears in the 19th century as a fusion of the two.

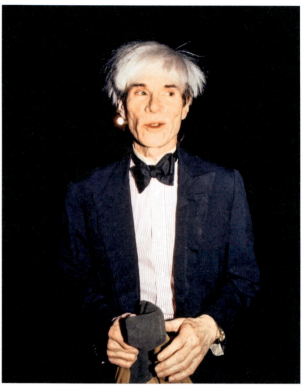

↑ Andy Warhol, *Life* magazine

### « BOWTIES ARE COOL. »
DOCTOR WHO

### BLACK TIE DRESS CODE
First popularized by the dandies (p. 324), it is well-established by the second half of the 19th century, accompanying powerful men and bourgeois of the Industrial Revolution. With the development of the tuxedo, it becomes an essential part of men's evening wear. Pierre Lorillard likely invents the modern version of the tuxedo and bowtie for James Potter for a ball at the Tuxedo Club in New York, with the success of the silhouette launching the concept of black tie.

### NIGHT AND DAY
Still in New York, the story continues in 1924, when the tie-maker Jesse Langsdorf creates a necktie model that deviates from the design of the bowtie. It becomes a common and versatile accessory, worn for elegant soirees as often as for days at the office.

### HUMOR AND SEDUCTION
Vaudeville acts such as Charlie Chaplin and Laurel and Hardy bring the bowtie to the movies, adding a comic element. Actresses like Marlene Dietrich and Katherine Hepburn wear it too, hinting at a provocative gender fluidity. Inversely, it plays the role of seductive masculinity on the dancing body of Fred Astaire, in the insolent style of the Rat Pack, and with the distinguished allure of James Bond.

#### TO EACH HIS BOWTIE
James Bond
Charlie Chaplin
Donald Duck
Dracula
Chippendales
Laurel and Hardy
Doctor Who
Winston Churchill
Playboy Bunnies
Hercule Poirot

### UNHIP TO TRENDY
Still, in the 1960s, it loses its panache. Too conventional, too conservative, too masculine. It is marginalized and, worn by comic characters and out-of-it geeks, the brunt of jokes. But it comes back in the 2000s, thanks to designer Tom Ford, adherent of nostalgic virility.

### MYTH IN SONG
Legend has it that in 1904, the first representation of the opera *Madama Butterfly* confirmed the popularity of the bowtie. It is worn by the opera singer and the men in attendance. The performance is a success; thus, by association, the bowtie is too. It becomes a statement accessory. Indeed, according to the legend, the French term *nœud papillon*, which means « butterfly knot » in English, refers to the Butterfly of the opera.

# SHORTS
## HIGHER, SHORTER

| FACES OF | JANE BIRKIN, MR T., GEORGE MICHAEL |
| --- | --- |
| PODIUM | JACQUEMUS, GUCCI, DOLCE & GABBANA |

Men's legs are uncovered at the end of the Middle Ages when doublets are accompanied by breeches (short billowing trousers). Later, adult men slowly leave breeches behind, preferring pants; in the 19th century, they are worn by young boys to set them apart.

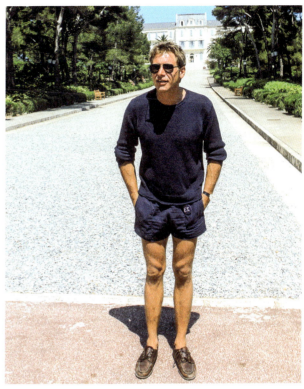

↑ Harrison Ford, *Cannes Film Festival*, 1982

« A MAN SHOULD NEVER WEAR SHORTS IN THE CITY. »

TOM FORD

**RIGHT OF PASSAGE**

Children's fashion emerges in the middle of the 19th century within the context of industrialization and a newly burgeoning middle class. Young boys from wealthy and noble families wear short trousers; transitioning to long pants marks the symbolic passage to adulthood.

**HEAT STROKE**

During British colonization, many English soldiers find themselves in regions where their uniforms are incompatible. In Bermuda, in 1914, they imitate shopkeeper Nathaniel Coxon, who shortens his employees' uniforms. When the general public begins to travel more after the Second World War, Bermuda shorts become increasingly popular.

**SHORT TROUSERS**

As the popularity of recreational sports grows, its enthusiasts adapt their clothing. Short pants are worn by those who golf, ride bicycles, and skate. But it isn't until the 20th century, particularly the 1920s, that short trousers become known as shorts and are adopted by the elite. The streamlining of the bathing suit (p. 72) accompanies the evolution of shorts, which are as popular on the beach as on the tennis courts.

**BEACH SHORTS**

Grown men now have the right to reclaim their short trousers. In 1930s France, paid vacation is standardized, and shorts come to represent carefree fun. Women wear them too, but only at the beach. They are imitating Hollywood actresses who reveal their legs in flirtatious shorts, thus circumventing censorship rules that ban cleavage.

**LIBERATED BODIES**

In the 1960s and 1970s, women shorten everything, and men flirt with affirmed androgyny. Shorts, sometimes short shorts, are everywhere, even in cities. From disco to sportswear, they are at the heart of a revolution of social mores and a liberation of the body.

**THE DEEP END**

Even as shorts are normalized in cities starting in the 1960s, they are still linked to summer recreation. In 1967, Rosita and Tai Missoni devise an original idea for a fashion show: stage it at the Solari swimming pool in Milan. Designer Quasar Khanh creates a collection of inflatable furniture and a small inflatable house. During the finale, the house collapses, and the models, wearing the brand's signature ethereal dresses, floral ensembles, and knit shorts, all end up in the water. The show becomes a party and sets a now well-established trend in fashion.

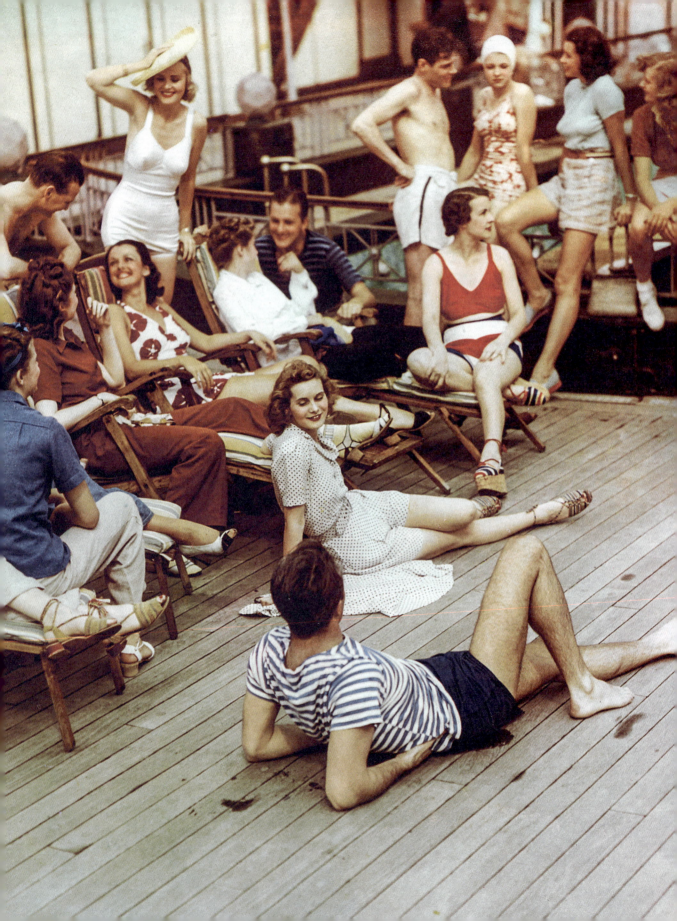

← Scene at the pool, *photo by Egidio Scaioni*, 1934-1937

↑ **Amazon Pavel Shorts**, Balibaris

# ONE-PIECE BATHING SUIT
## ON A DESERTED BEACH

| FACES OF | PAMELA ANDERSON, ROMY SCHNEIDER |
| --- | --- |
| PODIUM | MOSCHINO, SAINT LAURENT, CHANEL |

The 19th-century leisure class embraces a previously rebuked activity: sea bathing. The first bathing suits are full coverage. Men wear a mid-length suit while women's bathing outfits are composed of a corseted dress and trousers. The practice of swimming will necessitate the suit's evolution.

↑ Aquarelle One-piece, Eres

### NO SUNBATHING
Until the 1910s, beachgoers don't lounge on the sand, and sea bathing consists of a quick dip in the water because few people know how to swim. Since modesty prevails, women change in cabanas, some of which are horse-drawn carriages that carry the bather straight to the water, allowing her to avoid being seen in such « revealing » attire.

### FREE SWIM
Australian professional swimmer Annette Kellerman challenges these practices. She needs comfortable gear to practice her sport, so in 1907, she wears a fitted one-piece suit, shortened at the arms and legs. Though arrested for indecency, she nonetheless launches popular demand for less restrictive beachwear.

### THE FEMALE GAZE
A pioneer of fashion photography, Louise Dahl-Wolfe collaborates with *Harper's Bazaar* from the 1930s to the 1960s. She takes her models out of the studio to the beach, where she captures them in bathing suits with natural light. The women's bodies are in harmony with their environment, sensual, authentic, and alive.

### ON VACATION
Starting in the mid-1910s, men and women wear similar suits, close in length to shorts. In early 1920s France, the beach is fashionable. Breaking free from conventions, the elite are fond of the Riviera and the Normandy coast. The rest of the country joins them after paid vacation is established in 1936.

### ACCIDENTALLY SEXY
The arrival of the bikini (p. 73) does not mean the end of the elegant and modest one-piece suit. In the 1980s, it borrows the fluorescent shades of aerobic wear, and its high-cut leg exposes the athletic body in an era obsessed with appearance. On TV, red bathing suits make a splash on the beaches of Malibu. Today, it emancipates women by giving them a choice; it symbolizes liberty, not modesty.

### THE BODY OF DANCE

**Gymnastics leotard:** close cousin of the bathing suit, this knitwear is created in the middle of the 19th century by gymnast Jules Léotard, who is searching for more ease and security during his trapeze numbers.

**Dance leotard:** dancer and choreographer Martha Graham popularizes the leotard in modern dance in the 20th century.

**Fashionable item:** the figure-hugging, sensual leotard becomes fashionable in the 1970s, and the designer Donna Karan turns the bodysuit into the pinnacle of style in the 1980s.

# BIKINI
## « YELLOW POLKA DOT BIKINI »

| | |
|---|---|
| FACES OF | URSULA ANDRESS, BRIGITTE BARDOT |
| PODIUM | CHANEL, THOM BROWNE, COPERNI |

With the development of seaside resorts, the first swimsuits emerge. Non-revealing, they allow a certain modesty, but during the 1920s, some daring women decide to wear two-piece bathing suits. When the nuclear bomb is created during the Second World War, it develops a surprising connection with the bikini.

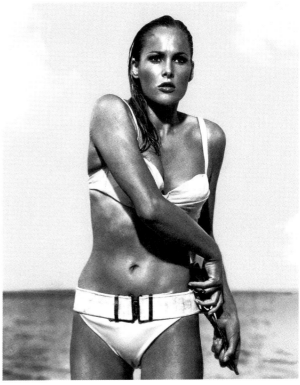

↑ Ursula Andress, *Dr. No*, 1962

### BEFORE THE BIKINI: THE ATOM
In 1932, Jacques Heim creates his two-piece bathing suit and calls it the « Atom » because of its small size. It reveals the stomach, though not the belly button, and highlights the hips with a horizontal strip of fabric. Few women wear it until after the war when codes of etiquette relax, and the two-piece bathing suit becomes popular on the beaches of France.

### ATOMIC BOMBSHELL
In 1946, his rival, engineer Louis Réard, creates a two-piece model composed of fabric triangles connected by string – revealing more skin makes tanning easier. On July 1, 1946, an atomic bomb test shakes Bikini Atoll in the Pacific, and since the expression « atomic bomb » has been used to describe actress Rita Hayworth in a two-piece, the suit is named the bikini.

### ANATOMY OF A SCANDAL
It is presented at a beauty contest at the Molitor Pool in Paris on July 5, 1946. But only one of the models dares to wear it: Micheline Bernardini, a nude dancer at the Casino de Paris. Judged indecent, it is banned from women's magazines, rejected by the Vatican, and forbidden by law in many countries. The communists see it as a class symbol, and feminists accuse it of objectifying the body.

### GYMNASTS
Women didn't wait for the 20th century to reveal their bodies. Already in Ancient Rome, gymnasts and athletes wear only a band of fabric covering the chest with bottoms similar to underwear, as seen in the Villa del Casale mosaics in Sicily. Though not specifically bathing suits or bikinis, the Roman women's sportswear shares a similar silhouette.

« THE BIKINI, SMALLER THAN THE WORLD'S SMALLEST BATHING SUIT. »

LOUIS RÉARD

### BODY TYRANNY
The music and movies of the 1960s finally liberate the bikini. It's a symbol for an outraged generation seeking political liberation and asserting the right to have control over one's body. However, rebellion evolves into oppression when the bikini imposes a new aesthetic authority on the newly revealed bodies.

### BOND... JAMES BOND
The 1962 movie *Dr. No* marks a shift in the acceptance of bikinis. The actress Ursula Andress, looking like Botticelli's Venus, emerges from the water on a paradisaical beach wearing an ivory bikini and a knife. The objectifying scene becomes iconic, and the suit sells for 60,000 pounds at Christie's in 2001.

↑ St Barth Bikini, Carioca

→ **Actress Charley Weaver**, Acapulco, 1972

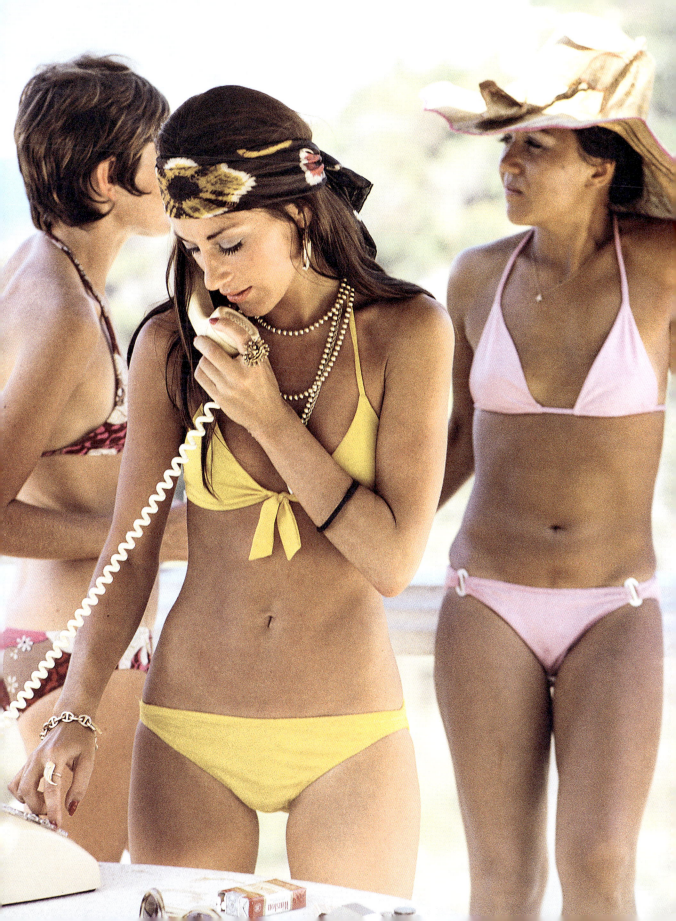

# PUFFER JACKET
## NICE AND WARM

FACES OF ............ RIHANNA, DRAKE, BILLIE EILISH
PODIUM ............ BALENCIAGA, JUNYA WATANABE, MARC JACOBS

Humans have always relied on animals for food and clothing. Very early, Inuit communities and Vikings understood the benefits of down-lined garments. In the 20th century, adventurers define the contemporary look of down coats capable of providing warmth even in extreme conditions.

↑ Silent Down Jacket, Patagonia

### SURVIVAL INSTINCT

In 1935, after suffering from hypothermia while fishing, Eddie Bauer creates a quilted jacket with goose down distributed throughout the entire coat. Patented in 1936, it becomes essential gear for outdoor winter activities. French mountaineer Pierre Allain has the same idea and creates a lined jacket for skiers that soldiers also appreciate. When skiing becomes the preferred activity of the jet set after the war, puffer coats proliferate.

### CHIC PUFFER

The American designer Charles James creates the first « couture » puffer coat in 1938. He designs an ivory evening jacket with the same fabrication technique used for quilts. He describes his creation as the « pneumatic jacket ».

### IN FASHION

Luxury designers such as Emilio Pucci, André Courrèges, and Christian Dior integrate the jacket into their collections. The French brand Moncler creates its first puffer coats in 1954 and attracts attention by outfitting the French downhill team at the Grenoble 1968 Winter Olympics. The event highlights the puffer coat's universal appeal just as skiing becomes more popular.

### IN THE SCHOOLYARD

In the 1980s, it becomes more urban. Its intense colors appeal to young people, pop culture, and especially hip-hop culture (p. 316), partly because it accentuates the body frame, inspiring respect. A lighter version is seen on high school grounds, as brands like Chevignon entice teenagers. On the catwalks of the biggest fashion houses, the puffer plays with transcending the boundaries of elegance.

### SECURITY BLANKET

Polyvalent, it is both a luxury item and a comfortable accessory for young people looking for warmth and anonymity. It can act tough in hip-hop videos, but it can also frolic down the ski slopes.

### BEDTIME

For their Fall/Winter 2005 collection, Dutch designers Viktor & Rolf present bedtime-inspired silhouettes. Some models have their heads resting on pillows, their bodies wrapped in comforters. Sheets become ruffles that evoke 17th-century Dutch collars. These quilted bedclothes resemble oversized puffer coats for indoors, the ultimate expression of comfort and idleness.

# WAIST BAG
## WAISTBAND

| | |
|---|---|
| FACES OF | BEYONCÉ, THE ROCK |
| PODIUM | STELLA MCCARTNEY, KENZO, RICK OWENS |

Transporting your belongings is one of life's basic necessities; bags hanging from the waist are found in almost every culture. In Europe during the Middle Ages, men and women wear leather pouches. In the Renaissance, they hang gold or silver chatelaines from their belts.

↑ Waist bag, Barbour X Supreme

> « THE FANNY PACK IS USEFUL FOR CYCLISTS, HIKERS, AND EQUESTRIANS. »
>
> SPORTS ILLUSTRATED, 1954

### WAIST BAGS AND FANNY PACKS

Women in the 17th century wear cloth purses knotted at the waist under their dresses, accessible via discreet openings in the dress's fabric. In the middle of the 20th century, hikers place pouches on their backsides. The names fanny pack and bum bag are born.

### TOURISTS AND ATHLETES

The waist bag is popular in the 1980s thanks to the fitness craze, the development of physical activities in the urban space, and mass tourism. It's also a decade of dynamic youth culture. Inspired by flashy outfits in MTV videos, middle-class teenagers wear nylon waist bags in fluorescent colors or with vibrant graphic patterns.

### STREET-INSPIRED LUXURY

Relaxed and colorful on the sidewalks, it becomes refined and brand-named on the catwalks in the early 1990s thanks to designers like Karl Lagerfeld. In the late 1990s, rave kids (p. 342) wear it out late at night and hip-hop fans (p. 316) prefer versions with flashy logos.

### NOT SO TACKY

During the luxury-obsessed early 2000s, it fades into the background. In the 2010s and 2020s, it is brought back into the limelight and reinvented. New geometric, minimalist models are attractive and are available in innovative formats. Still popular with clubbers and hip-hop fans, it is part of the streetwear vocabulary. Tacky becomes the ultimate snobbery.

### OUT OF POCKET

Men have pockets sewn into their clothes from the 16th century, but women must wait until the middle of the 19th century to benefit from the concept. Until then, they wear a separate accessory consisting of two small flat pouches connected by a fabric band that ties around the waist between the petticoat and the chemise.

### FAR WEST

Starting in the Middle Ages, men use leather or animal-skin waist pouches to keep their weapons at the ready. On the mid-19th century American frontier, belt holsters are developed: these leather sheaths are warrior waist bags that allow quick-draw cowboys to shoot from the hips.

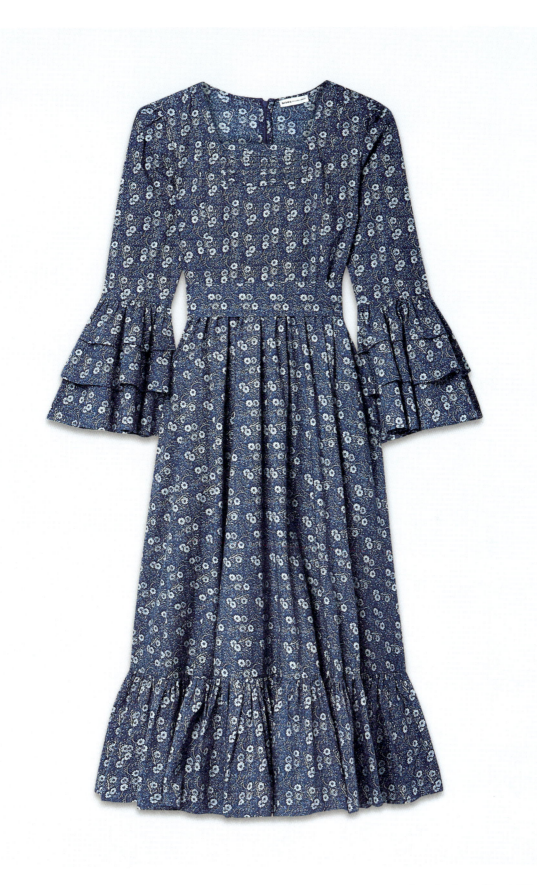

Ava Amande, London, 2021

↑ Batsheva Floral Dress, Waverly X Laura Ashley

# PRAIRIE DRESS
## YOUNG WOMEN IN BLOOM

FACES OF · · · · · · LADY DI, FLORENCE WELCH, LOULOU DE LA FALAISE

PODIUM · · · · · · JOHN GALLIANO, LOUIS VUITTON, GUCCI

The hippie movement romanticizes far-off places and times past. Hippies express this nostalgia when they change modes of consumption and shop in thrift stores and vintage shops where silhouettes of the Belle Epoque influence their quaint and romantic style.

↑ The actors of *Little House on the Prairie*

### A TASTE OF THE PAST

The appeal of historic styles proliferates, especially in England and in the U.S., reviving silhouettes evocative of the Victorian and Edwardian eras: high collars, long skirts, lace, ruffles, and floral prints. The anti-consumerist hippies (p. 326) unearth them in flea markets, while certain brands, like Gunne Sax in San Francisco, reinterpret them in their trendy boutiques.

### COUNTRY STYLE

After the highly synthetic 1960s, the 1970s promotes a return to nature. The prairie dress invokes rural life, far from the city and its modernity. The British designer Laura Ashley offers a version that deviates from Swinging London's sensual and bohemian silhouettes. It is aimed at a previously ignored clientele: the ordinary woman who wants beauty and refinement.

### OFFICIAL PRESENTATION

In 1981, future princess Diana Spencer is photographed in the nursery school where she works. She is wearing a pale Laura Ashley dress, which, backlit by the sun, becomes transparent and reveals her legs while the wind blows the fabric against her body. It's a scandal, but it's also an extraordinary publicity boost for the brand.

### MOTHERS AND DAUGHTERS

Laura Ashley dresses emanate a gently conservative, bucolic spirit. The brand's advertising campaigns represent romantic and idyllic pastoral scenes with images of mothers and their children intended to speak to prim, traditional stay-at-home moms.

### COMMERCIAL SUCCESS

The brand becomes a chain and Laura Ashley, an empire. In the 1980s, the success holds steady, especially since Princess Diana wears the delicate, conventional, and distinguished dresses. And in the 1990s, grunge style (p. 338) adds a new twist.

### BACK TO THE FUTURE

Today, as ecological questions agitate many consumers, the dresses are making a comeback.

### ICONIC FAMILY

In 1974, *Little House on the Prairie* is born, and the Ingalls family appears on American screens for the first time. The series, with its strong family values and bucolic landscapes, is deeply connected to the prairie dress.

### HIPPIE CHIC

When she marries Bill Clinton in 1975, Hillary Rodham wears a dress from the Gunne Sax boutique, popular at the time with young brides.

# STRAW HAT
## WELL-DESERVED VACATION

FACES OF ·················· MAURICE CHEVALIER, AUDREY HEPBURN

PODIUM ·················· JACQUEMUS, JOHN GALLIANO, SCHIAPARELLI

Heads have been covered since prehistoric times. Headwear made of plant fibers, worn for comfort, protection, and sometimes sacred rituals, develops during antiquity, everywhere from the African continent to Asia via Europe.

↑ *Student at Winchester College*, United Kingdom, 1960

> «WITH MY BOATER / ON THE SIDE, ON THE SIDE / I MADE THE WHOLE WORLD / DANCE THE TWIST.»
>
> MAURICE CHEVALIER, *LE TWIST DU CANOTIER (THE BOATER'S TWIST)*

### FIELD HAT
Raffia, jute, reed, and hemp are commonly used to fabricate the hats. Accessible, malleable, and inexpensive, these plant fibers render straw hats accessible; they are especially popular with field workers. Aristocrats prefer more luxurious materials, except for Tuscan nobility, who value the woven hats.

### EQUADORIAN PANAMA HAT
Beginning in the 15th century, Ecuadorians wear a woven hat made from toquilla, a palm leaf fiber. After being exported from Ecuador, it is nicknamed the « Panama » when it is worn by the country's gold-seekers in the 19th century, then by the laborers of the canal of the same name between 1904 and 1914. Soon after, it is adopted by Hollywood, which leads to its popularity among the American public.

### CHAPEAU DE FEUILLE
In Vietnam, the nón lá (« leaf hat ») is made of palm leaves. Popular with farmers, especially in the rice fields, it is recognizable by its conical shape. Dating back to prehistoric times, it especially develops in the 13th century, in a larger, more voluminous form, before taking its more modern conical look in the 1930s.

### PASTORAL FANTASY
In the Middle Ages, style spreads from the aristocracy to the lower classes, but with the approach of the French Revolution, trends are increasingly influenced by the people. At the end of the 18th century, Queen Marie-Antoinette styles herself as an elegant shepherdess, and the fashionable women of Versailles imitate her rustic inclinations and top their looks with straw hats. Aristocrats of the colonies precede them, wearing straw hats to protect themselves from the blazing sun.

### A GOLDEN AGE
The 19th century is the century of the hat. Fashion designers strive to be the most imaginative and offer original, extravagant, and graceful headwear. The straw hat accompanies the great artistic movements, reflecting the misery depicted in realism and the fresh air of impressionism. And then, when society begins to promote leisure, it flouts conventions and becomes the boater hat.

### UNDER THE SUN
In 1930s movies, the straw hat is playful, as when worn by Maurice Chevalier. On the streets in the 1970s, it transforms into a bohemian and carefree sunhat. From labor to leisure, the straw hat always finds its place in the sun.

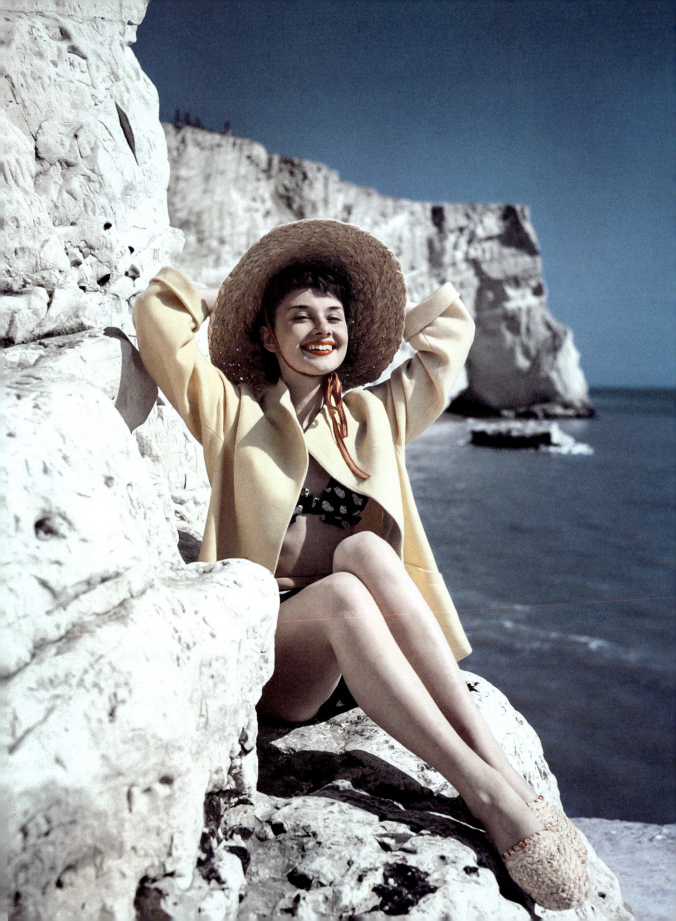

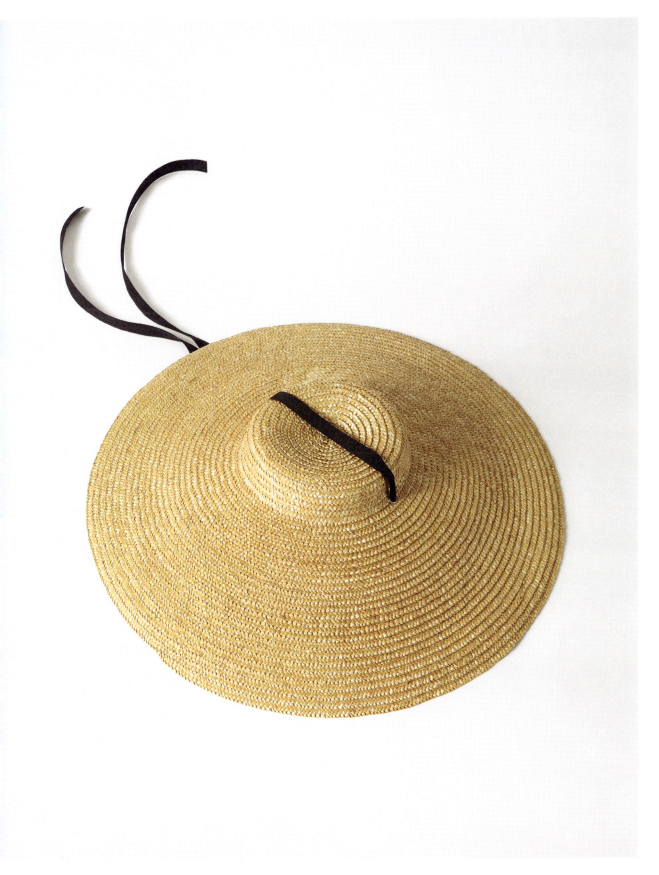

← Audrey Hepburn *near Brighton, England*, 1951 ↑ Traditional Provencal hat

# QIPAO
## FEMINISM AND STEREOTYPES

FACES OF — ANNA MAY WONG, NANCY KWAN, MAGGIE CHEUNG
PODIUM — ALTUZARRA, SHIATZY CHEN, MARQUES ALMEIDA

When the Republic of China is founded in 1912, feminists demand a more egalitarian society. As a sartorial declaration of their principles, they adopt an item of clothing inspired by a long androgynous Manchu tunic; their garment is now known as the « qipao » in Mandarin.

↑ **Qipao Dress**, Huishan Zhang

### NATIONAL SYMBOL

The qipao is particularly fashionable in the cosmopolitan and dynamic port city of Shanghai. Eventually, it becomes so popular that in 1929, the Republic of China claims the long version as a symbol of national culture. Afterwards, it continues to evolve and is even integrated into stylistic elements of Western fashion. The qipao gets shorter and tighter and incorporates two audacious slits that can be thigh-high, thus perpetuating a feminist ideology that affirms the emancipation of the body.

### HOLLYWOOD FANTASY

Beginning in 1949, the qipao is replaced by a standardized, unisex ensemble. Nonetheless, it lives on in Hong Kong, where it is everyday wear. International visitors notice it, and beginning in the 1920s, the qipao moves West, where Hollywood picks it up and subsequently contributes to a fantasy that sexualizes the Asian woman's body.

#### VOCABULARY

The term « cheongsam » comes from the Cantonese *chèuhngsàam*, while « qipao » is Mandarin. « Cheongsam », the name established by the English in Shanghai, applies to the original men's version of the style and its feminine evolution, while « qipao » is only used for the woman's dress.

### MOVIE CHARACTER

But in 2000, Chinese cinema reclaims the dress when Hong Kong filmmaker Wong Kar-wai directs *In the Mood for Love*, an ode to romance, desire, and... the qipao. Worn by the actress Maggie Cheung, against the backdrop of a sensual and languid 1960s Hong Kong, the dress becomes a character, leaving stereotypes behind and underscoring the emotions of the story.

### NEW GENERATION

Today, the qipao is being revisited by young Chinese people looking to take control of their cultural heritage, particularly via TikTok, where they denounce its Western erotic exploitation.

#### FEMME FATALE

1930s movies perpetuate the stereotype of a venomous, predatory Asian woman. Actress Anna May Wong particularly suffers from the cliché. It doesn't get better after the war when the cheongsam becomes an object of fantasy. In the 1960s, Nancy Kwan, a Hollywood darling from Hong Kong, declares that if the cheongsam has slits, it's because « Chinese girls have pretty legs ».

# CHORE JACKET
« WORKERS OF THE WORLD, UNITE! »

| FACES OF | BILL CUNNINGHAM |
| PODIUM | YOHJI YAMAMOTO, ALEXANDER MCQUEEN, KRIS VAN ASSCHE |

The Industrial Revolution leads to the development of automated machines and protective clothing. « Work blues », dyed with an inexpensive indigo, replace smocks. Work blues can also be overalls and coveralls, but in France, the pocketed chore jacket remains the most identifiable workwear model.

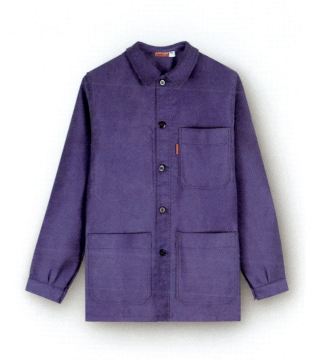

↑ Work Jacket, Lafont

### BLUES AREN'T ALWAYS BLUE
The color depends on the worker's trade. It is usually made of moleskin, a heavy cotton fabric that offers reinforced protection. In the U.S., the jean jacket (p. 64) plays the same role. Robust and practical, the chore jacket is part of the laborer's toolkit and creates visual uniformity among workers.

### FROM THE FACTORY TO THE STREET
Artists take the chore jacket out of its purely professional context. Rejuvenated at the beginning of the 20th century, it participates in a modern movement that rethinks the role of aesthetics and comfort in everyday life. Its functionality inspires other practical and universal styles.

### A SOCIAL SYMBOL
The garment virtually erases the individual and instead exemplifies a class or even a class struggle. It becomes the emblem of laborers in opposition to the middle class, especially between the two World Wars: the blue collars rise against the white collars of management. Whether worn by warehouse workers, artisans, or farmers, the moleskin jacket is manual labor. It's the people.

### IMAGE HUNTER
Bill Cunningham's photographs (and iconic chore jacket) haunt the American fashion landscape: he's the inventor of street style. Passionate about personal style, he captures the look of passersby and celebrities on the streets of New York, which he publishes in the column « On the Street » in the New York Times starting in 1978.

> « THE BLUE-COLLAR CULTURE, IT'S NOT REALLY A BUTTONED-UP AESTHETIC. IT'S A HEAVY LABOR THING, BECAUSE YOU'RE, LIKE, SWEATING. »
> VIRGIL ABLOH

### FASHION FRENZY
In May 1968 in France, workers and students come together and take to the streets. The chore jacket becomes the symbol of the rebellion. After the revolution, it stays in the streets, where it suits bohemian souls and free spirits. Designers like Marithé + François Girbaud and agnes b. make it fashionable. Starting in 2010, it garners a remarkable number of new enthusiasts, prompted by its popularity among Japanese youth.

### CHINA BLUE
Between the wars, Algerian dockworkers discover the indigo blue suit of Chinese sailors, composed of pants and a jacket with similar buttons to those of the Tang jacket. Other port cities, like Bastia and Marseille, are seduced by the lightweight, functional workwear. After the war, this Chinese blue workwear is only made in Algeria or Marseille.

# SAMUE
## STAY ZEN

| FACES OF | YOHJI YAMAMOTO, HAIDER ACKERMANN |
| --- | --- |
| PODIUM | DAMIR DOMA, CRAIG GREEN, BALENCIAGA |

Sober and meditative Zen Buddhism develops in Japan in the 12th century. Mindfulness is considered an essential part of samu, utilitarian tasks practiced daily in monasteries and convents. While performing these tasks, monks and nuns wear a functional ensemble: the samue.

### NO DISTRACTIONS
Designed for meditation, the earliest version consists of pants and a long tunic that will be shortened over the centuries. The cropped sleeves liberate the hands, which, along with the drawstring ties of the pants, make for an ensemble that is easy to wear on any occasion.

### MULTIPURPOSE
Craftspeople, artists, and doctors adopt it as workwear. In the 20th century, this ally to comfort is worn for leisure activities and for sleep. It is more comfortable to slip on and less codified than the kimono (p. 148). Monochrome, unisex, and made of sturdy cotton, it promotes sobriety and uniformity in a very hierarchical society.

### THE MODESTY OF BEAUTY
With the rise of Japanese deconstructivism (p. 308) in the 1980s, designers like Rei Kawakubo and Yohji Yamamoto reinterpret these flowy traditional garments, tantalizing the West with new aesthetics. The loose samue pants surround the body with refined lightness, while the jacket is elegantly unaffected as it drapes across the bust with ties. Most often dark or dyed indigo, the modest and beautiful ensemble doesn't need to sparkle to stand out.

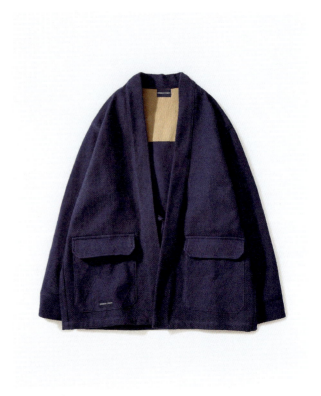

↑ Samue, Indigo Union

« FASHION IS ONLY COMPLETE WHEN IT IS WORN BY ORDINARY PEOPLE. »

YOHJI YAMAMOTO

### CLOSE COUSIN
The sturdy samue can be worn year-round. However, during the summer, some prefer the jinbei because of its cropped sleeves and pants. The relaxed ensemble stays close to home; it is rarely worn outside and only for short outings.

### THE RENAISSANCE OF JAPANESE STYLE
A new creative generation blends European trends with classic models. Yohji Yamamoto turns the samue into the epitome of nonchalant chic sportswear and affirms a global revival of workwear garments.

# CAP

## IN THE STREET AND ON THE PLAYING FIELD

| | |
|---|---|
| FACES OF | SPIKE LEE, LADY DI, RIHANNA |
| PODIUM | BURBERRY, CHANEL, LACOSTE |

Looking to boost the wool industry in 1571, the British Parliament decrees that all non-noble men and boys over six years old must adopt wool headwear on Sundays and public holidays. A flat wool cap becomes the symbol of the working class.

↑ Elton John, 1970

« I ALWAYS ENJOY WEARING BASEBALL CAPS. I GOT MY FIRST WHEN I WAS SIX OR SEVEN YEARS OLD. ALL THE KIDS HAD THEM. BACK IN THE DAY IT WASN'T REALLY A FASHION THING. »

SPIKE LEE

### GAVROCHE

In the 19th century, the flat cap is rounder and has a visor. It is worn by students and young boys of the lower classes, especially newspaper boys. In France, it is called Gavroche, named after the child character in *Les Misérables* by Victor Hugo. He is the perfect incarnation of the mischievous Parisian street urchin. All poor children in the city become Gavroche; their flat caps do, too.

### AMERICAN DREAM

In the U.S., Irish immigrants bring their caps with them. At the same time, the Industrial Revolution expands the reach of the Gavroche cap: the elite now wear it while hunting or golfing, and it is the ideal accessory for the first outings in motorized cars.

### TAKING THE FIELD

Today's cap comes from baseball. The sport develops in the second half of the 19th century, and its players wear a variety of models. In 1901, the Detroit Tigers is the first team to put its logo on the front: the modern baseball cap is born.

### FASHION STATEMENT

New Era standardizes the baseball hat in the 1930s and defines the current version in 1954. It furnishes almost every American baseball team. In the 1970s, it is beloved by sports fans, is prominent in the hip-hop community (p. 316), and is worn for athletic activities requiring sun protection. In the 1990s, celebrities like Spike Lee make it cool.

### BIG RIG

Trucker caps, designed for American truck drivers, develop in the 1970s. They are recognizable by the breathable mesh back and a wide front panel that provides ad space for companies. The trucker cap becomes the epitome of an American style propagated by TV and film.

### AGAINST THE GRAIN

In the middle of the 20th century, U.S. Army sharpshooters and certain athletes, especially baseball players, turn their hats around. The shooters thus avoid the visor bumping into the weapon's sight, and the players now see the ball more easily. In the 1980s, the hip-hop scene adopts the gesture, and it becomes one of rebellion.

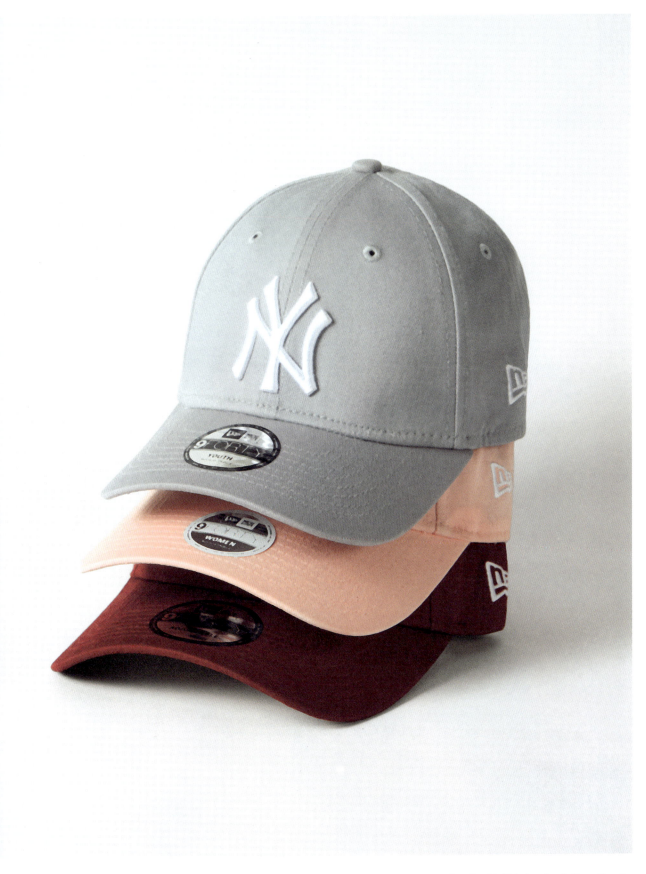

- Baseball player Clem Labine, Brooklyn Dodgers, 1955

↑ 9forty New York Yankees baseball cap, New Era

# SNEAKERS
## THE ESSENCE OF COOL

FACES OF ......... MICHAEL JORDAN, KURT COBAIN, FARAH FAWCETT

PODIUM ......... COMME DES GARÇONS, GUCCI, CHRISTOPHER KANE

Vulcanization, the addition of sulfur to rubber – rendering it flexible and water-resistant, is invented in 1839 and leads to the birth of sneakers. In the U.S. and Britain, rubber manufacturers integrate this process to make shoes worn at the beach and on the croquet court.

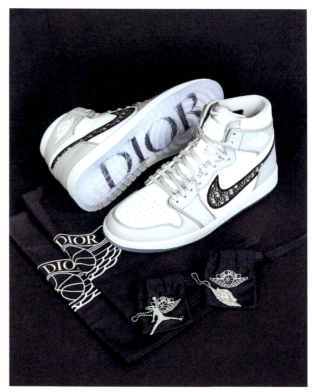

↑ Air Jordan 1 High Dior, Nike

### CANVAS SHOES

The technique initiates the rise of tennis shoes in the middle of the 19th century. Composed of a canvas upper and a rubber sole, they fare better than leather shoes when worn on grass. Still reserved at the time for seasoned athletes, in the 1910s, their popularity grows thanks to Keds and Converse All Stars.

### WEEKEND WARRIORS

With the mediatization of the Olympics and the growing fascination for athletic exploits, they make their way onto the feet of the fans. After the war, they move beyond the athletic fields and are worn by rebellious kids who proudly wear jeans (p. 136), T-shirts (p. 10), and sneakers. They come to represent youth and renewal.

#### FEND FOR YOURSELF

In 1924, the German brothers Adolf and Rudolf Dassler launch their sneaker company. They have a falling-out in 1947; the first founds Adidas, the second, Puma.

### TEAM SPIRIT

Sports culture and popular culture merge. As fans go wild for Bruce Lee or Charlie's Angels, the sneakers of these idols become popular, and brands like Nike, New Balance, Reebok, and Adidas diversify their offerings. Favorites are selected based on trends and their celebrity trendsetters.

### SNEAKERS FOR ALL

Sportswear style, established by hip-hop (p. 316) and popularized by the birth of MTV in 1981, influences a wide variety of styles that teenagers imitate. Sneakers are the epitome of cool. Then in 2010, luxury fashion moves in. They become an object of desire, sometimes provoking collective hysteria. Part of everyday life now, they are banal, versatile, relaxed, and prized – they're not just for sports anymore.

« A WOMAN CAN SLIP ON A PAIR OF EMBELLISHED CAGE HEELS ONE NIGHT AND A PAIR OF STREAMLINED, LIGHTWEIGHT SNEAKERS THE NEXT DAY. THE BEAUTY OF MODERN LUXURY IS THE ABSENCE OF RULES. »

GIUSEPPE ZANOTTI

#### SALESPERSON OF THE YEAR

In 1921, Converse hires Chuck Taylor as a salesperson. A coach and a basketball fan, he promotes the brand like no one else, selling millions of pairs. Closely linked to Converse, his name appears on the All Stars beginning in 1932.

*Previous page:*
**Time Line-up**, *photo by Hugh Holland*, California, 1976

## ALL-TERRAIN

**1839**
**INNOVATIVE PROCESS**
Charles Goodyear invents vulcanization.

**1906**
**PIONEERING COMPANY**
New Balance is founded.

**1916**
**SPORTY SHOES**
The U.S. Rubber Company launches Keds.

**1917**
**ICONIC MODEL**
Converse creates All Star high-tops for basketball players.

**1936**
**ATHLETIC SYMBOL**
All Stars are the official shoe of the American basketball team at the Olympics.

**1948**
**NEW BRAND**
Rudolf Dassler founds Puma.

**1949**
**COMPETITION**
Adolf Dassler creates Adidas.

**1964**
**FUTURE GIANT**
Blue Ribbon Sports, which will become Nike in 1971, is founded.

**1966**
**ADOPTED BY RIDERS**
Vans is created. The shoes become popular among skaters in the 1970s.

**1969**
**ICONIC MODEL**
Adidas launches the Superstar. The hip-hop movement adores it, and it is the first low-top basketball shoe.

**1976**
**ICONIC LOGO**
New Balance releases its first sneaker model with the « N » logo.

**1978**
**TENNIS SHOES**
Adidas pays homage to tennis player Stan Smith.

**1982**
**SPORTY ENDORSEMENT**
Nike launches the Air Force 1, and it earns a devoted following thanks to NBA players.

**1985**
**BRILLIANT COLLABORATION**
Michael Jordan teams up with Nike, and the iconic Air Jordan is born.

**1986**
**MUSIC**
Run-DMC releases the hit « My Adidas ».

**1989**
**THE SILVER SCREEN**
Marty McFly wears futuristic Nikes in *Back to the Future Part II*.

**2003**
**ON THE RUNWAY**
Yohji Yamamoto collaborates with Adidas, and sneakers become high fashion.

**2004**
**GREEN AWARENESS**
The brand Veja creates the first fair-trade and eco-friendly sneakers.

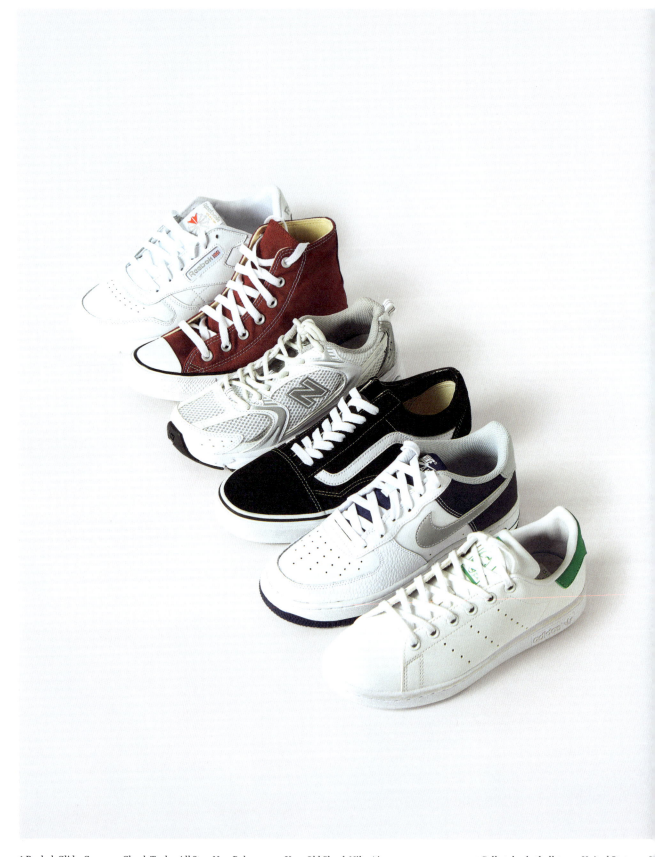

↑ Reebok Glide, Converse Chuck Taylor All Star, New Balance 530, Vans Old Skool, Nike Air Force 1, Adidas Stan Smith

→ College basketball game, United States, 196

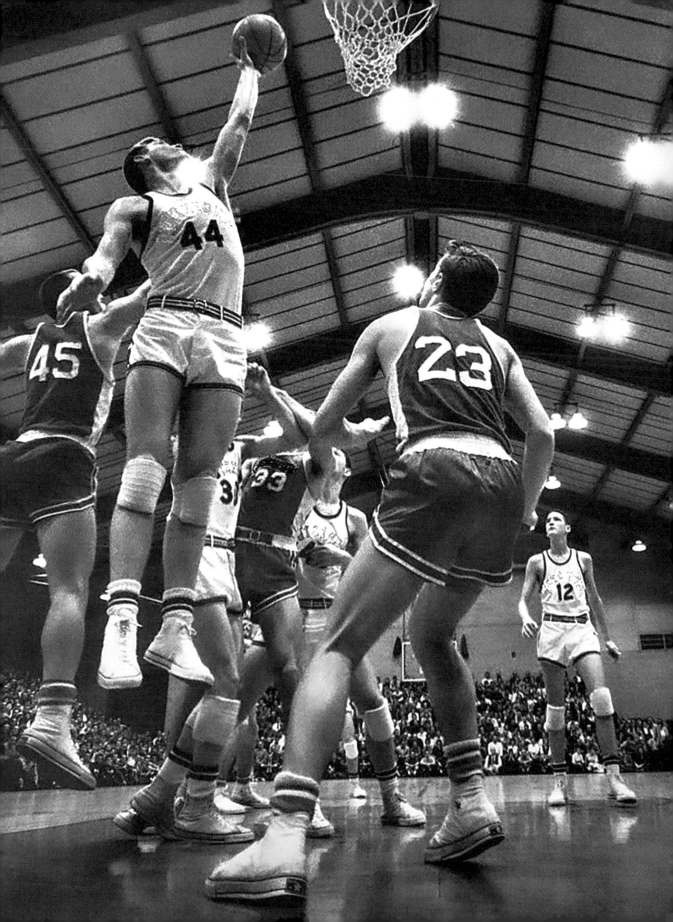

# PUMPS
## STILETTO HEELS

**FACES OF** ·· DITA VON TEESE, MARYLIN MONROE, SARAH JESSICA PARKER

**PODIUM** ······· SAINT LAURENT, BOTTEGA VENETA, PRADA CRUISE

Apart from platform shoes, worn since antiquity, the first high heels appear in Persia around the 10th century. Horseback riders wear them to better stabilize their feet in stirrups. Diplomatic exchanges introduce the heeled shoes to Europe in the 12th century.

↑ Flower Buckle Pumps, Roger Vivier

> « YOU PUT HIGH HEELS ON AND YOU CHANGE. »
> 
> MANOLO BLAHNIK

### UNLADYLIKE
High-heeled shoes become a symbol of elegance, power, and masculinity. Women who adopt them beginning in the 17th century incur disapproval and accusations of masculinity.

#### SHOES AND BODIES
Towards the end of the 20th century, the shoe brand Charles Jourdan calls upon fashion photographer Guy Bourdin to shoot an ad. He cuts the female body into pieces, showing only individual parts, especially legs and feet. In these surrealist and suggestive images, the pumps conquer the woman's body, and she is submitted to men's desires.

### AMONG WOMEN
After the French Revolution, the heel loses influence; men choose flat shoes as they turn towards more modest clothing. In the middle of the 19th century, it is reintroduced into women's wardrobes in the form of boots during the day and graceful shoes in the evening.

### FEMININITY AND FANTASY
With the emergence of photography and its erotic applications, the high-heeled shoe is fetishized on the feet of naked models. At the time, clothes entirely cover women's bodies, and a glimpse of a pair of pumps invites fantasy; therefore, they are immoral. It's not until the 1920s that they are unobjectionable. After the war, Roger Vivier designs shoes to accompany Christian Dior's « New Look » (p. 213), creating the pump with a slender heel and arched sole that we know today.

### BEWARE THE HEEL
Pumps project an exaggerated femininity that manages to be both domestic and sensual. 1950s housewives wear them while they vacuum, and pin-ups flaunt sky-high versions when they pose for the camera. Even if men in the 1970s perch themselves on platforms (p. 131), pumps belong exclusively to women. Their high heels render them intimidating, even dangerous. When associated with eroticism and violence, pumps become fetishistic. And when a man wears them? It is the ultimate transgression.

#### TRANSALPINE
The French word for pumps, *escarpin*, comes from the Italian *scarpino*, which means « little shoe ». It is in use as early as the 14th century and concerns small shoes with an open instep.

# IN STEP

### 10TH CENTURY
**SADDLE UP**
Persian horsemen wear small, high-heeled boots.

### 17TH CENTURY
**ROYAL FASHION AND FLAIR**
Members of European court nobility adopt high-heeled shoes.

### FRENCH REVOLUTION
**ARISTOCRATIC SYMBOL**
High-heeled shoes are rejected by the people.

### 1910
**FROM DANCE TO THE STREET**
Tango shoes become fashionable.

### LATE 19TH CENTURY
**ACCESSIBLE**
Industrial production of high-heeled shoes begins.

### 1850S
**VICTORIAN ETIQUETTE**
Heels are required in the British Court.

### 1920S
**CLIC-CLIC**
Salvatore Ferragamo is the first to use metal to reinforce his heels.

### 1940
**NEW SILHOUETTE**
Shoemaker André Perugia slims down the heel of his pumps.

### 1947
**INDISPENSABLE**
Christian Dior's « New Look » introduces the pump as the ultimate symbol of femininity.

### 1954
**UP TOP**
Roger Vivier creates the stiletto.

### 2000S
**PUMP PASSION**
*Sex and the City* popularizes the shoe brand Manolo Blahnik. Carrie Bradshaw's shoes are veritable characters of the show.

### 1993
**LEGENDARY**
Christian Louboutin paints his soles red. An icon is born.

### 1959
**THE SILVER SCREEN**
Salvatore Ferragamo creates pumps with a pointed toe, and Marilyn Monroe wears them in *Some Like It Hot*. They become his signature.

# BRA
## BODY STRUGGLE

**FACES OF** .......... EVA HERZIGOVÁ, MADONNA, RAQUEL WELCH

**PODIUM** .......... ALEXANDER MCQUEEN, GUCCI, MUGLER

Women's bodies have been supported since antiquity. At first, breasts are covered with bands of material, but sculpting corsets soon dominate and are imposed on women until the end of the 19th century. The modern bra, worn hesitantly at first, is born as a hygienic response to the corset.

↑ *Jeanne Bra*, Yasmine Eslami

### « HELLO BOYS »
The breast-lifting Wonderbra is established in the 1960s. But it isn't successful until the release of a cult 1990s ad campaign where Eva Herzigová asks gawkers to look her in the eyes. The commercial propels the brand's popularity: in 1992, Wonderbra produces 20,000 bras per week. Even the Spice Girls celebrate the bra in the film *Spice World*.

### A CORSET CUT IN TWO
Beginning in the 19th century, doctors sound the alarm about the damaging effects of the corset. Feminists immediately support early alternatives. At the 1889 Paris Exposition, Herminie Cadolle presents a corset cut into two pieces, thus distinguishing the bra as a separate undergarment. But it isn't until the S-shaped silhouette of the Belle Époque transitions into the straight dresses of the 1920s that the bra is truly established.

### INDUSTRIAL PRODUCTION
In the Roaring Twenties, it is adopted by young flappers (p. 320), and in the 1930s, it becomes even more popular, thanks to a broader range of cuts, fabrics, fits, and sizes. After trendsetting Hollywood icons wear it, it is mass-produced. With the invention of the underwire and the creation of bralettes for teenagers in the 1950s, it becomes commonplace, while the conical cups of bullet bras (p. 263) proliferate.

### BURN YOUR BRA?
1960s androgynous fashion abandons the cone-shaped cup, and 1970s feminists challenge the entire idea of wearing a bra, citing comfort as a factor. But it comes back into favor in the 1980s in the form of frilly, exposed lingerie that subscribes to an extravagant aesthetic falling somewhere between erotic and materialistic.

### « LOOK ME IN THE EYES »
In the 1990s, waifish minimalism and flashy sexuality coexist. XXL breasts are celebrated in series like *Baywatch*, and in commercials for brands like Wonderbra and Aubade. Intimate lingerie comes out of hiding and sex sells it.

### SMOKE WITHOUT THE FIRE
Legend has it that feminists burn their bras in protest for the first time during the Miss America contest of 1968. Although they do denounce the competition, they do so by throwing undergarments in the trash. A journalist compares the gesture of these women to that of men burning their draft cards to protest the war. Her words are misunderstood, and the very next day, the *Times* reports that the women had burned their bras.

# PANTIES
## WHAT'S THE WORD FOR IT?

| FACES OF | SCARLETT JOHANSSON, KATE MOSS |
| --- | --- |
| PODIUM | GUCCI, CHANEL, SONIA RYKIEL |

The word « panties », evokes women's underwear. But originally it is used to designate pants worn by men or boys. In contemporary French, women's panties are called *culottes* and often preceded by *petite* (little), as if to highlight their scantiness and evoke the intimate and erotic aspects of wearing such a small fragment of fabric.

### CULOTTE OR PANTALON

Aristocrats of the end of the 17th century in France popularize the culotte, short pants worn by men until the French Revolution. Elegant and practical, they exemplify the *habit à la française*, an ostentatious three-piece suit worn by Louis XIV and his court. The end of the 18th century establishes the *pantalon* (pants) among the sans-culottes who renounce the nobles' garment and choose a military-inspired garment instead. Gradually, this version of the culotte disappears.

### UNDERWEAR

In France, the « pantalon » arrives first in women's intimate lives. During the Renaissance, Catherine de' Medici attempts to bring drawers, a type of loose underpant, into women's wardrobes. But the basic underclothing of the time remains the chemise, and drawers are relegated to unvirtuous women, domestic workers, or little girls.

### NEW MODESTY

It isn't until the 19th century, with its emphasis on hygiene and exaggerated Victorian morals, that women are encouraged to cover up, with the help of lingerie pants. The ballets of the Paris Opera and the dances in the cabarets also support this new undergarment that favors movement and convenience.

### PANTALON OR CULOTTE

Styles change, and silhouettes evolve. Long puffy pants are less and less suitable, so they are shortened and slimmed down, influenced by men's culottes of pre-Revolution France. Language changes, too. In French, « pantalon » is now the word for men's pants, and « culotte » is used to describe panties worn by women.

↑ **Amoureuse Panty,** Henriette H

### LESS FABRIC

With the commercialization of spandex in 1960, panties become thinner, more malleable, and more elastic. The sexual revolution leads to simplified lingerie. Stockings, garter belts, and push-up bras give way to colorful tights, printed panties, and the thong, which becomes popular in the 1970s. The body is liberated and revealed.

### LIBERATED WOMAN

Panties, initially resembling wool open drawers, evolve in 1918 when Étienne Valton offers them in cotton or wool, without legs or slits, and with an elastic waist. His knitwear factory near Troyes, named Petit Bateau in 1920, is part of the history of women's emancipation because his panties change the relationship between a woman and her body.

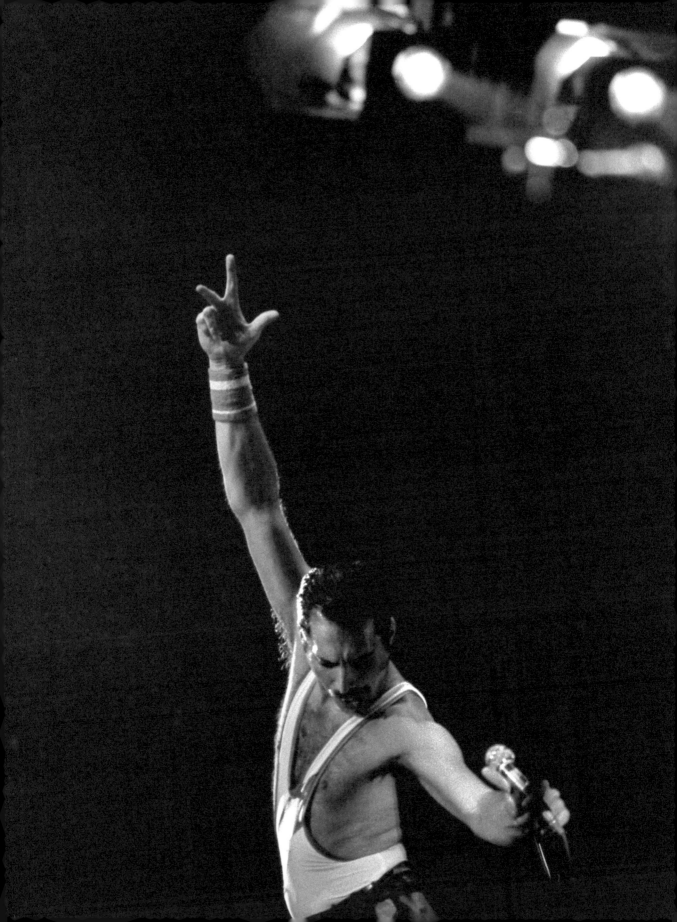

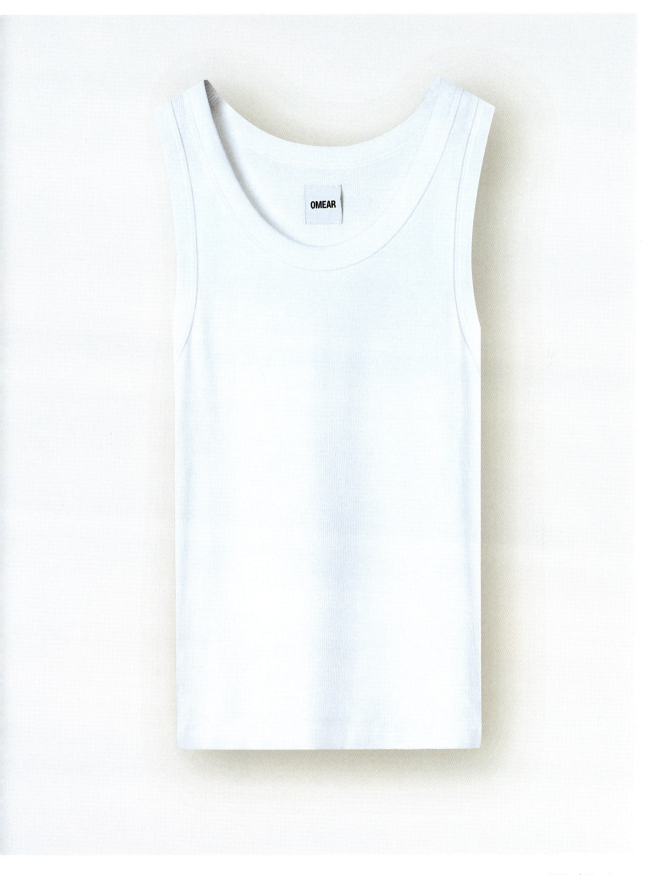

**Freddie Mercury,** *National Exhibition Centre,* Birmingham, 1984

↑ DB Tank Top, Omear

# TANK TOP
## IN OR OUT?

FACES OF ......... FREDDIE MERCURY, BRUCE WILLIS, RENÉE PERLE

PODIUM ......... PRADA, ANN DEMEULEMEESTER, HELMUT LANG

The tank top is one of those versatile wardrobe items – underwear turned outerwear. The rise of the tank top is closely tied to the development of the knitwear industry. What we put on underneath comes out on top.

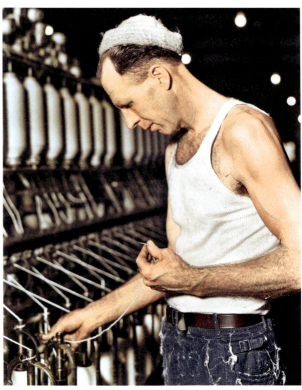

↑ Textile worker, High Point, North Carolina, 1937

« WHEN I TAKE MY HAND OUT OF THIS BLANKET, MY NAIL WILL BE GROWN BACK, MY HANDS WILL BE CLEAN. MY BODY WILL BE CLEAN. I'LL HAVE ON CLEAN SHORTS, CLEAN UNDERSHIRT, A WHITE SHIRT. »

J.D. SALINGER

### STAY CLEAN

Initially, it's associated with hygiene because it gets its shape from wool or cotton undershirts worn next to the skin. Similar to the leotards gymnasts and wrestlers wear and to the sleeveless bathing suits of the early 20th century, it is also connected to physical activity.

### HERS & HIS

In the 1990s, Calvin Klein turns the tank top into the ultimate androgynous symbol. When his first unisex perfume, CK One, is launched in 1994, tank tops appear throughout the advertising campaign.

### TOXIC MASCULINITY

In 1947, a man is arrested for having beaten his wife to death. The newspapers publish his photo on the front page, calling him « The Wife Beater ». He is wearing a blood-stained tank top, and the nickname is applied to the garment. The expression eroticizes the tank top's allure in an unhealthy and virile ambivalence.

### THE BELLY OF PARIS

But the working-class milieu fraternizes the most with the tank top. In French, it is called « débardeur, » which is the word used to describe a worker who loads and unloads lumber and other merchandise. In 1860, in the stalls of Les Halles, the large food market formerly in the center of Paris, a warehouse worker cuts the sleeves off his sweater for more liberty of movement. The hosier Marcel Eisenberg sees it and is inspired. He mass-produces a sleeveless undershirt labeled with his name, and it becomes commercially known as the Marcel.

### MASCULINE...

It carries social connotations, accompanying the muscular and hardworking male body. Hollywood capitalizes on this symbolism in *A Streetcar Named Desire*. Marlon Brando wears a tank top that sexualizes the fantasy of working-class virility.

### OR ANDROGYNOUS ?

It can also be androgynous and audacious. In the Paris Carnaval, the « débardeur » is a character, man or woman, who wears a blouse and pants, popularized by the illustrator Gavarni in the 19th century. In the 1930s, the tank top is worn by emancipated women. In the 1970s, it is adopted by the gay community. Since then, it has continued to blur lines by representing the crude animality of men's bodies and the audacity of those fierce women who take ownership of masculine stereotypes.

# MEN'S BRIEFS
## THE MALE BODY

FACES OF .......... MARK WAHLBERG, DAVID BECKHAM
PODIUM .......... JOHN GALLIANO, JEREMY SCOTT, WILLY CHAVARRIA

The earliest undergarments are hybrids. Men sometimes wear a loincloth as an inner garment, and sometimes, it's their only garment; a loincloth worn alone is a sign of poverty. In Egypt, for example, it is reserved for laborers and domestic workers, whereas full nudity qualifies someone as a slave.

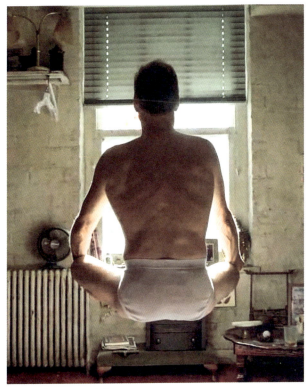

↑ Michael Keaton in *Birdman*, 2014

## AN OVERSHIRT

In France, the end of Antiquity changes everything. The chemise eventually prevails as the only undergarment. Men adopt culottes (short pants) with their *habit à la française*, the flashy suit favored by Louis XIV, until the revolution sweeps away these aristocratic relics and establishes the three-piece suit.

## FROM LONG JOHNS TO BOXER SHORTS

New rational and hygienist principles lead to new habits, and the dark suit is worn over long underwear, which becomes shorter in the 20th century. Briefs are exclusively for athletes until, in 1918, Pierre Valton, the future founder of the French brand Petit Bateau, cuts the legs off a pair of long underwear and adds an elastic waist. The wheels are in motion. As for boxers, they are created in 1925 by American boxing equipment manufacturer Jacob Golomb for his brand Everlast.

## A MODERN BRIEF

In 1935, American company Cooper's Inc. begins selling men's briefs. Surprising ads promote them with illustrations of naked male bodies. Until then, only women's bodies had been thus exposed. A new era opens for men. Sex sells. Their bodies are now subjected to this rule, too.

### FOR WOMEN

In the 1990s, Calvin Klein puts his briefs on women's bodies. Eroticism is redefined. A woman borrowing underwear from a man suggests intimacy in its most sexual sense. The images evoke the morning after a sleepless night, with a pair of undergarments taken as a souvenir.

## « IT'S FUN SEEING MY LABEL ON SOMEONE'S BEHIND – I LIKE THAT. »
CALVIN KLEIN

## SEDUCE MEN... AND WOMEN

After the war, women, who do the shopping, struggle to reconcile the opposing depictions of men in these ads as both hyper-masculine and seemingly embarrassed. In the 1960s and 1970s, even though the ads become commonplace, they continue to unnerve. In the 1980s, Calvin Klein changes everything. His ads dare to be erotic without shame or false pretenses. The more audacious, the better.

### STAR SYSTEM

In the early 1980s, Calvin Klein collaborates with photographer Bruce Weber for his ads. Guided by an erotic aesthetic, often homoerotic, they portray scenes of oiled, muscular young men, recalling the canons of ancient Greco-Roman sculpture. In the 1990s, they lean into pop culture with teen idols like Mark Wahlberg.

↑ Boxer Shorts, Ron Dorff

→ Tom Hintnaus in Calvin Klein briefs, *photo by Bruce Weber*, 1984

# LITTLE BLACK DRESS
## MODESTY IS CHIC

| | |
|---|---|
| FACES OF | LADY DI, AUDREY HEPBURN, LIZ HURLEY |
| PODIUM | SAINT LAURENT, CHANEL, VERSACE |

The arrival of the little black dress is mythologized – not surprising given fashion's fondness for stories and legends. There's the one about how Gabrielle Chanel created a dress that would become an essential of the feminine wardrobe: Chanel, the architect of elegance in black. Except that isn't how the story goes…

↑ Catherine Deneuve, *photo by Walter Carone*, 1963

« YOU CAN WEAR BLACK AT ANY TIME, AT ANY AGE, FOR ANY OCCASION. A LITTLE BLACK DRESS IS ESSENTIAL TO ANY WOMAN'S WARDROBE. »

CHRISTIAN DIOR

### THE COST OF BLACK

The history of fashion is also the story of pigment. In the late 15th century, black is in style. It shows social status: black fabric requires a long and expensive process whereby the color is obtained from gall nuts. Wearing black becomes the standard of luxury.

### PRINCES, NOT KINGS

But it also carries moralistic values of integrity and dignity. Philippe le Bon, the Duke of Burgundy, wore black to stand out from the opulent purple of the monarchy, launching a trend among princes and the wealthy.

### MODEST PROSPERITY

Whether it's in the countries of the Protestant Reformation or in powerful, anti-reform Spain, wearing black displays the rank and virtues of aristocrats who shun extravagance without renouncing distinction.

### AN ORDINARY BLACK

In the 19th century, it becomes accessible thanks to less expensive synthetic dyes, though it is primarily restricted to the masculine wardrobe, more serious than that of women; men are power, after all. Only a daring few upper-class women wear black dresses, passing for independent, or as femmes fatales. The rest wear colors and frills.

> **THE AESTHETIC OF POVERTY**
>
> The little black dress also belongs to the working class. In the 19th century, along with a white apron, it is part of a streamlined uniform for domestic workers. After the Industrial Revolution and the subsequent development of new trades, saleswomen in department stores and workers in Parisian haute couture houses wear it to avoid overshadowing their clients.

### WIDOWS AND MODERNITY

Beginning in 1914, it is worn by widows. Then by Gabrielle Chanel, who simplifies the feminine silhouette with a versatile, comfortable, and practical black dress. In 1926, *Vogue* Magazine compares it to a Ford car, and the legend is launched: a new definition of chic is established.

### MULTIFACETED AND ONE-OF-A-KIND

Today, the little black dress has come into its own. Versatile and timeless, it has a place in every style.

> **BLACK SCREEN**
>
> Black-and-white movies lead Hollywood to define two types of femininity: the sweet romantic blonde in white and the vamp dressed in black. More modest stereotypes exist, too, like that of the saleswoman or the secretary. With their black dresses, they embody modernity and independence.

## BLACK GOLD

### 15TH CENTURY
**EXCLUSIVE COLOR**
The color black is reserved for princes.

### 16TH CENTURY
**RELIGIOUS CODES AND CLOTHES**
Virtuous and luxurious black dresses appear during the Reformation and Counter-Reformation.

### 1883
**PORTRAIT OF A DRESS**
John Singer Sargent paints the *Portrait of Madame X*.

### 1926
**ASSEMBLY LINE**
Chanel's little black dress is described as the Ford of fashion in *Vogue* magazine.

### 1946
**SILVER SCREEN**
Rita Hayworth wears a beguiling Jean-Louis Berthault sheath dress in *Gilda*.

### 1960
**TREVI FOUNTAIN**
Anita Ekberg takes a moonlight swim wearing a black dress in *La Dolce Vita*.

### 1961
**ICONIC IMAGE**
In *Breakfast at Tiffany's*, Audrey Hepburn lingers in front of the Tiffany's shop window, wearing a black Givenchy dress.

### 1967
**SILVER SCREEN**
Catherine Deneuve wears a black Yves Saint Laurent dress with a Peter Pan collar as a falsely naïve, wealthy woman in *Belle de Jour*.

### 1972
**AUDACIOUS BACKSIDE**
Mireille Darc stuns in a backless dress in *Le Grand Blond avec une chaussure noire (The Tall Blond Man with one Black Shoe)*.

### 1994
**REVENGE DRESS**
Prince Charles admits to adultery, and on the same evening, Lady Diana wears a black dress that, until then, she'd considered too audacious. The media calls it « the Revenge Dress ».

### 2018
**INSTRUMENT FOR CHANGE**
The black dresses of the women who participate in the Golden Globes ceremony become a symbol of protest. The #TimesUp movement unfolds.

↑ Givenchy Dress

→ Jane Birkin, Paris, 1968

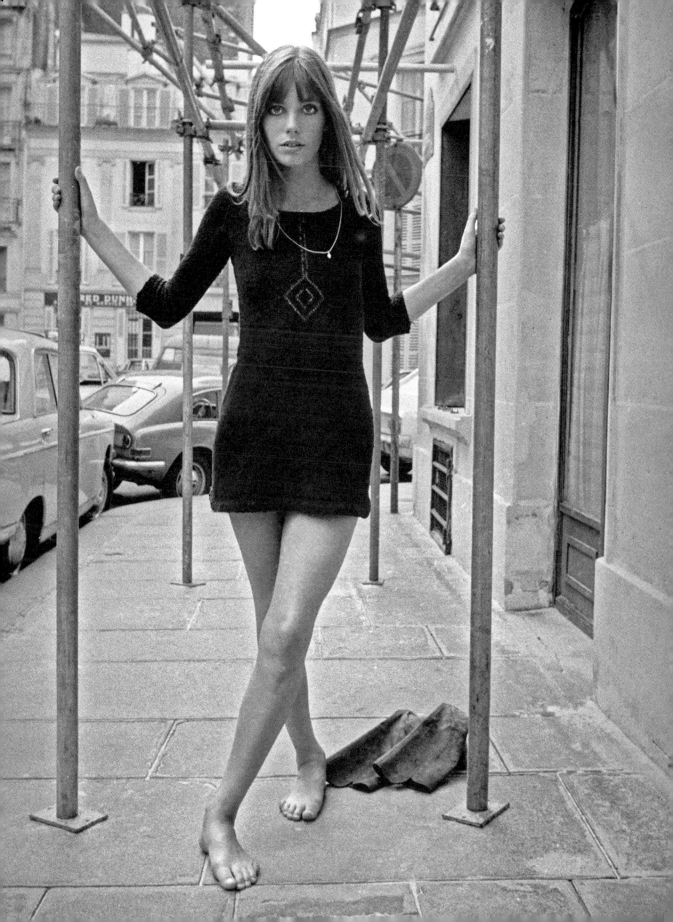

# DJELLABA
## COMFORT AND TRADITION

| | |
|---|---|
| FACES OF | LL COOL J |
| PODIUM | CHRISTIAN DIOR, MISSONI, VERSACE |

Of Moroccan origin, the djellaba is rooted in Berber culture, known since antiquity for its numerous interactions with the Mediterranean Basin. It also owes its aesthetic to influences from the Ottoman Empire, even though Morocco is one of the few Maghreb countries to have resisted its domination.

### A MOROCCAN TRADITION
Popular in the Maghreb region, especially in Algeria, this long loose robe with a pointed hood (*kobb*) protects from the sun and wind. Its origins are imprecise: for some, it's a garment of the djellab, the slave trader, whereas others see in its name an alteration of djilbab, which means « draped garment », even if the djellaba isn't draped.

### ONLY ONE VERSION?
Initially, it is worn by men and made of wool, often white. But once adopted in cities, it is offered in softer fabrics, varied colors, and ornamented with tassels and trimmings.

### BETWEEN MATURITY AND EMANCIPATION
As a symbol of virility, it participates in rites of passage to adulthood for 13-to-14-year-old boys; wearing it affirms their maturity. But it also accompanies the emancipation of women. Beginning in the 1940s, especially with the declaration of Moroccan independence in 1956, women start to wear men's clothing because it is more practical than their traditional haïk, a heavy fabric that wraps around the body.

#### OF MEN AND COLORS

**White djellabas :** typically reserved for men of the highest ranking

**Earth-toned djellabas :** typically reserved for agricultural workers

↑ Traditional Hooded Djellaba

### EVERYDAY CLOTHING
The djellaba is functional. It is simply slipped on over everyday clothes, like a coat. Women, less and less confined to the domestic sphere, borrow it and evolve its style, guiding it towards modernity without ignoring tradition.

### AGAINST THE GRAIN
Fascinating despite its banality, the djellaba defines an ideal of gender neutrality, far from the strict stereotypes of Arab clothing.

#### ALL'S FAIR IN WAR

While under the French Protectorate, Morocco contributes to the First World War. The foot soldiers of the Moroccan Brigade protect themselves from the cold with the djellaba, and it becomes a symbol. Moroccans nickname themselves « Djellabas », while the Germans call them « Death Swallows » because the fabric of their djellabas flies, bird-like, in the wind during charges.

# KUFI
## INDIVIDUAL EXPRESSION

**FACES OF** ......... MARVIN GAYE, QUEEN LATIFAH, SALT-N-PEPA
**PODIUM** ......... WALES BONNER, DURO OLUWU, RICHARD MALONE

The first brimless, felt headwear can be traced back to Greece and Egypt. Adopted by the Ottoman Empire, these hats spread through Africa and Southeast Asia with the expansion of Islam. The kufi is the symbol of a religion and a of cultural identity.

↑ Spinall, *MTV Europe Music Awards*, Düsseldorf, 2022

### MARKET INFLUENCE
The use of the kufi isn't limited to Islam. It is worn by many African men regardless of their religious affiliation. Though similar to the calotte, a skullcap worn by Catholic priests, it is primarily a wardrobe item borrowed from Muslim merchants beginning in the 7th century. As a result, there are many variations within different cultures, like the taqiyah, used during Muslim rituals, the doppa in central Asia, the Tunisian chechia, and the Turkish fez.

### PIETY AND TRADITION
The kippa has the same characteristics as the kufi. Cultural and religious, it, too, is similar to a calotte. While covering the head is a tradition anchored in the Middle Ages, it's in the 19th century that it becomes the norm within Judaism. Made by hand or manufactured, the kippa is worn to celebrate special events and merges with popular culture in the 1970s.

### MATERIAL AND SPIRITUAL
In Europe, the kufi is worn by men on their way to pray and is closely associated with the Muslim religion. Elsewhere, it is ordinary, worn as an everyday accessory, especially in West Africa, where it is an attribute of wise elder men. It can be crochet-knit or have colorful patterns.

### AMERICAN LANDSCAPE
In the 1960s, in the U.S., the expansion of the civil rights movement popularizes the kufi. Combined with the dashiki, it asserts Black identity. By introducing traditional African clothes on the American continent, the Black population reclaims an identity while also bringing it into local popular culture. Kufis are worn in Blaxploitation movies and by Marvin Gaye, who wears them to express his Muslim beliefs.

### VERSATILE
Since then, it has been in and out of style, at the crossroads of fashion, religion, and tradition, covering vast terrain.

### MULTIFACETED
Kufi is a general term that describes headwear similar to the calotte, worn in African and Muslim cultures. In Pakistan, it is a topi; it's the fez in Turkey, and the tarbouche in Morocco. There is the Malaysian songkok and the Afghan pakol, while Tunisians wear the chechia and East Africans prefer the kofia.

Photographer Norman Parkinson, 1984

↑ Original Kente Kufi, Afrohemien

# DASHIKI
## AFRICAN ROOTS

**FACES OF** .......... LUPITA NYONG'O, BEYONCÉ, CHADWICK BOSEMAN

**PODIUM** .......... MAXHOSA BY LADUMA

The dashiki's roots are in West Africa. Its name comes from the Yoruba word « danshiki », which refers to a loose-fitting and functional tunic suitable for hot weather. Danshiki is derived from the Hausa term « dan ciki », which designates a garment worn by men under large robes.

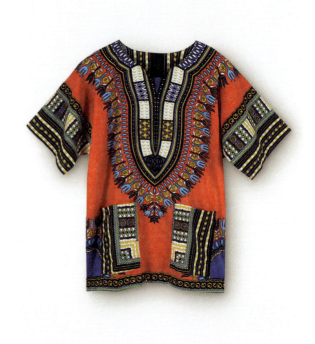

↑ Traditional Dashiki

### A SYMBOL
It's a traditional African garment, but its symbolic use is built outside the continent. In the U.S., in the 1960s, the civil rights movement imbues it with political and social power. Wearing this item of clothing, like wearing an afro, allows Black men to express their rejection of Western aesthetic and cultural norms while affirming Black pride.

### IN WAX AND COLOR
It usually features a colorful print of geometric patterns made with the Indonesian batik technique, which consists of protecting certain zones of fabric with hot wax before applying colors to create contrasting patterns. Wax, the African material made popular by the Dutch company Vlisco in the 19th century, is born of batik.

> « POLITICAL POWER DOES NOT FLOW FROM THE SLEEVE OF THE DASHIKI; POLITICAL POWER FLOWS FROM THE BARREL OF A GUN. »
>
> FRED HAMPTON (BLACK PANTHER)

### AMERICAN BUSINESS
To wear it is to connect to Africa through allegory. Activists in the 1960s reclaim an identity that was stolen from their ancestors. New York brand New Breed mass produces the dashiki and distributes it nationally to celebrate the heritage of the Black community and promote its economic independence.

### POP CULTURE
In the 1960s, Vlisco creates a floral batik pattern inspired by the Ethiopian caftans of the 19th century. The fabric becomes popular, and different versions are named after popular cultural references: « Angelina, » based on a song by the Ghanaian group Sweet Talks & A. B. Crentsil, « Ya Mado », after a Congolese dance, and « Miriam Makeba », after the South African singer.

### CASTING AGAINST TYPE
Whether worn by Black Panthers (p. 340) or the characters of blaxploitation films, the context is the « Black is beautiful » movement. But at the end of the 1960s, the hippie community (p. 326) gets ahold of the garment. The white counterculture aspires to show solidarity and diversity. The Black community warns of the dangers of banalization and the risks of the traditional garment becoming an accessory, which would diminish the real struggle it is meant to represent.

### BLACK IDENTITY
On the African continent, it is endlessly rediscovered by new generations, assuring its lineage. Women also make it their own, as a dress. Outside of Africa, it serves to transmit and honor African roots and the heritage of the Black American experience of the 1960s.

# BIKER JACKET
### REBEL WITHOUT A CAUSE

| FACES OF | MARLON BRANDO, JOHNNY HALLYDAY, RAMONES |
|---|---|
| PODIUM | CELINE, BALMAIN, VERSACE |

The name says it all. It tells the story of a jacket originally designed for those who travel for miles and miles perched on their rumbling motorcycles. Intrinsically connected to their image, the biker jacket absorbs its characteristics: rebellious, and sometimes even a little criminal.

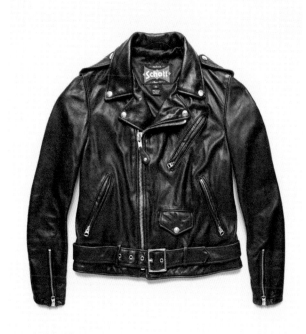

↑ *Perfecto*, Schott

« I DON'T NEED ANYONE, ON A HARLEY DAVIDSON. »

SERGE GAINSBOURG AND BRIGITTE BARDOT

### THE MOTORCYCLE: A NEW HOBBY

Beginning in the late 19th century, the two-wheeled vehicle intrigues thrill-seekers, and competitions multiply. For workers, it is a functional means of transportation, while during the two World Wars, it is helpful as a military vehicle. In the roaring 1920s, its popularity grows, and suitable clothing becomes necessary.

### CURSED

Ironically, the jacket's popularity in 1950s music and film leads to a drop in sales. Associated with rogue behavior, many American schools forbid their students from wearing it. Sadly, it's the accidental death of James Dean in 1955 that relaunches sales. The actor becomes a legend, and his rebellious wardrobe – iconic.

### FROM SKY TO EARTH

Aviator jackets are the most suitable existing option, but they don't protect from the wind. In 1928, Schott Bros, a company run by New Yorkers Irving and Jack Schott, offers a leather biker jacket with a zipper down the front; the « perfecto. » They continue to develop models throughout the 1930s.

### THE WILD ONE

The biker jacket enters the public arena via the Boozefighters, a motorcycle gang. After a brawl in 1947, the jacket comes to represent the dissidents and biker clubs that embody postwar tensions. In 1953, a film inspired by the gang is released. It is called *The Wild One*, and it establishes Marlon Brando as the rebellious hero of a new generation.

### BUILT-IN FANS: THE REBELS

In the 1970s, rockers, revolutionary high schoolers, French *blousons noirs* (black jackets), and punks (p. 328) all emerge in black leather. The biker jacket can be studded, spray-painted, and distressed, Sex Pistols-style, or it can be tight and quirky, in the manner of the Ramones. It's a provocation in the face of cliché masculinity. As a caricature of itself, the biker jacket loses its rough edges. Today, it is conventional in the wardrobes of both men and women.

### LUXURIOUS

In the 1990s, it is sanctified and revisited by haute couture designers Gianni Versace and Karl Lagerfeld. Gold chains or studs are added. It becomes insolent and ostentatious. Peter Lindbergh immortalizes supermodels as bikers, and Winona Ryder and Johnny Depp wear them on the red carpet.

*Next page :*
A group of punks, 1989

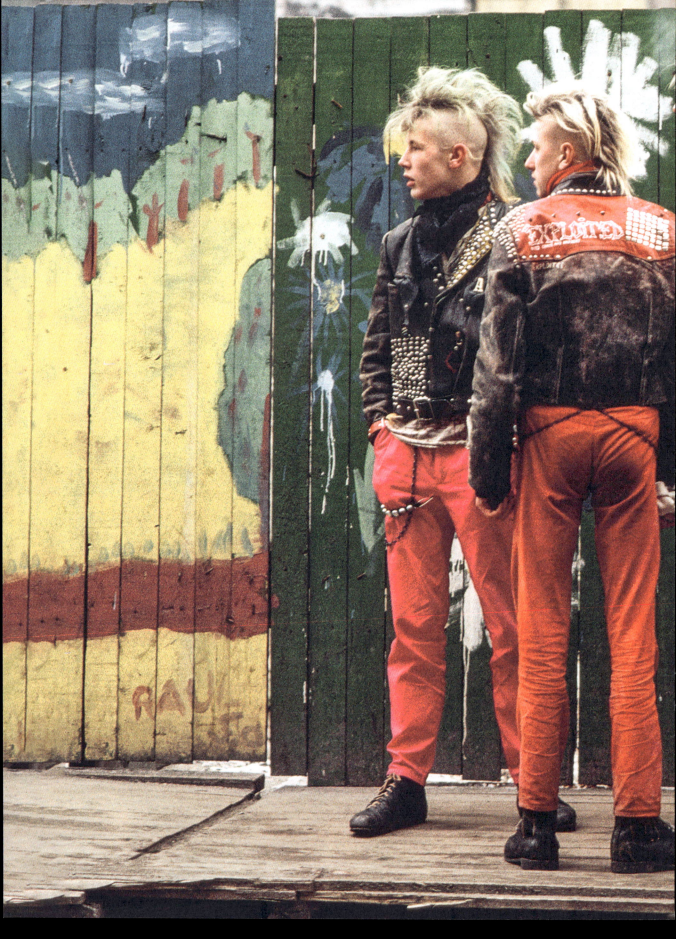

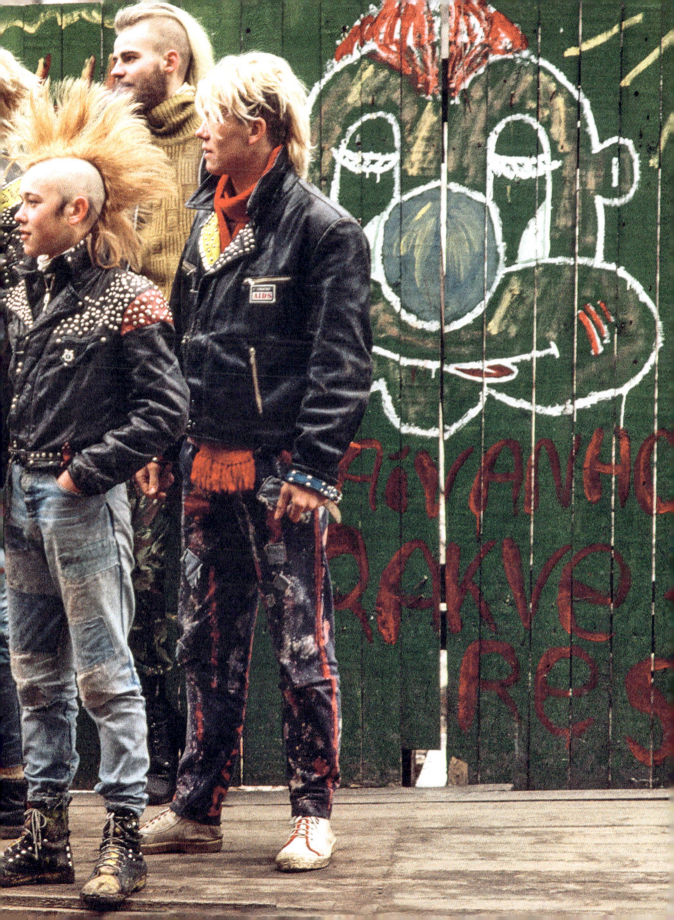

# GUAYABERA
## COMFORT WINS

| | |
|---|---|
| FACES OF | ERNEST HEMINGWAY, FIDEL CASTRO |
| PODIUM | BODE, LOEWE, ISSEY MIYAKE |

The origins of the guayabera are imprecise. It is primarily associated with Latin America, especially Cuba, though there are versions in Southeast Asia. The link between the two continents? Hot and humid climates.

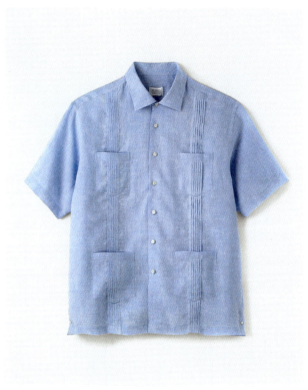

↑ Linen Guayabera Shirt, Mirto

### CUBAN LEGENDS

There are numerous legends about the emergence of the guayabera. According to some, it is first created in the early 18th century, after a wealthy Cuban landowner asks his wife to make him a lightweight shirt with multiple pockets. His employees copy the shirt because it is suitable for heat and hard work. It is named « yayabera, » after the nearby Yayabo River. According to others, the name comes from a garment with pockets large enough to carry guavas (guayabas). And then, in the 19th century, there is a military uniform called « guayabera ». What do the three potential sources have in common? Cuba.

### INTERNATIONAL

The shirt is worn today in Indonesia, Mexico (especially in the Yucatán region), in the Dominican Republic, and in Zimbabwe via Cuban missionaries. In Jamaica, it is the emblem of the anticolonial struggle.

### A LONG JOURNEY

Still, others advance the theory that it all started in the Philippines in the form of the barong, a light, traditional embroidered shirt. Spanish colonists are said to have been inspired by their version in the 15th century. The model eventually arrives in Cuba, having passed through Mexico via the slave trade.

### HOLIDAY SOUVENIRS

Looking specifically at social and cultural history, however, it's Cuba that prevails, because after starting out as a work shirt, the guayabera becomes an everyday garment there in the 20th century. Some Cubans resent its popularity in the late 1940s. They believe the casual shirt underlines negative stereotypes that are intensified by the growing numbers of American tourists who associate wearing a guayabera with being perpetually on vacation. For these tourists, the shirt represents souvenirs and folklore.

### VIVA CUBA

But it's also an emblem of identity for Cuban immigrants in Miami, who wear it with nostalgia and pride. Since 2010, it has been the uniform of Cuban diplomats and politicians, who must wear it during official engagements. Already in the 1980s, the Jamaican prime minister had set up the guayabera as a symbol of anticolonialism. Proof that formalities can also be a matter of ease.

### THE ORIGINAL GUAYABERA

**4 patch pockets** with buttons on the front of the shirt

**2 rows** of vertical pleats (alforzas) in front and 3 on the back

**2 side slits** with buttons on the bottom of the shirt

**2 possibilities :** linen or cotton

**Few colors :** white and, rarely, pastels

# BERET
## GREEN PASTURES AND DISSIDENCE

**FACES OF** — MICHÈLE MORGAN, FAYE DUNAWAY, CHE GUEVARA
**PODIUM** — MARINE SERRE, JEAN-PAUL GAULTIER, CHRISTIAN DIOR

Felt hats have existed since ancient times. They are helpful for sun and rain protection. Malleable and practical, they are also adaptable. Among them is the beret, which, moving from green pastures to the city, is more eclectic than stereotypical.

↑ Ernesto « Che » Guevara, Cuba, 1964

### BETWEEN THE BERET AND *BOINA*

The soft wool headwear we know today comes from the Béarnese beret, worn by shepherds in the Pyrenees (in black for everyday activities or red for festivities). The Basque people adopt it in the 15th century as the « boina. » In the 19th century, bohemian Parisians give it a romantic and pastoral air. And in the early 20th century, the artistic avant-garde emphasizes its original emancipatory allure when it is worn in films by women like Michèle Morgan and Marlene Dietrich.

### AT WAR

Meanwhile, it becomes a military accessory around the world, like the « tarte » worn by elite mountain infantry soldiers in France. It also assumes insurrectional significance for members of the French Resistance during World War II, Cuban revolutionaries in the 1950s, and American Black Panthers fighting for civil rights (p. 340).

### WILD THING

Its revolutionary connotations appeal to rebellious postwar youth. Bohemian existentialists in the Saint-Germain-des-Prés neighborhood of Paris, jazz connoisseurs, and nomads of the Beat Generation all add it to their look. Born bucolic, it comes to exemplify urban modernity.

### MILITARY COLORS

**Dark blue :** the most widespread in France. Worn by infantry, artillery, foot soldiers, high-ranking officers, riflemen, air commandos…
**Turquoise blue :** UN soldiers
**Red :** French Army parachutists
**Coral :** common in Germany
**Brown :** Belgian infantry
**Green :** French Foreign Legion
**Black :** basic color for the U.S. Army

### IRONIC CLICHÉ

And yet, despite its turbulent past, it has become part of an archetypal French fantasy that includes a baguette, red wine, and a bicycle. Maybe that's where the beret's secret lies: it's so discreet that its transgressions are all the more surprising.

### WORLD TOUR

Around 2019, thanks to a Magnum photo and archival research, French company Laulhère discovers that Che Guevara's beret came from their brand. How the Béarnese cap found its way to Cuba is a mystery.

Brigitte Bardot, Paris, 1962

↑ Laulhère Berets

# AVIATOR JACKET
## AIRBORNE

**FACES OF** ......... STEVE MCQUEEN, TOM CRUISE, HARRISON FORD

**PODIUM** ......... BURBERRY, LOEWE, HERMÈS

As its name suggests, the aviator jacket is a flight jacket. It appears during the rise of aviation to protect pilots from the elements. The military and two World Wars accelerate the development of this technical and practical lined jacket.

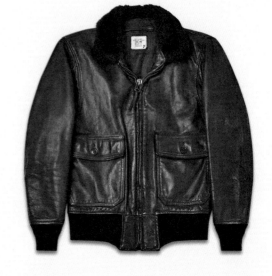

↑ Vintage US Navy '80s G1 Flight Jacket, Alpha Industries

### FLY WARM
In the early days of civil and military aviation, pilots wear jackets made of thick tweed or leather. But it isn't enough to counter the extreme temperatures at higher altitudes. During the Great War, the Sidcot flying suit, a waterproof jumpsuit with a thick fur collar, is created. It is the predecessor of the aviator jacket, which appears between the two wars.

#### SNIP SNIP
According to legend, during World War I, Manfred von Richthofen, a German aviator nicknamed the « Red Baron », tires of his long, bulky leather coat and decides to cut it shorter, foreshadowing the birth of the aviator jacket.

### DESIGNER PILOT
American pilot Leslie Leroy Irvin turns to the military industry at the end of the 1910s. He establishes a parachute factory in England in 1926 and, beginning in 1931, produces his first sheepskin jackets. The wool lining keeps the body warm, while the soft leather allows pilots to stay agile and comfortable in their narrow cockpits.

### WAR UNIFORM
With a thick chin-high collar and a belt at the waist to keep out cold air, it becomes the uniform of British Army aviators during the Second World War. The U.S. Army offers pilots its own version, the B3, beginning in 1934.

### EVERYBODY LOVES HEROES
After the war, the jacket enters pop culture via Hollywood movies, like *The Great Escape* with Steve McQueen, and through TV series that depict the conflict. Aviators are shown as cool, brave heroes. In 1986, *Top Gun* is released, and men everywhere imagine themselves as pilots.

#### AN ICONIC JACKET
The G1 jacket with a detachable fur collar becomes an instant classic when Tom Cruise, straddling his motorcycle, wears it in *Top Gun* in 1986.

#### MILITARY ROLE MODELS

**A :** aviator jackets

**B :** bomber jackets

**A1 :** lambskin leather, worn by Charles Lindbergh when he crossed the Atlantic (1927)

**A2 :** iconic Hollywood jacket, more modern and accessible than the A1

**B3 :** American version of the jacket designed by Irvin in England

**B6 :** simpler than the B3

**D1 :** sleeker version of the B6, adopted by fighter pilots

# BOMBER JACKET
## ACCIDENTAL HERO

FACES OF ......... RYAN GOSLING, STEVE MCQUEEN, EWAN MCGREGOR

PODIUM ................................ RICK OWENS, SACAI, RAF SIMONS

The growth of aviation contributes to the development of jackets worn by aviators, often in open cockpits. As soldiers' uniforms become lighter and planes improve, a nylon jacket is born. The U.S. Army's MA-1 model, with a small knit collar, appears in 1949.

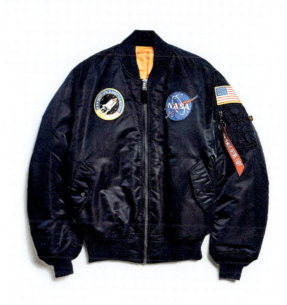

↑ **Bomber NASA**, Alpha Industries

### WAR SOUVENIRS

At the end of the Second World War, American soldiers based in Japan have their sukajan (souvenir jacket) decorated with embroidery, mixing Western and traditional Japanese patterns. The lining of the reversible jacket often presents controversial designs. Later, it becomes popular with young rebels, gangs, and Japanese delinquents before becoming a global phenomenon.

### REVERSAL

In 1984, the British singer and gay rights activist Jimmy Sommerville releases the hit *Smalltown Boy* with his group Bronski Beat. The song is about the persecution suffered by a young gay man in a small town. In the video, the singer appears wearing a bomber jacket. He publicly thwarts the negative connotation of the bomber created by homophobic skinheads; the jacket becomes universal.

### AN AMERICAN IDENTITY

Nicknamed « bomber », there are also sage-green and navy-blue versions. They have an orange lining that allows accident victims to stand out for emergency services. In the 1950s, the jacket appears on the big screen (even Marylin Monroe wears one!), creating a connection between civilians and the military. In the 1960s, brought back into style by the Vietnam War, Americans wear it to show patriotism – or to express countercultural rebellion. In Europe, surplus stores make it accessible to younger buyers.

### ENGLISH SUBCULTURE

The skinhead movement, born in the 1960s in England, makes the bomber part of its identity in the 1970s. Wider popularity, thanks to fashion trends and, once again, pop culture, allows the bomber to distance itself from the violent movement.

### A VIRIL GARMENT

In the 1980s, Jean-Paul Gaultier makes a high-fashion version, and the hero of *MacGyver* wears a bomber that represents combative and seductive masculinity.

### TIMELESS APPEAL

The movie *Drive*, in 2011, jars viewers with its violence. The main actor Ryan Gosling, the costume designer Erin Benach, and the director Nicolas Winding Refn create a look that includes an aesthetically refined jacket inspired by 1970s glam rock and the sukajan. The wardrobe item, a white satin bomber with a yellow scorpion embroidered on the back, becomes iconic.

### URBAN STYLE

In the 1990s, the bomber is everywhere. Grunge, hip-hop, and techno looks (see Styles- p. 301 and following) all have the « alternative » jacket in common, and it becomes a fixture of the urban landscape. Designers like Raf Simons and Helmut Lang turn it into the signature piece of insubordinate style. The jacket blurs the line between luxury and streetwear in the hands of Demna at Balenciaga and Virgil Abloh chez Louis Vuitton (p. 283).

*Next page:*
New York subway, 1989

# DUFFLE COAT
## BRITISH, BUT NOT ONLY

**FACES OF** ········ NOEL GALLAGHER, JEAN-PAUL SARTRE, JEAN COCTEAU

**PODIUM** ············ LOEWE, MARGARET HOWELL, BALENCIAGA

Though the duffle coat is associated with British culture, Belgian and Polish garments actually inspired its characteristic silhouette. Popularized by the Royal Navy, it doesn't take its definitive shape until between the two wars. By the 1950s, it is a favorite among young people.

### BELGIAN HISTORY

The duffle coat's precursor develops in Belgium in the late Middle Ages, when thick water-resistant wool from the town of Duffel is used to make long coats, embellished with rope ties and buttons made of small wooden cones. Then, in the 1820s, the Polish Army wears a hooded coat with the same closure; it inspires English textile industrialist John Partridge to create an early version of the wider, shorter duffle coat in the 1850s.

#### BACK TO CHILDHOOD

In 1958, *A Bear Called Paddington*, the first book of the legendary English series, is published. It's the story of a bear found by a London family, the Browns, on a platform at Paddington station. His adoptive family gives the bear, named after the station, a blue children's duffle coat. He is never seen without the coat; it becomes his visual signature.

### NAVY FABRIC

The coat is practical, thanks to its hood, buttons, and sturdiness, and it attracts the attention of the British Navy. Lengthened and slimmed to conform to military standards, it becomes the official uniform coat in the 1880s. Soldiers wear it in navy blue or camel, turning it into a symbol of bravery and commitment during the Second World War.

### LETTERS OF NOBILITY

After the war, surplus stores increase its popularity. In 1953, the brand Gloverall launches the first civilian duffle coat, lighter and sharper. With its satin lining, its cotton ties, and the brand name embroidered in golden letters on the label, the practical garment becomes a fashion statement.

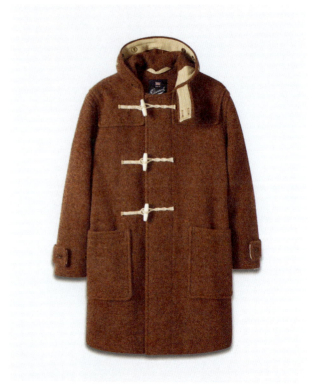

↑ Original Monty Duffle, Gloverall

> « I REMEMBER WHEN DUFFLE COATS WERE IN STYLE. »
>
> GEORGES PEREC

### YOUNG REBEL

As for numerous other military pieces, irony turns the duffle coat into a symbol of protest and an icon of antiwar counterculture. It is taken over by students, revolutionaries, and intellectuals. In popular culture, it represents both rebellion and youth, both Noel Gallagher and Paddington Bear.

#### OF WOOD OR BONE

**Wooden toggles :** slid into jute rope loops; made popular by the Royal Navy during the Second World War – today cotton has replaced the rope

**Buffalo horn toggles :** nicknamed « walrus tusk », toggles, they are slid into leather loops

# PEACOAT
## SOFT SAILOR

FACES OF ········ JACQUES BREL, ROBERT REDFORD, ALI MACGRAW

PODIUM ········ YVES SAINT LAURENT, RAF SIMONS, COACH

Sailors need warm clothes to protect themselves from the elements, so they wear thick navy-blue overcoats with large lapels that fold over the chest. The peacoat is another example of a functional military garment becoming an everyday item.

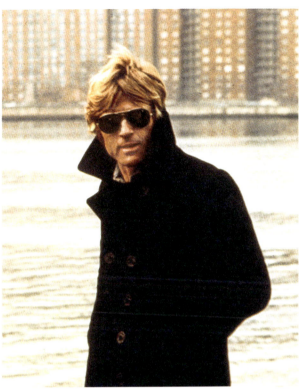

↑ Robert Redford in *Three Days of the Condor*, 1975

**FROM PIRATE TO SAILOR**

It is possible that 15th-century European sailors created the peacoat, based on the qaba, a wool cape worn by Barber pirates of Maghreb. Beginning in the early 19th century, the Royal Navy adapts it, but it's the French version, established by their Navy in 1845, that we know today. Descendent of the raincoat, it replaces the topcoat.

**IDENTITY CARD**

The coat is navy blue and mid-thigh-length, with buttons decorated with anchors in double rows down the front and on the corners of the wide collar. Identifying information about the sailor is printed on the sleeves, including his rank and specialty.

**GEOGRAPHY**

Gabon is believed to be named after the peacoat. When in 1472, Portuguese sailors arrive near the coast of the current region of Libreville, they find that the shoreline resembles the shapes of the peacoat, or gabão, in Portuguese.

**SAILOR ON DRY GROUND**

It enters the civilian world thanks to former sailors who are permitted to keep their peacoats if they remove the anchor-engraved buttons that are symbols of the Navy. Changes in military uniforms also contribute to broader availability among the general population, where it is easily identifiable thanks to its large vertical pockets.

**SETTING SAIL**

From man of the sea to elegant intellectual, its connotations evolve in the 1950s. Bohemians and subversives adopt it to embody a modest yet proud masculinity. It is a classic that combines the Left Bank culture of Boris Vian and Jacques Brel, the Hollywood prestige of Robert Redford, and the youthful enthusiasm of the Rolling Stones.

**WOMEN AT SEA**

In 1962, Yves Saint Laurent's first collection offers women a blue peacoat over white pants. The look exudes confidence. Nonchalant, hands in pockets, the women stand tall, proud, and defiant.

**FLURRY**

The peacoat's double-breasted front allows for closing on one side or the other, depending on the direction of the wind.

**CARTOON PEACOAT**

The peacoat first appears in comics in 1941, worn by Captain Haddock as he joins Tintin on his adventures. But it's the character Corto Maltese, created by Hugo Pratt in 1967, who establishes the peacoat as the archetype of spirited masculine elegance.

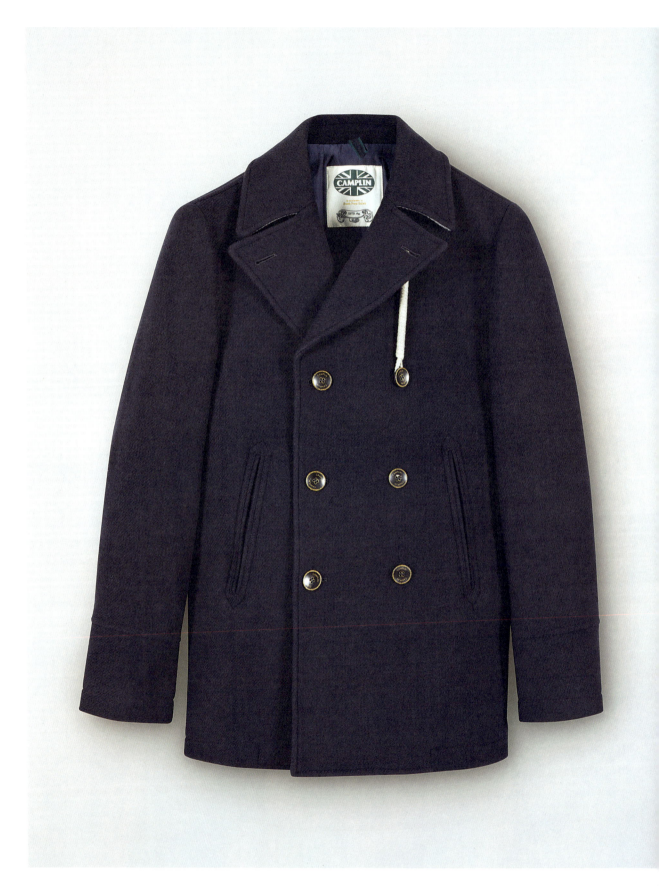

↑ Peacock Island Peacoat, Camplin    → Winston Churchill and his wife leaving the Queen Mary, September 23, 1943

# ESPADRILLE
## SHOES FOR SUNSHINE

| FACES OF | GABRIELLE CHANEL, SALVADOR DALI, GRACE KELLY |
| PODIUM | VALENTINO, LANVIN, DOLCE & GABBANA |

Soles made from woven natural fibers have existed around the world since ancient times. But it's during the Middle Ages that the espadrilles we know today are developed. Initially designed for agricultural work, they are now associated with a life far from fields and hard labor.

**VEGETAL SOLE**
The soles are made of rope (either hemp or jute); the upper is cotton or linen fabric. The Catalan version has long ribbons that wrap around the ankle or the leg, whereas the Basque version opts for minimalism.

> **ATHLETIC...**
> It isn't unusual to see photos of the tennis player Suzanne Lenglen wearing espadrilles during her games; flexible and enveloping, the shoes appeal to athletes in the 1920s.

**FOLK RITUALS**
They bear witness to a cultural history rich with folklore and tradition when they accompany Sardana dances and processions. They also represent the craft of artisanal production. After the Spanish colonists arrive in South America, cowboys and gauchos wear espadrilles, alluding to national pride, labor, and patrimony.

**SEASHELLS AND SEASHORES**
With the rise of leisure activities in the late 19th century, espadrilles arrive at the beach. The wealthy embrace the modest accessory. In the 1920s and 1930s, the sandals embellish the silhouettes of refined vacationers in the South of France. Coco Chanel, Le Corbusier, Salvador Dalí, and Pablo Picasso wear them with elegance. They also evoke physical exercise, outdoors, and sculpted bodies.

**ON THE BIG SCREEN**
Because of supply shortages during the Second World War, raffia or hemp is used for the soles. Then Salvatore Ferragamo makes a luxury version.

In Hollywood, they become cinematic after the war, worn by Grace Kelly and Cary Grant.

**HIGH-UP**
In the 1970s, the bohemian spirit of the hippie movement (p. 326) invades fashion. Yves Saint Laurent collaborates with the Castañer ateliers; he raises the soles, combining the platform look (p. 131) with the nonchalance of summer.

↑ Jean/053 Espadrilles, Castañer

> « HOW LOVELY IT IS, THE SARDANA THAT WE DANCE HAND IN HAND IN TRAMONTANE LAND. »
> CHARLES TRENET

> **... OR NOT**
> Comic strip character Gaston Lagaffe is a lazy outsider in a pair of espadrilles. His creator, Franquin, emphasizes the character's carefree idleness by drawing him in shoes that are synonymous with vacations and sunshine.

# PLATFORM SHOES
### REACHING NEW HEIGHTS

FACES OF ·········· LADY GAGA, CARMEN MIRANDA, SPICE GIRLS
PODIUM ·········· SIES MARJAN, DRIES VAN NOTEN, ERDEM

The first platform shoes appear in ancient Greece. In the Middle Ages, in the Ottoman Empire, wooden platform sandals called « kabkabs » are worn in the hammams for hygiene reasons. But, above all, beyond their functionality, platforms are an expression of rank.

↑ Paul Stanley, Kiss guitarist, 1980

**WEARABLE ART**

For his Spring/Summer 2010 collection, Alexander McQueen presents the Armadillo – futuristic and organic, quasi-fantastical platform shoes with an exaggerated platform (30 centimeters high). The twenty-one models produced for the show, never sold, are religiously collected by devotees like Daphne Guinness and even Lady Gaga. More than just shoes, they are works of art.

**VIEW FROM ABOVE**

The higher you are, the more eminent you are. Even kabkabs rise according to social rank. In Spain and Venice, aristocrats' platforms show status and wealth: their height makes it possible to wear long dresses with onerous fabrics.

**« FLOWERPOT SHOES »**

In 17th-century Japan, elevated geta shoes (p. 32) are adopted by high-ranking courtesans, while in China, in the 19th century, the Manchus favor platforms nicknamed « flowerpot shoes ». Platforms don't become more universal until the 20th century.

**GIRL POWER**

In 1995, the German shoe brand Buffalo launches two new models: the Classic and the Rising Tower. These imposing sneaker-like shoes feature a high sole (5 centimeters minimum) and are soon popular in the techno scene. But it's the Spice Girls who will make them a '90s staple by wearing them in their videos, on stage, and during appearances. Platform shoes become a symbol of powerful, playful, liberated femininity.

**HOLLYWOOD DREAM**

Moshe Kimel creates the first contemporary models and supplies American actresses in the 1930s. Elsa Schiaparelli, in collaboration with Roger Vivier, introduces platforms into a fashion collection. In 1938, Salvatore Ferragamo designs a sandal with a sculptural, multicolor platform.

**COMMON SENSE**

During the Second World War, leather is rationed. Only wood, rope, and cork are used. Robust and practical, platform shoes are an essential of the 1940s feminine wardrobe before being replaced by the stiletto heel of pumps (p. 96) in the 1950s.

**ANDROGYNOUS ALLURE**

Reintroduced by hippie culture, they become unisex. Glam-rockers, funk singers, and London Peacocks (see Styles, p. 301 and following) dare to wear extravagant models, while in daily life, men wear more modest platform heights. They continue to appear in the counterculture until the 1990s turn them into a pop culture staple for the young.

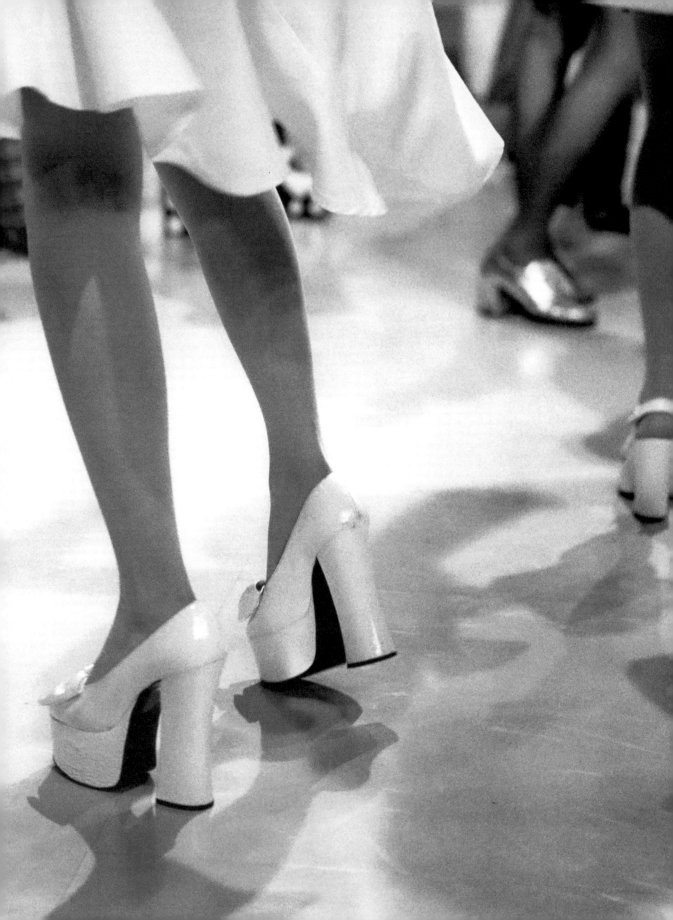

On the set of *American Brandstand*, May 29, 1973

↑ Bulla Babies 90, Nodaleto

# BOUBOU
## GRAND ATTIRE

| FACES OF | ANDRÉ LEON TALLEY |
|---|---|
| PODIUM | BADGLEY MISCHKA, ROKSANDA, CHRISTIAN DIOR |

Loose tunics are thought to have appeared in West Africa in the 8th century under the influence of Berber merchants. After the spread of Islam in the 11th century, caftans become popular. Ample and colorful, they are worn by the wealthy. A hybrid of these influences, the boubou remains traditional while inspiring a new generation of designers.

↑ **Mirabo Boubou,** Maison Beaurepaire

### SIGN OF WEALTH
With its wide sleeves and long and voluminous form, the boubou is an elective garment that requires a great deal of fabric (usually expensive and imported, such as silk or cotton) and the diligent work of artisans to embroider signs and patterns with tribal or spiritual significance. Boubou comes from the Wolof word « mbubb, » which means large garment, because the boubou is made using several fabric panels (*kitenge*).

### MODE D'EMPLOI
Men wear it as a three-piece ensemble: a long-sleeved shirt, pants, and a loose sleeveless tunic similar to a coat, accompanied by a chechia cap. However, it's also possible to wear just the tunic and pants for convenience.

As for the women's boubou, it consists of a long tunic, a turban, and a panel of fabric knotted at the waist like a skirt. All the pieces are made of the same material.

### TOWARDS REINVENTION
Carrying social, cultural, political, and sometimes religious significance and worn by men of the Muslim faith, it is endlessly renewed, appealing to African designers and young people seeking to link tradition and innovation.

### TECHNIQUES
Bazin is a cotton damask that is hand-dyed using a process that evokes tie-dye.

Adinkra refers to a printing technique using stamps dipped in ink.

> « MEN AND WOMEN ARE WEARING THEIR BEAUTIFUL BOUBOUS. »
> 
> AMADOU AND MARIAM, IN *DIMANCHE À BAMAKO (SUNDAY IN BAMAKO)*

### ALLEGORICAL ATTIRE
The boubou is adorned with symbolic colors and motifs and is made using traditional techniques, like adinkra or bazin. It is also available in wax fabrics beginning in the early 19th century, when European-made textiles, imitating Indonesian batik, arrive in West Africa and become a part of local culture.

### COLOR CODE

**Red :** passion, sunshine, fertility, power, mourning

**Blue :** cold, peace, purity

**Yellow :** luck, hope, decline

**Green :** growth, healing, virility

**Orange :** royalty, vitality

**Purple :** prosperity, Mother Earth

**White with gold embroidery :** for men who undertake the pilgrimage to Mecca.

# QAMIS
## A WORLD OF SHIRTS

FACES OF …………… DEEPIKA PADUKONE, HASSAN II

PODIUM …………… ANTONIO MARRAS, HERMÈS, DEREK LAM

In the West, shirts are associated with collars, cuffs, and buttons. But in the rest of the world, the upper body is dressed in garments that are successors of ancient tunics. These garments exist in a variety of forms that reflect the diversity of a broad stylistic vocabulary, but also a common heritage.

↑ Signature Kurta Qamis, Next

### SIMILAR ORIGINS

Before the shirt, there was the camisia, a medieval undergarment. This term is the source of many others, including the Italian camicia, the French chemise (p. 166), and the Arab qamis. With the evolution of Western fashion, the shirt takes the form that we know today – but that's a reductive view because in Arab cultures and in Southeast Asia, it takes a whole other shape.

### THE MEN'S TUNIC

The qamis is a tunic worn by men, even if some versions, like the African boubou (p. 134) or the kameez worn in India and Pakistan, are adopted by women. Often long, with long sleeves, it can be decorated with trim, buttons, or even a collar, depending on the tailor's discretion.

### RELIGIOUS ATTRIBUTE

The prevalence of the qamis grows along with Islam's expansion during the Middle Ages. Today, it is still the preferred garment for prayer. It is also closely tied to Muslim tradition and satisfies the precepts of the religion: to dress without ostentation and to conceal the body's shape. But the qamis isn't exclusive to Islam; it accompanies the daily life of men in the Arabian Peninsula and South Asia.

#### TO EACH HIS SHIRT

There are as many shirts as there are cultures. From the qamis derive the djellaba and the gandoura worn in the Maghreb region, the dishdasha or thobe of the Arabian Peninsula, the Indian kurta, and the African boubou. All the while, across centuries and continents, the tunics either conceal themselves as undergarments or come out into the light of day as the top layer.

### THE UNIVERSAL SHIRT

In the 1960s and 1970s, Westerners wear variants of the qamis. The hippie movement (p. 326) particularly appreciates the Indian kurta (a long collarless shirt, see p. 46), prized for its embroideries and ease. It's not unusual, even today, to see vacationers in light tunics. We reconnect with our ancestral histories by wearing relaxed garments that cover the body without suffocating it. The qamis is a common thread and a universal foundation. It's the source of adaptations, evolutions, and modifications. It's a garment that underlines our unity.

#### MODERN LIFE

In India and Pakistan, the qamis evolves into an ensemble, the shalwar kameez, composed of a tunic with slits at the thigh and pants that gather at the ankles (sarouel). It is worn by men and women, though its feminine variation is more successful as a daily garment. In India, it is often preferred to the less practical sari, and it is the school uniform of many young girls.

# JEANS
### A DECEPTIVE LABEL

FACES OF ......... JAMES DEAN, BROOKE SHIELDS, ELVIS PRESLEY
PODIUM ......... CELINE, TOMMY HILFIGER, JEAN-PAUL GAULTIER

From practical workwear to a manifestation of textile pollution, jeans, as iconic as they are banal, reflect society's evolution and have accompanied many cultural changes. But before the history of fashion, there is the history of fabric...

↑ Miners in Levi's, California, 1882

> « I HAVE ONLY ONE REGRET – THAT I DIDN'T INVENT JEANS. »
>
> YVES SAINT LAURENT

**FROM FUSTIAN TO JEANES**
In the Middle Ages, Northern Italy produces plain wool, linen, and cotton fabrics called fustians. Exported throughout Europe, they are used in the fabrication of sailors' pants and ships' sails. The English call them « jeanes », in reference to their port of origin: Genoa, or Gênes, in French.

**FRENCH OR ENGLISH?**
Later, in the 18th century, the French develop *serge de Nîmes*, a mix of wool and silk, often made by interweaving unbleached, undyed fabric with indigo fabric. The English, who were also involved in fustian production at the time, are said to have drawn inspiration from this weaving technique to create a softer cotton fabric: denim. The fabrication of cotton fabric, now preferred over wool, grows in England.

**JACKPOT!**
In 2000, some students find an original pair of Levi's from the 1880s in an old silver mine in California. Placed up for auction on eBay, the jeans, initially offered for 99 cents, eventually sell for 46,532 dollars!

**CROSSING THE ATLANTIC**
In England, two fabrics are now being produced: jean (robust, in a solid color) and denim (less rigid, blue, and natural ecru). Both are a success. Distributed as far as the U.S., they are copied and enter into the heart of the slavery-dependent American cotton industry. They become standard workwear for farmers, miners, and gold-seekers.

**WORK JEANS**
On May 20, 1873, workwear specialist Jacob Davis and dry goods merchant Levi Strauss obtain a patent for denim pants with copper riveted pockets: modern jeans are born. In 1890, the patent expires, and new American companies arise, like H.D. Lee Mercantile, which markets to factory workers, and The Blue Bell Overall Company (soon to be Wrangler), which sells to cowboys.

**JEANS? WHICH JEANS?**
Using the word « jeans » to designate pants is commercial. In the U.S., it doesn't appear until the 1930s. Jeans, made of jean (the material) or denim (like the pants that were patented in 1873,) were previously known as overalls. Even Levi's doesn't call their pants « jeans » until 1959.

> « I WANT TO DIE WITH MY
> BLUE JEANS ON. »
>
> ANDY WARHOL

### HOLLYWOOD HEROES

Hollywood creates a link between rural life and pop culture. In the 1920s and 1930s, the cowboy figure participates in the mythification of jeans, incarnated by actors in Westerns like Gary Cooper and John Wayne. They are seductive, lonely heroes who are virile and just.

### CONQUERING WOMEN

The Great Depression of the 1930s contributes to the rise of denim. Workwear becomes a part of the urban landscape, worn by those desperately seeking work. Levi's sells its first model of women's jeans, and *Vogue* devotes an editorial to them. In 1942, the American designer Claire McCardell creates her Popover dress, the first fashion piece in denim destined for 1940s housewives. Jeans are exported as a worldwide symbol of youth and modernity.

### REBELLIOUS YOUTH

Everything changes in the 1950s. The Hollywood archetype of the young rebellious man emerges, brazenly incarnated by James Dean and Marlon Brando in leather jackets (p. 115) and tight jeans. On the road, biker gangs travel across the country, and on TV, Elvis Presley plays rock'n'roll while gyrating his pelvis. Jeans represent defiance, nonconformity, sensuality, and delinquency.

### IN NUMBERS

**1** bale of cotton for **225** pairs of jeans

**7** jeans per person on average

**1,980** gallons of water to make **1** pair of jeans

**2.3** billion pairs of jeans sold per year

**40,000** miles traveled on average from fabrication to sale

**50,000** tons of indigo per year

**27,000** dollars: the price of the most expensive jeans in the world, a collaboration between Levi's and the artist Damien Hirst

Some schools forbid the controversial garment.

### A NEW WORLD

At the heart of 1960s counterculture, hippies (p. 326) wear jeans to denounce materialism and capitalist society and to pay homage to a working-class garment. At the dawn of the 1970s, counterculture is normalized, and jeans, worn by those demonstrating for women's and gay rights, are integrated into mainstream society.

### SPRAWLING INFLUENCE

Jeans become fashion in the hands of Calvin Klein, Willi Smith, and Yves Saint Laurent. Absorbing all styles and cultural phenomena, they tie together rock, punk, hip-hop, and grunge (see Styles, p. 301 and following). They are sophisticated, and they are basic. They are universal, and individual. Today, every 73 seconds, a pair of jeans is sold. Their history is also tied to the dark side of fashion: overconsumption and pollution.

↑ Young shoeshiners and urban cowboys, all in jeans, United States, circa 1975

> « D'THEY HAVE BLEWJEANS IN
> THEIR AMERICAN SURPLUS STALLS? »
>
> RAYMOND QUENEAU, *ZAZIE DANS LE MÉTRO (ZAZIE IN THE METRO)*

### FRENCH PRIDE

In 1944, American soldiers bring their rigid and raw denim jeans to France. At the end of the 1960s, Marithé + François Girbaud wash them with a pumice stone and create the first softened and faded stone-washed jeans. Urban and trendy, they look like they are worn-in. Soon, treatment techniques diversify, but not without provoking environmental and human damage.

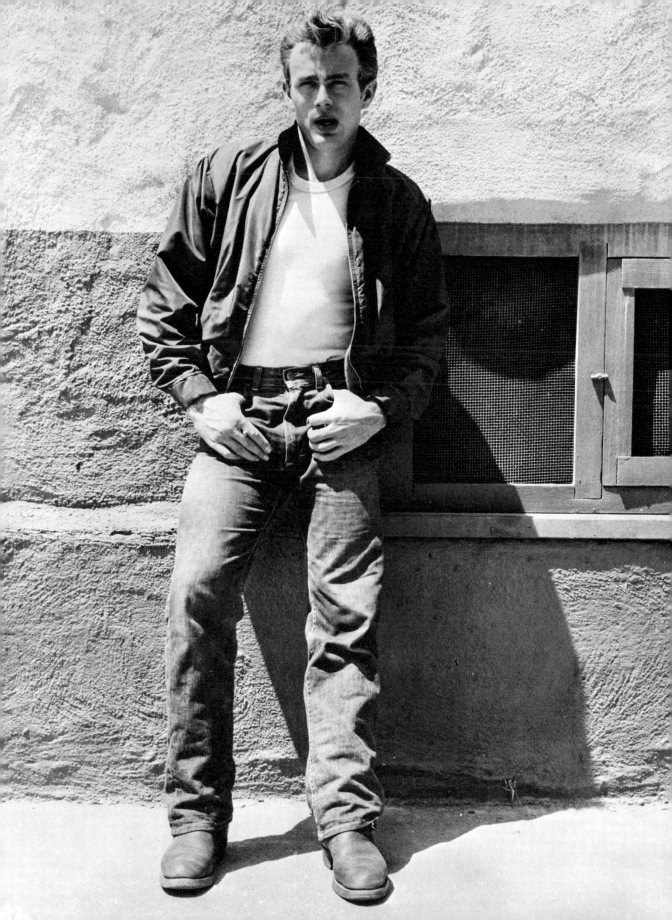

## BLUE PLANET

### MIDDLE AGES
**THROUGH THICK AND THIN**
Plain cotton, wool, and linen (or silk) fabrics, nicknamed « jeanes » by the Brits, are produced in Italy.

### 16TH CENTURY
**ITALIANS AND BRITS**
Following Italy's lead, England produces its own cotton and wool canvas.

### 18TH CENTURY
**IN FRENCH**
A wool and silk twill is developed in the Nîmes region of France.

### MAY 20, 1873
**PATENT**
Jacob Davis and Levi Strauss patent an indigo-dyed jean with pockets and rivets.

### 1860s
**TOWARDS BLUE JEANS**
Levi Strauss replaces the canvas in his workwear garments with indigo-dyed cotton denim.

### 19TH CENTURY
**AMERICAN JEAN AND DENIM**
Jean (blue) and denim (blue and ecru) are two distinct fabrics fabricated in the U.S.

### 1890
**BIRTH OF A CLASSIC**
Strauss and Davis create the 501 model.

### 1904
**NEWCOMERS**
The brand Blue Bell (Wrangler) is founded.

### 1912
**FOR THE LABORERS**
Lee Mercantile, founded in 1889, creates its first workwear.

### 1955
**GLOBAL ICON**
James Dean wears jeans in *Rebel Without a Cause*.

### 1939
**HEROIC REPRESENTATIVE**
John Wayne wears 501s in *Stagecoach*.

### 1934
**FEMININE VERSION**
Levi Strauss & Co. develops the first model of women's jeans.

### 1960
**THE JAPANESE DENIM**
The Kuroki Mills factory produces denim in Japan.

### 1970s
**HAUTE COUTURE DENIM**
Designer jeans develop (Gloria Vanderbilt, Calvin Klein...).

### 2020
**COMMERCIAL WARFARE**
More than 2 billion pairs of jeans are sold in the world.

→ Farrah Fawcett in *Charlie's Angels*, 197

# STYLE GUIDE

## THE CUT

**STRAIGHT**
Straight leg

**SKINNY**
Tight-fitting

**FLARE**
Bell bottoms & high waist

**BAGGY**
Relaxed fit

**TAPERED**
Narrower at the ankle

**MOM**
High waist, relaxed at hips

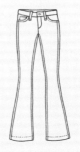

**BOOTCUT**
Slightly flared at ankle

**WIDE**
Wide fit throughout leg

## THE RISE AND THE LENGTH

**REGULAR**
Natural waist

**LOW-RISE**
Below navel

**HIGH WAIST**
Navel height

**MID-WAIST**
Just under navel

**DROP CROTCH**
Low crotch seam

① **CROPPED**
*Hemline just above the ankle*

② **CAPRI**
*Cropped below the knee*

③ **ANKLE**
*Ankle-length*

④ **TALL**
*Below the ankle*

⑤ **FOLDED**
*With a cuff*

# THE FINISHES

## IT'S ALL IN THE DETAILS

**DISTRESSED**  
Torn, frayed, worn

**CARGO**  
Multiple pockets

**BUTTON FLY**  
Button closure

**CORDUROY**  
Ribbed

**CUFFED**  
Folded

## A COLOR STORY

**RAW**    **STONE-WASHED**    **BLEACHED**    **USED**    **DIRTY**

## ABOUT FABRIC

**SERGE**  
Original denim fabric made from wool and silk using a twill weave, called serge, with a diagonal pattern that alternates blue and ecru threads.

**TWILL**  
1 - **Right-hand twill** :  
The diagonal pattern moves from lower left to upper right.

2 - **Left-hand twill** :  
The diagonal moves from lower right to upper left. The fabric is softer to the touch. It's the method adopted by the brand Lee.

3 - **Broken twill** :  
Zigzag weave, used by Wrangler.

**SELVEDGE**  
Developed in the U.S. in the 19th century for more sturdiness, this technique favors a tighter weave. It is recognizable by its finished edges (the word selvedge comes from self-finished edge), which are reinforced with a colored thread and thus resist fraying. In the 19th century, brands distinguish themselves with thread color: red for Levi's, yellow for Lee, and green for Wrangler.

# SWEATPANTS
## SUNDAY SUIT

| FACES OF | BOB MARLEY, MELANIE C, P. DIDDY |
| --- | --- |
| PODIUM | BALENCIAGA RESORT, GUCCI, BURBERRY |

At the end of the 19th century, a new emphasis on hygiene leads to new undergarments, especially for men. Long wool underwear, which absorbs sweat while keeping its wearer warm in winter, becomes popular. It is the first step towards sweatpants becoming more than just an intimate affair.

### STUDENT ATHLETES
While inspired by underwear, sweatpants are intended for practicing sports: in French, they are called "joggings" in reference to the English word. They develop at the end of the 19th century, especially in universities, where they are marked with the initials and logo of the schools.

#### POWER SUIT
Beginning in 1970, politicians showcase their athletic activities. Sports allow them to prove their dynamism, their power, and their good health. It brings them closer to the people and the young. And sometimes, sweats become a political tool, like when Fidel Castro wears them at the end of his life to influence his people.

### WARMED-UP MUSCLES
The tracksuit is an outfit composed of a sweatshirt or hoodie and soft pants with an elastic waist; athletes wear it as their competition gear. With the mediatization of the Olympics in the 20th century, the style is adopted by amateur athletes.

### RUNNING THE STREETS
As a society of leisure unfolds, the middle class adopts the suit, while the elite wears the soft sweatpants that echo it. In 1939, Le Coq Sportif sells them to the general French consumer.

### BIRTH OF AN ICON
Around 1939, American fashion begins to pursue sportswear. In 1967, Adidas creates its first colorful synthetic tracksuit with loose pants and a high-collared zip-up jacket. The triple bands on the arms and legs become iconic.

### MARTIAL ARTS AND HIP-HOP
The tracksuit invades pop culture and subculture, including hip-hop (p. 316). Young people imitate the looks of Bruce Lee, rappers, and break-dancers.

### BANLIEUE CHIC
It becomes popular in Europe among rappers, the British working class, and young people in low-income French neighborhoods on the outskirts of urban centers (*banlieues*). But it also participates in the ostentatious materialism of the 1980s, normalized by the cult of the body and accessed by the luxury sector, especially by Chanel.

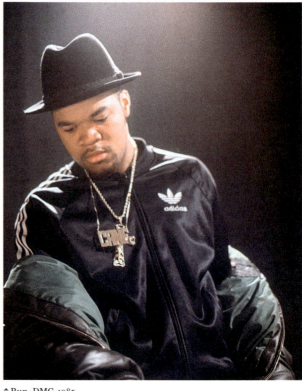

↑ Run–DMC, 1985

« RAY-BANS ON MY HEAD, MY TRACKSUIT'S TACCHINI / AND FOR THOSE WITH CLASS, LOAFERS FROM NUBULONI. »

IAM, *JE DANSE LE MIA (I DANCE THE MIA)*

#### AT EASE, ON SCREEN

**1976 :** Sylvester Stallone in *Rocky*

**1978 :** Bruce Lee in *Game of Death*

**1995 :** Vincent Cassel, Hubert Koundé, and Saïd Taghmaoui in *La Haine (Hate)*

**1999 :** James Gandolfini in *The Sopranos*

**2001 :** Ben Stiller in *The Royal Tenenbaums*

**2003 :** Uma Thurman in *Kill Bill*

**2013 :** Leonardo DiCaprio in *The Wolf of Wall Street*

## STARTING-BLOCKS

### 1921
**LOOKING FOR COMFORT**
The English sprinter Oliver Johnson Schofield wears a velour tracksuit.

### 1939
**COMMERCIAL CONCEPT**
Le Coq Sportif launches the « Sunday Suit ».

### 1967
**ICONIC PIECE**
Adidas gets into textiles with its first tracksuit.

### 1968
**PATRIOTIC UNIFORM**
Black American athletes John Carlos and Tommie Smith, wearing their tracksuits, lift their fists during the awards ceremony for the 200-meter race in the Mexico City Olympics. Sports become political.

### 1986
**MUSIC**
Run-DMC releases the song « My Adidas ».

### 1992
**PATRIOTIC UNIFORM**
The United States sends its first basketball team, composed of iconic NBA players, to the Olympics in Barcelona. They wear an American flag tracksuit.

### 1994
**MUSIC**
IAM releases « Je danse le mia ».

### 2001
**BLING-BLING**
Juicy Couture launches its velour tracksuit, and it becomes the quintessence of flashy early 2000s celebrity culture.

### 2003
**SPORTS AND FASHION**
Yohji Yamamoto collaborates with Adidas. Fashion meets sports.

### 2016
**COOL PRESIDENT**
Memes that embellish a 2009 photograph of President Barak Obama in a black tracksuit create a buzz on social media.

### 2020
**COVID STYLE**
Online retailer ASOS announces a shortage of sportswear due to overconsumption during the pandemic.

Athlete Paola Pigni-Cacchi, Munich, 1972

↑ Rochester 1919 Sweatpants, Champion

# KIMONO
« THING TO WEAR »

**FACES OF**   TILDA SWINTON, SUSIE BUBBLE, DAVID BOWIE
**PODIUM**   CHRISTIAN DIOR, YUMI KATSURA, YAMAMOTO

In the 5th century, Chinese influence leads to the birth of the kimono's predecessors. However, it isn't until the Edo period (1603-1868) that it becomes a social symbol, when the modern form of the kimono is established, and its name formalized.

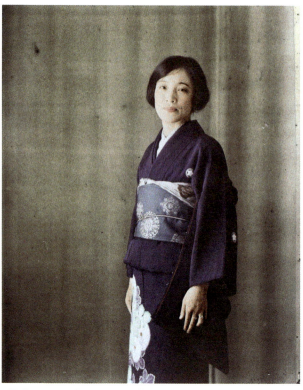

↑ *Madame Nagomi*, Japan, 1926, *Albert-Kahn Museum, Boulogne*

### THE THEATER OF FASHION
Members of the merchant class, Kabuki theater actors, and courtesans initiate trends when they produce new styles to distinguish themselves in a very hierarchical society. The ruling elite, irritated by this stylistic rivalry, imposes sumptuary laws. But the restrictions only push the middle class to be even more creative. This inventiveness is expressed with measured elegance.

### IDENTITY AND RESISTANCE
When the Meiji era is established in 1868, Japan opens to the West and begins to adopt its inclinations. The kimono is worn less often, but its symbolism grows stronger: it's the emblem of a resistant national culture.

### PUT TOGETHER
More than a garment, the kimono is a silhouette. Here is an overview of its indispensable elements:

**Nagajuban:** the underdress
**Koshihimo:** the thin silk or wool belts that keep the kimono closed (invisible under the obi)
**Obi:** the decorative belt
**Musubi:** the obi's knot, placed on the back
**Obijime:** the decorative rope that holds the musubi in place
**Tabi:** the socks – split between the first and second toes
**Zori:** the sandals (sometimes geta sandals, which are more generally worn with the yukata)

### EAST VERSUS WEST
In the 20th century, it is a guarantor of moral values, especially for Japanese women, as those who dare to appropriate trends from Europe are seen as corrupted. This moralizing philosophy increasingly defines the kimono until it is reserved for the older generation or for grand occasions. It also accentuates stereotypes built up by the Western gaze, such as folkloric clichés and fantasies that sexualize the geisha.

### RETURN TO SIMPLICITY
But when Japanese designers begin to attract media attention in the 1980s, a whole new generation sees its heritage with a new and less inhibited view: young Japanese people once again put on the kimono, now stripped of its solemnity. The kimono is liberated. It's no longer a cultural symbol; it is simply a garment.

### IDENTIFICATION

**Yukata:**
- Made of cotton
- Socks not required
- Worn mostly in summer or inside
- Worn without an underdress

**Kimono:**
- Made of silk
- Worn with tabi socks
- Worn for special occasions
- Worn with an underdress

# KITSUKE, OR THE ART OF WEARING A KIMONO

## A MATTER OF TRADITION

①

*Slip on the kimono, assuring that each side is balanced.*

②

*Take the right panel with the right hand and bring the fabric to the left hip.*

③

*Take the left panel with the left hand and bring the fabric to the right hip.*

④

*The excess kimono fabric folds over the waist and hips.*

⑤

*Wrap a belt around the waist to adjust the kimono.*

⑥

*Conceal the belt by puffing the fabric over. In the back, pull down on the material to reveal the nape.*

⑦

*Wrap a belt just beneath the bust line.*

⑧

*Conceal it with the obi, tied twice around the body.*

⑨

*Knot the obi on the front, concealing loose ends.*

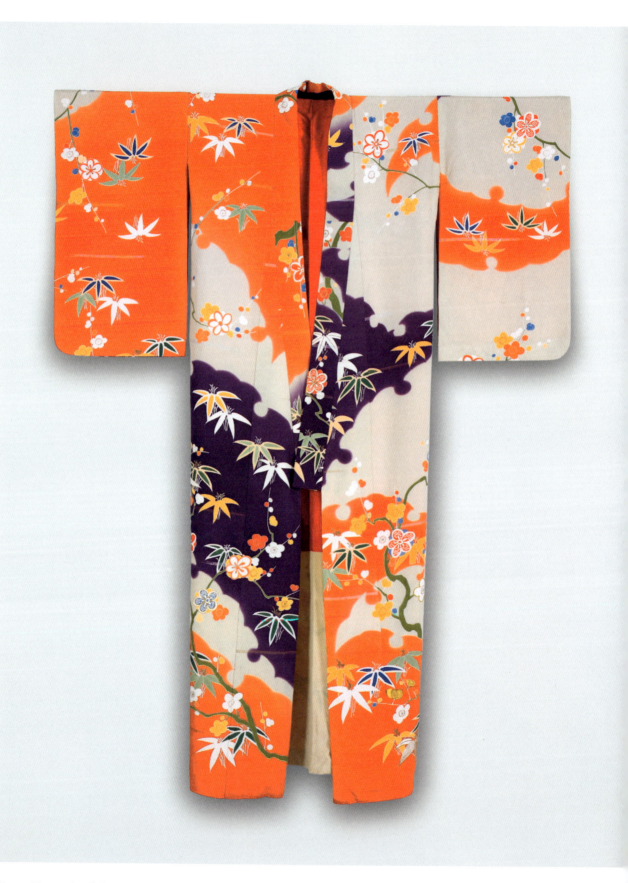

↑ Kimono, *Museum of Applied Arts and Sciences*, Sydney

→ Japan World Exposition, Osaka, 197

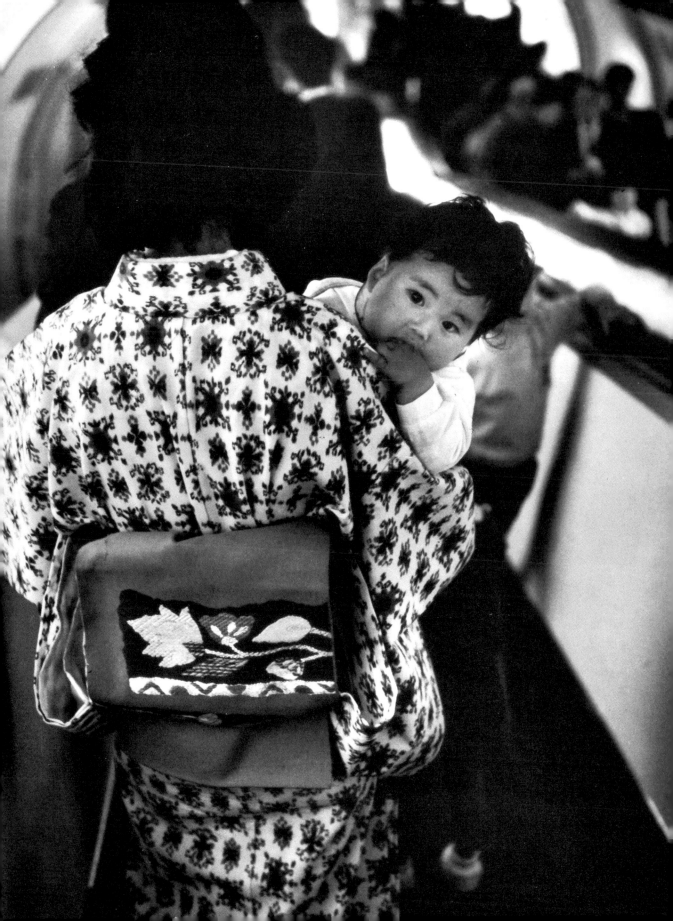

# OVERCOAT
### PROTECT YOURSELF

| | |
|---|---|
| **FACES OF** | CARY GRANT, JAMES DEAN, KIM NOVAC |
| **PODIUM** | FENDI, CHALAYAN, GARETH PUGH |

While we wear coats primarily to protect ourselves from the cold, their use has been imbued with strong social connotations since antiquity. In Rome, for example, an immense toga, worn as a warm top layer, distinguishes Roman citizens from women and slaves. The overcoat signifies and differentiates.

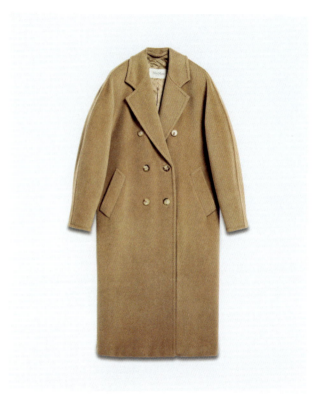

↑ 101801 Icon Coat, Max Mara

### CLOAKS AND HOUPPELANDES
In the Middle Ages, the fashion is to layer tunics to protect the body, and the coat takes the form of a cloak, sometimes called a « mantle ». The houppelande appears in the 14th century; its silhouette approaches our contemporary versions: long and loose, open all the way down the middle, with a high collar and flared sleeves. It is reserved for nobility.

### DRESS OR COAT?
In 17th-century France, the term « manteau » describes cloaks, with or without hoods, worn over aristocrats' clothes. But the word is also used at the time to describe dresses that court ladies wear open over a petticoat. Even if their function isn't the same as that implied by the French contemporary usage of « manteau » (coat), the shape of the manteau dress is closer to a coat than a cloak.

### CITY MEN
In England, the frock coat emerges; tighter and more streamlined, it allows its wearer to ride a horse. It boldly enters women's wardrobes at the end of the 18th century and adorns the dandies (p. 324) of the 19th century. The century of the Industrial Revolution marks the golden age of the coat. The middle class blends into the urban landscape in dark and somber garments. The wool overcoat is born in England.

### ROGUE SPIRIT
Double-breasted or single, it becomes a staple. As dialogues between the military, sports, and civilian worlds multiply, overcoat models become more widespread in the 1930s, before the British Teddy Boys (p. 346) of the 1950s give them a rogue connotation.

### OPEN TO THE WORLD
The most well-known overcoat model is the Crombie coat, created in Scotland in the 1860s by the textile company of the same name. It is worn by the British Army, and also finds success in Japan. After the Second World War, skinheads adopt it as part of their subversive uniform.

> « MEN HAVE BEEN BUYING MY WOMEN'S COATS FOR YEARS. »
> — ISSEY MIYAKE

### WORK COAT
Founded in 1951 in Italy, the brand Max Mara builds a reputation on its elegant overcoats for women in wool, cashmere, or camel hair. In 1981, they create the 101801 model, and it's a best-seller: a double-breasted, minimalist, camel overcoat with kimono sleeves and a belt that knots in front. It's a symbol of 1980s power dressing.

# FEDORA
## A HOLLOW STORY

FACES OF ········ FRANK SINATRA, HUMPHREY BOGART, MARLENE DIETRICH

PODIUM ················· GUCCI, SAINT LAURENT, TEMPERLEY

In the 19th century, headwear becomes popular among people of every social class. Top hats, bowler hats, cowboy hats, caps, and berets enhance the different faces of society because, until the 1950s, it is customary for a man to wear a hat in the public sphere.

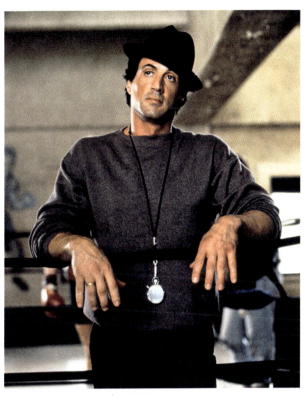

↑ Sylvester Stallone in *Rocky V*, 1990

« COCK YOUR HAT – ANGLES ARE ATTITUDES. »

FRANK SINATRA

**COW GUARDIANS**
Wide-brimmed felt hats are appreciated for work in the great outdoors: Stetson cowboy hats in the American West, Guardian hats in the Camargue in France, sombreros in Mexico… But only one will escape the plains for urban landscapes, where it will shine in the limelight.

**A LITTLE PINCH**
The fedora is closely linked to both heroic and villainous virility. Its shape is said to have been inspired by police repression during the unification of Italy: in 1857, Giuseppe Borsalino, observing the deformed bowler hats of protesters, had the idea to pinch the dome of his designs to create two dimple-like hollow indentations, rendering the hats easier to grip or grab.

**A HISTORY OF NAMES**

Fashion history retains the word « fedora » when describing the hat sold by Borsalino, as is the case in English. In French, the term « borsalino » is often preferred, likely the legacy of the legendary 1970 film of the same name with Alain Delon and Jean-Paul Belmondo, even though Borsalino is above all the name of the brand.

**STAR OF THE SHOW**
And yet, it's a star of the stage who most contributes to its renown and even its name. In 1883, Victorien Sardou presents the play *Fedora*, named after the main character, played by Sarah Bernhardt. The actress, a veritable trendsetter, wears an indented, soft, felt hat in the play. The fedora is born and is soon picked up by the feminist movement.

**TOWARDS THE DARK SIDE**
King Edward VIII revives its popularity among men in the 1920s. In the U.S., it tops off the silhouette of 1930s gangsters whose style is scrutinized by a fascinated public. This legacy moves into the movies with film noir. Beginning with the 1942 film *Casablanca*, it is the signature of Humphrey Bogart's mysterious and elegant look.

**LITTLE COUSIN**

In the 1980s, the trilby develops. Though close to the fedora, it has a reduced format and narrower brim. It also owes its name to a cultural reference: the novel *Trilby* by George Du Maurier. The Blues Brothers wear it in their film of the same name.

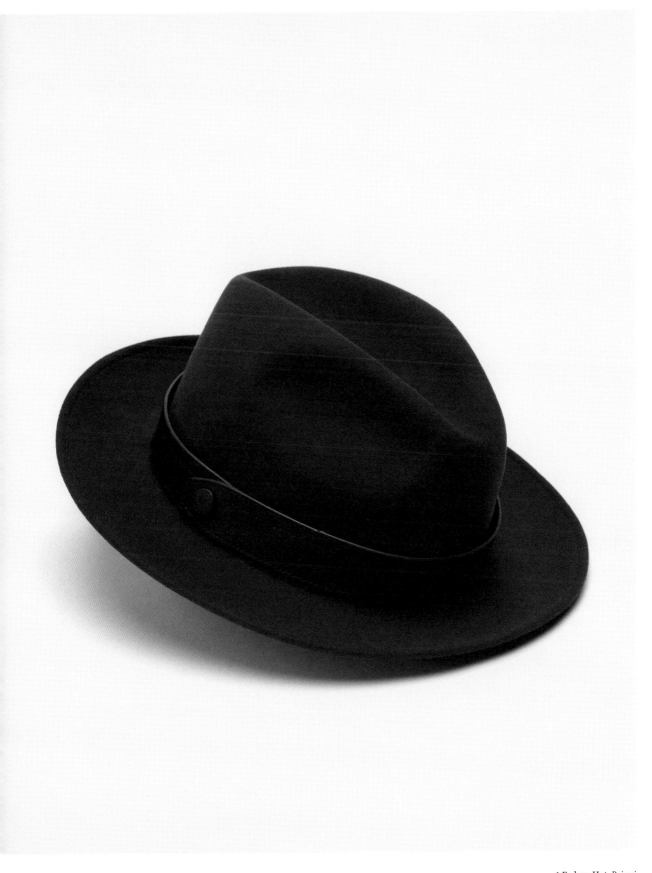

Tina Turner, 1977

↑ Fedora Hat, Brioni

# SWEATER
## HEART-WARMING

**FACES OF** ...... NASTASSJA KINSKI, MARYLIN MONROE, ROBERT REDFORD

**PODIUM** ................................ DIOR, ISSEY MIYAKE, THE ROW

Comfortable, resistant to water, and accessible thanks to proximity to animals, wool is present in every primitive civilization. It is used in various garments, from underwear to outerwear, but it is particularly valuable in the fabrication of a winter staple: the sweater.

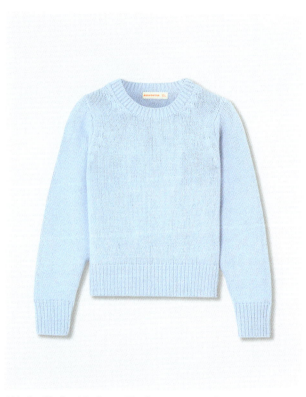

↑ Merino Wool and Cashmere Blend Sweater, &Daughter

« MY FAVORITE STYLE IS A BLACK SWEATER AND A SKIRT, WHICH YOU CAN WEAR ALL THE TIME BY CHANGING THE ACCESSORIES. »

YVES SAINT LAURENT

**HOSTILE COUNTRY**

The sweater is a thick wool knit born in the Middle Ages. Designed for those who confront harsh elements and sea salt, it is a garment of labor and rough outdoor life. Islands, coastal lands, and hostile lands specialize in knitwear techniques.

**A SWEATER NAMED CHANDAIL**

But in the 19th century, a new society of leisure changes everything. The sweater is worn by those who practice sports outside. In France, the Navy adopts a navy-blue version, while sweaters worn by merchants in Paris food markets are nicknamed « chandails ».

**ISN'T IT PRETTY?**

In the 1950s, Christmas sweaters become popular in the U.S. thanks to special TV programs celebrating the Holidays, in which crooners and actors wear festive knits. In 2001, Christmas sweater contests are organized after the release of *Bridget Jones's Diary* – the ugliest and most absurd wins. Since 2011, the third Friday of every December has even been decreed International Ugly Sweater Day!

**IN STYLE**

It's color that brings sweaters onto the path to fashion. In 1921, the Prince of Wales publicly wears a Fair Isle sweater, recognizable by its multicolored patterns. It becomes the emblem of British style. Gabrielle Chanel launches her designs in jersey while Elsa Schiaparelli makes her *trompe l'oeil* sweater the foundation of her surrealist look. The sweater is in style.

**ONE SWEATER, SEVERAL SWEATERS**

Which model to wear? The English playwright Noël Coward makes the turtleneck (p. 21) popular in the 1930s, while sweater girls cause a stir in Hollywood. After the war, the traditional Irish Aran sweater finds favor among the general public. They are influenced by movie stars, like Steve McQueen, who make it a signature garment. Beatniks and Ivy League students (p. 334) share the crew neck sweater and punks (p. 328) thrash their sweaters with scissors. The sweater is an adaptable and ubiquitous wardrobe essential.

# READY FOR WINTER

## A QUESTION OF SHAPE

**V-NECK SWEATER**

**TURTLENECK SWEATER**

**CREW NECK SWEATER**

**ARAN SWEATER**

**PONCHO**

**SWEATER VEST**

## ABOUT KNITS

**JERSEY**
All the loops are stitched in the same direction.

**INTERLOCK**
Both sides are identical; it is thicker and more solid than jersey.

**RIBBED**
It's a knit with raised ribs.

**OPENWORK**
The knit has eyelets.

**GARTER STITCH**
Stitches form regular rows of wavy bumps.

**CABLES**
Several layers of wool are crossed over one another.

↑ Miniskirt, Miu Miu →  Pro-miniskirt demonstration, London, 196

MINI SKIRTS FOREVER

DIOR UNFAIR TO MINI SKIRTS

# MINISKIRT
## A CALL FOR CASUAL SIMPLICITY

**FACES OF** ............ TWIGGY, CLAUDIA SCHIFFER, FRANÇOISE HARDY

**PODIUM** ............ MIU MIU, CHANEL, VERSACE

In the 1960s, the foundation shakes and young people take over. The phenomenon is called the Youthquake. They want to demolish traces of the past and rebuild anew. This social revolution is also reflected in fashion. And for women, the big novelty is the miniskirt.

↑ **Mary Quant**, London, 1967

### « IT'S A BAD JOKE THAT WON'T LAST. NOT WITH WINTER COMING. »

GABRIELLE CHANEL

**SCANDALOUS**

Legs are revealed as never before. The decade's shortened dresses and skirts stop above the knee or at mid-thigh and leap into the future. One woman doesn't like it: Gabrielle Chanel – she hates knees.

**LONDON VS. PARIS**

A war rages between the French capital and Swinging London. The French attribute the invention of the miniskirt to André Courrèges, and the English attribute it to Mary Quant. Both designers offer miniskirts simultaneously, but the true initiators of this trend are the women themselves; the miniskirt has been in style since the end of the 1950s.

**THE POWER OF THE STREETS**

The provocative miniskirt marks a turning point in fashion history; it represents modernity and anticipates retrofuturism (p. 266). It also incarnates upheavals of 1960s fashion, like the development of prêt-à-porter, new ways of selling and buying, and especially the influence of the streets. Gone is the dictatorship of couturiers! But the miniskirt is also a global embodiment of pop culture, feminism, rock music, revolution, modernism, and the liberation of body and mind.

**FEMININE, BUT NOT TOO FEMININE**

It is accurate to say that the miniskirt evokes a wildly erotic vision of women's bodies, but it is also reductive. 1960s fashion, behind its apparent sexualization of physiques, is, above all, an invitation to androgyny. It even represents an almost infantile naivety, incarnated by models with a juvenile and candid look, colorful tights, and playful Mary Janes. Where the 1950s had accentuated femininity, the 1960s prefer to erase it.

**SHORT WORD, LONG STORY**

Usage of the word « mini » becomes widespread in the 1960s after the 1959 release of the so-called small car. The shortened version of « miniature » is first used in English at the end of the 1930s to describe a small camera. In 1966, it enters the cultural landscape in France: Jacques Dutronc sings « Mini, Mini, Mini » and the *yéyés* (a French 1960s musical movement) dance the twist.

# TURBAN
## HEAD WRAP

| FACES OF | ERYKAH BADU, ALICIA KEYS, BIANCA JAGGER |
|---|---|
| PODIUM | LABRUM LONDON, ELIE SAAB, MARC JACOBS |

The turban, or rather, turbans, since there are so many varied expressions, have been present since antiquity. Carrying an undeniable cultural symbolism, they can be a social marker or a sign of status; sometimes, they are a religious attribute. They are also a reminder that covering the head is universal.

### ON ALL THE CONTINENTS

Mesopotamian priests and ancient Egyptian pharaohs cover their heads during ceremonies. In the Middle Ages, women conceal their hair to highlight their social rank and Christian modesty. During the Renaissance, among artists and intellectuals, it's worn for panache. Meanwhile, the turban appears on the African continent and among the Muslim Moors, while Indian Sikhs wear the dastaar.

### IMPERIALIST CHIC

The turban distinguishes the elite among various indigenous peoples, but it also stigmatizes religions. Imperialists appropriate it, stripping it of its meaning: it becomes a fashionable accessory for European women in the 18th century.

### CREOLE TIGNON

This equivocal circulation continues, with the turban as a tool for both social and cultural differentiation. It is worn by Westerners and imposed on enslaved people in the colonies. In 1786, the tignon is outlawed in Louisiana for women of African descent and becomes a colorful instrument of rebellion.

### ALIENATION OR LIBERATION?

Always both. While the turban characterizes 19th-century domestic workers and slaves, it also represents their cultural identity. Westerners continue to appropriate it in the early 20th century.

↑ Indian photographer Umrao Singh Sher-Gil, 1926

> « WHEN THE FEATHERS OF THEIR TURBANS TOUCHED THE GROUND. »
>
> JEAN GENET

### A DISTINCT STYLE

It remains a fashionable accessory in Europe but is worn for religious purposes on the African continent, for functional reasons among the Bedouins and the Tuareg, and to affirm rank among Arab rulers.

### TIPS AND TRICKS

During the Second World War, it becomes an essential accessory for women. It hides the hair of those who can no longer maintain styles and protects those who replace men in the factories. In the U.S., it is recommended to prevent hair from catching in the machines. Attractive, functional, and inexpensive, it replaces the hat.

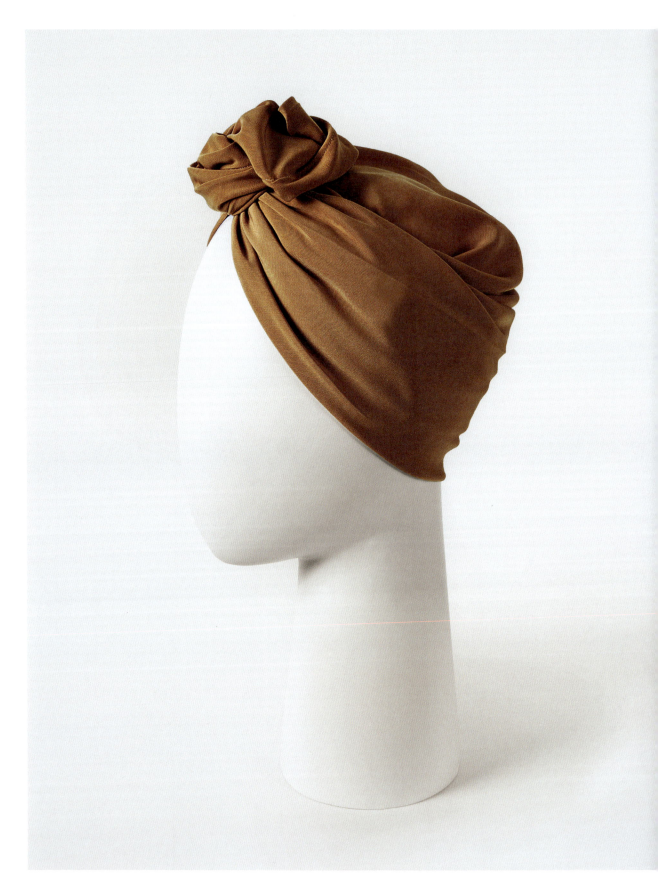

↑ Cuban Turban in macadamia, Indira de Paris → Models, *photo by Geneviève Naylor,* 19

# BARBOUR JACKET
## ENGLISH TASTE

| FACES OF | ELIZABETH II, ALEXA CHUNG, KATE MIDDLETON |
| --- | --- |
| PODIUM | DIOR, CARVEN, ARMY OF ME |

Definitively British, the Barbour jacket evokes rain, heaths, moorlands, and the great outdoors. Barbour, a brand with working-class roots, has successfully turned its image into a prized blend of sportswear, traditionalism, a touch of rebellion, and the elite. A very English brew!

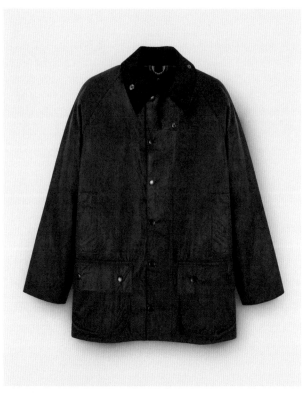

↑ Beaufort® Waxed Cotton Jacket, Barbour

« IT'S VERY DESIRABLE TO HAVE A VERY WELL-WORN BARBOUR JACKET. »

MARGARET BARBOUR

### AD VITAM

Barbour continues to reinforce its identity as an enduring brand. Barbour jackets come with a lifetime guarantee; if damaged, they can be sent to Barbour to be repaired. This service supports the brand's connection to traditional artisanry while emphasizing an ecological approach that supports sustainability.

### GOOD PUBLICITY

Barbour is the only textile company that has been awarded three Royal Warrants of Appointment by the British court. This system has been used to endorse commercial companies since the 18th century. A royal warrant guarantees a prestigious image and non-negligible publicity.

### INDUSTRIAL REVOLUTION

Innovation is at the core of this outerwear garment. Established in Northern England in 1894, J. Barbour and Sons specializes in oilcloth. Seeking to distinguish itself from competitors, the company creates waxed cotton. It isn't the first company to apply the process, but it is the most successful at selling its products thanks to marketing sense and a catalog sent to workers all over the world.

### WAR ZONE

By addressing motorcyclists in the 1930s, the brand branches out beyond professional garments. In the 1940s, Barbour supplies the Royal Navy Submarine Service uniform. After the war, their designs reach civilians, and in 1970, Margaret Barbour, a woman, takes the company in a new direction.

### HUNTING GROUND

1974 brings the launch of the Bedale model, an equestrian jacket with a corduroy collar, perfect for hunting. Publicity campaigns depict an elegant man accompanied by his dog. From then on, Barbour typifies aristocratic gentlemen and British tradition.

### THE ESSENCE OF COOL

But its image isn't pretentious: the English know how to bring together the most unlikely styles. From hooligans to the rockers of the Glastonbury Festival, passing through London Fashion Week and even James Bond, the Barbour wears its monarchical connotations without abandoning its working-class roots.

# BEANIE
## CLOSE-KNIT

| FACES OF | COMMANDANT COUSTEAU, MACAULAY CULKIN |
| PODIUM | MISSONI, BRANDON MAXWELL, MICHAEL KORS |

Different versions of soft brimless headwear made of leather or plant fibers have existed since prehistoric times. During antiquity, caps are attested in Eastern civilizations. The Greeks and Romans introduce the Phrygian cap in Europe where it is worn by freed slaves and becomes a marker of identity.

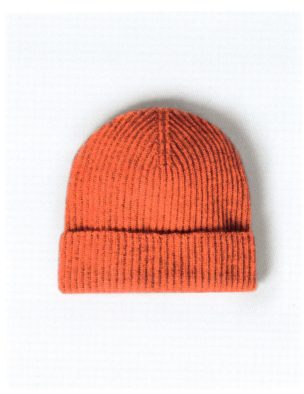

↑ Ribbed Cashmere Beanie, Johnstons of Elgin

**EXPRESSION OF COURTLINESS**
In the Middle Ages, it is customary to cover the head for comfort, modesty, and social status. Men wear an ivory linen coif, often underneath another layer, like a hood. Nobles, on the other hand, flaunt very tall hats. During the Renaissance, particularly in Italy, brimless hats are the fashion. Worn straight on the head, they are raised by an internal frame.

**HAT OR BEANIE?**
In the 16th century, the toque arrives, recognizable by its rolled brim. Its dome is more or less wide or puffy and, in some ways, is closer to today's hats, though the fabric is soft, like a beanie. Meanwhile, sailors and fishermen adopt wool headwear that is resistant to water.

**RUSTIC TASTE**
Though out of fashion during the Neoclassical period, Navy sailors and peasants wear the brimless hat in France. It becomes an emblem of tradition and folklore. But in the U.S., at the turn of the 20th century, the beanie takes a tentative first step into the civilian, urban milieu when it becomes popular with students.

**THE MEANING OF SACRIFICE**
French undersea explorer Commander Jacques-Yves Cousteau goes down in history while wearing a red wool beanie. It's an homage to the 19th-century Bagnards de Toulon (prisoners of a notorious prison in Toulon, France) used as test subjects for early diving suits and as free labor for submarine operations – at the risk of drowning. The prisoners' red beanies distinguish them from blue beanie-wearing sailors.

**URBAN LOOK**
It largely remains a working-class or military accessory until after the war when it becomes a wardrobe essential among those who resist the status quo: on beatniks, rebellious teenagers, and hippies (p. 326), it is emblematic of the counterculture. Today, it represents the gentrification of urban zones. Whether signifying nostalgia, appropriation, or a quest for authenticity, unless it's for keeping warm, the beanie inhabits the image of coolness.

**HOMEWEAR HAT**
In the 17th and 18th centuries, aristocrats wear a nightcap in the privacy of their homes. Rarely used for sleep, it's an indoor accessory accompanying the robe. Its rigidity, its silk, and its embroideries attest to this. In the 19th century, women use it to protect their hair while they sleep. Silk is replaced by cotton or linen.

# WHITE BUTTON-UP
## MAKE THE INVISIBLE VISIBLE

**FACES OF** ⋯ JULIA ROBERTS, CAROLYN BESSETT KENNEDY, TOM CRUISE

**PODIUM** ⋯ GIANFRANCO FERRÉ, CELINE, GIVENCHY

At the beginning of the Middle Ages, an undergarment called the « chemise » (a simple white shift made of linen or wool) is worn by all. During the Renaissance, the chemise and its deceptively subtle decorative effects are discreetly revealed, participating in the more demonstrative styles of the era.

↑ White Shirt, Jil Sander

### SHOWING OFF
The Renaissance shifts the function of the chemise. Aristocrats invest in refined shifts made of delicate fabrics. But the expensive undergarments aren't meant to be visible. The solution? They slash slits in their outer garments to expose the chemise worn underneath.

### INSIDE OUT
From the middle of the 17th century in France, the chemise is increasingly visible in men's wardrobes. It is both an outer garment, noticeable under the waistcoat of the *habit à la française* (18th-century men's suit), and also an undergarment, since it's sufficiently long to cover intimate body parts under the culottes (French ancestor to pants). It is decorated with an extravagant collar and detachable cuffs.

### BUTTONED UP
The 19th century highlights the chemise by standardizing the male silhouette, even if the waistcoat is still conventional. Production of the chemise is industrialized, its removable collars are popularized, and the first shirts buttoned from waist to neck are created.

### MODEL EMPLOYEE
In the 20th century, by removing the waistcoat from men's suits, fashion exposes the shirt more than ever before. After the war, as youth culture emerges, the white button-up becomes relegated to a conservative and capitalist culture, especially as variations in shape (short sleeves), color, and print compete with it.

> « SLIPPING FIRST FROM SHOULDER TO HIP WITH NONCHALANT FOLDS, THE CHEMISE FLUTTERED TO HER WHITE FEET LIKE A WHITE TURTLEDOVE. »
>
> THÉOPHILE GAUT*

### WHITE COLLAR
A New York housewife invents removable collars in 1827 to ease domestic chores.

### MASCULINE-FEMININE
The white button-up shirt also appeals to women. Subconsciously, it remains a man's garment, however, and women remain its bold captors.

### BUTTON-UP SHIRT
London-based Brown, Davis & Co. creates the first shirt that buttons all the way up, from bottom to top. Intended for mass production, it is patented in 1871 but doesn't become common until the end of the First World War.

# IN SHIRTSLEEVES

## IT'S ALL ABOUT THE FIT

| RELAXED | STRAIGHT | SLIM | TAPERED |

## IT'S ALL ABOUT THE COLLAR

**COL FRANÇAIS**
It's a classic.

**BUTTON-DOWN COLLAR**
Buttons hold the collar in place.

**SPREAD COLLAR**
The collar points are wider.

**BAND COLLAR**
Has a stand-up collar.

**REVERSE COLLAR**
The collar is folded in on itself so that the flaps are not visible.

**TAB COLLAR**
A tab connects the two sides of the collar.

**CLUB COLLAR**
The collar points are rounded.

**WING COLLAR**
Stand-up collar with small flaps.

## IT'S ALL ABOUT THE CUFFS

**STRAIGHT**

**ANGLED**
Beveled edges

**ROUNDED**
Gently rounded edges

**COCKTAIL**
Turnback cuff

**CÔNE**

**FRENCH**
Long cuffs worn with cufflinks

↑ Denim Shirt, Ralph Lauren → Sade, *photo by David Montgomery,* 198

# DENIM SHIRT
## AMERICAN DREAM

FACES OF ……… SERGE GAINSBOURG, SADE, PAUL NEWMAN

PODIUM ……… MM6 MAISON MARGIELA, CELINE, LOUIS VUITTON

Levi's creates denim workwear in the 19th century, and variations like the jean jacket and denim shirt develop. The latter has chest pockets, handy for carrying tools. But the most significant impetus for the shirt's generalization is the rodeo.

↑ Yves Saint Laurent, Marrakech, 1972

**FROM THE FACTORY**

The first cotton or chambray shirts appear in 1910 on cowboys and laborers. They are progressively worn by a broader population after specialized factories are created in the 1930s by Levi's, Blue Bell (known as Wrangler beginning in 1947), and Rockmount Ranch Wear.

**HORSEPOWER**

In the 1940s, rodeos abound, and the riders are adulated and influential celebrities. Cowboy style takes root, and Hollywood gives it mass appeal with its romanticized representations of the Great West, incarnated by John Wayne and Montgomery Clift. Wrangler, who dominates the market, launches an exclusive line in 1947 in collaboration with rodeo professionals. As for Rockmount, they create a shirt adorned with mother-of-pearl snaps in 1946, and it becomes the epitome of the Western shirt.

**COWBOY STYLE**

The denim Western shirt is the most popular. It is recognizable by its pockets with snaps available in several types, including sawtooth. The pocket buttons are placed towards the side, allowing the cowboys to grab a cigarette from their pack without removing it.

**THRIFT-STORE CHIC**

1960s subculture transforms the denim shirt from traditional American archetype to symbol of rebellion. Hippies (p. 326) thwart wardrobe conventions by shopping in thrift stores. The worn-out denim shirt symbolically incarnates the erosion of a society in need of renewal.

**HOLLYWOOD BOOST**

From Steve McQueen to Robert Redford, the denim shirt embellishes a seductive and rebellious masculinity. Even James Bond wears one in *Dr. No* in 1962. Ralph Lauren rises to prominence in the late 1960s and participates in the renewal of this American style when he turns the denim shirt into a classic and cool unisex uniform.

**FROM FRANCE TO THE U.S.**

Chambray is a linen fabric created in the 14th century near Cambrai. Between the 18th and 19th centuries, it is replaced by cotton and dyed indigo blue: it is often confused with denim. Very successful in the U.S., it is used for workwear and becomes the official textile of U.S. Navy shirts in 1901.

# TRENCH COAT
## WHEN THE RAIN COMES

| FACES OF | MERYL STREEP, HUMPHREY BOGART |
| --- | --- |
| PODIUM | VUITTON, FENDI, BALENCIAGA |

In 1823, Scottish chemist Charles Macintosh invents waterproof rubberized cotton. Coats made with this material come to be called « Mackintosh » raincoats (or even more often, « Mac ») in Great Britain. Made for men of the elite, they are also prized by high-ranking Army officers.

↑ Pharell Williams, Champs-Élysées, Paris, 2006

### « FETCH ME MY BURBERRY. »
KING EDWARD VII

### THE INVENTION OF GABARDINE
The English tailor John Emary, owner of Aquascutum, defines the look of an elegant raincoat in 1853. However, it's Thomas Burberry, founder of the brand of the same name, who will go down in posterity. In 1880, he creates a lighter and more resistant material: gabardine. Patented in 1888, it is reserved for Burberry's exclusive use until 1917.

### « TRENCH WARM »
At the dawn of the First World War, Burberry and Aquascutum are in direct competition. They dress elite officers who associate their leisure activities with their patriotic duties. In 1916, Burberry sells its military raincoat by calling it the « trench warm ».

### SYMBOL OF SOLIDARITY
The trench is born. Its characteristics are recognizable: double-breasted, epaulettes, mid-length, a belt, khaki-colored. It is, above all, a symbol of class, even in the heart of the trenches, before becoming democratized. Less wealthy officers of the British Army wear less expensive copies, and civilians appropriate the trench coat to express solidarity with those fighting at the front.

### CHARISMATIC ACTOR
Hollywood embraces this androgynous waterproof warrior: femmes fatales, gangsters, and melancholic inspectors all wear it. It conceals the mysteries of film noir and shelters passionate kisses and broken hearts. The 1970s see it become a utilitarian and versatile garment that nonetheless conserves its elegant and distinguished aura.

### MILITARY INVENTORY

**Metal buckle:** the D-ring, for hanging weapons and other accessories

**Storm flap:** extending down from the shoulder to protect the wearer from firearm recoil

**Shortened length:** to prevent fabric from dragging in the mud

**Epaulettes:** to secure a gas mask

**Truncated cape:** to direct rainwater away from the body

### MOVIE VERSION

**1942:** Humphrey Bogart in *Casablanca*

**1948:** Marlene Dietrich in *A Foreign Affair*

**1958:** Jacques Tati in *Mon oncle (My Uncle)*

**1961:** Audrey Hepburn in *Breakfast at Tiffany's*

**1963:** Peter Sellers in *The Pink Panther*

**1964:** Catherine Deneuve in *Les Parapluies de Cherbourg (The Umbrellas of Cherbourg)*

**1973:** Robert Redford in *The Way We Were*

**1979:** Meryl Streep in *Kramer vs. Kramer*

Meryl Streep in *Kramer vs. Kramer*, 1979

↑ Mid-length Kensington Heritage Trench Coat, Burberry

# MOCCASINS
## CASUAL CHIC

FACES OF ................. GENE KELLY, MICHAEL JACKSON
PODIUM ................. GUCCI, PACO RABANNE, CELINE

Today's moccasins originate as soft leather shoes in various regions of the world. Men and women have made and worn this style of shoes for millennia – it's possible the footwear style even goes back to prehistoric times.

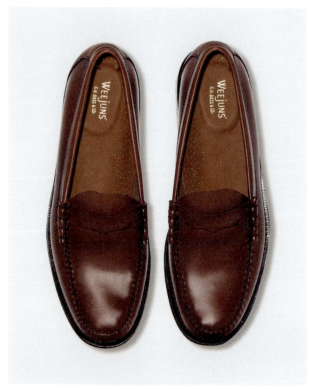

↑ Weejuns Larson Penny Loafers, G. H. Bass

### SEA MOCCASINS
The other summer shoe to enter the traditional wardrobe is the boat shoe, worn by American sailors. Created by Paul Sperry in 1935, their rubber soles are white, so they don't mark the boat deck, and they are grooved, so the sailors don't slip. Docksides, launched in 1970 by the American brand Sebago, become their emblem.

### GONE FISHING
Leather slippers are worn by Native Americans as early as in the 17th century. The word « moccasin » comes from Indigenous languages of North America. In Norway, in the 19th century, peasants wear soft shoes that appeal to tourists on fishing trips. At the turn of the 20th century, the shoes become the essence of chic for an elite class attracted to sports and leisure.

### IVY STYLE
The American brand G.H. Bass & Co. decide to launch their version of the Norwegian shoes in 1936, and they call them Weejuns. This sturdier model in brown or black leather becomes the archetypal moccasin. After the war, American college students adopt them as a standard of their preppy Ivy League style (p. 334). Elegant and comfortable, they are appreciated by independent young people.

### LA DOLCE VITA
In 1953, the Italian brand Gucci offers a luxury moccasin adorned with a horse bit, worn by the European jet set. Then in 1963, Car Shoe innovates the first moccasins with flexible rubber studded soles. The moccasin becomes symbolic of idol leisure and nonchalance, but never of negligence.

### THE KING OF POP
In the early 1980s, hip-hop culture (p. 316) embraces the shoes. But it's especially Michael Jackson who brings them into pop culture, featuring them as a key character in his music videos. The conservative and distinguished moccasin becomes cool. Timeless, delightfully bourgeois, and old-fashioned, moccasins adapt to every style without ever actually being in style.

« IN THE 1930S IN HOLLYWOOD THERE WAS THIS TENDENCY TO PORTRAY EVERYONE AS RICH. THAT'S WHY I DECIDED TO WEAR WHITE SOCKS, LOAFERS, T-SHIRTS AND BLUE JEANS. I WAS A CHILD OF THE DEPRESSION. »

GENE KELLY

### GOOD PUBLICITY
In 1978, Diego Della Valle founds the brand Tod's and creates a hand-sewn soft moccasin with a rubber sole composed of 133 studs: the Gommino. He immediately sends a pair to industrialist Giovanni Agnelli, the charismatic head of Fiat, who wears them during a televised interview. The Tod's moccasin becomes synonymous with Italian chic.

# IF THE SHOE FITS

## IT'S ABOUT FORM

MOCCASIN

BROGUE
(Decorated with numerous perforations)

DERBY

OXFORD

BOAT SHOE

MONK

CHELSEA BOOT
(Ankle boot with elastic on sides)

DESERT BOOT
(Clarks)

CHUKKA BOOT
(Clarks)

## IT'S ABOUT MATERIALS

(1) Full grain
(2) Corrected grain
(3) Split leather

**Buffed**

**Brushed**

LEATHER

NUBUCK

SUEDE

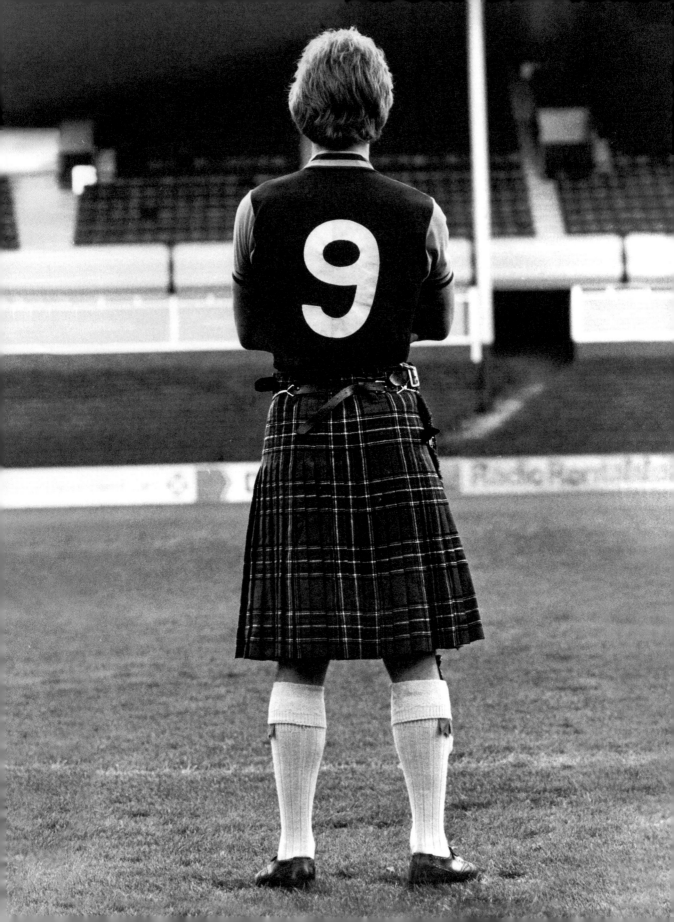

Andy Gray, Scottish footballer, circa 1978

↑ Traditional Scottish tartan kilt

# KILT
## MEN IN SKIRTS

**FACES OF** ····· JEAN-PAUL GAULTIER, SEAN CONNERY, EWAN MCGREGOR

**PODIUM** ················ CHANEL, VIVIENNE WESTWOOD, VERSACE

It's impossible to talk about the kilt without talking about tartan, a woven wool fabric with crisscross patterns worn by prehistoric Celts. A social and political object, in the 20th century, it becomes an essential element of pop culture and fashion, in all its contradictions.

↑ Mini kilts, Vivienne Westwood

### OF COLORS AND CELTS

Tartan is originally a woven wool fabric with a colorful pattern of interlocking stripes (often called plaid in North America). It is found in prehistoric and Celtic tombs. Among the Celts, subordinates are allowed one color, two for peasants, three for officers, six for artists and druids, and seven for kings. The colors also have geographical significance. In the 19th century, tartans enable clan identification.

### AND UNDERNEATH?

It is said that traditionally, a Scottish man wears nothing under his kilt. This custom seems to date back to the 18th century, when Scottish regiments receive instructions about their uniform – with no mention of undergarments. The question of whether men today choose to perpetuate this rite naturally follows.

### FROM LONG TO SHORT

At first, the kilt is a long, belted tartan from the Highlands. It wraps around the lower body and up over the shoulder. From the late 17th century, shortened, skirt-like versions appear. Thanks to various tartans, clans identify and distinguish themselves. But during the conflicts between England and Scotland in the 18th century, they are banned and subsequently disappear.

### ENGLISH NATURALIZATION

In the 19th century, the kilt reigns... in England. The country promotes a fantasized vision of its national history, with folklore as a factor in identity. The kilt becomes a nationalist fetish: the royal family claims it, and the military wears it until the middle of the 20th century.

### YÉYÉ AND PUNK

In the 1960s, the kilt is worn in private schools and on the joyful streets of Swinging London. Even French pop singers adopt it, tapping into its false air of innocence with a miniskirt version (p. 160). But at the end of the 1970s, it becomes subversive when the punks (p. 328) appropriate elite social codes, including the tartan, as a form of ridicule.

### THE KILT IN NUMBERS

**8 yards** of tartan for a traditional kilt

**5 yards** of tartan for a casual kilt

### OBJECT OF FANTASY

Vivienne Westwood, pioneer of punk rock style, puts it on the runway in 1993, while Alexander McQueen denounces the atrocities committed by the English in Scotland with his collection « Highland Rape » in 1995. The kilt follows this back and forth between tradition and pop culture, including its erotic connotations. It is the uniform of young, falsely naive women in movies and manga. It's also the fantasy of masculinity in a skirt.

# HUIPIL
## WOMEN'S HISTORY

FACES OF ............... FRIDA KAHLO, SALMA HAYEK

PODIUM ............... MOSCHINO, ALBERTA FERRETTI, ISABEL MARANT

The huipil has existed in Central American culture since the pre-Columbian era. It gets its name from the Aztecs, in reference to the huipilli, a women's tunic similar to a poncho, made by assembling two or three pieces of fabric. Its patterns and colors reflect cultural and social symbolism.

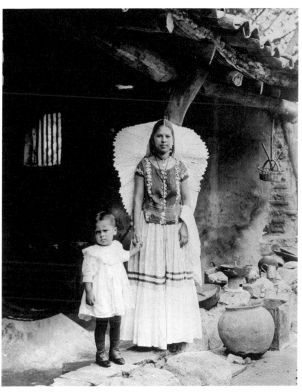

↑ Mexican Native Americans, Tehuana, Mexico, 1921

### IDENTITY CARD
With Spanish colonization, floral and figurative designs are added to the tunics. The huipil, with or without sleeves, can be made in a short version, like a blouse, or a longer version, reaching the knees or ankles. It is still worn by women in Southeast Mexico and in Guatemala: it varies according to regions and cultures, functioning like an identity card. A simplified version is typical in everyday life, and a richly decorated version is worn for more formal ceremonies.

### ARTISTIC ICON
Beyond its practical function, it carries eloquent religious and patrimonial symbolism, as shown by the artist Frida Kahlo. She wears the traditional Tehuana costume from her mother's native region, Tehuantepec, Mexico, to pay tribute to the region's matriarchal culture but also to celebrate her Mexican identity in opposition to the dominant Western aesthetic and to show that femininity can be demonstrated in different ways. Composed of a large skirt, a short huipil, and an elaborate headdress, it quickly becomes her uniform of choice.

> « THE GRINGAS HERE LIKE ME A LOT AND TAKE NOTICE OF ALL THE DRESSES AND REBOZOS THAT I BROUGHT. THEIR JAWS DROP AT THE SIGHT OF MY JADE JEWELRY. »
>
> FRIDA KAHLO TO HER MOTHER, SAN FRANCISCO, 1930

### IN SUPPORT OF WOMEN
Although Frida Kahlo's fame and the exploitation of her style may have confined the huipil to a fetishized and reductive interpretation of her aesthetic, it benefits from her notoriety to emerge in the Western consciousness. Today, it helps to maintain an economy favorable to women, especially for the Amuzgos of Southwest Mexico. That's the power of feminine identity and mastery of craft.

### ICON
With a German father and a Tehuana mother, Frida Kahlo, proud of her mixed origins, combines Western trends with traditional pieces. She adopts the Tehuana costume, long and ample. It is easy to slip on, hides her corset, and covers her legs.

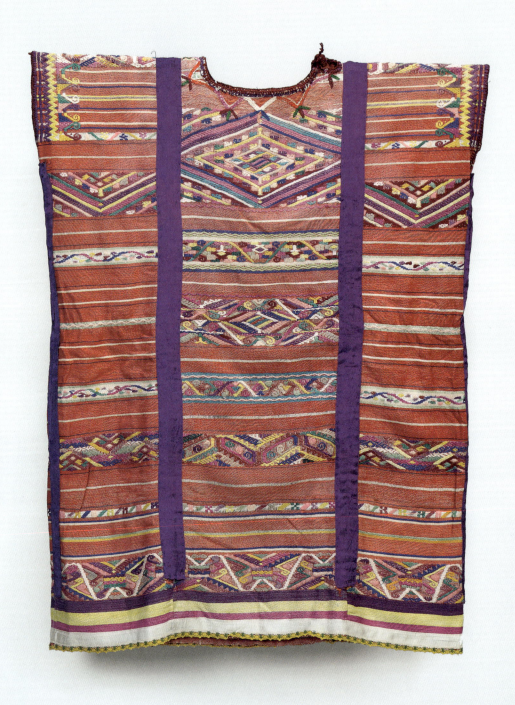

↑ Huipil, *Musée du Quai Branly*, Paris   → **Frida Kahlo**, *photo by Nickolas Muray*, New York, 19

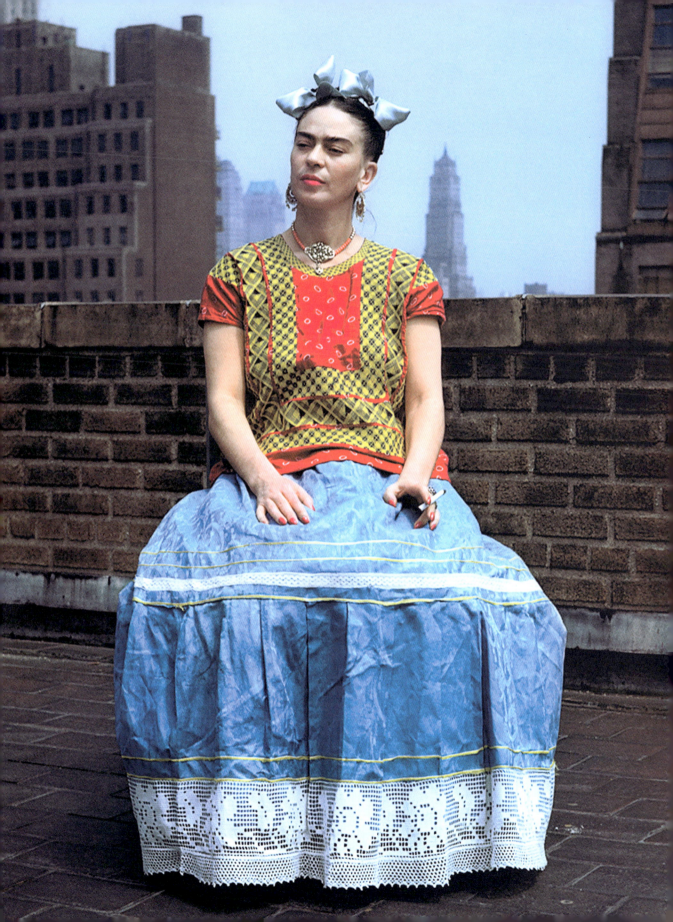

# NECKTIE
## TIE THE KNOT

| | |
|---|---|
| **FACES OF** | DIANE KEATON, ANDY WARHOL, MALCOLM X |
| **PODIUM** | LOUIS VUITTON, VALENTINO, RAF SIMONS |

Women's necks, subject to the erotic expectations of a masculine society, are often uncovered. Men's necks, on the other hand, are often covered to better display social status. The adorned and wrapped neck is the hallmark of an elite class manifesting a superior attitude. And it all begins with a military scarf.

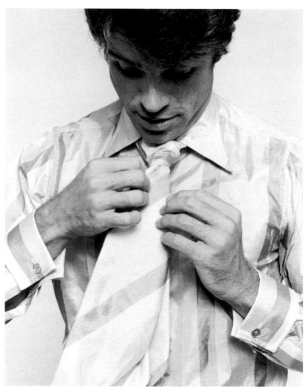

↑ Warren Beatty, 1970

> « A WELL-TIED TIE IS THE FIRST SERIOUS STEP IN LIFE. »
> 
> OSCAR WILDE

### CROAT INFLUENCE

The soldiers of the Imperial Chinese Army are the first to wear fabric around their necks as a marker of distinction. Then, in the 17th century, Croatian soldiers wrap their necks during the Hundred Years' War. The court of Louis XIV likes the look and takes the accessory out of the military milieu. « Cravate, » the French word for necktie, is likely derived from the word « Croate » (Croatian).

### SOBER CHOICE

Beginning in the Renaissance, ruffs and jabots invade men's wardrobes. The cravat offers a more sober solution, while promoting a superior air. In the early 19th century, dandies (p. 324) adopt it and distinguish themselves with complex knots. Therein lies the ambivalence: men's wardrobes must be more measured, but they also accentuate stylistic details.

### OFFICE WORKER

The Industrial Revolution brings a multitude of administrative jobs, and the cravat with a simple knot dresses office employees. At the end of the 19th century, the modern necktie arrives in England, then heads to New York with the tie-maker Jesse Langsdorf, who gives it its definitive shape in 1923, at which point it becomes commonplace.

### CODIFIED CRAVAT

Nevertheless, the necktie follows trends: extravagant during the Roaring Twenties, minimalist among the London mods (p. 304), flamboyant during the 1970s. Associated with social conventions, it juxtaposes professional imperatives with distinction. Some wear it to work out of obligation, and others by choice, for its shape, material, and patterns that evoke the refinement of its origins.

### MEMBERS ONLY

Club ties appear at the end of the 19th century to signify membership in a group or club. The Oxford rowing team creates the first club tie when one of its members takes the ribbons off his hat and ties them around his neck.

### ROYAL KNOT

According to Swedish mathematicians, there are thousands of ways to knot a tie. The three most famous are the simple, double, and Windsor knots. The latter comes from the Duke of Windsor, who wears larger knots due to thicker fabric. It is the official knot of the Royal Air Force.

# THE ART OF TYING

## IT'S ALL IN THE KNOT

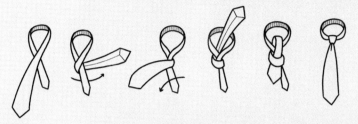

**SIMPLE KNOT**
The simple knot is a cinch to achieve.

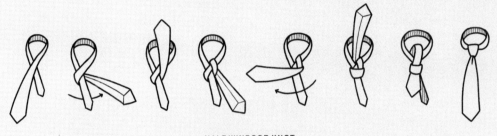

**HALF WINDSOR KNOT**
The half Windsor knot is perfect for skinny ties.

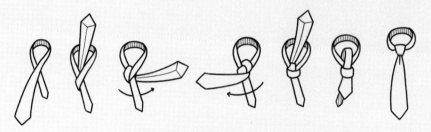

**WINDSOR KNOT**
Made famous by the Duke of Windsor, the knot that wears his name is reserved for special occasions.

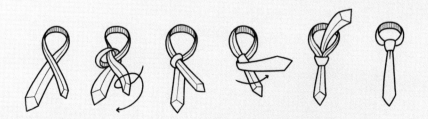

**PRATT KNOT**
The Pratt knot, popular in the U.S. in the 1980s, starts with the tie facing backward!

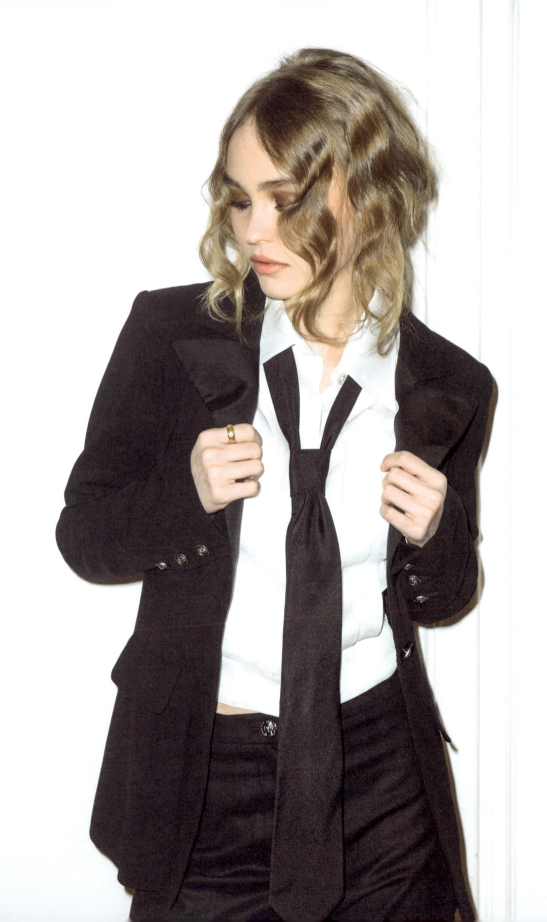

Lily Rose Depp, *Césars Révélations event*, January 2017

↑ Neckties, The Nines

# MODERN SUIT
## LOOK THE PART

| FACES OF | RICHARD GERE, HARRY STYLES, DAVID BOWIE |
| PODIUM | GUCCI, VICTORIA BECKHAM, AMI |

Men's and women's wardrobes aren't very different until the late Middle Ages, when silhouettes evolve: women wear dresses, and men, a top and a bottom. Fashion eventually establishes an ensemble for men consisting of a jacket and breeches (which are replaced by pants at the end of the 18th century).

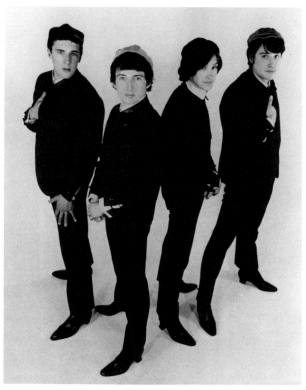

↑ The Kinks, 1964

« I WOULDN'T SAY THAT THE POWER SUIT WAS A REFLECTION OF FEMINISM. »

GIORGIO ARMANI

### HABIT À LA FRANÇAISE

Wealthy men adopt a uniform that is comfortable enough to appreciate equitation and distinguished enough to address the importance of appearances at the royal court. Louis XIV understood this very well with his *habit à la française*, the three-piece suit worn first by the monarch and the men of his court and later worn by everyone, everywhere.

### MIDDLE-CLASS SUIT

The suit as we know it today becomes established in the West in the 19th century, driven by the Industrial Revolution. This is partly due to the standardization of manufacturing methods. Wardrobe demands also play a part, as men are pushed to wear dark suits to consolidate their image as reasonable, hard-working individuals. The three-piece suit becomes the model of a middle-class society.

### POWERFUL WOMEN

In the 1980s, women take on more prominent positions, and along with these new responsibilities, women adopt a wardrobe that prioritizes jackets with padded shoulders. The style is called power dressing. But far from powerful, it implies that for a woman to be respected as much as her male superiors, she must adopt codes of masculinity.

### MULTIFACETED ALLURE

Well-worn Sunday best or daily outfit, the suit becomes a standard. It comes in light colors in the 1920s, with shoulder pads in the 1930s, cinched at the waist in the 1970s. Its style evolves according to trends.

### FRIEND OR ENEMY?

In the 1980s, it is king. Giorgio Armani (p. 290) turns it into a classic – a sensual second skin with flowing fabric and dropped shoulders. Women adopt it as an expression of power, and Richard Gere eroticizes it in *American Gigolo*. The suit is constantly proclaimed dead, obsolete, and conservative. Yet, it is still endlessly reinterpreted (p. 242) and deconstructed. Donned each morning with irritation in order to prepare for work or worn proudly during special occasions, it will persist for as long as there are men… and women.

### SMOKING JACKET

At the end of the 19th century, Edward VII asks his tailor to design a hybrid jacket, something in between the tailcoat required for evening meals and his light smoking jacket, that can serve as both. The tuxedo is born. In the 1930s, it takes on the definitive form that we know today and becomes characteristic of formal wear for special occasions.

## DRESSED TO THE NINES

### 1670s
**ROYAL ETIQUETTE**
Louis XIV establishes the *habit à la française*.

### 17th CENTURY
**MODERN AMAZONS**
Women, inspired by menswear, adopt the frock coat for riding.

### FRENCH REVOLUTION
**SANS-CULOTTES**
Pants replace the breeches (*culottes* in French) worn by the aristocracy.

### 1810s
**AVANT-GARDE ELEGANCE**
English dandy George Brummell lays the foundations for the modern dark suit.

### 1850s
**A LESS FORMAL JACKET**
The smoking jacket is developed.

### 19th CENTURY
**A SUIT WITH SOCIAL CODES**
The Industrial Revolution imposes the sober three-piece suit.

### 1860
**A CLASSIC IS BORN**
Creation of the tuxedo.

### 1930s
**TOWARDS A BIT OF NOVELTY**
Double-breasted jackets are a must for suits.

### 1940s
**DIVERSION AND PROVOCATION**
The zoot suit shows defiance in Latino and Black American communities (see p. 322).

### 1966
**A FIRST FOR WOMEN**
Yves Saint Laurent designs the first tuxedo for women.

### 1975
**RENOWNED DESIGNER**
Giorgio Armani establishes his brand.

### 1980
**THE SILVER SCREEN**
*American Gigolo* with Richard Gere is released.

### 1980s
**MASTER OF DECONSTRUCTION**
Yohji Yamamoto deconstructs the Western suit.

### 2000s
**SEXY IN A SUIT**
With a minimalist rock version, Hedi Slimane makes the suit desirable to young people.

↑ Lancej Wool and Linen Blazer, Ted Baker

→ Man in a suit, *photo by Stephen Shore*, United States, 197

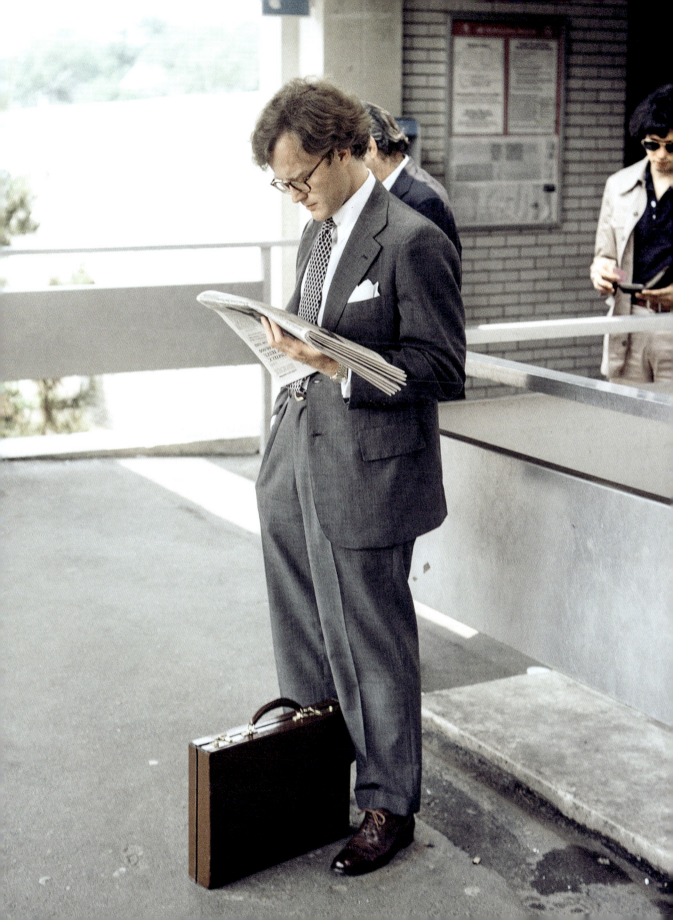

PART 2

# DESIGNS

60 ICONS

| | |
|---|---|
| *Floral shirt* – Paul Smith .................................. p. 194 | *Edgy embroidery* – Balmain .............................. p. 246 |
| *Moon print* – Marine Serre ............................... p. 195 | *Angkor dress* – Chloé ....................................... p. 247 |
| *Baroque* – Versace ............................................ p. 198 | *Kelly bag* – Hermès .......................................... p. 248 |
| *Psychedelic prints* – Pucci ................................ p. 199 | *Silk square* – Hermès ....................................... p. 249 |
| *2.55 handbag* – Chanel ..................................... p. 202 | *Santon* – Jacquemus ......................................... p. 252 |
| *Women's suit* – Chanel ..................................... p. 203 | *Pouf skirt* – Christian Lacroix .......................... p. 253 |
| *Homeless chic* – Dior ........................................ p. 206 | *Dress Meets Body* – Rei Kawabuko ................... p. 256 |
| *Pop culture* – Moschino .................................... p. 207 | *Stockman jacket* – Margiela ............................. p. 257 |
| *Athleisure* – Prada ............................................ p. 208 | *Stripes* – Sonia Rykiel ...................................... p. 260 |
| *Pigalle pumps* – Louboutin ............................... p. 209 | *Men's skirt* – Jean-Paul Gaultier ...................... p. 261 |
| *Tuxedo* – Yves Saint Laurent ............................. p. 212 | *Bustier* – Issey Miyake ..................................... p. 262 |
| *Bar suit* – Dior .................................................. p. 213 | *Cone bra corset* – Jean-Paul Gaultier .............. p. 263 |
| *Italian fashion* – Dolce & Gabbana ................... p. 216 | *Space Age* – Pierre Cardin ............................... p. 266 |
| *Slip dress* – Calvin Klein .................................. p. 127 | *Vinyl jacket* – Courrèges .................................. p. 267 |
| *Neoclassicism* – Alix Grès ................................ p. 218 | *Metal dress* – Paco Rabanne ............................ p. 270 |
| *Disco* – Halston ................................................ p. 219 | *Mondrian dress* – Yves Saint Laurent .............. p. 271 |
| *Sculptural dress* – Balenciaga .......................... p. 222 | *Backless dress* – Guy Laroche .......................... p. 274 |
| *Crinoline* – Balenciaga ..................................... p. 223 | *Bumster* – Alexander Mcqueen ........................ p. 275 |
| *Teddy bear jacket* – J.-C. de Castelbajac .......... p. 226 | *Wrap dress* – Diane von Fürstenberg ............... p. 278 |
| *Table skirt* – Hussein Chalayan ........................ p. 227 | *Speedy bag* – Louis Vuitton .............................. p. 279 |
| *Delphos gown* – Mariano Fortuny .................... p. 228 | *Antibacterial fabric* – Coperni ......................... p. 282 |
| *Meme dress* – Viktor & Rolf .............................. p. 229 | *Urban luxe* – Virgil Abloh ................................ p. 283 |
| *Bandage dress* – Azzedine Alaïa ....................... p. 232 | *Red couture* – Valentino ................................... p. 286 |
| *Birth of Venus dress* – Thierry Mugler ............. p. 233 | *Robe de style* – Jeanne Lanvin ......................... p. 287 |
| *Optical illusion hat* – Elsa Schiaparelli ............ p. 236 | *Armani suit* – Giorgio Armani ......................... p. 290 |
| *Buttons and hearts* – Patrick Kelly ................... p. 237 | *Monokini* – Rudi Gernreich ............................. p. 291 |
| *Joyful fashion* – Kenzo Takada ......................... p. 238 | *Mini-crini* – Vivienne Westwood ...................... p. 294 |
| *Safari jacket* – Yves Saint Laurent ................... p. 239 | *Ghillie Shoes* – Vivienne Westwood ................. p. 295 |
| *Slim silhouette* – Hedi Slimane ........................ p. 242 | *Exposed genitalia* – Rick Owens ....................... p. 296 |
| *Porno chic* – Gucci ........................................... p. 243 | *Ethereal technology* – Iris van Herpen ............. p. 297 |

**BEHIND THE SCENES**

**1858**
Charles Frederick Worth founds his fashion house with Otto Bobergh. He invents haute couture and the figure of the grand couturier.

**1868**
Charles Frederick Worth establishes the Chambre Syndicale de la Confection et de la Couture pour Dames et Fillettes.

**1900**
The haute couture industry is represented at the Paris Exposition world fair.

**1947**
Christian Dior's « New Look » relaunches haute couture.

**1945**
A decree protects the « haute couture » label.

**1945**
The « théâtre de la mode » tours the world with small mannequins modeling Parisian couture.

**1954**
Gabrielle Chanel makes a stunning comeback.

**1968**
Cristóbal Balenciaga retires from fashion.

**1973**
The Fédération Française de la Couture, du Prêt-à-porter, des Couturiers et des Créateurs de Mode is founded.

**2021**
Kerby Jean-Raymond, founder of Pyer Moss, is the first Black American designer to be invited to present a couture collection in Paris.

**2021**
Demna revives haute couture at Balenciaga.

**2017**
La Fédération is renamed Fédération de la Haute Couture et de la Mode.

**1905**
Lady Duff-Gordon, of the fashion house Lucile, organizes the first show-like presentations of collections.

**1911**
La Chambre becomes Chambre Syndicale de la Couture Parisienne.

**1917**
Couture house employees, called midinettes, go on strike.

**1919**
Gabrielle Chanel sets up shop on rue Cambon.

**1933**
Paul Poiret creates the first designer perfume.

**1942**
Lucien Lelong organizes a collective runway show in the free zone.

**1977**
Hanae Mori is the first Japanese woman designer to become a member of the Chambre Syndicale de la Couture Parisienne.

**1983**
Yves Saint Laurent is the first designer to be exhibited during his lifetime at the Metropolitan Museum of Art in New York.

**1985**
First « Fashion Oscars » honors designers.

**1997**
The Federation creates the category « corresponding members », offering foreign designers the possibility of showing collections called « couture ».

**1998**
The Federation now supports guests who can show their collections in parallel to the official haute couture shows.

**2002**
Yves Saint Laurent retires and closes the house's couture division.

# FLORAL SHIRT
## CLASSIC WITH A TWIST

| | |
|---|---|
| DESIGNER | PAUL SMITH (p. 361) |
| DATE | AROUND 1980 |

Hard to be more English. Paul Smith underlines the ambivalent spirit of his country with silhouettes that are classic and extravagant at the same time. Even if, to hear him tell it, he's just an eccentric bike enthusiast and compulsive collector, he's managed to turn his name into a renowned brand.

↑ Liberty Floral Cotton Shirt, Paul Smith

« I TAKE INGREDIENTS FROM UPPER-CLASS TAILORING, HAND-MADE SUITS AND SO ON, AND BRING THEM TOGETHER WITH SOMETHING SILLY. »

PAUL SMITH

### ENGLISH TASTE

It all starts in 1970, in a tiny boutique on an obscure Nottingham alley in North London. Dedicated to innovative designers of the time, like Kenzo and Margaret Howell, the boutique, Paul Smith Vêtements Pour Homme, rapidly integrates his personal designs. Paul Smith, who came to fashion partly by chance, makes a name for himself with his classic silhouettes that pay homage to English taste. He presents his first collection in Paris in 1976.

### COMEBACK

Inspired by childhood memories, Smith reinterprets his brother's post office uniform shirt, the traditional tweeds (p. 42) of his native countryside, and jeans (p. 136) imported from America. Above all, he embraces English craft, supported by London tailors who exalt custom-made clothes that he translates into bold colors. He likes to add an element of surprise, like brightly colored lining and colorful prints.

### FROM PAST TO PRESENT

Paul Smith especially appreciates floral prints and rainbow stripes. They are put on shirts, adding an exuberant touch to the dark suit's sober silhouette. Smith must have seen these unique shirts in 1960s England. He takes inspiration from androgynously styled men, like the peacocks (p. 344), who redefine a masculinity confined to subdued restraint since the Industrial Revolution.

### JOYFUL MASCULINITY

Paul Smith also wants a peacock-inspired style for men who prefer to dress without affectation and are free to dare humor and levity. Perhaps that's where his success lies. Because jubilation is timeless, it transcends trends.

### TEXTILE TEMPLE

In 1875, Arthur Lasenby Liberty establishes the department store Liberty of London, specializing in textiles and works of art imported from Asia and the Middle East. Beginning in the 1900s, the store offers fabric of its own conception, sometimes in collaboration with English artists like William Morris. Their iconic Tana Lawn cotton is named after the Tana Lake in Ethiopia. Floral motifs created in the early 1930s are adopted by London Peacocks in the 1960s.

# MOON PRINT
## A BETTER WORLD

| DESIGNER | MARINE SERRE *(p. 361)* |
| --- | --- |
| DATE | 2017 |

In 2017, Marine Serre, a young graduate of La Cambre art school in Brussels, wins the LVMH prize before showing her first collection in 2018. Things move fast for the young designer who mixes haute couture and sportswear and creates « futurewear », new in forms and modes of production.

**A NEW LIFE**

Nothing is lost; everything is transformed. Such is the credo of Marine Serre, who brings upcycling into luxury fashion. Honoring used textiles and clothing by collecting and transforming them requires technical craft that pushes the boundaries of fashion. For Marine Serre, recuperation isn't a platitude; it's a visceral commitment and a personal challenge. The designer represents new behaviors and a new vocabulary of fashion that doesn't interfere with commercial success.

**MOTIF MYSTIQUE**

Make what's old beautiful. But above all, make it desirable – that's the secret to Marine Serre's success. Nonetheless, in this day of social media, consumers are seeking status symbols and identifiable motifs. The designer found one: the crescent moon motif she designed for her 2018 collection. The moon evokes primal mystical femininity. It is also an ancestral symbol, the mark of certain religions like Islam. This is not an accident. Marine Serre deliberately uses the crescent moon to symbolize communion, erasing borders and hatred.

**DYSTOPIA**

Beyond these creative and aesthetic principles, Marine Serre engages politically via thought-provoking runway shows anticipating social movements. In her Fall/Winter 2019 show, models walked an apocalyptic runway wearing hoods and masks. The masks are antipollution. A few months later, COVID masks grace faces around the world.

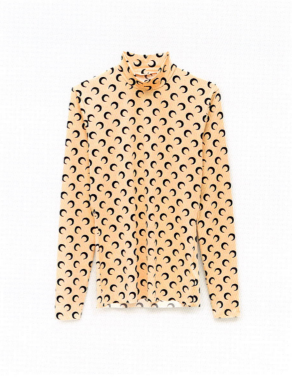

↑ Second Skin Turtleneck Moon Top, Marine Serre

**« I LIKE TO PROTECT THE BODY. »**

MARINE SERRE

**CONSUMPTION CULTURE**

The motif becomes a logo. It's a must-have. Instagram influencers and celebrities like Beyoncé flaunt it. It's unveiled on jumpsuits, covering the entire body with her logo. Marine Serre denounces the ravages of the fashion industry, but she can't control consumerist distortions. Therein lies the paradox to which the brand bears witness. Marine Serre offers a message that is endlessly profaned by the fashion world within which she creates it.

**SIGNATURE**

In 2019, Marine Serre wishes to register her crescent moon motif with the European Union Intellectual Property Office. The organization dismisses her request, seeing only a decorative print rather than the distinctive character of a brand. Her crescent moon is hers without really belonging to her.

**CUSTOM MADE**

In 2020, Beyoncé reveals her musical film *Black Is King*. The singer and her dancers wear bespoke Marine Serre bodysuits in brown, a color otherwise unavailable.

# BRANDING

## A HISTORY OF MOTIFS

Marking clothes with an identifier is a historical practice. Some kings embroidered their shirts with their monograms, queens put them on their stockings, and liveries were adorned with the court's colors. In 1896, Louis Vuitton is the first luxury house to create a brand motif. Others, following suit, play with unique colors, patterns, and prints.

SONIA RYKIEL

MARINE SERRE

MISSONI

PAUL SMITH

ALEXANDER MCQUEEN

BURBERRY

PUCCI

VERSACE

VUITTON

→ Louis Vuitton handbag, *Fall/Winter 2023-2024 Fashion Week attendee*, Par

# BAROQUE
## DECORATIVE OBJECTS

| | |
|---|---|
| DESIGNER | GIANNI VERSACE *(p. 362)* |
| DATE | 1990s |

In 1978, Gianni Versace founds his brand and stands out thanks to daring, colorful prints, baroque patterns, and sensuous fabric. These aesthetic codes perfectly accompany 1980s materialism. He applies these same stylistic preferences to his men's collection.

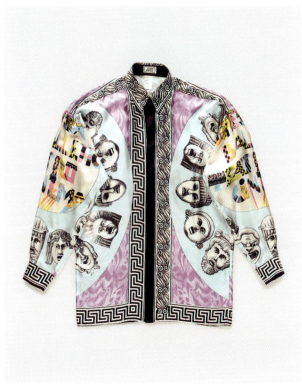

↑ Versace Shirt, 1990s

« I LIKE THE BODY. I LIKE TO DESIGN EVERYTHING TO DO WITH THE BODY. »

GIANNI VERSACE

### PLAYBACK

In 1990, George Michael reunites the most famous supermodels of the era for his *Freedom! '90* video. A few months later, Gianni Versace invites Linda Evangelista, Naomi Campbell, Christy Turlington, and Cindy Crawford to walk in the show's finale while singing the hit that immortalized them onscreen. The moment goes viral long before social media is born.

### FETISH FASHION

For his Fall/Winter 1992 collection, Gianni Versace presents a runway show called « Little Miss S&M ». The explicit title says it all about the landmark collection's fetishistic references. Daring to present leather, dog collars, studs, and laced-up, corseted bodies, Versace celebrates a divisive, sexualized femininity. Some commentators see it as debasing the body, while others see it as a celebration of an otherwise shunned feminine sexuality.

### LUXURY, ALWAYS

The 1990s mark the golden age of Versace, perhaps because the brand goes against the grain of the dominant styles of the decade: minimalism, deconstructivism (p. 308), and grunge (p. 338). Gianni Versace doesn't compromise with his glamorous and theatrical designs that suggest sex, power, subversion, and luxury. His shows and ad campaigns are iconic, and his work exalts the prominence of the supermodels who reign supreme at the time.

### FINDING INSPIRATION

Passionate about art, theater, and history, especially Italian, Versace distills his cultural references into his always luxurious designs, even for daywear. In 1992, he buys a grandiose villa in Miami, and the city's Latin culture and vibrance feed his inspirations, which become even more colorful and even more extravagant.

### ECLECTIC MEN

The designer also liberates men from sartorial conventions and constraints. He redefines the volumes of men's silhouettes and, above all, the motifs that adorn them. Advocating a decorative, exuberant style, he embellishes men with color and artistic elements borrowed from 1960s American art, antiquity, and Italian baroque – an eclecticism to which he adds animal, floral, and nautical prints that express the exuberance of his Miami life.

### SEXUAL OBJECT

Where Calvin Klein liberated men's sexuality by eroticizing its representations in ads (p. 105), Gianni Versace frees it through clothing. He doesn't hesitate to turn a man into a sexual object and embraces homoeroticism. Men are decorated to blend into the voluptuous, sensual, exhilarating décor.

# PSYCHEDELIC PRINTS
## FROM HEAD TO TOE

| DESIGNER | EMILIO PUCCI (p. 359) |
| --- | --- |
| DATE | 1960s |

Sometimes, in the insouciance of those born into the upper classes, there is a tendency to produce ideas that meet needs that only they are aware of because they are their own. Such is the case with Emilio Pucci, an Italian marquis and distinguished skier who seeks to enjoy winter sports in style.

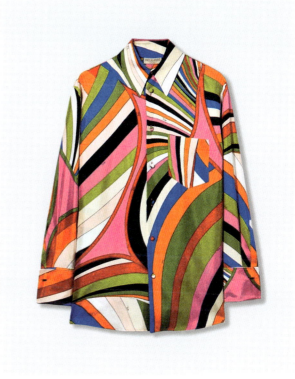

↑ Pucci Shirt

« GAIETY IS ONE OF THE MOST IMPORTANT ELEMENTS I BROUGHT TO FASHION. I BROUGHT IT THROUGH COLOR. »

EMILIO PUCCI

### HAPPY COINCIDENCE

In 1948, in Zermatt, a Swiss ski resort frequented by the wealthy, Emilio Pucci captures attention in a chic ski suit of his own design. Toni Frissell, photographer at the time for *Harper's Bazaar*, notices him and takes pictures that Diana Vreeland, his fashion editor, decides to publish. It's the first publication from which the Italian aristocrat will benefit. His career is launched.

### AFTER THE MOUNTAINS, THE SEA

In 1949, Emilio Pucci decides to establish his brand in Capri by opening a boutique there. From Jackie Kennedy to Sophia Loren, many are those who prize his designs that respond so well to the demands of a life of travel and society events, like his cropped pants – shorter for summer days. They are now known as capri pants.

### ARTIFICIAL SILK

From skiing, the designer conserves an affinity for materials and technicality. He works better than anyone else with stretchy fabric and creates bathing suits (p. 73) with colorful patterns. His prints become the quintessence of a chic yet impertinent *dolce vita*. The extravagant colors come to represent casual, carefree ease. In 1960, Pucci collaborates with Guido Ravasi, who specializes in the fabrication of artificial silk. Together, they create Emilioform, a revolutionary, wrinkle-free silk jersey for those who pack their bags for world travel like others go to work.

### LE PSYCHÉDÉLIQUE, C'EST CHIC

Pucci style is established in the 1960s. Some even call it « Puccimania ». Hippie fashion (p. 326) leaves the San Francisco streets to dress the international affluent. Caftans (p. 46) and long dresses revisited by the designer are part of a bohemian and refined approach. But the fantasy doesn't last and Pucci is left behind in the 1970s. In the 1990s, the brand is revived: Pucci is a perennial classic.

### IMMORTAL

Legend has it that Marilyn Monroe, a loyal client of the Pucci house, asked to be buried in a green Pucci dress.

*Next page:*
**Skier** wearing Pucci, 1969

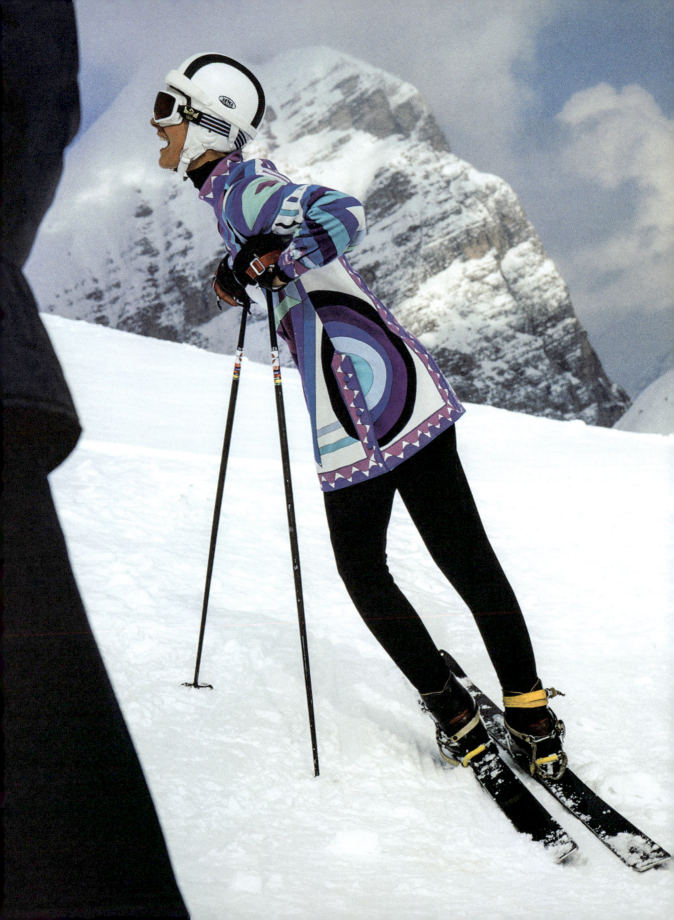

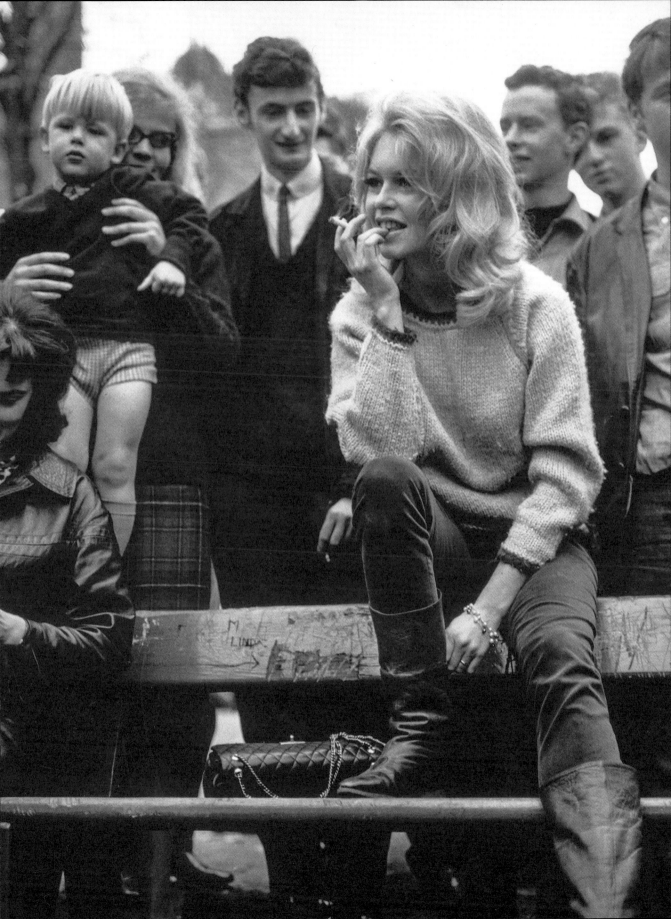

# 2.55 BAG
## ALL-PURPOSE

| | |
|---|---|
| **DESIGNER** | COCO CHANEL *(p. 351)* |
| **DATE** | 1955 |

After closing her couture house in 1939, Gabrielle Chanel returns in 1954. A year later, she creates a handbag that reflects her elegant and practical approach to dressing. Its identifiable vocabulary is still a vital part of the luxury brand today, long after the death of its designer.

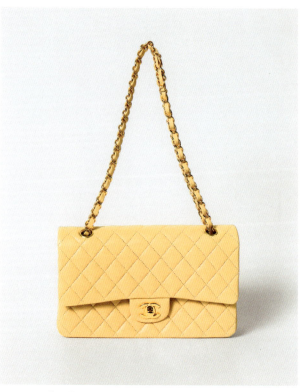

↑ 2.55 Bag, Chanel

### « THERE'S NO FASHION IF IT DOESN'T GO DOWN THE STREET. »

GABRIELLE CHANEL

### INSPIRED BY MEN
Chanel's heritage originates in the enduring appeal of the innovative motifs imagined by the designer. The aesthetic of the 2.55 bag is built upon legendary stories. The rectangular shape and the strap evoke the soldiers' satchels that Gabrielle Chanel observed. Loyal to her principles, the designer facilitates life for women by borrowing from men.

### INSPIRED BY MEMORIES
The bag's diamond quilting echoes the jackets worn by the stableboys she mingles with as a horsewoman and racing fan. The graphic motif of the stitching, originally available on leather, jersey, and silk satin, guarantees the solidity of a bag that is not merely a precious object; it is made to be used.

### INSPIRED BY DETAILS
The chain lining of her suit jackets (p. 203) inspires the shoulder strap that liberates hands and movements. Interweaving the chain with leather renders the strap soft and flexible so it doesn't dig into the skin. Grosgrain red lining makes it easy to find the bag's contents. There is also a small pocket for lipstick and another more discreet pocket for love letters.

### INSPIRED BY FREEDOM
The 2.55 bag expresses nonchalance in an era that is anything but. 1950s fashion imprisons women in stereotypes of restricted femininity. Wanting to share her affinity for ease, Chanel turns her bag into a small revolution.

#### CODE NAME
The bag's name simply comes from its date of birth: February 1955.

#### 2.55 BECOMES 2.88
Somewhat forgotten in the 1960s and 1970s, the 2.55 bag is resuscitated by Karl Lagerfeld in the 1980s and adorned, not with a rectangular closure, but with a flashy double C: it's the 2.88. Upon arrival at Chanel in 1983, Lagerfeld dusts off and expands the vocabulary defined by Gabrielle Chanel. The initially subversive 2.55 is now an eternally transformable icon.

#### ARTWORK
In 2008, the architect Zaha Hadid designs Mobile Art, an exhibit space that can be dismantled and transported. It is created to accommodate a tribute exhibit to the 2.55 bag and presents interpretations of the bag by contemporary artists such as Sophie Calle, Daniel Buren, and Subodh Gupta.

*Previous page:*
**Brigitte Bardot,** on-set for *Une Ravissante Idiote (The Ravishing Idiot),* 1963

# CHANEL SUIT
## THE UNIFORM OF ELEGANCE
### COCO CHANEL (p. 351)

DESIGNER .................................................
DATE ................................................. 1954

In 1947, Christian Dior sets the tone for the coming decade with an archaic style vocabulary featuring corsets and voluminous skirts. Gabrielle Chanel, who closed her fashion house in 1939, can't stand by and watch this retrogression. In 1954, she returns to offer an alternative.

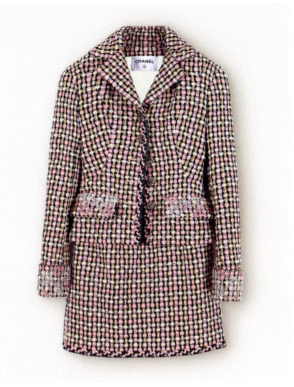

↑ Suit, Chanel

« LUXURY MUST BE COMFORTABLE, OTHERWISE IT IS NOT LUXURY. »

GABRIELLE CHANEL

**CORE VALUES**

Starting in 1913, the comfortable styles of Gabrielle Chanel thrive. Jersey, tweed (p. 42), and garments borrowed from menswear nourish her style vocabulary. In 1954, she returns with an unchanged aesthetic, determined to impose her idea of fashion on a decade that has swept aside the very idea of ease in the feminine wardrobe.

**A NEW SUIT**

To the adornments and embellishments of the 1950s, Gabrielle Chanel responds with a suit. The first show that signs her return on February 5, 1954, isn't a success. But her skirt and collarless jacket ensembles garner attention, especially among her American clientele. Their relaxed elegance reflects a new way of living for dynamic women who, even if they are wealthy, want to be able to dress themselves unaided.

**SIMPLIFIED STYLE**

The suit exemplifies the Chanel style: measured, practical, and refined. The aristocracy and the French New Wave adopt it – polar opposites demonstrating its polyvalence. A must-have, it heralds the simple silhouettes of the 1960s.

**AMERICAN HISTORY**

On November 22, 1963, President John F. Kennedy is assassinated next to his wife, Jackie, whose pink suit is stained with his blood. The images of the First Lady are seen around the world. Everyone thinks it's a Chanel suit she is wearing. Actually, it's a copy created by the American brand Chez Ninon, based on a Chanel-validated pattern – a copy that demonstrates the brand's reach.

**SECRET**

The bottom of the suit jacket is lined with a gold chain to weigh it down and help keep its shape.

**PLAYFUL RENAISSANCE**

Karl Lagerfeld becomes the brand's creative director in 1983 and offers a glowing tribute to Gabrielle Chanel by reinterpreting the house's archives. The suit doesn't escape reinterpretation, and while it expressed distinction in the 1950s, in the 1980s, it represents a flashy new generation. Over the years, it becomes a bubblegum-pink miniskirt (p. 160), is covered in shiny golden chains, and adopts a hip-hop (p. 316) spirit. It transcends eras.

**EVOLVING SUIT**

**1991** Like a wetsuit
**1994** Hip-hop style
**1995** *Itsy bitsy mini*
**2011** Gossamer
**2013** Baroque
**2016** In Jean
**2017** Futuristic

*Next page:*
**Inès de La Fressange,** Chanel Spring/Summer collection, 1984

# HOMELESS CHIC
## LOVE, NOT HATE

| | |
|---|---|
| DESIGNER | JOHN GALLIANO FOR CHRISTIAN DIOR *(p. 353)* |
| DATE | 2000 |

In 1996, John Galliano becomes the director of Christian Dior. Appointing a young English designer to head France's most prestigious couture house is considered an affront. And yet, he produces some of the most flamboyant and legendary shows of contemporary fashion.

↑ **Purse, Christian Dior** by John Galliano

### « I PREFER BAD TASTE TO NO TASTE. »

JOHN GALLIANO

### PATCHWORK OF INFLUENCES

Galliano's trademark is referential fashion with improbable cultural and historical blends. On his catwalk, Masai women, flirtatious Belle Époque women, Hollywood stars, and geishas all meet with unparalleled ease. Wildly nonsensical references and theatrical spectacles are the goal. Discovering a Galliano for Dior collection is like going to a dazzling show with the eyes of a child. And it fits the times – it's the era of extravagance: the luxury market is growing, and exuberant runway shows serve to push consumers towards buying accessories and perfumes.

### A LITTLE TOO IMPERTINENT

For the Spring/Summer 2000 collection of the luxury brand, John Galliano decides to take inspiration from the unhoused men and women he sees along the Seine River while he jogs. The models walk the runway wearing lacerated clothing, with everyday objects and bottles of alcohol hanging from their waists. Their faces are smudged; their hair is tousled. Some of the fabrics are coarse, like the jute canvas transformed into pants. The worst part? It's an haute couture collection.

### IT BAG

In 1999, John Galliano creates one of Dior's most emblematic bags of the 2000s. Inspired by a « D » shaped stirrup, it is worn on the shoulder, close to the body. The distinguishing touch is the monogrammed fabric, designed by Marc Bohan in 1967, which gratifies the logomania of the time. Stars adopt it, and *Sex and the City* makes it a must-have. In 2018, Dior relaunches the bag.

### GRANDEUR AND DECADENCE

The brand is accused of trivializing poverty. Worse still – of rendering it beautiful. As if the way members of the unhoused community manage to dress and warm themselves could be a creative pretext. Moreover, it's difficult to imagine a wealthy clientele spending considerable sums of money to adopt a vagabond air. Protesters snarl outside the show, and the political press is tense: it's a scandal. Inspiration has its limits!

### JOURNAL À PORTER

During the Spring/Summer 2000 Dior haute couture show, John Galliano unveils his newspaper print (the « Christian Dior Daily » in the form of dresses) to evoke the newspapers under which the homeless sleep. The idea is inspired by a 1930s Elsa Schiaparelli fabric. The print is a veritable success and is endlessly revisited in his Dior collections, as well as for the brand John Galliano.

*Previous page :*
Dior Spring/Summer 2000 runway show

# POP CULTURE
## CHEAP & CHIC

| | |
|---|---|
| **DESIGNER** | JEREMY SCOTT FOR MOSCHINO *(p. 361)* |
| **DATE** | 2010s-2020s |

Moschino is founded in 1983 and immediately stands out thanks to its eccentric, sometimes quirky, aesthetic – a rare thing in the luxury industry. When the American designer Jeremy Scott becomes creative director in 2013, his originality suits the brand's whimsy, which he takes even further.

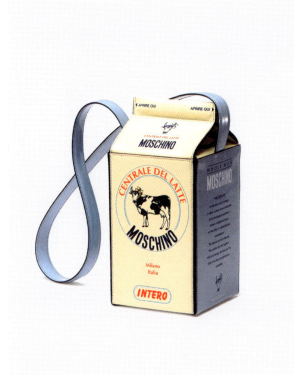

↑ **Purse**, Moschino

« FASHION SHOULD HAVE A TRANSGRESSIVE NATURE ... IT SHOULD BRING YOU JOY AND UPLIFT YOU. »

JEREMY SCOTT

### POP CULTURE

His first runway show sets the tone: in 2013, Jeremy Scott brings together McDonald's, the Chanel suit, SpongeBob, chips, and cereal. An explosive combination that reflects consumerism, culture, junk food, and entertainment. The designer uses fashion to distill his cultural inspirations without placing value judgments on them, all while interrogating our society without disapproval.

### QUESTIONING THE WORLD

Barbie, The Looney Tunes, and My Little Pony come next. Paper dolls follow. Dressing models in styles that evoke cardboard interrogates our tendency to consume fashion in two dimensions and evokes overconsumption of packaging due to e-commerce. The incredible outfits, creative and playful, seem hastily colored in.

### ARTISTIC MOTIF

For his Spring/Summer 2020 collection, Jeremy Scott adds fine art to his playful explorations. In homage to Picasso and his muses, the fashion designer explores the literal expression of the artistic gesture. Some of the models wear veritable works of cubist art. Occasionally, a Demoiselle d'Avignon or a Harlequin comes to life.

### AT THE MARKET

For his Fall/Winter 2014 show, Karl Lagerfeld also brings Chanel into the heart of the discussion about consumption culture. Under the glass roof of the Grand Palais in Paris, the brand re-creates supermarket aisles with shelves full of products renamed with puns referring to Chanel – a comment on the contemporary transformation of the luxury industry from virtuosic craft to supermarket of fashion.

### ART FOR ALL

Beyond the creative gesture, Jeremy Scott treats Picasso like just another pop icon. Not to devalue him but to inscribe him in a society that consumes art like we consume fashion: in an infinite gesture of scanning images that are then swept aside, only to be replaced by another, then another. He desacralizes art while elevating its place in our everyday lives.

### INSPIRATIONS PLURIELLES

**Fall/Winter 2014:**
McDonald's

**Spring/Summer 2015:**
Barbie Girl

**Fall/Winter 2017:**
Cardboard boxes

**Fall/Winter 2018:**
Jackie Kennedy

**Fall/Winter 2019:**
The Price is Right

**Spring/Summer 2020:**
Picasso

**Spring/Summer 2020:**
Marie-Antoinette

**Fall/Winter 2021:**
Hollywood

# ATHLEISURE
## OVERTIME

| | |
|---|---|
| **DESIGNER** | PRADA *(p. 359)* |
| **DATE** | 1999 |

At the dawn of the new millennium, the preference is for minimalist silhouettes featuring futuristic elements manifested in the technical aspect of garments. This style is imbued with sportswear. Since joining the family business, Miuccia Prada has never stopped reinventing its identity.

↑ Active Nylon Windbreaker, Prada

### LINEA ROSSA

In 1984, Miuccia Prada introduces nylon purses, and they are wildly successful. Moving into the women's prête-à-porter space, she blends artistic inspirations, 1960s references, and nonconformity – reinventing luxury along the way. In 1995, Prada creates the Italian team's uniforms for the America Cup. The designer is inspired by the techniques and materials used. She launches Prada Sport, Linea Rossa, in 1997: a men's sportswear line recognizable by its monochrome nylon ensembles marked with a rectangular, sometimes plastic, red logo.

### TECHNO MODE

Prada Sport moves into other territories. Starting in 1999, Miuccia Prada blends the minimalist silhouettes of her women's collections into her signature sportswear pieces. Linea Rossa delights the techno scene (p. 342), but it also finds its place in the daily wardrobes of those who lean towards utilitarian and high-tech looks.

> « UGLY IS ATTRACTIVE, UGLY IS EXCITING. MAYBE BECAUSE IT IS NEWER. THE INVESTIGATION OF UGLINESS IS, TO ME, MORE INTERESTING THAN THE BOURGEOIS IDEA OF BEAUTY. AND WHY? BECAUSE UGLY IS HUMAN. »
>
> GIANNI VERSACE

**DIVERSE INSPIRATIONS**

**Spring/Summer 2005:** Reggae
**Spring/Summer 2007:** 1971 Yves Saint Laurent show
**Fall/Winter 2010:** The Roaring Twenties
**Spring/Summer 2012:** 1950s Palm Springs
**Fall/Winter 2013:** Alfred Hitchcock
**Spring/Summer 2017:** 1980s Club Kids
**Fall/Winter 2020:** Vienna Secession

### TRENDY SPORTS

The Prada Sport adventure concludes in 2001, but intertwining luxury and sportswear is part of a trend that all brands borrow from thereafter. It is called athleisure, based on a word that appears in the 1970s. The expression defines a style adapted to both sports and everyday wear and finds new life in the 2010s.

### UGLY CHIC

In 2018, Miuccia Prada gives her athletic line a second chance. She dilutes various codes in her collection, like nylon, Velcro, sneakers (p. 92), and athletic socks, sometimes daring to create explosive combinations. Her style is nicknamed « ugly chic ».

# PIGALLE PUMPS
## FOLLOW ME...

| | |
|---|---|
| DESIGNER | CHRISTIAN LOUBOUTIN *(p. 357)* |
| DATE | 2004 |

As a child, Christian Louboutin visits the Palais de la Porte Dorée in Paris and sees a sign prohibiting stiletto heels on the fragile floor. It's a drawing of a single pump crossed out with a red line. As an adult, he will transgress the ban, and the transgression will become emblematic of his creativity.

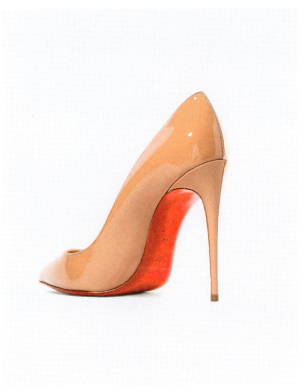

↑ *Pigalle Follies 100 Pumps,* Christian Louboutin

### FROM FORBIDDEN TO SECRET

As a teenager, Louboutin secretly watches dancers in Parisian cabarets. He admires the arch of their feet. In 1991, he launches his brand. His signature? Exaggerated femininity and uninhibited eroticism. Comfort is not the goal. Wearing his vertiginous heels demands a kind of bodily mastery that verges on instability with each step, provoking the rolling gait the designer seeks.

### SIGNATURE RED

Barely a year after founding his brand, Christian Louboutin comes up with the idea of coloring his soles in an intense red to mark his brand identity. Dissatisfied while working on prototypes, he grabs his assistant's nail polish as she paints her nails and slathers it on the sole of the shoe, establishing a legend.

### A NEW SHOE

In 2004, he designs the Pigalle pump. The name references his obsession with rehabilitating disavowed femininity. With insolence, he magnifies the sensuality of those who trade in it, of those who know which game to play to provoke desire. For the designer, it's about giving women control of their sexual power and letting them lead the dance, unsubmissive and seductive.

### PROVOCATIVE

With its red sole, characteristic of the brand, the Pigalle pump embraces the male gaze, usually so disapproved of. At a time when women wish to break free from their servitude to the gaze, from their identity being shaped into an object of fantasy, Christian Louboutin proposes to have fun with it. This scarlet sole is an invitation... for at least contemplation. As is the low-cut vamp that reveals an unhabitual décolleté and uses seductive codes while applying them to unprecedented parts of the body.

### GAME OF SEDUCTION

Pigalle pumps are a distraction. A quasi-fetishistic call to the foot to leave behind worn-out games of seduction and create new, more audacious ones that bring clandestine, subversive sensuality out into the exhibitionist open.

> « A GOOD SHOE IS ONE THAT DOESN'T DRESS YOU, BUT UNDRESSES YOU. »
> 
> CHRISTIAN LOUBOUTIN

### OLD NEWS

Already, under the « Ancient Régime » in France, red heels were all the rage. Philippe d'Orléans, Louis XIV's brother, is said to have set the trend by accident. After a night of festivities in the Parisian butcher district, he stains his high-heeled shoes with cow blood. Louis XIV appreciates the contrast of colors with red, a symbol of power. He has all his heels covered in red leather, and his close courtiers do the same. The red heel becomes characteristic of a privileged nobility until the French Revolution.

*Next page:*
Emma Stone, *Review Awards Gala*, New York, 2012

# TUXEDO
## (WO)MEN'S PLAYGROUND

**DESIGNER** ......... YVES SAINT LAURENT *(p. 360)*
**DATE** ......... 1966

Beginning with his first haute couture collection in 1962, Yves Saint Laurent suggests that women should wear pants, the emblematic garment of the masculine wardrobe. The designer isn't the first to dress women in pants, but he is the one who integrates them without pretention into women's closets.

↑ Tuxedo Jacket, Yves Saint Laurent

### OUTSIDE THE SMOKING LOUNGE
In 1966, he takes on the tuxedo. For his Fall/Winter show, Saint Laurent offers women the audacity to borrow men's most sophisticated formal ensemble. The tuxedo derives from the smoking jacket (p. 186) created for men to change into before retiring to the smoking room. It is essentially the archetype of virility and of the spaces from which women are excluded.

### POWERPLAY
Yves Saint Laurent ignores conventions. They are obsolete in this mid-1960s that redefines societal rules. If a woman wants to wear a tuxedo, that's her right! However, the designer rejects the idea of making demands. In his hands, the pants that accompany the protest are part of new seductive codes. For him, the tuxedo isn't a tool for dressing like a man; Instead, it gives women allure and status: they become the equals of men by playing freely with their stylistic language. It's a game of power, not a war of the sexes.

> **MUSES**
>
> In 1930, Yves Saint Laurent observes the impertinence of Marlene Dietrich's character in the film *Morocco*. One of her outfits is a three-piece suit with a bowtie and top hat. Her look is assured, ambivalent, defiant, seductive. He wants to re-create it. It is also said that Niki de Saint Phalle, who wears pants and suits with high heels, is a source of inspiration.

### SECOND VERSION
Françoise Hardy orders the first tuxedo of the collection. The others don't follow. Haute couture clients aren't ready to wear pants so spontaneously. Success doesn't come until the birth of the designer's 1966 prêt-à-porter line, Saint Laurent Rive Gauche. It's the same year, but the brand doesn't address the same clientele. Younger and more independent, these women treat themselves to an accessible tuxedo.

### A NEW FEMININITY
Revisited to better suit a woman's morphology, the slim-fitting Yves Saint Laurent tuxedo endlessly overturns expectations of fashion. It allows for a new, more androgynous femininity and for expressing sensuality without suffocating. Do women need to borrow from men to feel powerful? No. But they can play in their playground.

> « CHANEL LIBERATED WOMEN; SAINT LAURENT EMPOWERED THEM. »
>
> PIERRE BERGÉ

**THE TUXEDO IN NUMBERS**

**230 versions** of the tuxedo created by Saint Laurent

**36 years** of tuxedos, from 1966 to 2002

*Previous page:*
**Charlotte Rampling, 1974**

# BAR SUIT
## A NOT VERY NEW « NEW LOOK »

DESIGNER — CHRISTIAN DIOR *(p. 352)*
DATE — 1947

On February 12, 1947, Christian Dior presents his first haute couture show. 1950s fashion is launched. Everything in the collection from the designer who has just founded his fashion house delineates the next decade's trends, sweeping away the restrictions and austerity of the Second World War.

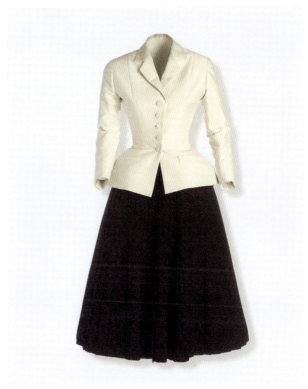

↑ **Bar Suit**, Christian Dior, 1947

### « UNKNOWN ON THE 12TH OF FEBRUARY 1947, CHRISTIAN DIOR WAS FAMOUS ON THE 13TH. »
FRANÇOISE GIROUD

### MODEL TO FOLLOW
At Dior, craft is the most important thing. Every technique is used to design the perfectly constructed garment. The designer asks his team to slim the body and cinch the waist. It's the head of the atelier who brings to life the Bar Suit designed by Dior. And it's not just anyone… it's Pierre Cardin.

### COCKTAIL HOUR
Why Bar? Because Christian Dior is inspired by the bar at the Hotel Plaza Athénée in Paris on Avenue Montaigne. It is situated across the street from his boutique, and he goes there often. It also allows him to identify the ideal moment for wearing the suit; the designer revives a social tradition whereby it is fashionable to change outfits throughout the day. Thus, cocktail dresses, eveningwear, day ensembles, afternoon dresses, and ball gowns all proliferate, requiring a well-stocked wardrobe.

### THE COROLLE LINE
Among the pieces of the show, there is one that stands out: the bar suit. The ensemble is composed of an ivory jacket and a voluminous black skirt. It perfectly illustrates his Corolle line. The designer wants people to forget the styles initiated during wartime. Square shoulders are rounded, shortened skirts gain length, basic is replaced with luxury. Dior offers « lady flowers » who brighten the day. This new approach becomes the credo of the collection after *Harper's Bazaar* editor-in-chief Carmel Snow calls it the « New Look ».

### OUT OF CONTEXT
But it's 1947, only two years after the end of the war. Its scars remain very present; many must still rely on ration cards to eat. Christian Dior is criticized for the opulence of his designs.

### ARCHAIC FEMININITY
This « new » silhouette also maintains a nostalgic vision of femininity. Women, liberated in the 1920s from obsolete sartorial shackles (p. 320), experience a new semblance of emancipation during the war. Yet, this designer arrives and asks women to sculpt their bodies, cinch their waists, and wear heavy skirts. It's like a return to the 18th century, to the time of corsets and panniers. Women are once again placed inside an archaic mold, reflected in the image of the ideal 1950s housewife, who is fulfilled by modern household appliances.

*Following pages :*
Dior Spring/Summer 2018 show;
A model tries on a Christian Dior dress, 1950s

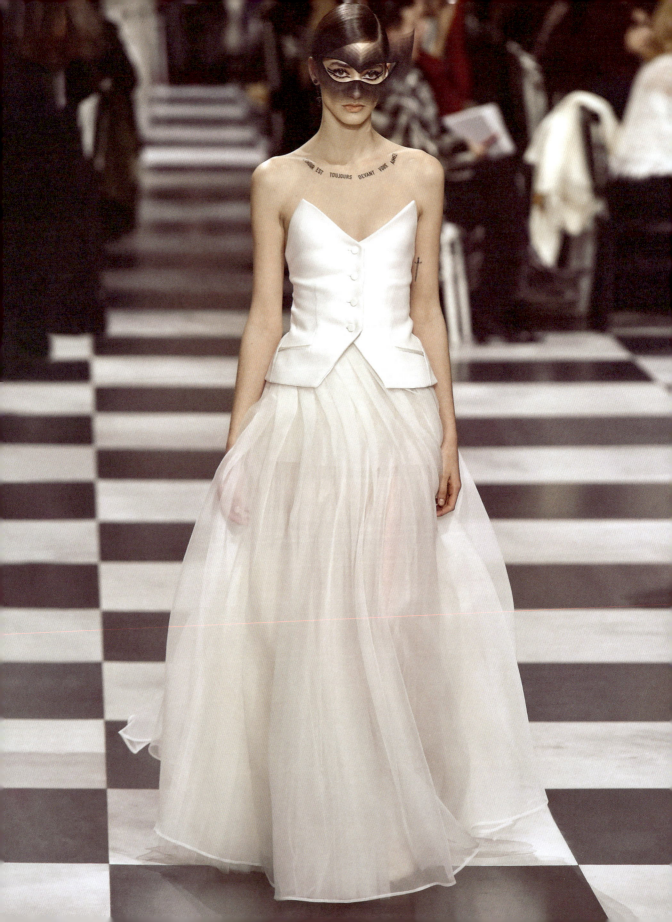

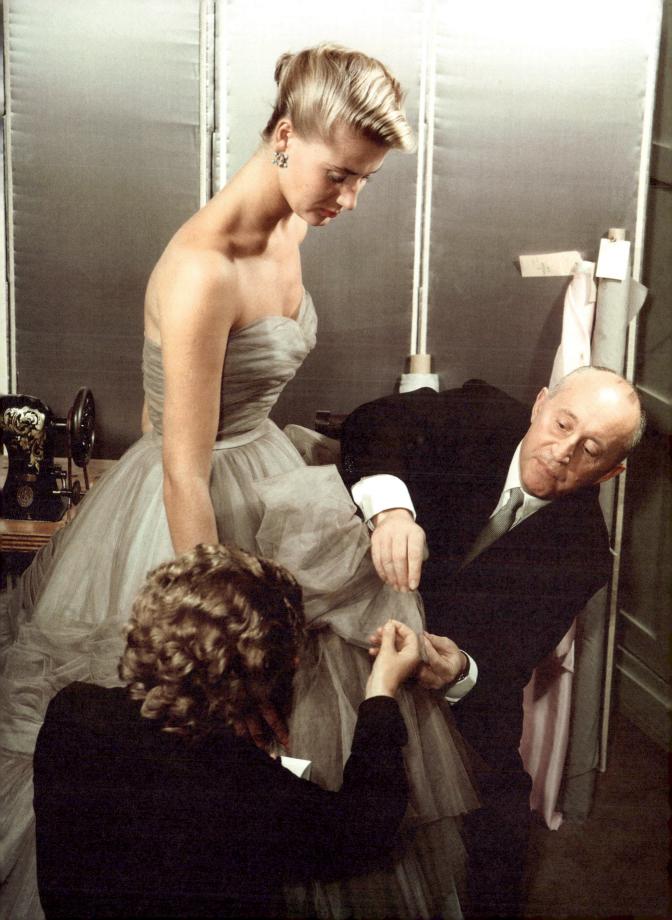

# ITALIAN FASHION
## LA DOLCE VITA

| | |
|---|---|
| **DESIGNER** | DOLCE & GABBANA *(p. 352)* |
| **DATE** | 1980s |

Italian fashion emerges after the war through couture runway shows and Fellini films. Its identity reflects a powerful textile industry that instills a taste for beautiful fabric and perfect fit. When Domenico Dolce and Stefano Gabbana found their brand in 1985, Italy is at the heart of their aesthetic.

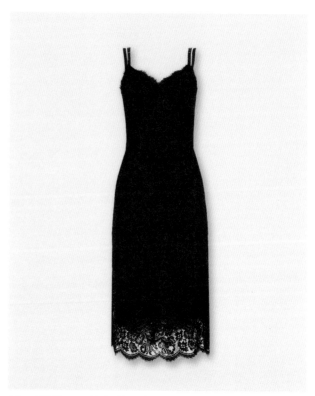

↑ Lace Midi Dress with double scalloped detailing, Dolce & Gabbana

### SICILY AT HEART

In this Italian story, Sicily dominates. Domenico Dolce is born there and never ceases to pay homage to it. Baroque architecture, Byzantine mosaics, colorful ceramics, and archeological sites nourish the duo's designs at Dolce & Gabbana. But what predominates is a preference for black and an ancestral look with a timeless feel (p. 106).

#### SURPRISING INSPIRATION

For their Fall/Winter 2015 show, the creative duo offers a collection titled « Viva la Mamma! » The title is far from anecdotic because the models, who are mothers, walk the runway with their children and babies; one is even pregnant. The garments' motifs are inspired by drawings by the designers' nephews and nieces.

### WOMEN'S STORIES

The designers endlessly revive these silhouettes that are as familiar to us as they are foreign, registered, often despite themselves, in our collective memory. We imagine these older women, dressed in widow's black, who discuss, sometimes quarrel, during the least hot hours of the day in the Italian villages. Some even dress in embroidered lace, following an artisanal tradition from 16th-century Sicily.

### FROM THE STREET TO THE RUNWAYS

Obviously, Dolce & Gabbana register them in the fashion industry's canons of beauty. Older women become youthful muses. Yet, they conserve in their allure these traces of femininity that evoke the good life tinted with religiosity. Contradictory? No. Deliciously Italian.

> « I HOPE PEOPLE REMEMBER DOLCE & GABBANA FOR THE SENSUALITY, FOR THE MEDITERRANEAN SENSE, FOR OUR HONESTY TO LIFE. »
> 
> DOMENICO DOLCE

### ALL OF ITALY

All black? Not always. Here and there, a bit of leopard or a touch of gold enhances the austere silhouettes. Because Italian, it's also about ostentatiousness, whimsy, and sensuality. For each collection, the duo writes a manifesto in tribute to their country. Its strength lies in a taste for uninhibited archetypes and folklore that isn't old-fashioned. The Dolce & Gabbana brand is as much about mamma as it is about Sophia Loren.

### ITALIAN REALISM

Very early, Dolce & Gabbana use their advertising campaigns to register their entirely Italian aesthetic. Their memorable photographs represent religious processions, big, lively meals, and spirited families. Sometimes, they dare to show their models in confrontation with the realities of the country. In 1987, Ferdinando Scianna shoots spontaneous images of the models in the Sicilian streets. In 2016, photojournalist Franco Pagetti places models in the middle of Neapolitan passersby.

# SLIP DRESS
## SECOND SKIN

| DESIGNER | CALVIN KLEIN *(p. 356)* |
| --- | --- |
| DATE | 1990s |

Minimalism is part of the very essence of American fashion. In development since the end of the 19th century, it really takes hold in the 1940s with designers like Claire McCardell, whose elegant style is much more comfortable than Parisian fashion. This is the heritage that feeds Calvin Klein.

↑ *Slim Midi Slip Dress*, Calvin Klein

### PRACTICAL FASHION
Calvin Klein knows it; American style is practical style. Parisian fashion is refined but sometimes too far from American lifestyles. Like other designers before him, he advocates a more effortless aesthetic to wear every day, nourished by sportswear and an urban spirit.

### GRUNGE, BUT ONLY A LITTLE
In the 1990s, grunge (p. 388) seduces the youth. Calvin Klein shares its taste for fluidity, ease, and sensuality that feigns not to be. But he finds a gentler version of grunge: minimalism. He revives the slips worn by grunge girls with a T-shirt and big boots, and offers neutral-toned models in silk or satin.

### BODY TO BODY
This dress, with its informal drape, doesn't cling to the body, but it doesn't ignore it either. Its incontestable sensuality comes from its origin: it used to be an undergarment. It is boldly intimate. Yet, the 1990s silhouette has none of the extravagant sexuality of the 1980s styles. It is often revealed with cool nonchalance.

### BREAKING FREE FROM CLICHÉS
Chunky boots, high-heeled sandals, or even sneakers are its friends. That's what makes it '90s. It is worn with defiance, like when Kate Moss wears a transparent version from the designer Liza Bruce. It can be subtle on the Hollywood red carpet, frenetic and vintage on Courtney Love, or modest when worn as a wedding dress. It is sensual but not submissive. Women who choose it do so according to their own rules.

### DROWSY
The full slip, a dress-like undergarment with thick straps, is born at the end of the 19th century and is soon popular. It shortens slightly in the 1920s, then in the 1940s, American designer Sylvia Pedlar creates a knee-length sleeveless nightgown. Its popularity spreads in the 1950s with the movie *Baby Doll* and the popularity of pinups.

### INTERIOR DAY
It isn't the first undergarment that becomes a dress. In the 1780s, Marie-Antoinette and her aristocratic companions cause a stir with their cotton muslin dresses. The « chemise à la reine », known as a « gaulle », creates a scandal in 1783. A queen represented without her royal emblem, in a dress that evokes immodest intimacy, cannot be tolerated.

# NEOCLASSICISM
## GREEK GODDESS

| | |
|---|---|
| DESIGNER | ALIX GRÈS *(p. 354)* |
| DATE | 1930s |

The Wall Street Crash of 1929 ends the Roaring Twenties with the same tumult that the decade fostered. The Great Depression follows, along with a global economic crisis. On that slippery slope lies the 1930s. Restraint replaces frenzy, and glamour keeps people at a distance.

↑ Dress, Madame Grès, 1971

« I WANTED TO BE A SCULPTOR – TO ME IT IS JUST THE SAME TO WORK WITH FABRIC OR STONE. »

ALIX GRÈS

### QUIET LUXURY
Sumptuousness is no longer expressed with glitzy frills and flounces but with sophisticated cuts and fabrics. Hollywood, in black-and-white, becomes the reference for refined monochromes, and silhouettes become statuesque. Recreational sports develop; the suntanned body is sculpted and slimmed. A long, sinuous ideal is drawn for day and for night.

### QUIET STRENGTH
Tranquil, stylized elegance is also found in 1930s fashion photography. Black-and-white film allows photographers to skillfully create effects with geometry and light. For example, George Hoyningen-Huen defines a sophisticated and artistic style, and Horst P. Horst's work is sharp and experimental.

### APOLLO AND VENUS
The bodies are as perfect as those of classical sculpture. Fashion picks up Greek architectural codes, and designers chisel shapes that wrap, drape, and fold over the women. Alix Grès is one of the designers who borrows from antiquity, where she finds inspiration for the dresses she creates straight from the bodies of her models, with fluid silhouettes that she tames like a sculptor.

### SCULPT THE FABRIC
It becomes impossible to distinguish muslin from stone because the drape is so perfect and the folds so precise. Alix Grès refuses ostentation in favor of austerity. She seeks perfection but not complication. Advocating asceticism, her models nonetheless incarnate a conspicuous sensuality. Contradictory? No – because by exalting the simplicity of form, it's the body that prevails.

### RESTRAINT
It's not surprising that the 1930s revive the classical ideal. The economic context calls for a form of sobriety. The totalitarian movements taking hold in Europe encourage a dignified, imposing, insensitive return to order, promoting an Olympus that is anything but paradisiac.

### FLUTTERING
The neoclassical trend is also expressed in the work of Madeleine Vionnet, who designs ethereal silhouettes. She promotes the technique of cutting on the bias, which improves the fall of the fabric on the body and permits movement and volume effects. The designer is prized by Hollywood costume designers who adopt her dresses because actresses can wear them to execute frenzied dance numbers in the musicals that are all the rage.

# DISCO
## SATURDAY NIGHT FEVER

| | |
|---|---|
| DESIGNER | ROY HALSTON *(p. 355)* |
| DATE | 1970s |

Milliner Roy Halston gains recognition when Jackie Kennedy wears a hat of his design for John F. Kennedy's 1961 inauguration. Later, when headwear falls out of style, he turns towards New York fashion; inspired by the city's nightlife, he influences the style of an era.

### THE SPIRIT OF THE TIMES

Halston knows that active women want to play with the codes of menswear. For day, he creates minimalist silhouettes of elegant turtlenecks, refined coats, and perfectly cut pants. He takes inspiration from what he knows best: himself. He offers women his carefully constructed personal style.

### WATERPROOF...OR NOT

In 1971, Roy Halston meets Issey Miyake in Paris. The Japanese designer is wearing a shirt made of Ultrasuede (imitation suede). Halston admires the shirt and, due to a misunderstanding, believes that it's waterproof. He creates a trench coat with it, but the tissue absorbs water. In 1972 he uses it for a dress instead: the Ultrasuede shirt dress. It immediately becomes one of his bestsellers.

### IT HAPPENS AT NIGHT

The 1970s is the decade of disco. The musical style, born in underground gay nightclubs, diffuses a festive atmosphere – sensual, glamorous, and a touch decadent. Halston makes dresses for dancing. They are elegant and sexy and don't hinder movement.

### DRESSES FOR DANCING

He looks to the Hollywood musicals of the 1930s, reviving the pleated and draped silhouettes of the actresses of the time. If actresses can perform their numbers wearing these free-flowing bias-cut dresses, his clients can dance the night away in them. He is right alongside them at Studio 54, the ultimate New York nightclub, where the hip, carefree, and creative – famous or not – flock together.

### ON AND OFF THE DANCE FLOOR

Surrounded by his « Halstonettes », the nickname given to models who became his muses, he bathes in this nightlife, sometimes to excess. These debaucherous nights burn bright during the frivolous decade that precedes the coming AIDS epidemic. Halston scorches his wings a little, but he also accompanies the modern woman and gives her a wardrobe for liberation.

↑ **Ombre Gown,** Halston Heritage

### « HE PUT [A DRESS] ON YOU AND IT DANCED WITH YOU. »

LIZA MINNELLI

### STYLE WAR

On November 28, 1973, Halston participates in a runway show organized at the Château de Versailles in France. Five French houses confront five American designers. The French dazzle with their striking stage design, while the Americans opt for minimalism and comfort: relaxed, cheerful, and dynamic outfits and models. They make their mark in a system that is dominated by Europe.

*Next page :*
Beverly Johnson in Halston, 1975

# SCULPTURAL DRESS
## HAUTE COUTURE ARCHITECT

**DESIGNER** — CRISTÓBAL BALENCIAGA *(p. 350)*
**DATE** — 1950-1960

When Cristóbal Balenciaga opens his Parisian fashion house in 1937, he already has twenty years of work as a dressmaker behind him. The designer connects his pieces with one leitmotif: pure lines. But this simplicity doesn't limit creativity. On the contrary, it elevates it with confidence and rigor.

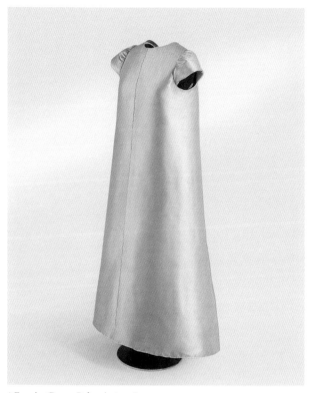

↑ Evening Dress, Balenciaga, 1967

### AGAINST THE GRAIN
Concentrating on one emblematic design would be reductive because Balenciaga's style is so broad. From the beginning, he imbues his work with references to history and to his native Spain, all within highly structured silhouettes. It's after the war that he most stands out: his abstract manner, which blurs the standards of the 1950s woman's body, clashes with Christian Dior's « New Look » (p. 213).

### ABSTRACT BODIES
As Dior concentrates on the waist and hips, Balenciaga works with the back. He reinvents volume, but he never confines the body. He offers a reassuring and regal shelter, always experimenting with cut and fabric, like the gazar fabric he creates in collaboration with textile firm Abraham – a fabric both solid and unforgiving, with no room for error. The designer is exacting, especially with himself.

### SPAIN IN HIS HEART
From Spain, Balenciaga retains black. He also takes bolero jackets, lace mantilla veils, and the undulations of flamenco skirts. He is inspired by Velázquez as if to remind himself where he comes from. And where he's from is also the 19th century – he was born in 1895. He evokes 19th-century bustles in his historicizing designs.

### A VISIONARY DESIGNER
The more the designer progresses, the more he leans towards minimalist and abstract garments. As the 1960s approach, his vision becomes more radical, anticipating the emerging demands of the decade. His late 1950s baby doll and sack dresses presage the A-line dresses of the 1960s. It's ironic because Balenciaga anticipates an era that will lead him to renounce his career.

### TURNING THE PAGE
Indeed, in 1968, Cristóbal Balenciaga announces his retirement. It is said that he is bitter and overwhelmed, and distraught by the direction fashion is taking at the time. But what if the couturier felt that he had already given his all? What if, rather than stubbornly reinventing himself, or worse, repeating himself to exhaustion, Cristóbal Balenciaga simply decided to quit while he was at the top of his game?

> « A COUTURIER MUST BE AN ARCHITECT FOR DESIGN, A SCULPTOR FOR SHAPE, A PAINTER FOR COLOR, A MUSICIAN FOR HARMONY, AND A PHILOSOPHER FOR TEMPERANCE. »
>
> CRISTÓBAL BALENCIAGA

### PARTNER
In 1954, Hubert de Givenchy creates a shirt dress that, in 1957, will evolve into a sack dress similar to Balenciaga. They both initiate the shape that will define silhouettes of the 1960s. Not surprising: Givenchy has a deep, well-known admiration for the Spanish designer, whom he considers to be a mentor and whom he refers to as « the Architect of Haute Couture ».

*Previous page:*
*Alberta Tiburzi in Balenciaga, photo by Hiro, 1967*

# CRINOLINE
## POLITICAL SATIRE

| | |
|---|---|
| **DESIGNER** | DEMNA GVASALIA *(p. 355)* |
| **DATE** | 2020 |

In 2016, Demna Gvasalia, founder of the popular brand Vetements, becomes Balenciaga's creative director. The choice is surprising: his deconstructed sportswear style, inherited from Martin Margiela, places him at the helm of a prestigious house known for refinement and virtuosity.

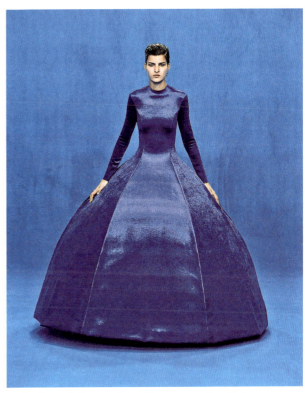

↑ Balenciaga prêt-à-porter Spring/Summer 2020 show, Paris

### « DESTRUCT TO CREATE. I THINK THAT'S VITAL. »

DEMNA GVASALIA

### A TRIBUTE TO HERITAGE

For his Spring/Summer 2020 collections at Balenciaga, Demna establishes his signature: exploring the archives of the Balenciaga house and deconstructing the designs to pay homage to its founder, Cristóbal Balenciaga. At Vêtements, he continues to pursue non-defiant provocation that questions the world and its evolution.

### MECHANICS OF FASHION

In 1858, American company Thomson patents the crinoline, a metallic circular cage that replaces the heavy petticoats worn under women's dresses to give volume to skirts. Revolutionary, it reflects the century's industrial progress. It is still cumbersome, however, as it creates an ample round silhouette that denies natural shapes.

### ALIEN OR ANONYMOUS?

Can you stand out while blending in? This is Demna's inquiry. He isn't afraid to bring sportswear and streetwear into luxury fashion, and he defends his transgressions by pointing out that fashion has evolved. Originally from the ex-Soviet Union, his vision of dressing is informed by resourcefulness and uniformity. And when he creates his quasi-dystopian 2020 collection, he denounces the monotony of politicians' suits, those garments of modern power.

### 19TH-CENTURY INSPIRATION

He ferociously exaggerates power dressing by presenting shoulder-padded silhouettes of the 1980s inherited from Renaissance sovereigns and by bringing back late 19th-century women's crinolines. The wink to the past serves as a story within a story. By reaching into the past, he pays tribute to Cristóbal Balenciaga, who appreciated the century that modified bodies and postures.

### POWER FOR ALL

The crinoline of 2020 conveys authority but also entertainment. The dresses float on the runway, airy and sculpted at the same time. Demna desacralizes power. He makes it a personal sovereign act that is chosen and not imposed.

### TRIVIAL PURSUIT

The art of misappropriation is one of the leitmotifs of Demna Gvasalia's designs.

**2015:** firefighter's sweater
**2016:** DHL T-shirt
**2017:** political scarf
**2018:** shopping bags
**2019:** optical illusion tattoos
**2020:** police shirt
**2021:** dollar bill jumpsuit
**2022:** Simpsons sweatshirt

*Next page:*
Balenciaga prêt-à-porter Spring/Summer 2020 show, Paris

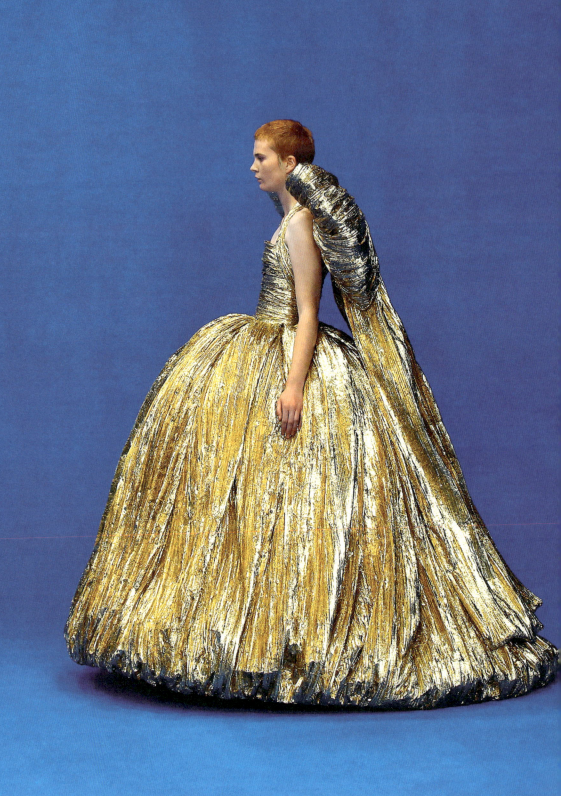

# TEDDY BEAR JACKET
## WRAPPED IN STUFFIES

DESIGNER .................... JEAN-CHARLES DE CASTELBAJAC *(p. 351)*

DATE ........................... 1988

From his very first steps into fashion design, Jean-Charles de Castelbajac infuses his work with irony, humor, and surrealism. An art connoisseur, he applies decorative principles or concepts linked with the great modern and contemporary movements to his garments.

↑ **Arche de Noé (Teddy Bear Coat)**, Jean-Charles de Castelbajac, 1988

### PLAYFUL HOMAGE
Jean-Charles de Castelbajac regularly pays tribute to artists he admires and even collaborates with some to create striking painting-dresses. Without adhering to any hierarchy, he salutes fashion figures such as Coco Chanel, icons of cinema and history, and pop culture. He is capable of juxtaposing Robert Combas with Jackie Kennedy and Mickey Mouse.

### AN ERA OF IMAGES
Like pop art, he absorbs and exploits the abundant iconography surrounding us, from ads to art, passing through music, cartoons, and movies. His collections are patchworks of everything he has seen, read, or heard. Above all, he doesn't take himself seriously. He knows that fashion depends on fantasy (p. 207).

### PETER PAN SYNDROME
If there is a world that doesn't reject fantasy, it's that of childhood. It's for this reason that it's never far from the designer's work. When, in 1988, he creates a jacket made of more than forty stuffed animals, he effortlessly brings together the accumulations of New Realism and the candor of the early years of life.

### MAN'S BEST FRIEND
In 1989, Castelbajac collaborates with Snoopy Incorporated, which holds the rights to the products derived from the cartoons. He creates various pieces consisting of dozens of stuffed Snoopy dogs, including a jacket worn by Vanessa Paradis during the runway show. The teen idol establishes a link between children's clothing and adult fashion.

### A DIFFERENT WAY OF DRESSING
He protests, in his unique way, against the usage of fur. Using childish stuffed animals, he imagines a fashion without violence and even thwarts it, offering a comforting stuffed carapace. The decade promotes ostentation; Jean-Charles de Castelbajac answers with insouciance. It's flashy, yes, but because it's joyful.

« **I'VE GOT A HUGE PICTURE GALLERY OF THE BEAU-BIZARRE IN ME !** »

JEAN-CHARLES DE CASTELBAJAC

### POP COUTURE

**1982 :** Babar dress
**1982 :** Robert Combas painting-dress
**1983 :** Coco Chanel dress
**1984 :** Lucky Strike dress
**1997 :** Vestments for Pope Jean-Paul II
**2000 :** Jimi Hendrix sweater
**2002 :** Keith Haring dress
**2008 :** Lego cap
**2012 :** Mickey Mouse dress

*Previous page :*
**Vanessa Paradis**, Jean-Charles de Castelbajac Fall/Winter 1989 runway show

# TABLE SKIRT
## POLITICAL FASHION

DESIGNER ................... HUSSEIN CHALAYAN *(p. 351)*
DATE ................... 2000

Since the 1990s, Hussein Chalayan has asserted a unique aesthetic, closer to performance art than fashion. The Cypriot designer uses the runway for experimentation, interrogation, and objection. He pushes the boundaries of garment design.

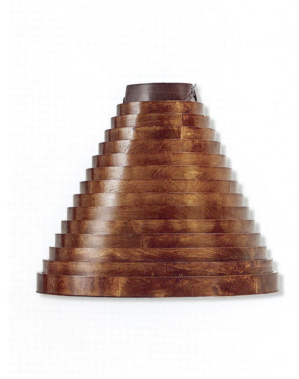

↑ Table Skirt, Hussein Chalayan

« MY INTEREST IN FASHION CAME FROM MY INTEREST IN THE BODY AS A CENTRAL CULTURAL FIGURE. »

HUSSEIN CHALAYAN

### STYLISH LIVING ROOM
In February 2000, Hussein Chalayan designs a spectacular runway show performance. Four models enter a living room furnished with a coffee table, four chairs, and a television. They are wearing plain gray ensembles. They approach the chairs, remove the covers, and, with a skillful play of pressure, pose the covers on their bodies, transforming them into elaborate geometric outfits.

### SHORT FILM
In 2005, Hussein Chalayan represents Turkey during the Venice Biennale. For the occasion, he creates a video featuring Tilda Swinton as a scientist taking DNA samples from people's clothes to decode their lives and activities, evoking the sacred link between our clothes and ourselves.

### OUTSIDE THE BOX
Chalayan is known for his unique runway shows.
**1998 :** Six women wearing chadors of various lengths, to the point of complete nudity.
**2000 :** A memorable motorized dress is transformed into an airplane cabin.
**2007 :** Dresses transform into and tell the sped-up story of the history of fashion.
**2009 :** Latex dresses represent aerodynamic motion.
**2011 :** A robotic dress drops small crystals that evoke pollen.
**2016 :** Dresses on the runway dissolve when exposed to water.

### TRANSFORMATION GAME
The fascinating and playful exercise takes a new turn, and a message comes to light. Assistants fold the chairs, and they become suitcases that are given to each model. A last woman, wearing a minimalist dress, appears and walks towards the coffee table. She places herself in the center before lifting it up and revealing connecting circular bands of wood. The table is a skirt.

### FASHION AS A METAPHOR
This message is political. The performance is not a creative pretext; it uses the transportable furniture as a metaphor for the circumstances of immigrants and war refugees. It's a personal subject because the designer's family fled the Turkish-Cypriot conflict. He is asking a simple question: what remains when we must leave everything behind?

### HOUSE OF CLOTHING
He sees clothes as a refuge, as demonstrated by the familiar objects that his models wear. He also interrogates the domestic space and its link with the exterior, especially in women's lives. This table skirt is the home that we never really leave behind.

# DELPHOS GOWN
## FEMMES FATALES

| | |
|---|---|
| DESIGNER | MARIANO FORTUNY *(p. 353)* |
| DATE | 1906 |

Of Spanish origin, Mariano Fortuny y Madrazo lives in Venice in the early 20th century, where he creates paintings, décors, engravings, and practices photography. In 1906, he moves on to clothing and textiles that he designs in the manner of an artist.

### ONE OF A KIND

Mariano Fortuny is soon noticed for his shawls and artisanal dresses that borrow from history and his own aesthetic style. The artist's creations are rare and thus very desirable. His most emblematic achievement is the Delphos gown, which alludes to a famous classical Greek sculpture, the Charioteer of Delphi.

### FREEDOM?

There is a nascent desire to emancipate women's bodies. The Belle Époque silhouette pushed physical constraints to the extreme with tyrannical corsets creating absurd curves. The simplicity of classical tunics serves a desire for change. Excessive bodily transformations are left behind in favor of more comfort and natural shapes.

### DANCE AS INSPIRATION

Artists like Loïe Fuller and Isadora Duncan abandon the tutu and move towards neoclassical tunics that accompany a more relaxed gestural style. In Paris, designer Paul Poiret notices these liberated dancers in the same way that he appreciates the aesthetic of the Ballets Russes. Fortuny will bring classical Greece and the East closer together, or rather, he will remind us that the two have always been linked.

### IRREVERENT LIGHT

The silk pleats of the Delphos gown create exquisite light effects. They evoke the Venetian Lagoon, as do the delicate Murano glass beads that adorn its clasps. The gown represents Fortuny's artistic touch. Above all, the Delphos gown is irreverently erotic. It is worn without a corset or undergarments. Audacious, considering that it is semi-transparent.

↑ **Delphos Gown**, Mariano Fortuny

### FOR THE BOLD

Wearing a Delphos gown requires aplomb. In a society that still locks women in shackles, only the most liberated try it – bohemian souls, artists like Sarah Bernhardt, but also brazen millionaires like Peggy Guggenheim. Fashion doesn't entirely liberate women, but Fortuny offers them a hint of freedom.

### ICONIC CREATIONS

The essayist Susan Sontag chooses to be buried in a Delphos dress. Her companion, the photographer Annie Leibovitz, photographs her on the day of her burial.

### MODERN PLEATS

In 1993, Issey Miyake launches « Pleats Please », a collection of tubular garments with fine pleats, after having presented his first pleated silhouettes in 1989. Even if, to this day, Mariano Fortuny's exact pleating technique is unknown, Miyake's pleats demonstrate the same desire to link comfort and elegance through geometry and lightness. Miyake brings Fortuny's craft into the world of technology.

# MEME DRESS
## HASHTAG

| DESIGNER | VIKTOR & ROLF *(p. 362)* |
| --- | --- |
| DATE | 2019 |

Our clothing choices are said to carry messages, whether subtle or vivid. Designers use their collections to distill their reflections about the world. The duo Viktor & Rolf turn their shows into performances with highbrow concepts to make a point, sometimes in a very literal way.

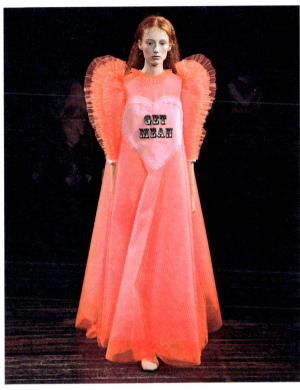

↑ Viktor & Rolf Spring/Summer 2019 show, Paris

### ALL-POWERUL MEME
Memes are everywhere on social media. These humoristic images and words are shot back and forth all day long. They have become a form of dialogue in their own right, quickly recuperated by marketing strategies. The meme is the deviation of an existing visual language, and fashion doesn't escape it. Indeed, Viktor & Rolf prefer to anticipate it.

### PRINCESS DRESSES
Eighteen tulle gowns parade down the catwalk in the Spring/Summer 2019 show. Colorful and voluminous, they evoke frilly prom dresses. They evoke the tackiness of those who want to go over the top. The dresses are embellished with graphic messages such as « no photos please » and « freedom » accompanied by emoji motifs.

### WORDS OF STYLE
On the Internet, those who speak loudest will be heard. Viktor & Rolf understand this phenomenon and how it reveals our narcissistic flaws. The gowns are affirmations – the collection is called « Fashion Statements ». Their three-dimensionality is juxtaposed with the flatness of their words to highlight their banality. The sour candy aesthetic contrasts with the sometimes aggressive messages.

### SWIRLING
The fashion industry moves at a frenetic rhythm, even beyond brands of fast fashion that sometimes renew their collections daily. The luxury industry is not immune; it is forever and always offering new objects. There are biannual fashion shows, pre-collections, capsule collections, resort shows offering summer styles in the middle of winter, collaborations, exclusive models... an eternal infernal spiral to satisfy every passing whim.

### NEVER ENOUGH
In 1999, Viktor & Rolf present a show that becomes legendary. Model Maggie Rizer, embodying a Russian Doll, is initially clad in a jute minidress. The young woman, standing on a rotating platform, is gradually dressed by the design duo in a dozen or so pieces inspired by refined historical forms until she is nothing but a mass of textile, only her head visible. The collection, called « Russian Doll », denounces the vicious circle of fashion production and over-consumption.

« FOR US, THE CLOTHES ARE JUST A PERFORMANCE, THE SHOW IS THE REAL WORK. »

VIKTOR & ROLF

### LIFE ONSCREEN
Viktor & Rolf respond to absurdity with irony and technical mastery. They celebrate the art of dazzling couture and criticize the trend of devouring things in two-dimensional formats via images frenetically exchanged on social media. We don't admire anymore; we scroll. We don't observe; we react. These meme dresses push boundaries... even at the risk of going too far.

*Next page :*
Viktor & Rolf Spring/Summer 2019 show, Paris

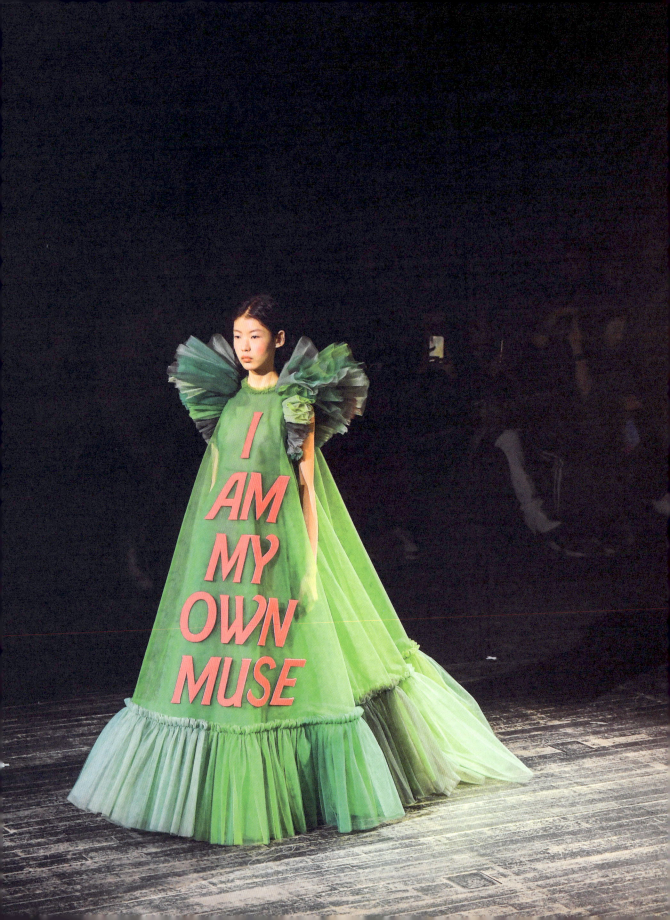

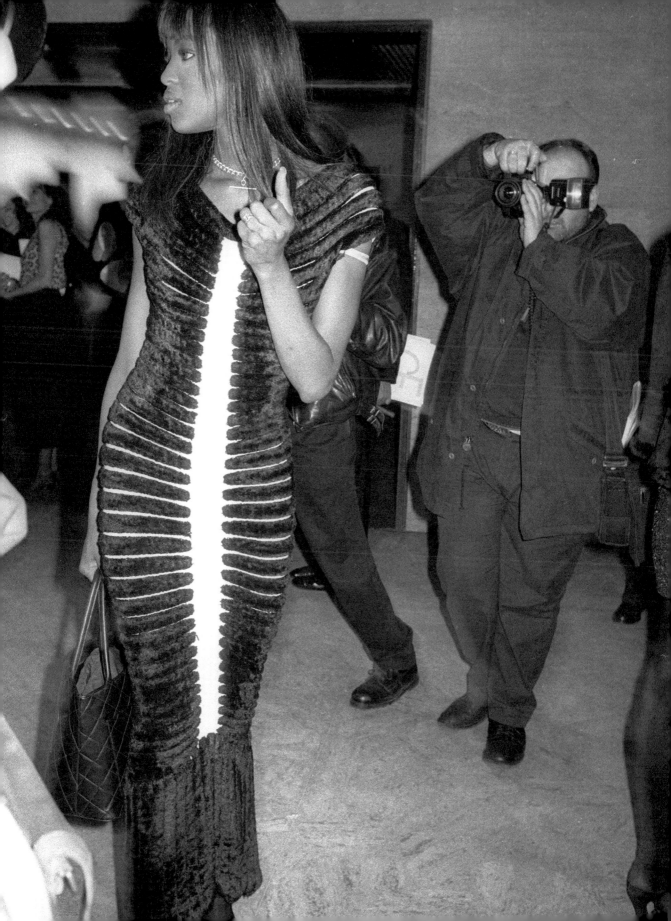

# BANDAGE DRESS
## SECOND SKIN

| | |
|---|---|
| DESIGNER | AZZEDINE ALAÏA (p. 350) |
| DATE | 1990 |

Growing up in Tunisia, Azzedine Alaïa studies sculpture. He arrives in Paris in 1950 and becomes a self-taught fashion designer for a wealthy and demanding clientele. He examines bodies to better reveal them; cut and fabric are central to his work.

↑ *The Mermaid Dress*, Azzedine Alaïa, 1994

« I HAVE NEVER FOLLOWED FASHION. IT'S WOMEN WHO HAVE DICTATED MY CONDUCT. I'VE NEVER THOUGHT OF ANYONE BUT THEM BECAUSE I AM CONVINCED THAT THEY HAVE MORE TALENT THAN ANY STYLIST. »

AZZEDINE ALAÏA

### 1980s : CONSECRATION

In a decade that glorifies the body, sometimes to the extreme, he plays the game in his own way. While the period reduces the body to a material object, he transforms it into a subject of study. Fascinated by its curves, lines, and folds, he accompanies it, sometimes even chaperones it, always letting it have the last word. Azzedine Alaïa's designs don't outline the exoskeleton; they melt into a second skin.

### TRUE WOMEN

Collaborating with Azzedine Alaïa, Peter Lindbergh brings his realist style, fed with expressionism, dance, and the social documentation style of August Sander, to accompany the pared-down and sensual look of the designer. In his portraits, strong, real women wearing little makeup, sometimes with dark circles under their eyes, are his subjects, not his objects.

### A PERSONAL VOCABULARY

Jersey, cut on the bias, zippers, leather… the designer uses diverse textures and materials with unparalleled technical skill to define his timeless silhouettes. Working directly on the bodies of his models and clients, he captures the science of shapes, channeling the work of master technicians like Cristóbal Balenciaga and Madeleine Vionnet.

### THE ESSENTIAL BODY

The body makes the dress come alive. By moving, by breathing, she who wears it transforms it: the slits open or close, pulsing at her rhythm. Skintight, the dress could imprison, but it liberates instead. It doesn't constrain; it breathes.

### MUSEUM QUALITY

Azzedine Alaïa participates in the recognition of those who revolutionized fashion by collecting their work. He has pieces by Cristóbal Balenciaga, Madeleine Vionnet, and Madame Grès. He also collects American creations by designers like Adrian and Charles James, as well as contemporary designs by Yohji Yamamoto and Rei Kawakubo. His foundation conserves hundreds of garments, drawings, photographs, and fabrics.

### THE BIRTH OF A DRESS

The mermaid dress is born in 1990. Inspired by mummies, it is lacerated like a Lucio Fontana work. The body is all-powerful, sometimes concealed, sometimes revealed. By slashing the fabric, Alaïa brings a new dimension: nothing becomes something–exposed flesh that is never indecent.

*Previous page :*
**Naomi Campbell**, *Lincoln Center*, New York, 1994

# BIRTH OF VENUS
## FEMMES FATALES

| DESIGNER | THIERRY MUGLER *(p. 358)* |
|---|---|
| DATE | 1995 |

At the end of the 1970s, fluid, androgynous, and sometimes bohemian shapes are in vogue – a style at odds with that of Thierry Mugler. The French designer chooses instead to accentuate, even exaggerate, shapes. He makes women the subject of his spectacular reflections.

↑ **Sheath Dress**, Thierry Mugler, 1986.

### LEGENDARY DESIGNS

**1984 :** The Madonna
**1988 :** The She Devil
**1989 :** The Mermaid
**1992 :** The Motorcycle Bustier
**1995 :** The Robot
**1997 :** The Insect Woman
**1997 :** The Rubber « Tire » Suit
**1997 :** The Chimera

### GRANDIOSE

In March 1984, Thierry Mugler is the first designer to organize a runway show open to the public. The show, at the Zenith in Paris, is worthy of a Hollywood blockbuster: 2,000 invited guests and 4,000 spectators. The public discovers 55 models presenting over 200 designs. The runway becomes a stage for the designer who theatricalizes, to excess, his silhouettes of anthropomorphic creatures, angels, and pop heroines. When Pat Cleveland descends from the starry ceiling, the audience is dazzled.

### A FLAIR FOR THE SPECTACULAR

After his grandiose presentation at the Zenith in 1984, Thierry Mugler offers a sensational show at the Cirque d'Hiver to celebrate 20 years of the brand. The designer, part of the closed circle of Parisian couture since 1992, presents his Fall/Winter 1995 collection.

### HYPER MODELS

He reiterates his creative codes: eroticism, subversion, fetishism, and futurism. The Mugler models are feminine stereotypes, archetypes that he pushes to their extremes by imagining hybrid creatures that flirt with cinema, comic books, and science-fiction.

### POWERFUL BODIES

With structured hips and waists shaped by corsets, the designer seems to present a reductive vision of submissive femininity. Yet, that's the opposite of what he offers because these women, sculpted to the extreme, do it for themselves. They are wearing armor that makes them powerful and unattainable, masters of their own bodies.

### THE BIRTH OF A WOMAN

Working girls, goddesses, and cyborg women all saunter down the runway at the Cirque d'Hiver in Paris. And among these heroines walks a woman wrapped in a black sheath dress fanning open like a pink satin shell, revealing a blush-colored corset under a shower of rhinestones. The model Simonetta Gianfelici emerges, adorned in pearls and gloves, both fantastical and refined. Mugler is inspired by *The Birth of Venus* by Sandro Botticelli. But his Venus knows what she wants. She is not naïve; she is self-assured. It's not birth, it's self-realization.

### TRIBUTES AND COLLABORATIONS

Thierry Mugler has been experiencing a renaissance since the 2010s, especially among American R&B singers and hip-hop artists. In 2008, his return is marked by his collaboration with Beyoncé. His past creations, brought up to date, are also popular. In 2019, rapper Cardi B chooses three silhouettes from 1995, including the Venus dress, for the Grammy Awards.

*Next page :*
Thierry Mugler Fall/Winter 1995 show, Paris

# OPTICAL ILLUSION HAT
## KIDDING ASIDE

| DESIGNER | ELSA SCHIAPARELLI *(p. 360)* |
| --- | --- |
| DATE | 1937 |

Optical illusions are at the heart of Elsa Schiaparelli's story. They launch the career of the Italian designer when she makes knit sweaters with ribbon and collar motifs, bringing a playful new vocabulary to Parisian fashion.

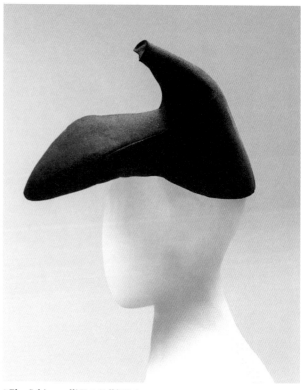

↑ Elsa Schiaparelli Hat, Fall/Winter, 1937

« IN DIFFICULT TIMES, FASHION IS ALWAYS OUTRAGEOUS. »

ELSA SCHIAPARELLI

### STORYTIME

It is the very end of the 1920s, and a new woman is replacing the flapper (p. 320). She is more glamorous, more slender, more subtle. Subtlety, however, does not appeal to Elsa Schiaparelli; she prefers playfulness, provocation, and decoration. Her designs tell stories and veer into absurdist territory. They are buttons in the shape of trapeze artists, necklaces teeming with insects, and gloves with painted nails.

### ARTIST FRIENDS

When the designer spends time with the surrealists, she observes their artistic jousting and fantastical universes. Why shouldn't she do the same? Schiaparelli introduces a new explosive language into Parisian couture, a language until then kept at a distance: that of humor. We are not supposed to laugh at fashion. But the designer defies these conventions because they ignore what's at stake during a decade seeking a way to palliate political and social malaise through irony. Elsa Schiaparelli celebrates levity, not through insouciance but through conscience.

### SALVADOR DALI

Schiaparelli dreams up surprising collaborations with the surrealists. She invites Jean Cocteau, Meret Oppenheim, and Leonor Fini to create pieces, accessories, cosmetic objects, and jewelry for her. But the artist she works with most is Salvador Dalí. Together, they design wild, sometimes scandalous garments, like the lobster dress, with obvious erotic connotations that do not go unnoticed, especially when worn in *Vogue* by Wallis Simpson.

### THE BIRTH OF A HAT

Salvador Dalí is on vacation with his companion, Gala. She photographs the artist with a woman's shoe resting on his head. The idea amuses Elsa Schiaparelli, and she creates a hat in the form of a high-heeled shoe. The accessory is presented during her Fall/Winter 1937 show and is a massive success. Despite the extravagance of its shape, it is nonetheless meant to be an elegant piece. The holiday memory becomes a mischievous object, in keeping with the designer's style.

### SHOCKING

Elsa Schiaparelli's shoe hat is presented in two versions. One is all black; the other is embellished with a pink heel. It's a bold fuchsia pink, unique to the designer – she launches the color in 1937. It is called « shocking pink », and it has been her signature ever since the creation of her perfume of the same name.

*Previous page:*
**Model wearing an Elsa Schiaparelli hat,** designed with Salvador Dalí, 1937

# BUTTONS AND HEARTS
## LOVE NOT HATE

| | |
|---|---|
| DESIGNER | PATRICK KELLY *(p. 356)* |
| DATE | 1980s |

Being born a black man in the segregated American South informs Patrick Kelly's creative process. Everything in his work breathes reparations. He calls for love, not hate, and reappropriates an otherwise deprecatory Black American iconography. The designer pays homage to his community without clichés.

↑ **Button Dress**, Patrick Kelly, Fall/Winter, 1986-1987

### « I WANT MY CLOTHES TO MAKE YOU SMILE. »
PATRICK KELLY

### PARIS CALLS
Discriminated against in his native country, Patrick Kelly moves to Paris in 1979, finally making his mark in the mid-1980s, supported by Victoire boutiques and *Elle* magazine. Very soon, he establishes his signature style of body-hugging minidresses decorated with colorful ornaments: buttons, hearts, ribbons, and joyful, charming motifs. The silhouettes echo the identity of his exuberant and euphoric brand.

### MAJOR
In 1988, Patrick Kelly is the first American designer to be inducted into the Chambre Syndicale du Prêt-à-Porter des Couturiers et des Créateurs de Mode.

### FIGHT BACK WITH HUMOR
Humor is a hallmark of 1980s fashion, which is also materialist, carefree, and excessive. Patrick Kelly finds his place with ease. But his affability and his references to the surrealism of Elsa Schiaparelli (p. 236) shouldn't overshadow the messages the designer distills. From his banana skirt in homage to Josephine Baker to the logo of his brand in the shape of a golliwog (a Black doll with wild frizzy hair) to his watermelon hat, he reappropriates a racist iconography as if to neutralize its harmfulness.

### BUTTONS EVERYWHERE
By putting them on his designs, Patrick Kelly honors the memory of his grandmother who, lacking means, used colorful mismatched buttons to mend her children's clothes. When these buttons form a heart, the designer expresses his love to his grandmother and all the Black women whose church outfits he admired every Sunday, these women who are excluded from fashion's language, history, and business.

### LOVE ALWAYS
Patrick Kelly designs hearts not out of candor or denial but because he knows that responding to hate with hate is pointless. Because fashion is a party, and when we are invited into its closed inner circle, it's preferable to spread love.

### HISTORIC
In 1958, Eunice Walker Johnson and John H. Johnson, founders of *Ebony* magazine, create the Ebony Fashion Fair. The particularity of these runway shows? They only present Black models and are addressed to a Black clientele, otherwise forgotten by brands. These innovative shows are new in their discourse and also in their contemporary staging. They steadily influence the fashion industry and define a different relationship between fashion and Black Americans.

# JOYFUL FASHION
## FLOWER POWER

**DESIGNER** ................................................. KENZO TAKADA *(p. 362)*

**DATE** ................................................................... 1970s-1980s

Upon arriving in France in 1965, Kenzo Takada sells his designs to the couturier Louis Féraud, department stores, and prêt-à-porter brands. He sets up a small boutique in the Galerie Vivienne in Paris, repaints it in a style reminiscent of Le Douanier Rousseau, and calls it Jungle Jap.

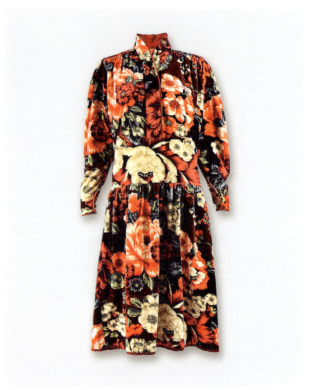

↑ *Floral Print Velvet Dress*, Kenzo, 1970

### GAIETY

On September 14, 1977, Kenzo Takada presents his Parisian collection at Studio 54 in New York. Open for only a few months, it's already a temple of the night for exuberant crowds. The designer, whose style is a call to levity and insouciance and who loves to organize playful runway shows, finds the perfect setting for his delightful silhouettes at the nightclub. During a musical interlude by the sculptural Grace Jones, the models dance and play with balloons.

### PRETTY GUTSY

The Japanese designer shows his work to fashion editors. And the silhouettes attract the attention of *Elle* magazine journalists, who attentively observe what this creative dreamer has to offer. In 1970, he presents his first collection, based on a misunderstanding, or rather on unfamiliarity. Little aware of fashion customs, he doesn't align with the seasons: he presents summer in summer and winter in winter. It makes aesthetic sense, but not commercial. It doesn't matter, though, because the dawning decade has liberty as its credo. Who needs conventions?

### BLENDING STYLES

Joyful floral motifs populate his silhouettes. Lightness also, inspired by the Japanese yukata. Kenzo Takada effortlessly blends traditional Japanese forms and Western codes. Kimono sleeves (p. 148) are mixed with micro-shorts; a rustic aesthetic meets bright multicolored urban motifs. He privileges volume and comfort, bringing hippie style (p. 326) out from the margins.

### FLORAL STYLE

Jungle Jap becomes Kenzo. Floral patches based on Japanese art become one of the designer's trademarks. They decorate his signature cotton quilted jackets, patchwork purses, and bucolic dresses that borrow from folklore.

### MELTING-POT

Because Kenzo Takada sees himself as a citizen of the world, he borrows from all cultures, from Africa to Japan, passing through the steppes of Mongolia. He makes gaiety his brand with dancing, jovial runway shows. He expresses the joy in curiosity about others and in blurring boundaries and borders.

> **WHEN ASKED ONCE WHY HE DIDN'T DESIGN TIGHT, SEXY CLOTHES, HE ANSWERED: « I CAN'T, I AM TOO SHY. »**
>
> KENZO TAKADA

### GIGANTIC

In Tokyo in 1975, Kenzo Takada organizes the biggest runway show in the world. For two days, 18,000 people discover his designs.

*Page 240 :*
**Kenzo Takada and two models,** prêt-à-porter Fall/Winter 1973 collection

# SAFARI JACKET
## WILD WORLD

**DESIGNER** ................ YVES SAINT LAURENT *(p. 360)*
**DATE** ................ 1967

In the late 19th century, British colonizers begin wearing safari jackets while hunting on Indian and African lands. The garment quickly becomes a symbol of heroic and imperialist virility that extends all the way to the United States in the 1940s.

↑ Safari Jacket, Yves Saint Laurent

### A MODEL FOR WOMEN

In 1967, Yves Saint Laurent introduces the safari jacket in his haute couture collection « Bambara » intended for women. The collection's version is close to the original.

### SCANDAL

On January 21, 1971, Saint Laurent presents his haute couture Spring/Summer collection. The discomfort is immediate; the concept is too provocative. Saint Laurent uses the somber years of the occupation as his inspiration. The reason? His friend Paloma Picasso's retro allure – she dresses in flea market finds. The public recognizes the bric-a-brac silhouettes of the war years, and it awakens terrible memories. The press finds the collection « hideous », but young people are enchanted, and the trend of wearing vintage clothing develops.

### LOW-CUT ALLURE

However, it's a later, more unique version that finds success. In 1968, for *Vogue Paris*, Saint Laurent revisits the safari jacket, this time with a laced-up plunging neckline, worn by a feline, sensual Verushka, photographed by Franco Rubartelli. The jacket is a hit and goes on sale the following year.

### AFRICAN INSPIRATION

The designer borrows from the masculine wardrobe to renew the feminine and emancipate women. This stylistic conquest conceals a cultural context that is difficult to ignore. The collection that launches the safari jacket presents silhouettes inspired by the Bambara people of Mali. Raffia dresses, shells, and architectural hairstyles (worn by white models) clash with this imperious safari jacket.

> « I'VE MOSTLY BEEN AN IMMOBILE TRAVELLER, WHICH HAS ALLOWED MY IMAGINATION TO DEVELOP. »
>
> YVES SAINT LAURENT

### TWINS

One night, at Parisian nightclub Régine, Saint Laurent observes a young blonde woman, thin and androgynous, on the dance floor. It's Betty Catroux. He sees his feminine double, and she becomes his muse.

### CULTURAL IMPERIALISM

The safari jacket is born of domination, and its presence in this collection maintains its conquering posture. The runway show is the reflection of a fantasized Africa compared to a civilized West: the African garments undress, the safari jacket dresses. The intention of Yves Saint Laurent isn't racist. But his designs reflect the imperialist vision inscribed in Western culture. At the same time in 1967, in Mali, Malick Sidibé photographs young people in bell-bottoms (p. 326) and miniskirts (p. 161), dancing the twist and riding scooters. This Africa also deserves to be seen.

*Page 241 :*
Betty Catroux, Yves Saint Laurent and Loulou de la Falaise, 1969

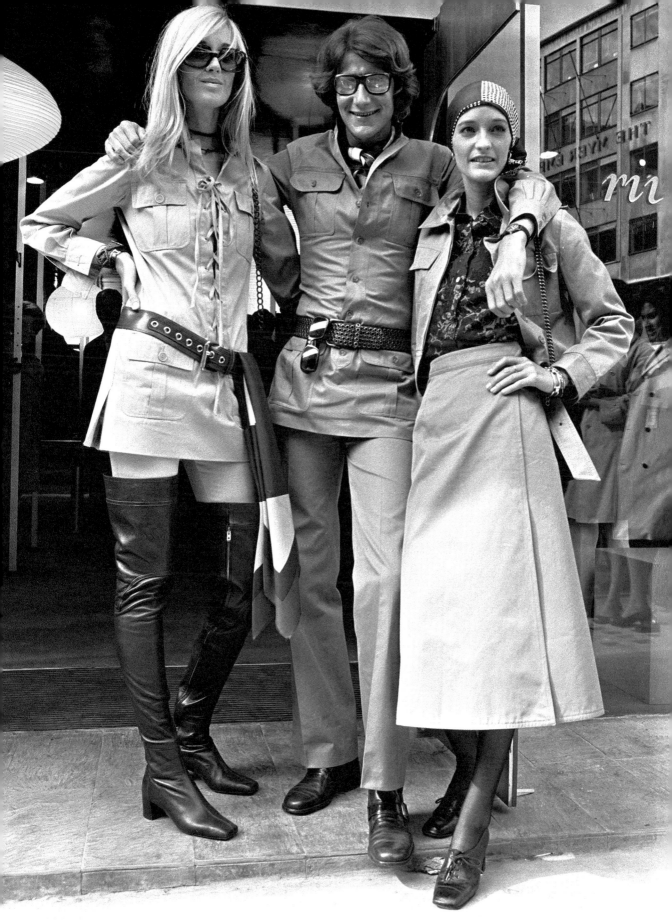

# SLIM SILHOUETTE
## A NEW MAN

| DESIGNER | HEDI SLIMANE *(p. 361)* |
| --- | --- |
| DATE | 2000s |

In 2000, creative direction of Dior Homme is entrusted to Hedi Slimane. The designer's style pays homage to the avant-garde. From runway show soundtracks to the garments and the ad campaigns, he brings a rock-and-roll identity to silhouettes that redefine masculinity.

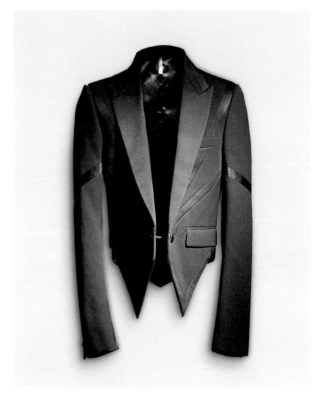

↑ Strip Collection Jacket, Dior, 2004

> « I'D LIKE MEN TO THINK ABOUT EVOLVING INTO SOMETHING MORE SOPHISTICATED, MORE SEDUCTIVE. TO EXPLORE THE POSSIBILITY OF AN ENTIRELY NEW MASCULINITY. »
>
> HEDI SLIMANE

### MEN'S BODIES

Hedi Slimane blends his 1960s and 1970s rock influences with inspiration from the new underground generation. An accomplished photographer, he documents and absorbs the styles of this rebellious youth to better transpose them into his creations. At the end of the 1990s, while he is already being noticed at Yves Saint Laurent, Hedi Slimane offers a new vision of men's fashion, and especially of men's bodies.

### INFLUENTIAL

Hedi Slimane's style has a considerable impact on contemporary fashion. It defines a whole new iconography and way of thinking about the masculine wardrobe, as much in luxury houses as in prêt-à-porter. Hedi prompts contemporary conversations about notions of gender in clothing design.

### VIRILITES

Masculinity is interrogated throughout the decade. Helmut Lang and Raf Simmons also feel the need to renew men's stylistic identity. Because more generally, the 1990s are marked by an exaggerated masculinity, sometimes conspicuous, as with Versace (p. 198), and sometimes banal, as in the case of sportswear. Hedi Slimane offers a new minimalistic, androgynous vision.

### VIRTUOSO FASHION

In his work, he applies haute couture techniques, which value cut, details, and materials, without leaning into excess. His silhouettes are sober, very sharp, and slender. By popularizing a new allure, he offers the possibility of another masculinity during an era otherwise imposing a very narrow vision.

### MASCULINE FANTASY

The version of the body drawn by the designer is nonetheless just as idealized and pernicious: young, slender, fragile. But it's a success because it transforms men's fashion, and more importantly, it transcends it. Previously a little neglected, it benefits from a renewed interest. Hedi Slimane makes the male wardrobe commercial, desirable, and cultural.

### MOTIVATED

Karl Lagerfeld says it himself: upon discovering Hedi Slimane's collection for Dior Homme, he decides to go on a drastic diet and lose 40 pounds in order to be able to wear the designer's ultraslim suits.

# PORNO CHIC
## SEX AND DECADENCE

**DESIGNER** ................................. TOM FORD FOR GUCCI *(p. 353)*
**DATE** ........................................ 1990s-2000s

In 1990, Gucci names Tom Ford as creative director of the house. Under the American designer's influence, the luxury accessories brand becomes the label everyone is talking about. Tom Ford infuses his creations with an aesthetic, or rather an atmosphere, borrowed from 1970s disco styles.

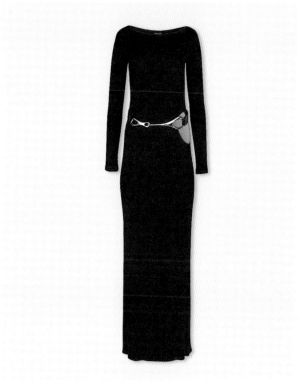

↑ Tom Ford Dress for Gucci, 1996

### « WHEN SEX GOES OUT OF BUSINESS, SO DO WE. »
TOM FORD

### SEX SELLS

Tom Ford retains a carefree and sensual state of mind from the disco years. The secret of the designer's success is that he adds sex into all of Gucci's vocabulary, from ads to clothes. Hedonism, glamour, and minimalism are the key words of his collections. Because Tom Ford sells sex, yes, but he does it with style. When his models parade around, mascara dripping, hair wet, skin glistening with sweat, he is telling the story of debauchery, but debauchery in a silk shirt and velvet pants.

### TRIPLE SHOCK

He creates porno chic. Or, more specifically, together with muse and consultant Carine Roitfeld and photographer Mario Testino, he revives an aesthetic reminiscent of the decadent photographs of the 1970s, created by Helmut Newton and Chris von Wangenheim. The campaigns imagined by the trio show embracing couples and reveal pubic hair shaped in the form of a « G ». Detractors are scandalized and denounce the objectification of women, while others praise the assumed sexuality.

### CHIEF EDITOR

In 2001, Tom Ford's partner in defining the iconography of porno chic is named chief editor of *Vogue Paris*. For ten years, Carine Roitfeld's regard for irreverence and liberty constructs the identity of the French magazine, distinguishing it from its colossal American cousin. The advent of blogs and street-style photographs make the editor famous. She becomes as legendary as the magazine.

### SENSUAL STYLE

While his images flirt with indecency, Tom Ford's designs are more subtle. He prefers to play with shirts (p. 166) that are a little too unbuttoned, low-waisted pants, straps that slip off the shoulder, and especially with sensuous fabrics that cling to the skin. For his Spring/Summer 1997 collection, he transgresses luxury codes and offers thong underwear with a Gucci logo.

### PROPHETIC TASTE

Tom Ford dares to push the limits, and it works. Gucci sales explode, and porno chic thrives. Above all, he anticipates the narcissistic and voyeuristic 2000s.

*Next page:*
**Kate Moss,** Gucci 1997 Spring/Summer show

# EDGY EMBROIDERY
## MAKE-BELIEVE

| | |
|---|---|
| **DESIGNER** | OLIVIER ROUSTEING FOR BALMAIN (p. 360) |
| **DATE** | 2012 |

In 2011, having worked there since 2009, Olivier Rousteing becomes Balmain's creative director at only 25 years old. He understands the signature of the brand founded in 1945 by Pierre Balmain: the art of cut, refined details, and youthful freshness.

↑ Dress, Balmain, Fall/Winter 2012

« FOR ME, A STRONG WOMAN WITH FULL-ON EMBROIDERY IS NOT AN OBJECT OR A TROPHY WIFE. SHE'S A WOMAN WEARING ARMOR. »

OLIVIER ROUSTEING

### NEW GLAMOUR
Olivier Rousteing shakes up nostalgia. Never renouncing the fundamentals of the Balmain house, he infuses his personal touch and mastery of contemporary societal codes. His taste for pop culture and those who compose it connects him with celebrities. His sexy and glamorous style corresponds to a new influential generation seeking glitz in their glamour.

### GUEST STARS
In 2021, for his 10 years as creative director at Balmain, Olivier Rousteing organizes a memorable runway show and invites the big names of 1990s modeling to present the key pieces of his career. Carla Bruni, Naomi Campbell, Karen Elson, and Milla Jovovich also make surprise appearances. .

### POWERFUL WOMEN
As the first Black creative director of a Parisian couture house, Olivier Rousteing cleverly tells the story of his struggles as a Black man, like when he pays homage to Egypt in 2018 by transforming Beyoncé into a pop Nefertiti at Coachella because the Egyptian queen had become symbolic for Black American women. Rousteing knows that behind the sparkle, there is inevitable social discourse.

### NEW GENERATION
Above all, he refuses the snobbery of those who denigrate social media. He courts influencers and reality TV stars like the Kardashian sisters because there is no hierarchy in his eyes. These new celebrities incarnate his generation, and they set the trends. It would be hypocritical to ignore them.

### THE BALMAIN ARMY
In 2012, he delivers his definition of femininity: androgynous and sensual at the same time. He pays tribute to Balmain by placing delicate, virtuosic pearl embroideries on his silhouettes. Many pieces have strong shoulders that are almost geometric. His models are nicknamed the « Balmain army ». Olivier Rousteing creates a battalion of women who may look like trophy wives, but who reveal themselves to be formidable businesswomen. This dichotomy echoes his designs, which are graceful and dominant at the same time.

### THE SUPERS
Before influencers, there were supermodels. The 1990 cover of British *Vogue* is considered the starting point of the phenomenon. Peter Lindbergh's photograph of Naomi Campbell, Christy Turlington, Linda Evangelista, Cindy Crawford, and Tatjana Patitz earns them the nickname the « Big Five ». Claudia Schiffer soon replaces Tatjana Patitz in the group.

*Previous page:*
Balmain, Fall/Winter 2010-2011 runway show

# ANGKOR DRESS
## ONE-WOMAN SHOW

DESIGNER .................. KARL LAGERFELD FOR CHLOÉ *(p. 357)*

DATE .................................................. 1983

In 1952, Gaby Aghion founds the brand Chloé. She aims to offer a modern and emancipatory style, liberated from the confines of high fashion. Her silhouettes are simplified, insouciant, and cosmopolitan. Because she isn't a designer, she surrounds herself with stylists with a similar vision.

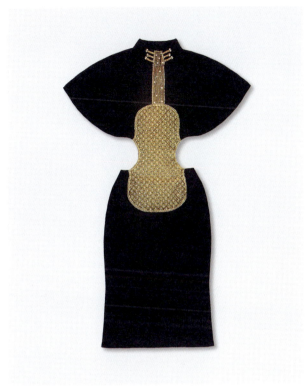

↑ *Angkor Dress*, Karl Lagerfeld for Chloé, 1983

### INTO THE SPOTLIGHT

The profession of stylist is unheard of in the fashion industry until her arrival. The postwar era and the 1970s belong to her. Previously anonymous independent workers for an endlessly developing industry, stylists are finally revealed to the general public as a new kind of designer who dictates a look more than a line. Karl Lagerfeld is one hybrid example, half-stylist, half-designer, who learned his trade at the big fashion houses.

### FROM CLÉO TO CHLOÉ

In 1900, Paris's Belle Epoque muse plays the role of exotic dancer. Responding to an Eastern fantasy, Cléo de Mérode dresses as a Cambodian divinity, inspired by bas-relief sculptures of the Angkor temples. Could Karl Lagerfeld have found inspiration for his violin dress in this bewitching artist, whose name is close to that of the brand for which he works?

### EVERYTHING FOR MUSIC

In 1964, Lagerfeld debuts at Chloé. He stays for over 20 years as a jack-of-all-trades, and also works at Fendi until moving to Chanel in 1983. That year, for his Spring/Summer collection at Chloé, he creates a show inspired by music. The show is well suited to this new decade that loves to dance the night away in fashionable nightclubs. It also lends itself to the joyful, twirling spirit of the brand's presentations.

### SURREALIST DRESS

That's when his optical illusion dress appears. From the back, it looks like a bolero with a strict black skirt. However, the front reveals a flashy, gold, embroidered violin. The dress is worn with ostentatious cuffs. Impossible not to see a wink to Man Ray's *Violon d'Ingres*, an ironic take on the concept of the woman as object. It isn't surprising: surrealism holds a preponderant place in the work of Lagerfeld at Chloé.

« I HAVE AN INNATE GIFT FOR RECOGNIZING TALENT IN OTHER PEOPLE. »

GABY AGHION

### SURREALIST FASHION

Art and culture are at the heart of the brand's DNA. Humor too, especially under Karl Lagerfeld, who doesn't hesitate to offer a flurry of surprising dress-objects.

**1979** : fan bag
**1983** : scissor dress
**1983** : mist dress with embroidered shower spray pattern
**1984** : hanger dress
**1995** : bulb dress
**2001** : pineapple panties
**2001** : bananas T-shirt

### MYSTERIOUS CITATION

But why Angkor? What is the link between this eye-catching violin and the Cambodian archeological site? The music of the country is said to have developed in the 7$^{th}$ century in that very location. It's a clue that speaks volumes about Karl Lagerfeld's erudition.

# KELLY BAG
## GRANDE DAME

**DESIGNER** ................ HERMÈS
**DATE** ................ 1956

In 1837, Thierry Hermès founds an equestrian equipment workshop. At the turn of the century, the company's mastery of leather leads to the development of leather goods that respond to the rising popularity of travel. The first bag is the « Haut à Courroies », meant for transporting saddles and riding boots.

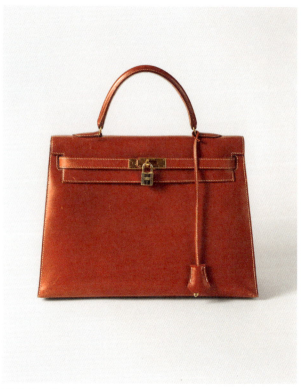

↑ Kelly Bag, Hermès

« LUXURY IS RARITY, CREATIVITY, ELEGANCE. »

PIERRE CARDIN

### IN KEEPING WITH THE TIMES

In the 1930s, Robert Dumas, Émile Hermès's son-in-law, offers a feminine version of the bag, a « petit sac pour dame à courroies » (small bag for ladies with straps): trapezoidal, with straps that close with a lock. There are studs on the underside, raising it slightly to prevent the leather from wearing out. The bag's geometric lines fit into the strict, minimalist aesthetic of the 1930s.

### JUMPING AHEAD

The bag is honored in the late 1950s when the actress Grace Kelly is photographed in Philadelphia carrying the handbag. She is accompanied by Rainier III, Prince of Monaco, whom she is about to marry. Legend has it that she used the bag to hide her early pregnancy.

### DREAM YOURSELF A PRINCESS

It is a false myth but also an advertisement. Women the world over are taken by this fairy tale: a beautiful Hollywood actress becomes a princess. Hermès pays homage and renames the bag. The Kelly becomes the symbol of storybook romanticism.

### DESIRABLE OBJECT

In 1981, during an airplane trip, Jane Birkin meets the president of the brand, Jean-Louis Dumas, who offers to redesign a chic, functional bag. The Birkin, soft, spacious, with two handles, pays homage to this impromptu meeting and is sold beginning in 1984. In the late 1990s, it becomes a true luxury phenomenon.

### LADY'S BAG?

It's a refined, ascetic bag carried politely by hand, but it rejects primness. It evokes its functional origins, establishing itself in a decade whose stereotypes and injunctions push femininity to extremes. It is chic but not conformist, distinguished but not ostentatious. Grace Kelly is an emblem of elegance and all-American laid-back cool. Her Hermès bag represents her pragmatism and consciousness of the patrimonial role that she must assume.

### CATCH-ALL

Fashion is all about precious bags, but also knows how to produce practical ones.

**1930s :** Goyard Saint Louis Tote
**1930 :** Louis Vuitton Speedy Bag
**1961 :** Gucci Jackie Bag
**1993 :** Longchamp Pliage Bag
**1998 :** Vanessa Bruno Tote Bag
**2000 :** Balenciaga City Bag
**2002 :** Jérôme Dreyfuss Billy Bag
**2003 :** Gérard Darel 24H Bag
**2011 :** Celine Phantom Bag

# SILK SQUARE
## MULTIFACETED

| DESIGNER | HERMÈS |
| --- | --- |
| DATE | 1937 |

During the 18th century, it is customary for a woman to slip a small piece of linen or muslin fabric into her bodice. The handkerchief, an attractive and flirtatious feminine accessory, becomes available in a masculine version in the 19th century when some men wear it as a neck scarf.

↑ « Brides de Gala » Hermès Silk Square, Hugo Grygkar

### NECK KERCHIEF

Until the 1930s, it isn't unusual for some soldiers to be illiterate, so the Army habitually provides soldiers with handkerchiefs printed with illustrated instructions. In 1937, Robert Dumas, son-in-law of Émile Hermès, follows military tradition and offers the first silk scarf of the fashion house: the silk square, measuring 35 by 35 inches. It is called « Jeu des omnibus et dames blanches » (Omnibus Game and White Ladies). It reproduces a popular game at the time, using images of Parisian public transportation to decorate the game board.

### NECKTIES

In 1951, Hermès launches their first ties in silk twill, 3 inches wide. From then on, they feature cheerful figurative motifs designed by Henri d'Origny.

### HOUSE SIGNATURE

The link to the equestrian world already established at Hermès isn't ignored. Robert Dumas uses silk twill for the scarves, a material used in the past for jockeys' racing silks. These varied scarves, which can have up to forty different designs, rapidly meet success among socialites and elegant ladies who make them their own.

### TO EACH THEIR SCARF

That's where the value of the Hermès silk square lies: it adapts to individual taste and personality. Men wear it around the neck, Queen Elizabeth ties it sensibly around her head, Colette in an extravagant butterfly knot; some tie it onto their handbags, others attach it to their waists, and in the 1950s, Grace Kelly (p. 248), with a broken arm, wears it as a sling.

### ALL-TERRAIN

The scarf leans into humor with its playful motifs and impertinent phrases. It also goes to unexpected territories; in the 2000s, it is fashionable to wear the scarf as a top, with the triangle of fabric on the bust, revealing an audacious bare back.

### THE SQUARE IN NUMBERS

**35 :** length of each side in inches

**3 :** number of ounces of pure silk

**280 :** number of miles of silk thread

**75 000 :** number of shades in the color palette

**2 :** number of years required for the fabrication of one scarf

*Next page :*
Grace Kelly and Prince Rainier, 1956

# SANTON
## DEAR CHILDHOOD HOMELAND

| | |
|---|---|
| **DESIGNER** | JACQUEMUS *(p. 355)* |
| **DATE** | 2017 |

Simon Porte Jacquemus comes from the South of France, a Provence between land and sea that he never ceases to claim and celebrate. Picturesque and surprisingly universal at the same time, his work explores Southern themes that pay homage as much to his environment as to individuals and his own family.

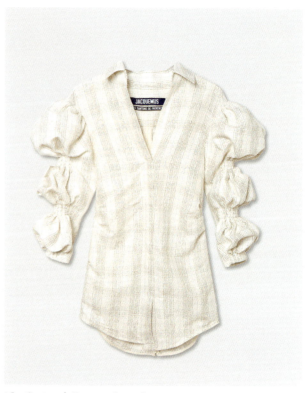

↑ Les Santons de Provence Dress, Jacquemus

« WITHOUT STORIES, THERE IS NO FASHION. A GARMENT IS HOLLOW. I'M INSPIRED BY MEMORIES, ATMOSPHERES, PEOPLE PASSING BY. »

SIMON PORTE JACQUEMUS

**IF ONLY YOUTH KNEW...**
In 2009, he founds his brand, Jacquemus, even though he isn't even twenty years old. With little means and a lot of nerve and determination, he manages to attract attention. He uses social media to tell his brand's story and his own, two concepts often linked.

**FASHION STORIES**
He differentiates the two because he is a storyteller. He brings narrative to the heart of his work: it feeds his designs and his runway shows, his marketing tools and his Instagram account. He frenetically exposes that which animates him and shares the store of images inside his mind.

**BETWEEN LAND AND SEA**
The images are authentic and fresh, nourished by his childhood memories and the present: his friends, the seaside, songs, family meals, scooter rides, and lavender fields. In 2017, he creates the collection « Les Santons de Provence », with nostalgic, timeless accents. His silhouettes delineate the standards of Occitan dressing: straw hats, blouses in the style of Arles, France, full skirts, contrasts of black and white, and many other winks to another lover of Provence, Christian Lacroix.

**INSTA FRIENDLY**
Instagram has enabled the prolongation of the work of numerous designers. They use it to expose their inspirations, share a creative process, and sometimes to tell stories about their personal lives. Immodest, but current: our era is an era of sharing. Instagram is a gateway that allows us to see an artist's life and understand how they work.

**REFUTING FOLKLORE**
The cuts are modern and graphic, sometimes deconstructed. Vintage lace evokes the concrete latticework of Mucem, a museum in Marseille, France; the dresses are maxi or ultra-mini, the polka dots are playful. Jacquemus links tradition with a contemporary feel: the charm of the past, summer memories, and our family histories.

**THE GREAT OUTDOORS**
Simon Porte Jacquemus presents his first collection for men at the Calanque de Sormiou in Marseille in 2018, seating the first row on beach towels. Then, in a lavender field lined with pink canvas in the manner of a Christo installation, and in a wheat field in 2020. All these unusual and surprising locations are part of his signature.

*Previous page:*
*Sophia Loren, 1965*

# POUF SKIRT
## BELLE OF THE BALL

| | |
|---|---|
| DESIGNER | CHRISTIAN LACROIX *(p. 356)* |
| DATE | 1980s |

The 1980s are said to be the second golden age of Parisian haute couture after the 1950s. During the 1980s, economic growth generates wealth for many individuals, and they want to show it. Fashion blazes, exuberant and ostentatious.

### FROM MUSEUMS TO FASHION

Christian Lacroix dreams of being a museum curator or costume designer before becoming a fashion designer. His appreciation for grandiloquence, history, and art informs his designs. He establishes himself during a carefree decade, marked by materialist effervescence, first at Patou, then with his own fashion house founded in 1987. His style meets the needs of affluent women of the 1980s who dress up to be seen.

### IN TOUCH WITH THE PAST

Sumptuous shapes from the past inspire Lacroix's silhouette. He revives 17th- and 18th-century style: a tight bust, as if corseted, set on a full, sometimes bouffant skirt. He compiles his inspirations and his history. Originally from Arles, he looks to Provence and the Camargue for the source of his motifs, wild colors, and bold scarves. His models strut and swagger, bubbly and spirited, like storytellers. Their stories are sometimes baroque, sometimes dramatic: the catwalk is Christian Lacroix's stage.

### THE CHARACTER OF A DECADE

His stories are nostalgic but never retrogressive. They are so contemporary that they express the character of the decade. Money is king, and there's no shame in that. Parties proliferate, and cocktails flow. Ensembles made obsolete by the 1970s are once again called for. The cocktail dress, between evening wear and dinner wear, is revived. Christian Lacroix offers ensembles composed of playful bolero jackets and short puffy skirts that evoke the poufs that inflated the dresses of the past.

↑ Miniskirt, Christian Lacroix

### « WE ALL LOOK FOR LOST TIME. »
CHRISTIAN LACROIX

### TWO IS BETTER THAN ONE

In 2009, Christian Lacroix closes his couture house. He abandons the catwalks. Ten years later, for his Spring/Summer 2020 show, Dries Van Noten presents designs that evoke the French designer's work. Surprise! He joins him for the final bow. The two designers reveal a four-hand collaboration – an even greater tribute. It is almost modest on the part of the Belgian designer to announce that if he is going to enhance the influence of Lacroix, he might as well ask him to accompany him, even to help him. This humility contrasts the wars of ego of a sometimes cruel business.

### THE LACROIX SIGNATURE

There are many markers of this pompous decade: shoulder pads, tapered waist, and Lacroix's signature pouf skirt. Elegant and insolent, it affirms the levity of the era. We imagine it teasing during fashionable parties; maybe it is even allowed a turn on the dance floor, seductive and flamboyant. Christian Lacroix resuscitates the aesthetic of a Sleeping Beauty in order to let her live a life at a million miles an hour.

*Next page :*
Faye Dunaway, New York, 1981

# DRESS MEETS BODY
## A NEW BODY

| | |
|---|---|
| DESIGNER | REI KAWAKUBO FOR COMME DES GARÇONS (p. 356) |
| DATE | 1997 |

Japanese designer Rei Kawakubo is associated with deconstructivism, which dismantles fashion norms. Strongly criticized at first by Western critics who accuse her of promoting ugliness, she offers a new point of view on the link between the garment and the body.

↑ Lumps Bumps Dress, Comme des Garçons, 1997

« FOR SOMETHING TO BE BEAUTIFUL, IT DOESN'T HAVE TO BE PRETTY. »

REI KAWAKUBO

### BUMPY BODIES

With her brand Comme des Garçons, Rei Kawakubo (p. 308) designs a series of silhouettes with surprising protuberances for her Spring/Summer 1997 collection. The outfits are padded with cushions: on the hips, under the neck, in the back. The placements are anarchic. The shapes clash and shock.

### TRANSFORMED WOMEN

It isn't the first time Western fashion has altered the feminine silhouette. There are the panniers that create imposing rectangular hips, the corset (p. 262) strangling the waist, and the bustle accentuating volume at the back of the body. Women are endlessly subjected to styles that ignore true morphology.

### PASSAGE OF TIME

Rei Kawakubo takes part in this game of extremes in her own way. She imagines an exoskeleton, a secondary body, born of fashion, that comes to rest on our natural anatomy. By choosing soft and round padding, she asks us to think about the body in terms of that which makes its essence: metamorphosis. Because contrary to what fashion trends would have you believe, the silhouette isn't a fixed and timeless paradigm. Our bodies change, grow older, put on weight, and lose it. She allows our bodies to occupy space more fully – space so often refused to women.

### TAKING THE LEAD

In 1997, American choreographer Merce Cunningham calls upon Rei Kawakubo to design the costumes for his contemporary ballet *Scenario*. She places padding on striped and checked pieces. It impacts the choreography because the dancers are constrained by the shapes. Thus, she destabilizes the vocabulary of fashion and transgresses the aesthetic conventions of dance.

### STRANGE DIALOGUE

Even if Rei Kawakubo doesn't claim it, her discourse is feminist and subversive. Critics compare her silhouettes to Quasimodo and qualify her collection as grotesque. But she remains a symbol of the strange dialogue that links fashion to the body.

# STOCKMAN JACKET
## THE ORIGIN OF FASHION

| DESIGNER | MARTIN MARGIELA (p. 358) |
|---|---|
| DATE | 1997 |

Martin Margiela's credo? Deconstruct our conception of fashion. Indeed, the expression « deconstructivism » is used for the first time in fashion to designate his work. The designer modifies a garment's essence and gives it a second life without eclipsing the first.

↑ **Semi-Couture Jacket**, Martin Margiela, 1997

### TWO LIVES IN ONE
Recycling is at the heart of Margiela's work. It is sometimes expressed as reproduction, sometimes as recuperation. Either way, he is motivated by a desire to dissect to better reevaluate, asking himself whether moving a sleeve modifies the sense of a garment or if wearing a plastic bag ennobles the object. Despite these metamorphoses, the original memory of the element is never abandoned.

### ONE FORM HIDES ANOTHER
Alexis Lavigne (the founder of fashion school ESMOD) invents the couture dress form in 1854. His student Frédéric Stockman founds his company in 1867 and successfully imposes his name as a generic term in French for the mannequin dress form.

### ARTISANRY
He works from knowledge and transmission. By altering and transforming objects, Margiela explores the very principle of conception, especially of the craft of making clothes. When some criticize him for disrupting fashion conventions, others answer that it's thus that the designer renders his tributes even more beautiful. Because Margiela evokes the foundational gesture of design. Sewing is, above all, working with hands and materials. To show a piece of fabric and its rough edges, expose poorly finished sewing, or reveal a garment's lining is to witness the skill in its execution.

### AN ESSENTIAL FORM
His Fall/Winter 1997-1998 collection attests to this. In continuity with his preceding presentation, Margiela evokes the essentials of the craft of fashion design, particularly the Stockman dress form, partner of seamstresses and tailors since the 19th century. He deconstructs, in the literal sense of the word, the dress form. He eviscerates it and dismantles its parts to create wearable pieces: here a breastplate, there a pair of sleeves, or even a jacket. He pushes the posture even further by associating the thick raw linen fabric of his dress form with scraps of patterns on paper.

### PAY HOMAGE
It is radical, but it also salutes the ancestralism of sewing. That is where all the irony lies. He is taken for a rebel when, in reality, he is faithful to heritage. He celebrates the modesty of the « petites mains » (little hands – the seamstresses) and others who work in the shadows. Honoring the artisanal triviality of the Stockman dress form suggests that couture is not the business of one person nor an egotistical parade. This isn't a surprising point of view from someone who, wishing to avoid the cult of celebrity, never shows himself in public.

*Page 255:*
**Maison Margiela** Spring/Summer 1999 prêt-à-porter show

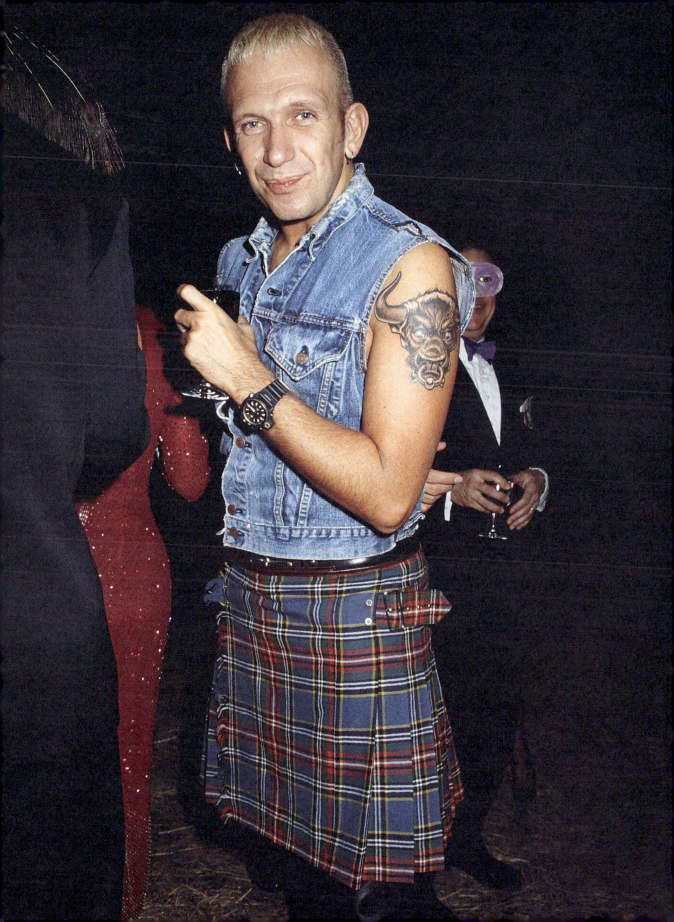

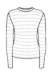

# STRIPES
## A BETTER WORLD

| DESIGNER | SONIA RYKIEL (p. 360) |
| --- | --- |
| DATE | 1968 |

In 1955, pregnant with her first child, Sonia Rykiel designs a maternity dress and body-hugging sweaters that she sells in her husband's boutique. The designs borrow from masculine shapes while displaying the slim measurements reserved for children's fashion. The Sonia Rykiel style is launched.

### A PERSONAL STYLE

The androgynous sweater is called the « poor boy sweater », Sonia Rykiel anticipates the needs of a new generation of women. The 1960s begin, and the press, especially *Elle* Magazine, laud the designer's work. She conceives each item as she would like to wear it, addressing active women juggling between private and professional life, looking for comfort without ignoring allure. Perfect for urban women like herself whose lives are changing at breakneck speed.

### A SIGNATURE STYLE

Stripes, black, and color: this is the Sonia Rykiel signature. After gathering a loyal clientele, she launches her brand and sets up shop on rue de Grenelle in Paris in 1968. Her tight-fitting silhouettes are elegant, racy, sexy, simple, and timeless. They encourage women to be themselves, to be liberated from trends, and to better find their individual styles. She even creates the concept of « anti-fashion », which, contrary to what Parisian couture promotes, emphasizes consumers' tastes and is not based on the dictates of a designer.

### FREE WOMEN

A liberator of women and their bodies, Sonia Rykiel even invents a braless cocktail dress. She breathes life into the austere atmosphere of runway shows by asking her models to laugh and dance on the catwalk, moving ever further away from the conventions that stifle women. Forget being objects! They are subjects, desirable and desiring. Seductive but also intellectual – the designer sells objects and books in her boutique, whose display window sometimes resembles that of a bookstore.

↑ *Poor Boy Striped Knit Cardigan*, Sonia Rykiel.

« BEAUTY WILL ALWAYS BE STRIPED. »

SONIA RYKIEL

### JOYFUL BODIES

Rykiel's stripes are masculine and child-like, twirling and sensuous as they wrap around women's bodies, defining and caressing their shapes. The advantage of these stripes is that they are full of movement – restless stripes that flutter, echoing the bodies that wear them. These dynamic bodies are exalted and alive.

### HALL OF FAME

Sonia Rykiel is part of a generation of stylists who invent designer prêt-à-porter: a more accessible fashion, creative and aesthetic, free from injunctions, leaving pride of place to personal style. At first mostly ignored, it is recognized during the creation of the Chambre Syndicale du Prêt-à-porter des Couturiers et des Créateurs de Mode in 1973. It is composed of Christian Dior, Yves Saint Laurent, Kenzo, Emanuel Ungaro, Dorothée Bis, Chloé, Sonia Rykiel and Emmanuelle Khanh.

*Page 258 :*
Sonia Rykiel, 1977

# MEN'S SKIRTS
## A NEW MASCULINITY?

**DESIGNER** — JEAN-PAUL GAULTIER *(p. 354)*
**DATE** — 1984

While women can appropriate pieces from men's wardrobes, there are some improprieties that fashion and society don't authorize. For men, it is difficult to break free from the codes associated with masculinity. Wearing a skirt is still seen as a transgression.

### A MASCULINE STYLE?

Strange how Western fashion can be so timid and how quickly it forgets. Because during ancient times and in the Middle Ages, men drape themselves in flowing tunics. And today, around the world, it is commonplace to dress in boubous (p. 134), djellabas (p. 110), qamis (p. 135), and sarongs (p. 33) without putting into question the integrity of a man's masculinity. Even in Europe, the kilt (p. 178) is popular in Scotland. Why, then, is a man in a skirt such a big deal? Because of questions of gender? Misplaced virility?

### QUESTIONS OF GENDER

Jean-Paul Gaultier overturns sartorial codes and interrogates sexual identity. In 1984, he presents his collection « And God Created Man ». The public discovers wrap-like skirts worn by men. The show is an ode to identity diversity and a hyper-sexualization that makes light of assignments. Unisex doesn't mean anything to Gaultier. He prefers exchanges and puts corsets (p. 263) and lipstick on men.

### THWARTING FEAR

The 1980s bring the AIDS epidemic. The LGBTQ+ community is stigmatized, and gay men are feared. Everything that seems effeminate is rejected in favor of exaggerated virility. Seemingly lighthearted and frivolous, Jean-Paul Gaultier strikes a blow to malice. But even if the skirt is a hit on the catwalk, it doesn't catch on. The commercial reception is timid because society is entangled in its beliefs.

↑ Iconic Tartan Kilt, Jean-Paul Gaultier

« WHY SHOULD MEN NOT SHOW THAT THEY CAN BE FRAGILE OR SEDUCTIVE? »

JEAN-PAUL GAULTIER

### NEW GENERATION

The young designer Ludovic de Saint Sernin, inspired by Robert Mapplethorpe's photographic works, also infuses his work with an eroticism that deconstructs masculinity. He injects an aesthetic that rejects restraint in his creations, destined for men. Even his male models' poses are suggestive, celebrating the uninhibited expression of the self. They dare bare backs, plunging necklines, transparent tank tops, low-cut briefs, and matching wraps.

### SHY IN THE STREETS

Men in skirts, nonetheless, multiply on the runways. From Walter Van Beirendonck to Rick Owens (p. 296), many men's designers incorporate them. Celebrities too. But in the street, it's another story. Perception and the behavior of others are to blame.

*Page 259 :*
Jean-Paul Gaultier, 1992

# BUSTIER
## TECHNOLOGICAL CRAFT

**DESIGNER** .................. ISSEY MIYAKE *(p. 358)*
**DATE** .................. 1980

Having settled in France in the 1960s, Japanese designer Issey Miyake presents his first Parisian collection in 1973. He offers an innovative vision of fashion by thwarting its aesthetic and creative codes. Above all, he places the body at the center of his exploration.

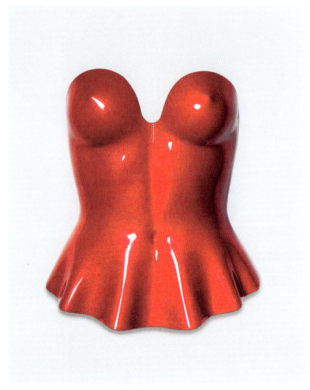

↑ Issey Miyake Bustier, Fall/Winter 1980

### « I'D RATHER LOOK TO THE FUTURE THAN TO THE PAST. »
ISSEY MIYAKE

### A SCULPTURAL DIMENSION
Understanding a gesture, a movement, a silhouette. That is what moves Issey Miyake. He doesn't make fashion for fashion. He designs garments that dialogue with the body in a sincere exchange. To establish this conversation, he considers the sculptural dimension of his garments and the way they take form. He valorizes materials and textiles, playing with pleated, embossed, geometric, or fluid effects. The garment is a vibrant and unique envelope.

### TOTAL TRUST
Beginning in 1986, the American photographer Irving Penn creates Issey Miyake's advertising campaigns. The graphic black and white of the images echoes the geometric allure of his designs. A collaboration so evident and natural that the designer doesn't attend the photo shoots, showing unparalleled trust.

### TEXTILE GUIDE
Technology is his ally in this quest for physicality. It allows him to design unique fabrics that sometimes dictate what form the garment will take.

### BODYWORKS
The 1980s are obsessed with the body. It is sculpted with aerobics and molded into flashy Lycra. Issey Miyake doesn't want to ignore this preoccupation. After all, it's been his for a long time. With his Fall/Winter 1980 collection, he launches the concept of « Bodyworks » : a reflection on the body and technology, inaugurated with a surprising resin bustier.

### SECOND SKIN
Hyperrealist and illusory at the same time, his bustier, molded on the silhouette of a woman, links the truth of the body to the chimera of the material. Because even if the anthropomorphic bustier reveals details like the navel and nipples, it wears an artificial hue: red or blue, depending on the model. It conflates organic and plastic. True and false. It defines a second skin that erases the reality of the body by transforming it without denying its elemental existence. It's a strange back and forth that speaks to the body exposed and the body camouflaged, of absence and of presence.

### MATERIALS AND A MAN

**1982 :** Rattan corset
**1985 :** Seashell coat
**1991 :** Dove dress
**1993 :** Pleats Please
**1999 :** A-POC
**2010 :** Origami Collection

# CONE BRA CORSET
## POINT BLANK

| | |
|---|---|
| **DESIGNER** | **JEAN-PAUL GAULTIER** (p. 354) |
| **DATE** | 1983 |

In the 1980s, the corset takes center stage. Vivienne Westwood and Chantal Thomas revisit it as a fashionable object brandished by powerful, sexual women. No longer a symbol of male domination or constraint, it supports an exaggerated, even outrageous, femininity.

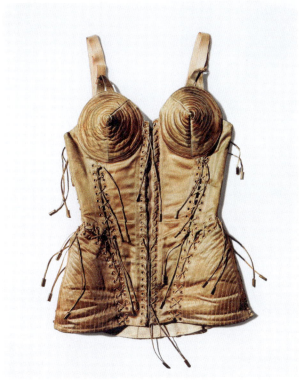

↑ **Corset by Jean-Paul Gaultier** for Madonna, 1990

« UNCONVENTIONAL DESIGNER SEEKS ATYPICAL MODELS. UNIQUE FACES WELCOME. »

JEAN-PAUL GAULTIER

### CHILDHOOD MEMORIES

In 1983, Jean-Paul Gaultier presents his first corset with his collection « Le dadaïsme ». The satin corset extends into a dress reminiscent of his grandmother's orthopedic girdles. He adds conical breasts, echoing the bras women wore when he was a child. The intimate becomes political as the designer transcends an item of controversial lingerie. The undergarment takes over.

### TEEN IDOL

In 1990, Madonna launches her Blond Ambition Tour and asks Jean-Paul Gaultier to design her costumes. The designer puts her in a corset that blends classicism and deconstruction. Worn with a suit with masculine allure, the powder-pink satin corset becomes a fetishistic weapon, almost phallic. Roles are reversed. Madonna shows her iconic power.

### MEANS AT HAND

This shape establishes itself in the work of Jean-Paul Gaultier. It reappears in 1984 for the « Barbès » show. This time, he adds multiculturalism to childhood memories and transformation. He wants to pay tribute to the African women he observes in the Barbès neighborhood he frequents in Paris. He studies the way they blend pieces, ennobling the materials at hand; it's a familiar concept for the designer who began his career without a dime.

### BODY POWER

Corsets and « seins obus » (bombshell breasts) serve as a leitmotif in this festive era where sexuality, humor, and extravagance cohabitate on the catwalks. Paired with a velvet rust-colored dress, they hint at course street culture; the powder pink highlights fetishistic clichés about lingerie. Jean-Paul Gaultier empowers women to take back the pieces that have imprisoned them. This reclaimed chest with almost dangerous, sharp spikes becomes an emancipatory tool for seizing power – the power of the body.

### PLAYING WITH CODES

From women to hyper-women. This is what Jean-Paul Gaultier is promoting. Not to support restrictive gender theories but to better disavow stereotypes – and to do so with a great deal of humor.

### MODELED BODIES

The Renaissance brings the corset into existence. It serves to support the chest and to modify the silhouette of women, sculpted by the dictates of society. Left behind in the 1920s (the body is nonetheless girdled), it reappears in the 1950s. Since the 1980s, it has become playful and assertive.

*Next page:*
Kim Williams for Jean-Paul Gaultier, *photo by Peter Lindbergh,* 1984

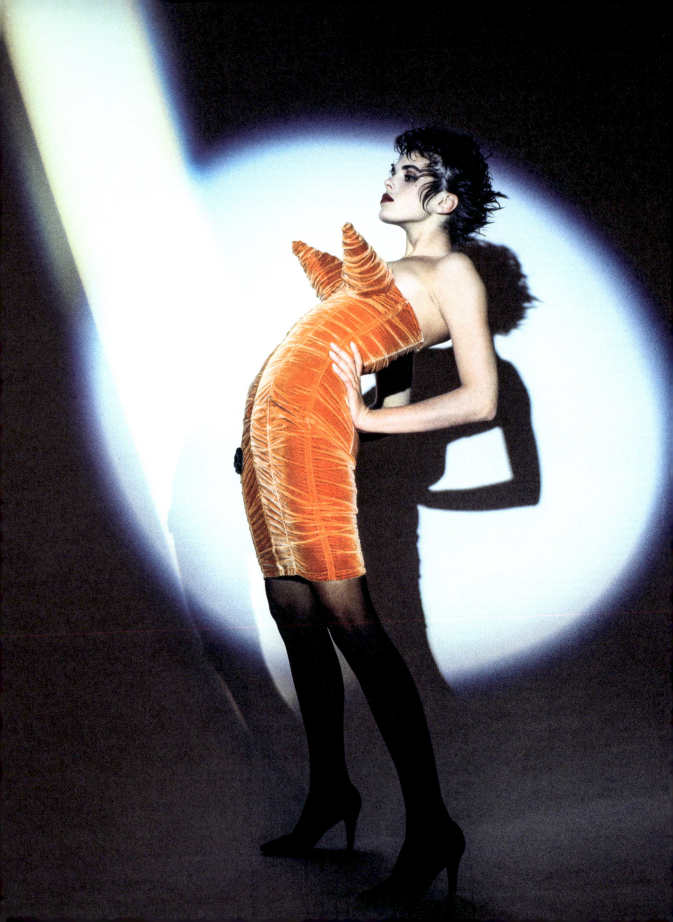

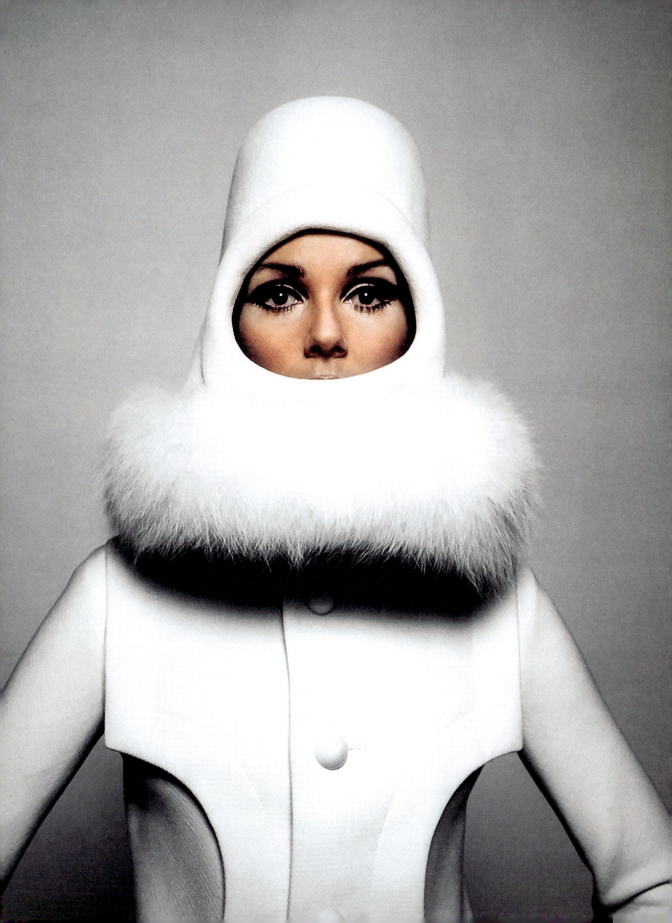

# SPACE AGE
## ONE SMALL STEP FOR MAN...

**DESIGNER** ................................................ PIERRE CARDIN *(p. 351)*
**DATE** ................................................................................... 1960s

In the 1960s, in addition to the emphasis on emancipation, novelty, and youth, a supreme fantasy reigns: that of space exploration; it is at the heart of the Cold War. Due to its immense and mysterious nature, the universe satisfies the aspirations of the decade.

### FASHION, A REFLECTION OF THE TIMES

This interest in outer space inspires the decade's new generation of designers, like André Courrèges (p. 267) and Pierre Cardin, who borrow from the rigorous forms of the cosmic aesthetic to contradict the vagueness of traditional haute couture. « Space Age » styles imbue fashion with innovative materials and techniques, sometimes borrowed from the industrial world.

### MULTICULTURAL

In 1960, Pierre Cardin introduces his men's prêt-à-porter line with the collection « Cylindre ». It is characterized by innovative and youthful collarless jackets, borrowing from the Nehru jacket – collarless jackets abound in India. While Western fashion rejects traditional norms, Cardin redesigns wardrobes by varying cultural styles.

### TOWARDS INNOVATION

In 1959, Pierre Cardin designs a prêt-à-porter line that leads to his removal from the Chambre Syndicale de la Couture Parisienne. But he's also the first designer to be attributed a dedicated space at the department store Printemps and to diffuse his brand's licenses without restraint. He designs as much for women as for men, and carried by his futuristic ambitions, he even creates unisex fashion.

### SPACE ARMY

With his line « Cosmocorps », launched in 1968, he establishes surprising silhouettes. Men are dressed in sleeveless tunics, with turtlenecks and knit pants. Women wear rigid A-line dresses. To each their wardrobe. However, a certain homogony stands out in the collection, as if these men and women make up a space-invading army.

↑ *Space Age Miniskirt*, Pierre Cardin, 1960s

« THE CLOTHES THAT I PREFER ARE THOSE I INVENT FOR LIFE THAT DOESN'T EXIST YET – THE WORLD OF TOMORROW. »

PIERRE CARDIN

### IN A GALAXY FAR, FAR AWAY...

**1960 :** John Lautner, Chemosphere House (Los Angeles)
**1962 :** John Graham, Space Needle (Seattle)
**1965 :** Pierre Paulin, Tulip Chair
**1966 :** *Star Trek*
**1968 :** Stanley Kubrick, *2001, Space Odyssey*
**1968 :** Roger Vadim, *Barbarella*
**1969 :** David Bowie, *Space Oddity*

### FUTURE FASHION

His designs are part of a context too marked to be timeless. But his vision is solid. By diversifying his brand and thinking like a businessperson, he establishes himself in contemporary fashion – in its ravages (mass production and pollution) as much as in its visionary dreams.

*Previous page :*
**Sputnik Girl**, Nicole de Lamargé in Pierre Cardin (A-line coat and porthole hat trimmed with white fox fur), Fall/Winter collection 1966, *photo by Peter Knapp*

# VINYL JACKET
## PLASTIC IS FANTASTIC

| DESIGNER | ANDRÉ COURRÈGES *(p. 352)* |
|---|---|
| DATE | 1971 |

After training under Cristóbal Balenciaga, André Courrèges founds his brand in 1961. At first, he timidly perpetuates the volumes of his mentor. He breaks free in 1964 with a revolutionary futuristic collection full of youthful and geometric silhouettes that free the body.

↑ Iconic Vinyl Jacket, Courrèges

### BACK TO THE FUTURE

Courrèges' popularity fades in the early 1980s when the future goes out of style. But in the 2010s, vintage and storytelling trends relaunch the brand. Vinyl jackets are reissued and create a new frenzy. The brand's original designs are sought after in thrift stores.

### SPACE AGE

Miniskirt (p. 160), legs wrapped in white boots, flashy colors: Courrèges' style is part of the Space Age aesthetic, which speaks to the fascination of an era for space and its mysteries. The 1960s bring a new clientele: young women seeking movement and liberty – women whose bodies disappear under the marked androgyny of straight dresses and audacious pants.

### THE CULT OF NOVELTY

André Courrèges plays with materials. Some are unprecedented, like the PVC and vinyl used for accessories and coats. Motifs, if they exist, are graphic and bold, though monochromes dominate. The shapes are inspired by a fantasy future of life in space, peopled with women astronauts wearing helmets, exuberant wigs, or ski masks paired with sunglasses. Everything is new, playful, and impertinent.

### THE COURRÈGES BRAND

The brand makes its mark. Courrèges rolls out his collections, blending prêt-à-porter, sportswear, and couture, refusing obsolete hierarchies of the archaic world. In 1971, the designer, who has been working with his wife since the beginning, designs a short jacket in vinyl with his white AC logo and patch pockets.

### THE SPIRIT OF THE BODY

The archetypal jacket marks the transition between the 1960s and the 1970s. It keeps the pop decade's futuristic codes but also absorbs a new sensuality, a more unbridled carnality, because of its slim fit. Like the A-line dresses and the boots of the 1960s, the jacket becomes emblematic of a brand and of an era.

> « LOOK AT THE CHANEL WOMAN: YOU CAN SEE HER BACKGROUND, HER OCCUPATIONS, HER HOBBIES, HER TRAVELS; LOOK AT THE COURRÈGES WOMAN: YOU DON'T WONDER WHAT SHE DOES, WHO HER PARENTS ARE, WHAT HER INCOME IS: SHE'S YOUNG, NECESSARILY AND SUFFICIENTLY. »
>
> PIERRE BOURDIEU

### PLASTIC IS NOT SO FANTASTIC

Courrèges decides to cease using vinyl. The remnants are used for one-of-a-kind designs. Silhouettes that imitate the historic material use jersey, onto which a 70% plant-based film is applied.

*Next page:*
**Courrèges**, Spring/Summer 1971 collection

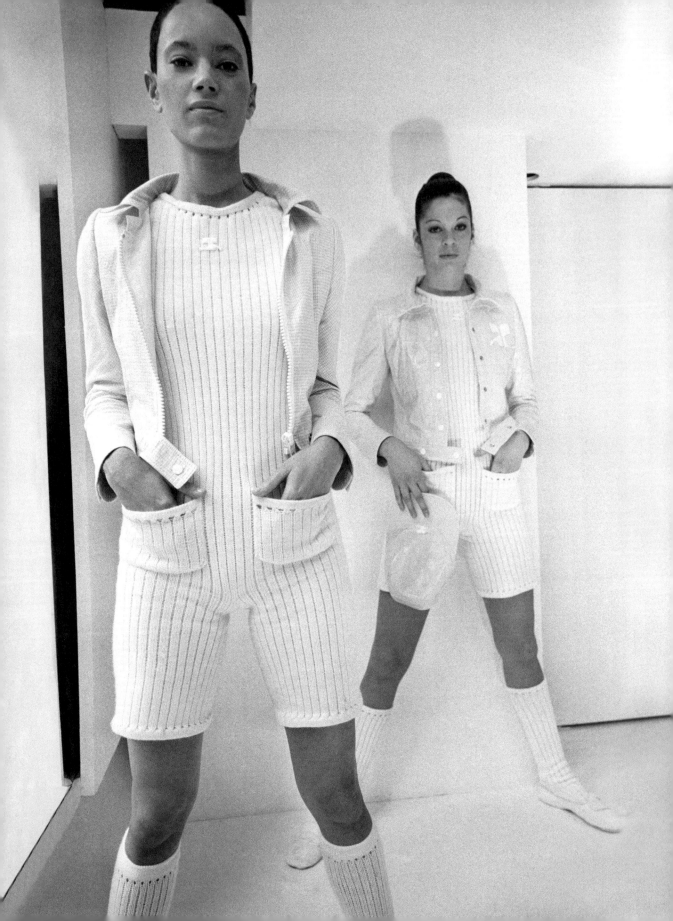

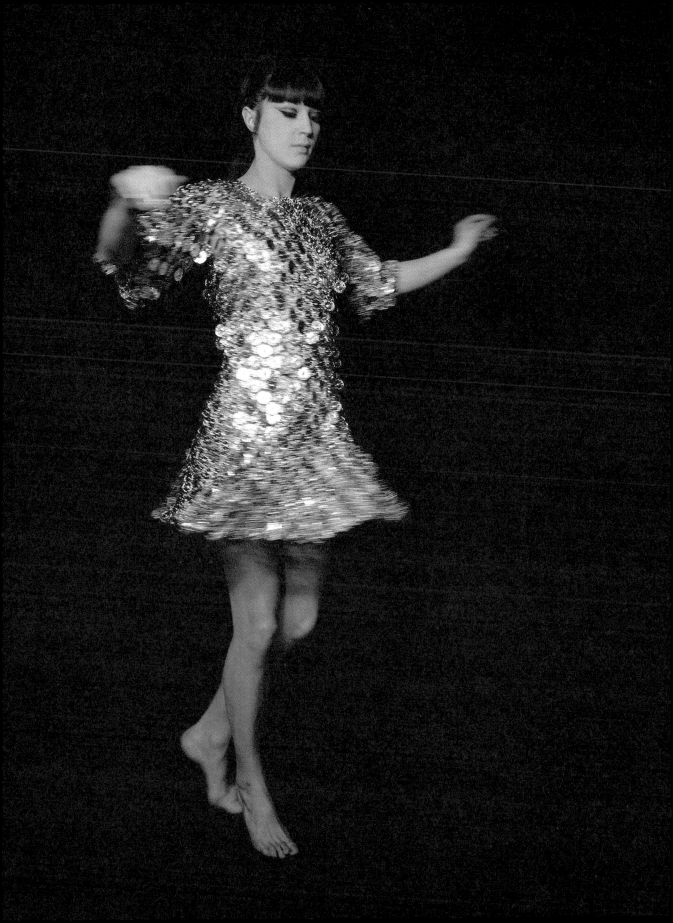

# METAL DRESS
## NUTS AND BOLTS

| DESIGNER | PACO RABANNE *(p. 359)* |
| --- | --- |
| DATE | 1966 |

In 1966, Paco Rabanne presents his first conceptual couture collection. He calls it « Twelve Unwearable Dresses in Contemporary Materials ». This impertinent title anticipates his critics; he already knows his metal and rhodoid designs won't please everyone.

↑ Metal Dress, Paco Rabanne, 1982

### A BRAND-NEW MATERIAL
In the middle of the innovative 1960s, it isn't surprising that Paco Rabanne turns towards unexpected materials. Others have already explored the stylistic qualities of PVC. But the Spanish designer goes even further with his metal dresses, whose look, feel, and methods of fabrication clash with fashion traditions.

### INDUSTRIAL FASHION
A former student at the prestigious Beaux-Arts de Paris with a background in jewelry design, Paco Rabanne is interested in experimentation. In an era that embraces novelty, why limit yourself? He turns away from textiles and vagueness and moves towards solidity – metal plates that he screws and assembles like a steelworker. The futuristic vision of the 1960s does not stop at plastic, it also becomes industrial.

### SHINY BODIES
His metal dresses shimmer, but not like the armor the critics describe them as at the time. They liberate women's bodies and dress them in light and sparkle. The metallic shapes that compose the silhouettes let the flesh peak through. Paco Rabanne manages to make the mechanical sensual.

### TO PLEASE AND DISPLEASE
The designer is mocked. In 1966, the photographer and director William Klein caricatures him to excess in his cult parody « *Who Are You, Polly Maggoo* »? But Paco Rabanne couldn't care less. He is appreciated by icons like Françoise Hardy, and he designs Jane Fonda's skimpy costumes in *Barbarella* by Roger Vadim.

« WE CAN DRESS IN ANY MATERIAL, NO MATTER HOW IMPROBABLE. WHEN THERE WILL BE 20 BILLION OF US ON EARTH, THERE WILL BE NO MORE WOOL, NO MORE COTTON, THERE WILL BE NOTHING LEFT! THERE WILL ONLY BE WHAT WE MINE AND OUR RECYCLED GARBAGE FOR MAKING CLOTHES. »

PACO RABANNE

### PACO RABANNE AT THE MOVIES

**1966 :** The designer creates the costumes for *Casino Royale*.

**1966 :** Audrey Hepburn wears one of his dresses in *Two for the Road*.

**1967 :** We see his designs in *Les Aventuriers (The Last Adventure)*…

**1967 :** … and *Deux ou trois choses que je sais d'elle (Two or Three Things I Know About Her)*.

### FREE FORM
Paco Rabanne's metal dresses don't only introduce a new aesthetic language. They completely reinvent the gesture of couture. Should fashion be all about sewing?

*Previous page :*
Metal Dress, Paco Rabanne, 1967

# MONDRIAN DRESS
## WEARABLE ART

| DESIGNER | YVES SAINT LAURENT *(p. 360)* |
| --- | --- |
| DATE | 1965 |

The 1960s shape new lifestyles and an innovative stylistic vocabulary for young people battling the past. In fashion, particularly in high fashion, reinvention is an existential necessity. And it's the key to Yves Saint Laurent's equilibrium between revolution and elegance.

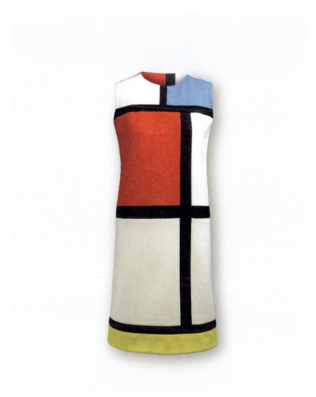

↑ **Piet Mondrian Dress**, Yves Saint Laurent, Fall/Winter 1965

« **THE POSITION OF THE ARTIST IS HUMBLE. HE IS ESSENTIALLY A CHANNEL.** »

PIET MONDRIAN

### A PAINTING, A DRESS

In 1965, for his haute couture Fall/Winter collection, the designer chooses subtle audacity. The striking cocktail dresses are all inspired by the pictorial work of the artist Piet Mondrian. The avant-garde geometry of the painter perfectly suits the new aesthetic language. Yves Saint Laurent offers a surprising motif: a painting animated by the body. Even if the dresses are three-dimensional, they conserve the lines and shapes of the original paintings.

### ART LOVER

**1966 :** Homage to Tom Wesselmann's pop art.

**1969 :** Claude Lalanne designs anthropomorphic sculptured jewelry for him.

**1988 :** Van Gogh's sunflowers are embroidered on a flamboyant jacket.

### STREET FASHION

For the designer, it isn't about providing only one artistic reference to upend tradition. Yves Saint Laurent also innovates by daring the purest sobriety. Haute couture now absorbs that which street fashion requires. comfort and simplicity. The designer concentrates on a no-frills, easy-to-wear jersey tunic.

### SIMPLY COMPLEX

Despite their apparent simplicity, the Mondrian dresses bear witness to the craft of sewing: the inlaid jersey leaves no visible sewing lines. Yves Saint Laurent thus shows that subversion needn't ignore technique.

### SINCERELY YOURS

In 1965, Catherine Deneuve must meet the queen of England. She places an order with Yves Saint Laurent. It's the beginning of friendship and collaboration whose culminating point is the creation of a dozen garments for the movie *Belle de Jour*. They reiterate the experience for *La Chamade* (Heartbeat) and *La Sirène du Mississippi* (Mississippi Mermaid). In 2021, the creative director of the Saint Laurent house, Anthony Vaccarello, pays homage to their relationship by choosing Catherine Deneuve as the face of the Spring/Summer collection.

### SHOE FETISH

The collection meets with resounding success and joins the legacy of the 1960s, confirmed by cinema. In 1967, Yves Saint Laurent dresses Catherine Deneuve in the movie *Belle de Jour* by Luis Buñuel. He puts her in pumps (p. 96) with a square buckle designed by Roger Vivier for the 1965 runway show. These shoes occupy a distinct status in the film's sultry narrative. The director fetishizes his actress's feet and shoes, turning pumps into a cult pop culture motif.

# FATEFUL LIAISONS

### 1911
**FLORAL MOTIF**
Paul Poiret designs the Persian coat, with a print by Raoul Dufy.

### 1913
**ARTIST AND STYLIST**
Artist Sonia Delaunay creates the simultaneous dress and launches a fashion trend based on contrast and geometry.

### 1921
**LANVIN BLUE**
The Daunou Theater in Paris is decorated by Armand-Albert Rateau and Jeanne Lanvin, who imposes her favorite blue.

### 1984
**DESIGNER(S) DRESSES**
The artist Ben signs a painting dress, « Je suis toute nue en dessous » (I am naked underneath), for the finale of Jean-Charles de Castelbajac's show.

### 1965
**ABSTRACT LINES**
Yves Saint Laurent creates his Mondrian dresses.

### 1936
**SURREALIST FASHION**
Elsa Schiaparelli and Salvador Dalí make a suit with drawers.

### 1985
**FASHION AND PERFORMANCE**
Willi Smith creates the participants' uniforms for the wrapping of Pont-Neuf by Christo and Jeanne-Claude.

### 1990
**ROCOCO ROCK**
Vivienne Westwood places *Daphnis et Chloé* by François Boucher on an audacious corset.

### 1991
**POP ART HOMAGE**
Gianni Versace designs a collection dedicated to pop art.

### 2014
**ARTISTIC FRATERNITY**
Sterling Ruby and Raf Simons create a collection together.

### 2008
**ART SCENE ASSOCIATION**
Marc Jacobs invites artist Richard Prince to reinterpret leather goods at Louis Vuitton.

### 1998
**ART AND ORIGAMI**
Cai Guo-Qiang designs a special print for the Issey Miyake's Pleats Please tunics.

### 1994
**AD CAMPAIGN**
Cindy Sherman photographs a series of print ads for Comme des Garçons.

### 2017
**IKB**
Phoebe Philo, at Celine, makes immaculate dresses inspired by Yves Klein's body paintings.

### 2018
**FLEMISH PRIMITIVES**
Ignasi Monreal reinterprets Hieronymus Bosch's *Garden of Delights* for the Gucci campaign.

### 2020
**RETURN TO CUBISM**
Jeremy Scott offers a tribute to cubism at Moschino.

→ Bella Hadid, Moschino Spring/Summer 2019 sho

# BACKLESS DRESS
## SURPRISE DÉCOLLETÉ

| | |
|---|---|
| DESIGNER | GUY LAROCHE (p. 357) |
| DATE | 1972 |

Some legendary creations never appear on a runway or in boutiques. Yet we recognize them instantly because they echo a key moment in popular culture that reaches beyond the garment itself. This is the case of the dress with a vertiginous décolleté…

↑ Mireille Darc *in Le Grand Blond avec une chaussure noire*, 1972

### MOVIE STAR
In 1972, Mireille Darc is cast in the movie *Le Grand Blond avec une chaussure noire (The Tall Blond Man with One Black Shoe)*. She knows that her costumes should be as incisive as her acting. So, she calls upon designer Guy Laroche, with whom she imagines a black dress (p. 106) that isn't what it first appears to be. When observed from the front, it is minimalist, even austere, with its monochrome tonality, high neck, and long sleeves. But from behind, it tells a whole other story.

### LOW-CUT BACK
A bare back is nothing new. In the 1920s, this part of women's bodies is revealed as a new erogenous and sexualized zone, while the rest of the silhouette is androgynous. 1930s fashion blends neoclassicism with sensuality, and bare backs underline the ambivalences of the decade's style. But Guy Laroche changes the direction of history by prolonging the décolleté of the back to the top of the buttocks, and especially by accentuating the arch of the back with a gold chain.

### PEEKABOO
Revealing the buttocks while dressed exposes a postulate of fashion. By covering and uncovering the body according to trends and preferences, we render the garment desirable and seductive. A naked body is trivial, biological, but a body that is undressed with fabric is provocative. Mireille Darc knows it. She later reveals that she was concerned about the director's reaction when she suggested the dress to him. It was a success – the scene was rewritten.

### THE ELEMENT OF SURPRISE
The idea works marvelously. Especially since spectators aren't the only ones to be taken by surprise. The actress's partner in the movie, Pierre Richard, doesn't see Mireille Darc before shooting the scene. When she turns her back, his shock isn't overplayed: he is also discovering the unprecedented cleavage. The dress becomes a third character in the sequence—a dress destined to become a legacy, at the crossroads of cinema and fashion.

#### EXCLUSIVITY
In 1974, in the sequel *Le Retour du Grand Blond (The Return of the Tall Blond Man with One Black Shoe)*, Mireille Darc wears an ivory version of the low-cut dress. In 2005, she decides to donate her dress to the Musée des Arts Décoratifs in Paris because she dislikes the idea of seeing someone else's backside in the dress!

#### IN FOCUS

**1939 :** The red ruby slippers of *The Wizard of Oz*

**1954 :** Marilyn Monroe's white dress in *The Seven Year Itch*

**1960 :** The New York Herald Tribune T-shirt worn by Jean Seberg in *À bout de souffle (Breathless)*

**1961 :** Audrey Hepburn's black dress in *Breakfast at Tiffany's*

**1984 :** The pink mohair sweater of *Paris, Texas*

**1994 :** The black suits in *Pulp Fiction*

**2001 :** Gwyneth Paltrow's fur coat in *The Royal Tenenbaums*

**2003 :** Scarlett Johansson's pink panties in *Lost in Translation*

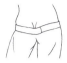

# BUMSTER
## VIOLENCE AT WORK

| DESIGNER | ALEXANDER MCQUEEN *(p. 358)* |
|---|---|
| DATE | 1995 |

The 1990s begin with an economic crisis that slows the eccentricities of 1980s fashion. Minimalism and a form of brutalism dominate. High fashion takes a back seat. Or at least until British designers decide to wake it from its gentle sleep.

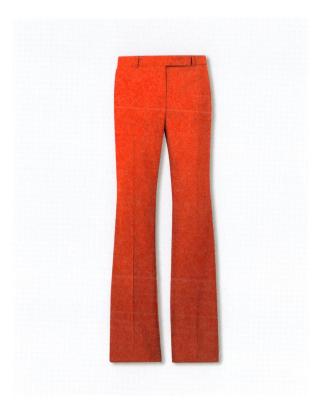

↑ Trousers, Alexander McQueen

« I DON'T WANT TO DO A COCKTAIL PARTY. I'D RATHER PEOPLE LEFT MY SHOWS AND VOMITED. »

ALEXANDER MCQUEEN

### AN IMAGINARY TABOO

On one hand, John Galliano, flamboyant and theatrical, on the other, Alexander McQueen, tortured and masterful. Both have a gift for spectacle. But for McQueen, performance is electroshock therapy. He wants to move, shock, provoke, and bewitch. The designer isn't afraid to talk about the things we prefer to keep quiet: he brings violence, sex, madness, and morbidity to the catwalk. It's never gratuitous; his collections and their presentations are nourished with his passions and neuroses. Above all, he manages to distill poetry and a form of mysticism into his taboo subjects.

### VIOLENCE AT WORK

In March 1995, Alexander McQueen targets a subject he cares deeply about: the Scottish ethnic cleansing exercised by England during the 17th and 18th centuries. Of Scottish origin, he wants to represent the violence that his people were subjected to. He calls the presentation « Highland Rape ». Because that's what it is in his eyes: rape – of a territory, and a violence suffered by individuals. But this reference to rape disturbs critics. He is accused of aestheticizing sexual assault. It's true that certain garments are lacerated and torn, as if ripped off.

### AND SEX TOO

The tops are low-cut or show the breasts with effects of transparency that sometimes also reveal the pubis. And there are surprising silhouettes: pants and skirts with very, very low waists. These bumsters reveal the top of the buttocks. Alexander McQueen treats them like a décolleté on the chest.

### WAR OF THE WORLDS

In the fall of 1999, McQueen sends Shalom Harlow onto the catwalk, wearing a white dress similar to a tutu. She stops on a platform that begins to turn. The Swan by Camille Saint-Saëns plays while two robots splash her with paint. The designer was inspired by *High Moon*, an installation piece by Rebecca Horn, where two weapons clash with paint. He questions the creative process in all its violence and fetishism.

### A NEW BODY

Showing backside cleavage with aplomb? That's not the creator's intent. He says that his true goal is to experiment with the elongation of the body. He wants to show off the lower spine and the curve it makes as it meets the buttocks, how aesthetically pleasing and erotic it is. The bumster could have been yet another sexual tribute, but, in his hands, it's a mutation.

*Next page:*
**Alexander McQueen,** Fall/Winter 1996 show, London

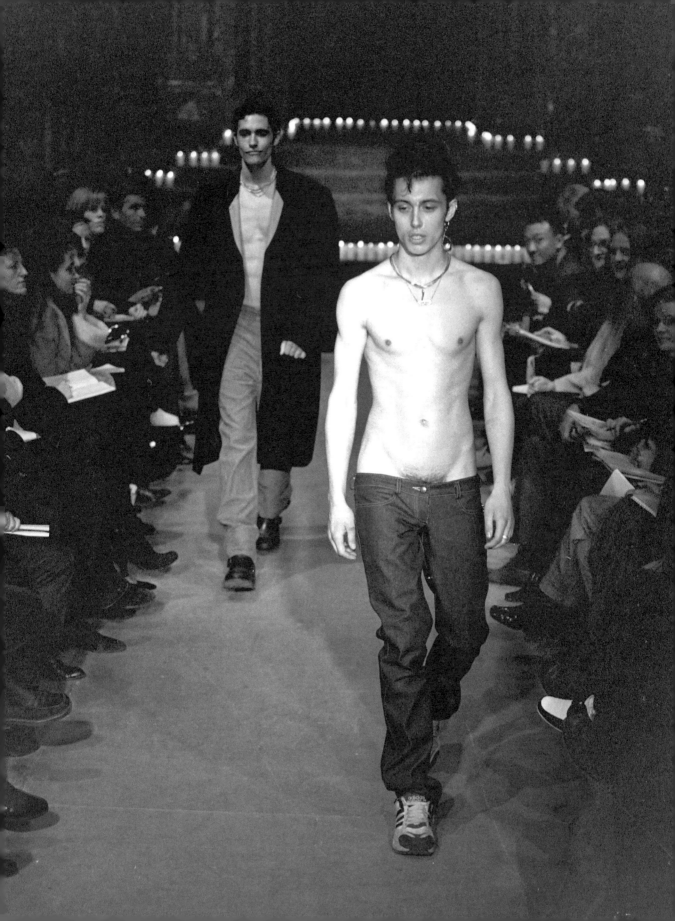

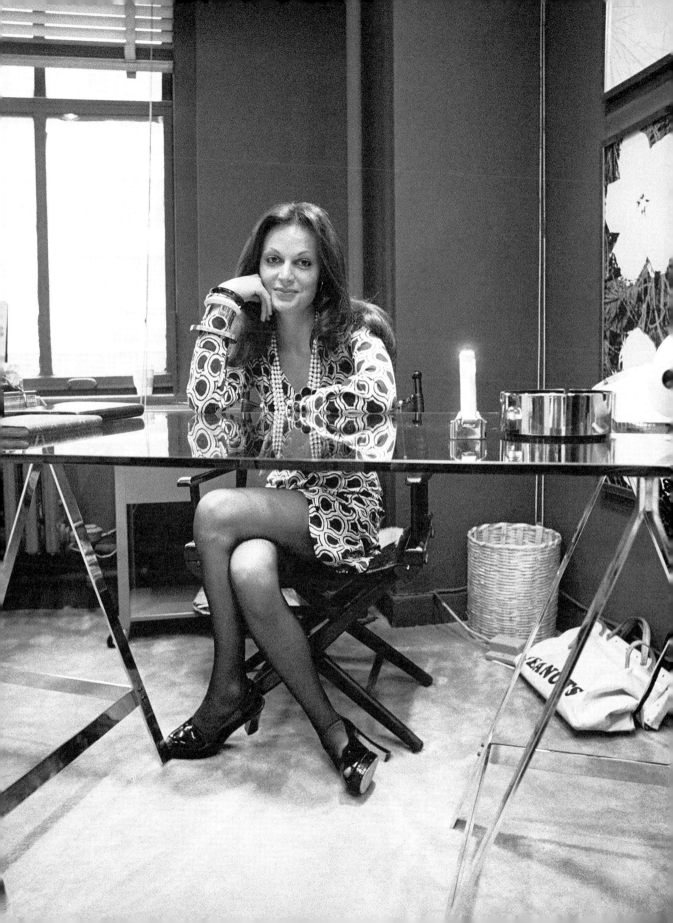

# WRAP DRESS
## LIBERATED WOMEN

| DESIGNER | DIANE VON FÜRSTENBERG *(p. 353)* |
|---|---|
| DATE | 1974 |

Draping a garment around the body is an ancestral gesture – simple, practical, and sensual. In a decade that liberates women from their shackles, Diane von Fürstenberg, ambitious autodidact, turns the gesture into an attribute of the active woman. In a matter of a few years, the designer builds an empire.

↑ Twigs Wrap Dress, Diane von Fürstenberg

**IN NUMBERS**

**1 dress** that becomes iconic

**2 portraits** by Andy Warhol

**25,000 models** sold per week in the 1970s

**29 years and 1 cover** of *Newsweek*

**Studio 54** : mythical nightclub where she spends time with the hottest celebrities

**15,000 prints** available

**1983** : when she sells her company

**1997** : when her brand is relaunched

### SIMPLE AND EFFICIENT
At a time when New York is already praising the young designer who arrived in 1974 with silhouettes designed in Italy, Diane von Fürstenberg hits a home run: she creates a printed wrap dress in cotton jersey that drapes over the bust and ties at the waist. Effortless, wrinkle-free, and easy to wash and wear, it answers to the needs of active women. Its success is immense.

### WORKING GIRL
The 1970s open more and more professional doors for women. They are emancipated and juggle between family life and career. They want to be credible in meetings while still feeling beautiful. The wrap dress, knee-length and low cut at the chest, blends modesty and sensuality.

### WOMEN'S BUSINESS
The dress adapts to all shapes, sizes, and ages. Ally of busy women, it is as wearable for the day as for the night. As a young, newly divorced mother of two young children who runs an empire during the day and goes to Studio 54 at night, Diane von Fürstenberg is her own muse and a perfect example of the femininity that she honors.

« IF YOU ARE TRYING TO SLIP OUT WITHOUT WAKING A SLEEPING MAN, ZIPS ARE A NIGHTMARE. HAVEN'T YOU EVER TRIED TO CREEP OUT OF THE ROOM UNNOTICED THE FOLLOWING MORNING? I'VE DONE THAT MANY TIMES. »

DIANE VON FÜRSTENBERG

### A DRESS, NOT PANTS
The wrap dress becomes an accomplice in women's emancipation. It is worn by a dynamic Cybill Shepherd in *Taxi Driver* by Martin Scorsese and becomes a feminist archetype even though women can finally freely wear pants. The designer wants to show women that it isn't necessary to borrow from men to assert themselves.

*Previous page :*
Diane von Fürstenberg, New York, 1972

# SPEEDY BAG
## AT FULL SPEED

| | |
|---|---|
| DESIGNER | LOUIS VUITTON |
| DATE | 1930 |

As soon as the brand is founded in 1854, Louis Vuitton puts travel at the heart of its approach. The company develops trunks and luggage but also extravagant and practical necessities for wealthy adventurers who seek the pleasures of evasion without renouncing luxury and comfort.

↑ **Speedy Bag**, Louis Vuitton

« THIS VUITTON MONOGRAM IS SORT OF THE *MONA LISA* OF THIS COMPANY. »

MARC JACOBS

**A MASTER'S CANVAS**

In 2001, Stephen Sprouse covers the Speedy bag with graffiti, while in 2003, Takashi Murakami stamps it with her colorful pop universe. In 2012, Yayoi Kusama sprinkles it with her legendary dots. And in 2017, Jeff Koons turns it into a backdrop for the greatest paintings in the history of art in a controversial and kitsch collection for a Speedy bag that playfully dialogues with the times.

**LUXURY BRAND**

Counterfeiting is not a new phenomenon; the brand has suffered from it since the beginning. In the 1880s, Louis Vuitton offers one-of-a-kind motifs, including the checkerboard in two shades of brown. But there is nothing that can be done; imitations proliferate. It's his son, Georges Vuitton, who, in 1896, designs the monogram of the brand: an L and a V intertwined, accompanied by stylized floral motifs. A signature becomes an emblematic canvas.

**WORLD TRAVEL**

In 1930, the world is in movement. From the jet set, who discover the exhilaration of aviation to the laborers enjoying paid vacations in some countries, travel is on the rise. For Louis Vuitton, it's the primary purpose of his designs. Since the middle of the 19th century, the brand has been adapting to changes in customs and to technological advances. With the invention of automobiles making travel more accessible, people can leave town on a whim, leading Vuitton to create the Keepall, the first soft travel bag.

**FASTER**

Seeking easier handling, the house develops the Express, Keepall's little brother. It's a travel bag that measures 12 inches, meant for small personal effects. Soon renamed Speedy in order to conform to the international renown of the brand, it is an immense success. And it's about to get an extra boost.

**HANDBAG**

In the 1960s, it changes its identity: Audrey Hepburn, fan of Louis Vuitton bags, orders a reduced-size version of the Speedy from the house. Her wish is granted, and a 10-inch model is born. The tone changes: from travel bag, it transforms into handbag, and, promoted by the star, it sees its sales skyrocket.

**ART AND FASHION**

The Speedy establishes itself in the fashion landscape, both as a legacy object and a seasonal accessory. Marc Jacobs, creative director of Louis Vuitton beginning in 1997, encourages reworking the house's greatest classics. Contemporary artists, one after another, create original pieces that interrogate the commercial link between art and fashion and that enter the Speedy into the battle of trends.

# IT'S IN THE BAG

## BAGS THAT ARE CARRIED BY HAND

## BAGS THAT ARE WORN ON THE BACK

## BAGS THAT ARE WORN ON THE SHOULDER

TOTE BAG

CROSSBODY BAG

SHOULDER BAG

BAGUETTE BAG

BUCKET BAG

SATCHEL

## BAGS THAT ARE WORN AROUND THE WAIST

WAIST BAG

FANNY PACK

# ANTIBACTERIAL FABRIC
## PROTECTIVE CLOTHING

**DESIGNER** ............... COPERNI *(p. 352)*
**DATE** ............... 2020

The runway shows of 2020 have a particular flavor. A few months before, the world discovered a threat that until then was relegated to disaster movies: a pandemic. Between lockdowns and social distancing, a new lifestyle emerges. Coperni demonstrates what tomorrow's – or even today's – wardrobe could look like.

↑ C+ Zip Bodysuit, Coperni

« WE LOVE PROGRESS, INNOVATION, AND SCIENCE. COPERNI IS A MIX OF THE FUTURE AND THE PAST. »

ARNAUD VAILLANT

### BACK TO THE FUTURE
The Parisian brand, led by Arnaud Vaillant and Sébastien Meyer, presents a minimalist and futuristic aesthetic with black-and-white monochromes, sometimes enhanced by vivid shades. In a nod to another era of newness and uncertainty, the collection has a spatial air reminiscent of the 1960s « Space Age » style (p. 267) (which isn't surprising – the duo previously worked at Courrèges). But whereas the 1960s were full of promises, the decade beginning with 2020 produces a great deal of anxiety. What to do when facing the unknown? Create and imagine a future in accord with different needs.

### IT'S TIME FOR SPORTS
Coperni notices that we have never devoted ourselves so entirely to physical activities as during the pandemic. They are a rare escape during months of lockdown. Their runway show evokes sportswear and its technicity, essential to well-being and performance. Clothing becomes a second skin and accompanies each gesture. A body already subjected to a trying ordeal doesn't need additional constraints.

### THE SPIRIT OF INNOVATION
Innovation motivates the two designers to consider a taut, flexible, sculptural material that hugs the body and creates shapes similar to origami. The show's highlight, however, is the C+ anti-UV synthetic jersey, which is anti-slip, moisturizing, and anti-bacterial. The intelligent garment isn't anything new in the textile industry, but its usage in fashion is unusual, probably because of its non-aesthetic connotations.

### SANITARY FASHION
Should we integrate health into fashion? The pandemic shows us that it is perhaps time to do so. The body is linked to appearance, so it should be central to fashion, not only in its decorative form but also in its organic essence. The future is now.

### TECHNO CHIC
Technology is essential to the brand's DNA. In September 2023, two men in black spray a solution on naked model Bella Hadid. In contact with her skin, the product transforms into a dress, thanks to spray-on fabric invented by the scientist Manel Torres.

# URBAN LUXE
## STREET IS CHIC

| | |
|---|---|
| **DESIGNER** | VIRGIL ABLOH FOR LOUIS VUITTON *(p. 350)* |
| **DATE** | 2021 |

Since the 1990s, urban culture has significantly influenced fashion aesthetics, and urban elements are now a standard of contemporary style. The exaltation of streetwear provides a new commercial vocabulary. The luxury industry, constantly seeking renewal, understands this well. It is in this context that Louis Vuitton hires Virgil Abloh.

↑ **Neo Porte Documents Voyage,** Virgil Abloh for Louis Vuitton, 2021

« **COMPOSING WITH SAMPLES IS TO UNDERSTAND THAT CREATION IS UNLIMITED.** »

VIRGIL ABLOH

### MULTITALENTED

As a DJ, Virgil Abloh mixes new sounds from samples. Creating something new from existing works is at the core of his exploration. A former architecture student, he composes in fields as varied as furniture design, fashion, and contemporary art, redefining fragments of our culture without ever ranking his references. From the street to conceptual art, everything has its place.

### FASHION FOR THE STREET

Artistic director of Louis Vuitton's menswear collection from 2018 until his premature death in 2021, the American designer applies his appreciation for streetwear to his creations. Since the 1990s, the dialogue between street and luxury has been well established. Virgil Abloh redefines those codes for a younger and more diverse public. He addresses a public that resembles him. And as a Black man in the middle of a prestigious luxury house, he is a symbol. The gesture, as political (and strategic) as it is stylistic, is not insignificant.

### CREATIVE CAPSULES

**2011** : with rappers Jay-Z and Kanye West for the album *Watch the Throne*
**2016** : Moncler
**2017** : IKEA
**2018** : Takashi Murakami
**2020** : Mercedes
**2021** : Nike

### THE INDIVIDUAL...

For his Fall/Winter 2021 collection, Virgil Abloh interrogates his identity as a man and as a child of immigrants by probing men's clothing in the public space. He blends traditional Ghanaian fabrics and costumes, archetypes of Western fashion, tartans, cowboy boots, and sweatshirts. He imagines a panel of stereotypes based on appearance, depicting an artist, a gallerist, and a salesperson, among others, to better deconstruct those cliches.

### ... AND THE REST OF THE WORLD

Airplanes are omnipresent alongside puffer jackets with relief maps of two cities: Paris and Chicago. Like an irrefutable observation or an unrelenting question: can we be at home everywhere? Will the Black man remain an eternal tourist in the spaces conceived of and dominated by White people?

### COMPOSITE

The first model on the runway is the poet Sail Williams. He pronounces names, convoking inspiring ghosts: "Akhenaton, [Frida] Kahlo, [Allen] Ginsberg, Gandhi, [Billie] Holiday, [Miles] Davis, [Toni] Morrison, [Janis] Joplin, [Jimi] Hendrix, [Federico] Fellini, Nefertiti..." Virgil Abloh is also inspired by *Stranger in the Village*, an essay by James Baldwin evoking a village where inhabitants have never seen a Black man.

*Next page :*
**Louis Vuitton,** Fall/Winter 2021 show, Paris

# RED COUTURE
## EMPIRE OF SENSES

| | |
|---|---|
| **DESIGNER** | VALENTINO *(p. 354)* |
| **DATE** | 1960s |

Legend has it that when he is still a young student who hasn't yet founded his famous brand, Valentino Garavani is enchanted by a woman in a red velvet evening gown at the Opera in Barcelona. This dazzling vision will stay with him, and red will become his almost sacred signature.

↑ **Red Poplin Dress**, Valentino

« **ELEGANCE IS A BALANCE BETWEEN PROPORTION, EMOTION, AND SURPRISE.** »

VALENTINO

### GOOD LUCK CHARM
After working with couturiers Jean Dessès and Guy Laroche in Paris, the young Italian apprentice decides to open his own house in Rome in 1959. He calls it Valentino. Already in his first show, red is represented by a bustier cocktail dress called « Fiesta » that evokes the designer's Italy: festive, impertinent, and elegant. Each subsequent collection features a mandatory red dress as a good luck charm.

### QUEEN OF COLORS
His choice of the color red isn't meaningless. The shade evokes power: he is an Italian couturier placing himself as the descendant of Roman emperors. There's a grandiloquence to Valentino's gesture but also an assertive commitment to traditional refinement and a familiar, reassuring classicism. His clients know that behind his romantic designs lies the self-assurance of a decisive red. Romantic, yes, but not naïve.

### RED VALENTINO
Recognizable, it wears its own identity. And yet, in 1968, it is a collection entirely realized in white and a wedding dress, also white, designed for Jackie Kennedy for the day she becomes Onassis, that propel the designer onto the international stage. It's almost as if the immaculate canvas is necessary for the red to assert itself all the more.

### TO EACH THEIR SHADE
Valentino isn't the only couturier to have a favorite, lucky color. Jeanne Lanvin has her blue, Elsa Schiaparelli has fuchsia pink, Cristóbal Balenciaga black, Christian Dior gray, and Martin Margiela white.

### COMMON THREAD
In 2008, Pierpaolo Piccioli and Maria Grazia Chiuri (the latter leaves for Dior in 2017) take on the creative direction of the house after the founder's departure. The Valentino vocabulary persists with incandescent and timeless red as the common thread.

### ITALIAN STYLE
After the war, Italy seeks industrial growth, especially in textiles. The government doesn't want the country to be merely a purveyor of fabric; they want it to be a country of fashion. In 1951, Giovanni Battista Giorgini launches the first runway shows that exhibit Italian style and make its couturiers known. Presented in Florence, they attract attention. The context is favorable: Hollywood makes movies like *Roman Holiday* in Italy, and legendary works of Italian cinema, like *La Dolce Vita*, are exported.

*Previous page:*
**Valentino** Fall/Winter 2021 runway show, Venice

# ROBE DE STYLE
## OLD-FASHIONED FASHION

| | |
|---|---|
| DESIGNER | JEANNE LANVIN *(p. 357)* |
| DATE | 1920s |

In the 1920s, not all women are bold and androgynous flappers. Knowing this, Jeanne Lanvin offers another vision of femininity: less daring, more traditional, and more accessible. Boring? No. Jeanne Lanvin offers a gentle transition for the timid.

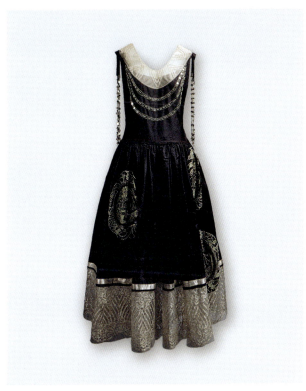

↑ Robe de style, Jeanne Lanvin, 1924

« AS FOR THE LANVIN NAME, IT WAS LINKED, FOR ME, TO THE MEMORIES OF YOUNG WOMEN IN ROBES DE STYLE, WITH WHOM I DANCED MY FIRST FOX-TROTS, CHARLESTONS, AND SHIMMIES. AT THE BALL, THEY WERE ALWAYS THE BEST DRESSED. »

GIANNI VERSACE

### A FORGOTTEN CORSET

Beginning in the 1910s, a weight is lifted from women's bodies—that of centuries of shaping their bodies to conform to the male gaze and their conception of beauty. With the corset gone, the body's shape is distinguishable under the fabric. This is a difficult adjustment when, for so long, the preference was for the artificial. The 1920s take a new direction: to exaggerated femininity, women respond with androgyny. But once again, under the guise of liberation, the same discourse is merely repeated once again, that which refuses to let women's bodies be just as they are.

### A REVISITED CRINOLINE

During the First World War, a style called « wartime crinoline » emerges. Its high waist and full skirt promote the fashion industry despite the conflict. Jeanne Lanvin adopts and perpetuates the style in the 1920s with dresses that borrow certain codes from the 18th century, like panniers that round the hips. However, she doesn't forget the imperatives of the decade: low waist, strong ornamentation, light top, close to the body, and fluid shapes.

### ROBE DE STYLE, LANVIN STYLE

The silhouette becomes her signature. It makes sense within a fashion house that values romanticism and a form of naivety inspired by Lanvin's early designs for her daughter and her clients' children. The voluminous skirt of the *robe de style* is reassuring: it suits all body types and women of all ages and from all different backgrounds. Her proposal is copied because outside of cities, it is easier to wear a *robe de style* than to become an impertinent flapper (p. 320).

### A SHADE OF HER OWN

Beginning in the 1920s, Jeanne Lanvin develops colors exclusively for her brand in her dye factory. She creates Lanvin Blue, inspired by the works of the Italian Renaissance artist Fra Angelico.

### FAR FROM CLICHÉ

Lanvin masterpiece, the *robe de style* contradicts stereotypes about the Roaring Twenties, years during which many women are intimidated by the injunctions of emancipation and extravagance.

*Next page:*
**Jeanne Lanvin** draping fabric on a model, 1930s

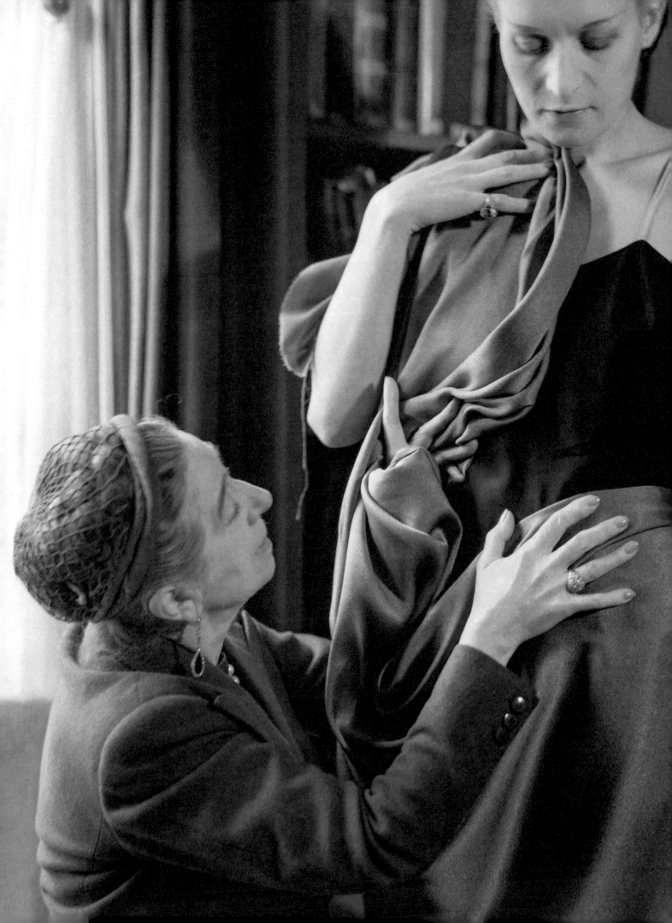

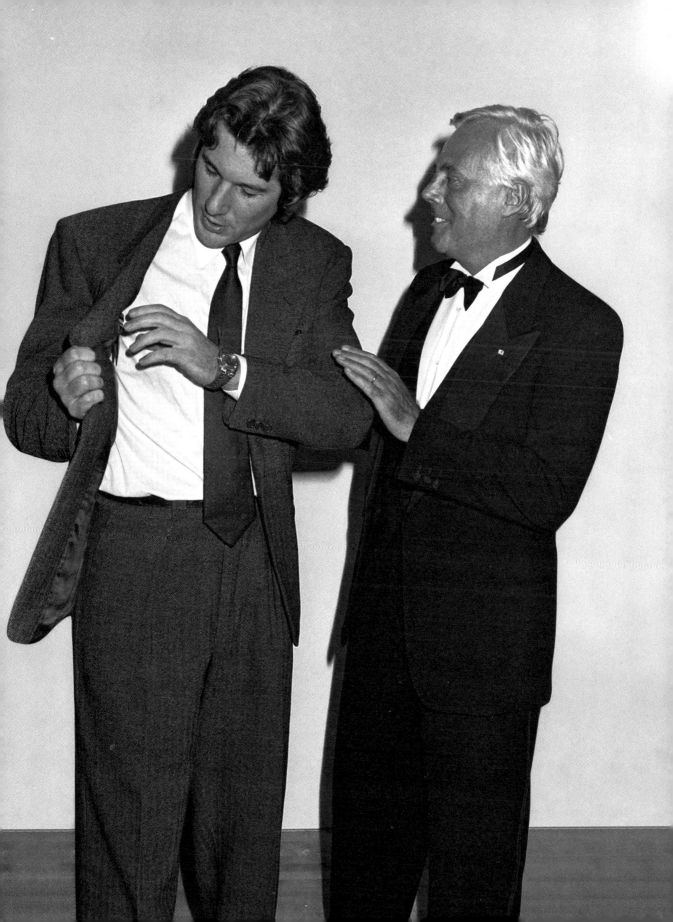

# ARMANI SUIT
## EMPIRE OF SENSES

| | |
|---|---|
| **DESIGNER** | GIORGIO ARMANI *(p. 350)* |
| **DATE** | 1975-1980 |

In the 1980s, power and money dominate. The materialistic, flashy decade empowers a new financial aristocracy. They are young and urban and get rich through speculation. They are called « yuppies ». Masculine power finds itself a uniform – a suit with confident shoulders.

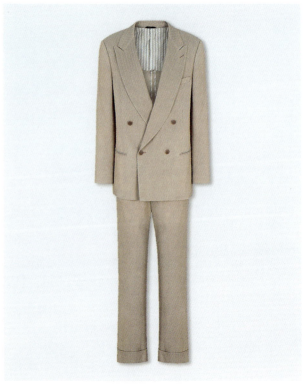

↑ **Heritage Suit**, Emporio Armani

### « I'VE CHANGED THE WAY PEOPLE LOOK, DEFINITELY. »
GIORGIO ARMANI

### MOVIE SUITS

Giorgio Armani quickly understands the influence of movies and television on trends, so he collaborates with a number of productions:

**1984** : *Miami Vice*
**1987** : *The Untouchables*
**1992** : *The Bodyguard*
**1994** : *Pulp Fiction*
**2000** : *Shaft*
**2008** : *The Dark Knight*
**2009** : *Inglourious Basterds*
**2013** : *The Wolf of Wall Street*
**2014** : *A Most Violent Year*

### POWER DRESSING

During this time, an Italian designer emerges: Giorgio Armani, who founded his brand in Milan in 1975. He makes the suit his specialty. Without entirely ignoring the power dressing trend of the era, which promotes geometric shoulder pads and double-breasted jackets inherited from the 1930s, Armani breathes a touch of modernity into his silhouettes.

### SECOND SKIN

The designer aims for more softness. Where suits (p. 189) are previously structured, like armor hiding the body, Giorgio Armani offers a new sensuality in a more fluid drape, more like a second skin. Powerful, yes, but not imposing. He is quickly nicknamed the « King of the Blazers », but a movie will bring him even more glory.

### AN ACTOR, A MUSE

In 1980, Armani accepts when John Travolta asks him to dress him for an upcoming film: *American Gigolo*. Travolta eventually backs out of the role, but Armani stays, and dresses a still virtually unknown actor named Richard Gere. Their collaboration will go down in the annals of history because the designer offers a previously ignored vision of the suit that is highlighted by the actor's carnality: its erotic power.

### THE SUIT OF AN ERA

The film is a living advertisement for Armani. Richard Gere's silhouettes are copied. At the same time, the designer launches his first international prêt-à-porter collection. The brand dominates the menswear market until the 1990s, when entrepreneurs opt for a more casual look. Still, before society leaves the suit behind, Armani redefines how it is worn.

### NEW WORD

The word « Yuppie » appears in the 1980s and means « Young Urban Professional ».

*Previous page:*
**Richard Gere and Giorgio Armani,** Fall/Winter 1988

# MONOKINI
## JOKES ASIDE

| DESIGNER | RUDI GERNREICH (p. 354) |
| --- | --- |
| DATE | 1964 |

Austrian-American designer Rudi Gernreich shocks, not for gratuitous provocation, but because he interrogates societal norms of his time, especially those that pertain to the body, sexuality, and gender. He believes in emancipation, liberty, and freedom from conventions.

↑ *Monokini*, Rudi Gernreich, 1964

« IF A BODY CAN NO LONGER BE ACCENTUATED, IT SHOULD BE ABSTRACTED. »

RUDI GERNREICH

### THE ORIGIN : THE BODY

Rudi Gernreich expresses himself first and foremost through dance. He knows the body's postures and movements. But not only: his first job is washing corpses at the morgue. In the 1950s, he sets out to work in fashion as a freelance stylist, but it's a 1964 design that will propel him into the spotlight. Urged by magazine stylist Susanne Kirkland to demonstrate the topless trend, he creates the monokini, a bathing suit composed of a bottom held up by straps over the shoulders.

### A PARABLE OF HIS TIMES

The bathing suit is first revealed in the pages of *Women's Wear Daily*, worn by the designer's muse, model Peggy Moffitt. He sells very few but is much talked about. Commentators and journalists underline his provocative aesthetic while applying its characteristics to the styles of the era. Gernreich's monokini becomes a parable of the 1960s: carefree, innovative, and scandalous. To see the designer as a revealer of women's bodies is to miss his point entirely.

### THE FUTURE IS NOW

In 1970, Rudi Gernreich reveals his vision of the future of fashion in *Life* magazine. The designer chooses bald and beardless models – a man and a woman who look like twins. Their bodies are bare when they aren't wearing similar clothing. For Gernreich, the future will abolish the notion of gender. His « Unisex Project » refuses the posture. He redefines binary structures, aiming to completely reinvent fashion. Rudi Gernreich's vision of the future is clairvoyant.

### EQUALITY

Undress the body? Yes, but not for exhibition. Gernreich effectuates a political statement. He shows that women's bodies don't have to be sexualized. He wants women's flesh to be as trivial as men's. With the monokini, he removes the top because men are allowed to do so. He knows that to expose is to remove the mystery. He denounces the hypocrisy of appropriating women's bodies and condemns those who decide when they should cover or uncover them.

### A FASHION ACTIVIST

Fashion is his field of expression. Tired of its demands and misunderstandings, Rudi Gernreich prefers to cease his role as designer at the end of the 1960s. Nonetheless, he continues to distill his thoughts and his « prophecies », like in 1970 with his « Unisex Project ». All that interests him is the body, in its purest essence—an androgynous body subject to social construction.

*Next page :*
Rose Williams in a Rudi Gernreich monokini, Hollywood, 1964

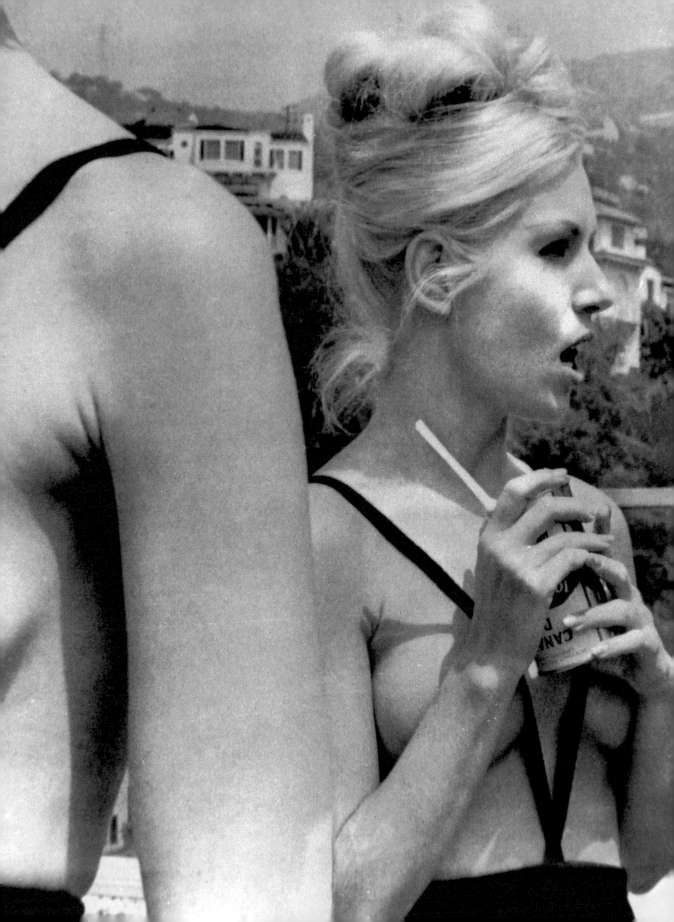

# MINI-CRINI
## UNDER WOMEN'S SKIRTS

**DESIGNER** ......... VIVIENNE WESTWOOD *(p. 362)*
**DATE** ......... 1985

Some contemporary designers revive historical characteristics to better interrogate sexuality, the body, and its representations. In the 1980s, it is a full-fledged movement; the trend uses historicism to express the creativity and spectacle of fashion.

↑ *Lace Mini-Crini,* Vivienne Westwood

### HISTORY REVISITED
Situating her style somewhere between traditional and irreverently punk, Vivienne Westwood plays with the outrageous misappropriation of historical fashion to thwart class and gender conventions. She shows how garments can create a social and identity-related status different from what is assigned at birth. In her hands, historical pastiche is destined for a new narrative. Women are, too. From submissive creatures stifled in restrictive garments, they rise into powerful figures.

### SHORTENED CRINOLINE
The crinoline (p. 223) is dead, long live the crinoline! By 1985, women haven't worn crinolines for a long time. But Vivienne Westwood, loyal to her historical reinterpretations, decides to bring it up to date for her Spring/Summer collection. Better still, she makes it the theme of her show « mini-crini ». The English designer offers shortened versions, creating an iconoclastic and sensual crinoline.

### FROM UNDER TO OVER
In the 19th century, the crinoline camouflaged. The 1985 version exposes. Initially, its name designates both the structure worn under clothes and the silhouette shape it creates. Vivienne Westwood plays with its first identity. Indeed, her mini-crini reveals its structural hoops, and the fabric, sometimes thick velvet, sometimes transparent embroidered lace, is reminiscent of petticoats. The intention is clear: to make the undergarment an outer garment without losing its intimate connotation. It is a deliberate nod to the garment's eroticism.

### A BODY OF ITS OWN
The designer offers a challenge: reclaim the body through playfulness. Without taking herself seriously, she accentuates a powerful discourse – a commitment that relies on a short skirt swaying with levity and determination.

> « MY CLOTHES HAVE A STORY. THEY HAVE AN IDENTITY. THEY HAVE A CHARACTER AND A PURPOSE. »
> VIVIENNE WESTWOOD

**IMPORTANT CAUSES**

Vivienne Westwood is a designer committed to activism, especially environmental. She isn't alone. Her compatriot Stella McCartney refuses to use leather, feathers, or fur in her designs. Gucci has also banned fur since 2018. In 2021, it's *Elle* magazine's turn: they announce a ban on fur in editorial and advertising content.

**ART EVERYWHERE**

The history of art and fashion is a consistent source of inspiration for Vivienne Westwood. In 1990, she designs a legendary runway show, the « Portrait Collection ». She reveals a flexible Lycra corset on which the 1743 painting *Daphnis et Chloé* by François Boucher is replicated. Reproducible and democratized, the classical repertoire becomes a wearable motif.

*Previous page:*
Vivienne Westwood, London, 2012

# GHILLIE SHOES
## PERCHED HIGH

| DESIGNER | VIVIENNE WESTWOOD *(p. 362)* |
| --- | --- |
| DATE | 1993 |

For her 1993-1994 Fall/Winter collection, the English designer Vivienne Westwood places her models on very high platform shoes. Her collection « Anglomania » is inspired by Scottish traditions. The designer reinterprets the ancestral dance shoes known as ghillies.

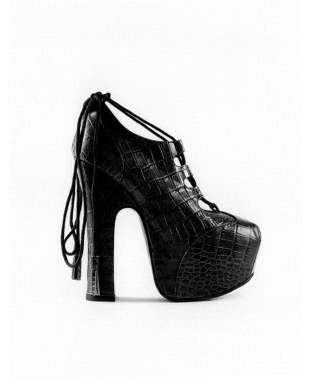

↑ Elevated Ghillie, Vivienne Westwood

### PUNK HERITAGE

This is not surprising, coming from Vivienne Westwood. After her years building the punk (p. 328) wardrobe of the 1970s, she continues to blend subversion and tradition. The runway show is a tribute to English style, from the Renaissance to the 1950s, distilling the Scottish heritage so often borrowed by the elite. With a tartan pattern (p. 178) conceived specially for the brand, the designer also pays homage to the art of punk misuse. It is a way to signify her legitimate presence among the big names of high fashion without forgetting her origins.

### VIEW FROM ABOVE

A pedestal. That is what these wild platform shoes seem like. She says it herself: these shoes elevate women, make them powerful and imposing. It's for this reason that she reintroduces platform shoes (p. 131) into 1990s fashion.

Various versions of the style have existed since ancient times in cultures as varied as the Ottoman Empire with its kabkabs, Japan with its geta sandals (p. 32), and the Venetians with their chopines. In the 20th century, it's Salvatore Ferragamo who brings them up to date in the 1930s and 1940s, before they become a signature of 1970s style.

### FROM FOLKLORE TO FASHION

From ghillies, similar to dance slippers in soft black leather, Vivienne Westwood conserves the ribboned lacing and the slits on the instep. She adds an extreme platform sole and a heel, modifying the entire vocabulary of the shoe, taking it out of folklore and into a mischievous and fetishistic universe where we again see her punk legacy.

### CHANGING HISTORY

The body, power, and eroticism are at the heart of the designer's exploration. And her whimsical ghillies reflect that. Rebellious and outrageous, they reveal another British history—a history where women are playful and independent heroines.

> « I USE FASHION JUST AS AN EXCUSE TO TALK ABOUT POLITICS. BECAUSE I'M A FASHION DESIGNER, IT GIVES ME A VOICE, WHICH IS REALLY GOOD. »
>
> VIVIENNE WESTWOOD

### FASHION VICTIM

During the runway show, one woman suffers from the ghillie shoes: the supermodel Naomi Campbell. She succumbs to the oversized platforms, is thrown off balance, and is the victim of a memorable fall from which she gets back up, laughing. It is a legendary episode of catwalk history. The Victoria and Albert Museum of London decides to acquire the purple ghillies worn by the model for their collection as a testament to fashion's torments.

# EXPOSED GENITALIA
## A SENSITIVE MAN

**DESIGNER** — RICK OWENS *(p. 359)*
**DATE** — 2015

Rick Owens is one of those designers who doesn't answer to trends. Multifaceted, he brings a liberated, almost anarchist air to his collections that interrogate the body and the world. The American designer asserts an aesthetic that dares to transgress, but never out of pure provocation.

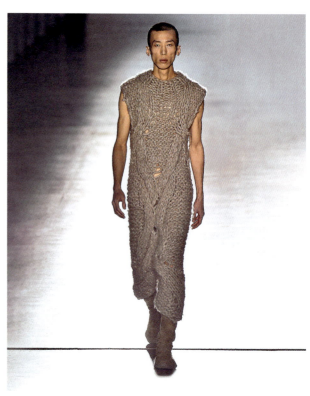

↑ Rick Owens collection, Fall/Winter 2015

> « ALLOWING YOURSELF TO BE VULNERABLE IS ONE OF THE MOST ATTRACTIVE THINGS YOU CAN DO. »
>
> RICK OWENS

### ANGRY

In September 2013, Rick Owens presents his summer collection: step dancers perform, choreographed by Lauretta Malloy Noble and her daughter Lee Anét, who breathe a touch of Zulu dance into the routine. These black women from U.S. sororities are powerful, with an almost military gait. Wearing menacing expressions, they move forward, combative. These strong women with bodies that transgress norms recount all the violence inscribed in the collective memory of their community.

### A SUBVERSIVE SIGNATURE

Even if Rick Owens has accustomed his audience to subversive runway shows examining clothing as a layer of skin that modifies the being, his Fall 2015 menswear collection might still confuse some.

### TWENTY THOUSAND LEAGUES UNDER THE SEA

Inspired by a film that takes place in a submarine, the show offers evocative pieces: peacoats (p. 127), sailor sweaters, and fabrics similar to the neoprene of diving suits. Here and there, he leaves traces of rust to evoke the ravages of the sea. Not surprising: the decay of bodies and nature is a leitmotif in his dystopian and civilizational work.

### MEN'S INTIMACY

But the submarine also refers to the way confined spaces push us towards shared intimacy. Owens parades men wrapped in slightly open tunics: some reveal the torso, others the ankles, and yet others expose genitalia. It's surprising, possibly shocking, but there is also something primitive in the designer's approach, like a reminder of the body's truth when it is rid of cultural and social pretexts.

### MYSTICISM AND PHYSICALITY

Rick Owens makes the runway show into a ceremonial affair. This is manifested in the ascetic material of the tunics, recalling the monk's habit. It also recalls Joseph Beuys's precious felt, which became part of his artistic vocabulary after saving his life during the war. For Owens, everything merges: spirituality and humanity, the invisible and the visible, the mind and the body. The show evokes the masculine strength we expect to see and the masculine vulnerability we authorize so little of.

### LAID BARE

In 1971, Yves Saint Laurent launches his first men's perfume, Pour Homme. The ad campaign features the designer photographed by Jeanloup Sieff. But Yves Saint Laurent is naked. The image is a scandal, refused by a number of media outlets. But it also reinvents the image of a profession, moving away from the rigorist figure of the white-coated couturier to create a new kind of designer – an iconic and captivating star.

# ETHEREAL TECHNOLOGY
## FUTURISTIC NATURE

**DESIGNER** — IRIS VAN HERPEN *(p. 355)*
**DATE** — 2010s-2020s

Creating work that is both art and fashion, Iris Van Herpen sculpts original shapes, often realized with unusual materials and techniques like 3-D printing and laser cutting. The Dutch designer creates fashion with textures and expressions that are both futuristic and organic.

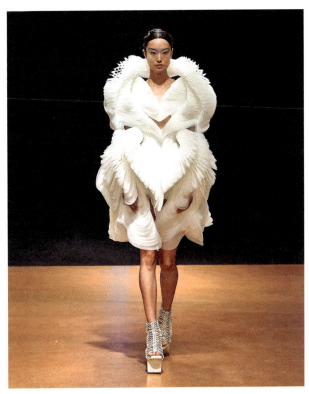

↑ Iris Van Herpen ensemble, Spring/Summer 2020

« I'M OFTEN INSPIRED BY THINGS I CAN'T SEE AND DON'T UNDERSTAND, BECAUSE IT GIVES MY IMAGINATION FREE REIN. »

IRIS VAN HERPEN

#### COUTURE AND TECHNOLOGY
Linking couture craft and technological innovation, Iris Van Herpen pushes creativity to its limits and interrogates the very contours of what a garment can be. Should it be practical or conceptual? In 2016, she designs a dress made of hundreds of hand-blown glass bubbles coated with silicone to simulate water droplets on skin. She also designs ethereal outfits with meticulous pleats. The two statements coexist.

#### OMNIPRESENT NATURE
At Iris Van Herpen, nature and technology come together. She seeks to give shape to that which we cannot see within our organic world. In 2008, it's industrial smoke, which she materializes with the help of metallic thread. In 2013, electricity comes to life in the form of flexible dresses, as if to express the energetic tensions that pass through us. While in 2010, she imagines dresses that evoke splashes of water.

#### VULNERABLE FASHION
Behind her intimidating silhouettes hide the poetry of our existence. Between armor and ornament, Iris Van Herpen's designs reveal powerful, sometimes unsettling demeanors. But she infuses them with lightness and the fragility of that which composes us and our world. These are ambivalences that she observed during her internship with Alexander McQueen.

#### A NEW REALITY
As a pioneer, Iris Van Herpen invites technology into fashion not to contradict it but to exalt it. Blurring the boundaries between real and digital, she anticipates a future of fashion that investigates the virtual.

#### ANOTHER WORLD
Iris Van Herpen's hybrid designs announce the arrival of a new era. With the development of virtual environments within which we can evolve, in a prolongation of our real existence, many brands are now betting on a presence in the metaverse. They are designing clothes and accessories, called wearables, to dress our avatars. Others are offering NFTs, digital acquisitions that blur the boundaries between the real and the virtual.

#### FREE FALL
At a moment when runway shows rival each other in creativity, Iris Van Herpen pushes the limits of possibility in 2021 by inviting the world champion of parachute jumping for the finale of her 18-look collection. Domitille Kiger makes a jump while wearing a dress in gradients of blue, expressing the immensity of the sky to evoke Planet Earth floating in the middle of space.

*Next page:*
**Iris Van Herpen** Fall/Winter 2019 runway show

PART 3

# STYLES

## 22 LOOKS

| | |
|---|---|
| Mods .................................................. *p. 304* | Hippie ................................................ *p. 326* |
| Glam rock ......................................... *p. 306* | Punk .................................................. *p. 328* |
| Decontructivism ............................. *p. 308* | Lolita ................................................. *p. 330* |
| Funk ................................................... *p. 310* | Blitz kids ......................................... *p. 332* |
| Normcore ......................................... *p. 312* | Ivy League ..................................... *p. 334* |
| Sapeur ............................................... *p. 314* | Emo ................................................... *p. 336* |
| Hip-hop ............................................. *p. 316* | Grunge ............................................. *p. 338* |
| Goth ................................................... *p. 318* | Black Panther ............................... *p. 340* |
| Flapper ............................................. *p. 320* | Techno ............................................. *p. 342* |
| Zoot suit .......................................... *p. 322* | Peacocks ........................................ *p. 344* |
| Dandy ................................................ *p. 324* | Teddy Boys & Girls ..................... *p. 346* |

# STYLE CHRONOLOGY

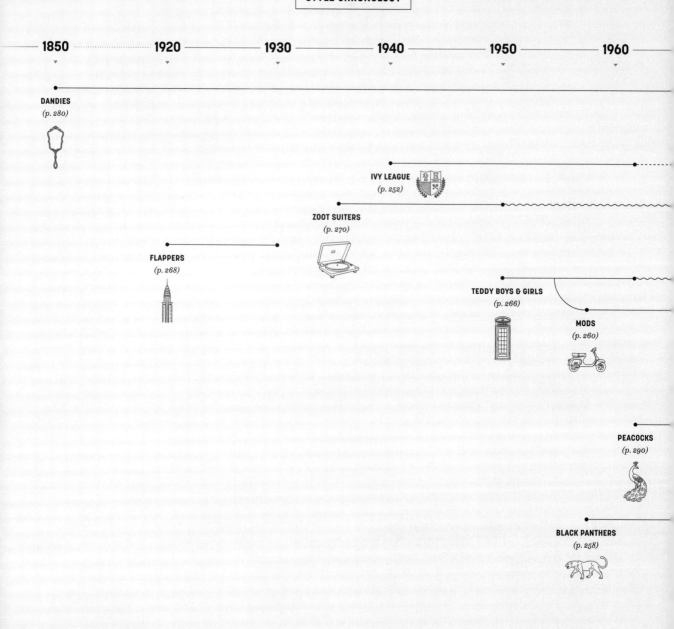

| 1850 | 1920 | 1930 | 1940 | 1950 | 1960 |

**DANDIES**
*(p. 280)*

**IVY LEAGUE**
*(p. 252)*

**ZOOT SUITERS**
*(p. 270)*

**FLAPPERS**
*(p. 268)*

**TEDDY BOYS & GIRLS**
*(p. 266)*

**MODS**
*(p. 260)*

**PEACOCKS**
*(p. 290)*

**BLACK PANTHERS**
*(p. 258)*

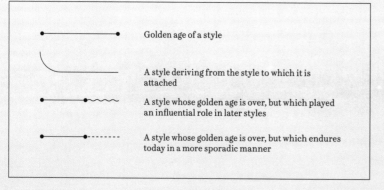

- Golden age of a style
- A style deriving from the style to which it is attached
- A style whose golden age is over, but which played an influential role in later styles
- A style whose golden age is over, but which endures today in a more sporadic manner

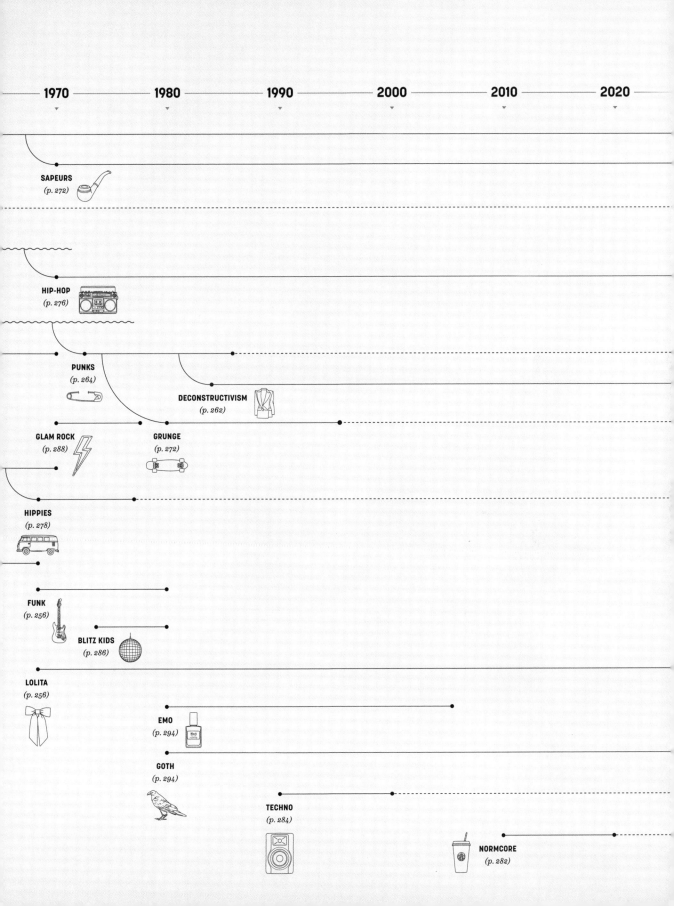

# MODS
## YOUNG AND HIP

| | |
|---|---|
| BIRTHPLACE | ENGLAND |
| PEAK | 1960s |

In the London neighborhood of Soho in the 1950s, there are the trads, who listen to traditional jazz, and the mods, who are interested in modern jazz, American soul music, R&B, and Jamaican music. The mods rapidly attract the attention of popular culture.

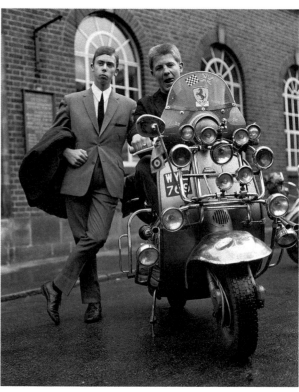

↑ Two young mods, London, 1964

> « ARTISTS AND MUSICIANS OF THE SIXTIES WERE DEFINITELY INTO CLOTHES. »
> 
> YOKO ONO

### A CLAN

The novel *Absolute Beginners* by Colin McInnes describes these middle-class teenagers fond of jazz, scooters, Italian clothes, French New Wave, and amphetamines. They are the heirs of the French existentialists and American beatniks and oppose the Teddy Boys (p. 346) while borrowing their taste for a sophisticated look that they protect with parkas as they speed along on their scooters.

### AN ERA

As Swinging London is swept into the frenzy of the 1960s, the movement expands beyond its countercultural roots and becomes a reference of style with its slim suits (p. 186), ties (p. 182), button-up shirts (p. 166), and ankle-boots (p. 61). The runaway success of the Beatles propels the popularity of the silhouette around the world.

Today the mod style has become the aesthetic catch-all of the decade. We now associate it with girls' miniskirts (p. 160) and their androgynous style. But the mod look is above all masculine. The mods fit perfectly into a decade where everything is fresh, young, and modern.

### STYLE WAR

In London, between the mods and the rockers, harmony is not in order. There are those who parade around on their scooters in tight Italian suits, and there are the others, showing off in leather jackets on their motorcycles. It's an ideological and stylistic war. They even provoke an actual physical conflict at Brighton Beach in 1964. It's an ironic opposition, considering that the two movements have the same ancestors: the Teddy Boys.

### LONDON IN PICTURES

Photographer David Bailey perfectly encapsulates 1960s Swinging London. His images reflect the energy of English youth, and he brings a spontaneous spirit to his fashion photography and a dynamic style to his high-angle shots. As famous as his subjects (he marries Catherine Deneuve), David Bailey serves as director Michelangelo Antonioni's inspiration for the photographer in *Blow-Up*.

### SECOND WIND

In 1973, the group The Who releases a rock opera composed by Pete Townshend: *Quadrophenia*. The album explores the history of a young mod, Jimmy, searching for his identity. The album and its 1979 movie adaptation – in which a young Sting has a role – are part of a nostalgic 1970s revival of the mod movement in England.

## MOD ATTRIBUTES AND REFERENCES

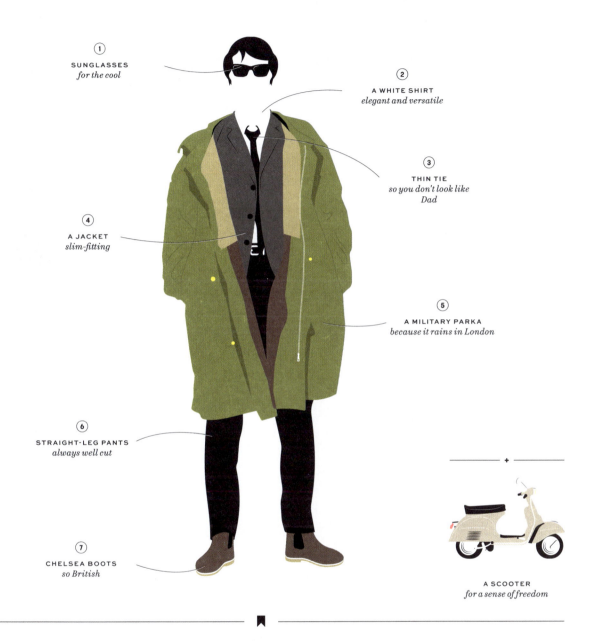

1. **SUNGLASSES** *for the cool*
2. **A WHITE SHIRT** *elegant and versatile*
3. **THIN TIE** *so you don't look like Dad*
4. **A JACKET** *slim-fitting*
5. **A MILITARY PARKA** *because it rains in London*
6. **STRAIGHT-LEG PANTS** *always well cut*
7. **CHELSEA BOOTS** *so British*

**+ A SCOOTER** *for a sense of freedom*

---

**FASHION**
Twiggy
John Smedley
Hedi Slimane
Mary Quant

**SPORTS**
Bradley Wiggins

**CINEMA**
*Quadrophenia*
Martin Freeman
Jamie Bell

**MUSIC**
The Kinks
Les Beatles
Small Faces

**INFLUENCED**
Oasis
Miles Kane
The Libertines

**FASHION**
Blur's *Parklife* video
Cathy McGowan

# GLAM ROCK
## EMBRACING KITSCH

| BIRTHPLACE | ENGLAND |
|---|---|
| PEAK | 1971-1975 |

Although it only lasts a few years, supplanted by punk from 1977 onwards, glam rock has a considerable impact, bringing previously marginalized underground styles and codes into the spotlight, where drag becomes mainstream, and music becomes the territory of exuberance.

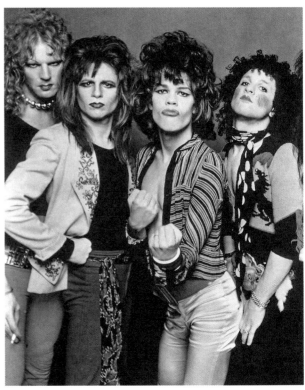

↑ New York Dolls, circa 1970

### MEN

Glam rock is, above all, a musical style that doesn't take itself seriously. It is rock stripped of the social and political demands of the 1960s. In the first half of the 1970s, it magnifies the cult of celebrity with glitter, boas, and platform shoes (p. 131). Incarnated by male groups, especially in England and the U.S. (there's also a Zambian version, zamrock, where musicians wearing XXL hats combine funk and rock), this theatrical style reinvents gender and performance norms.

#### THE DAVID BOWIE VERSION

**1972:** Ziggy Stardust
**1973:** Aladdin Sane
**1974:** Halloween Jack
**1975:** Thin White Duke

### GLITTER

The group T. Rex, led by Marc Bolan, launches the new style of comprehensive spectacle that falls somewhere between dandyism (p. 324) and cabaret. Men wear makeup, tight, shiny fabric, and long hair. There is no such thing as bad taste, only humor and extravagance. Glam rock rejects the conservatism that is so prevalent in 1970s England and spurns stereotypes of masculinity, sometimes with a sense of insolent provocation, like when David Bowie comes out as bisexual and poses in a dress. Puritanism is out.

« I WANT FUN NOW. LIFE IS HERE TO ENJOY. NOT TO COMPLICATE AND MAKE DIFFICULT. »

MARC BOLAN

### DRESSES

In December 2020, *Vogue* magazine puts a man alone on the cover for the first time. It's the British singer Harry Styles. Defying the dictates of gender, he wears a dress and jacket. David Bowie, who posed in a dress on the album *The Man Who Sold the World*, would have been proud.

### MAKEUP

It is said that glam rock is born in 1971. More precisely, on March 24th, when the group T. Rex is invited to play for the British music show *Top of the Pops*. The singer, Marc Bolan, seeks to bring a final touch to his silver outfit and long curly hair. He finds a solution in his girlfriend's makeup bag: he paints drops under his eyes with her glitter. His performance becomes iconic, and glam rock is born.

## GLAM ROCK ATTRIBUTES AND REFERENCES

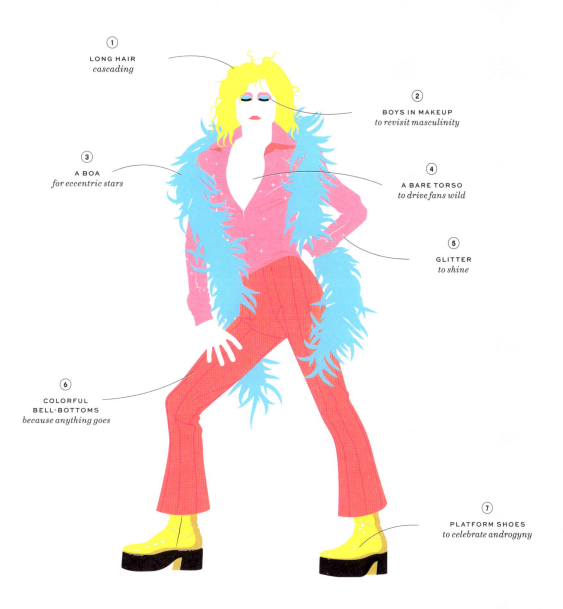

1. **LONG HAIR** *cascading*
2. **BOYS IN MAKEUP** *to revisit masculinity*
3. **A BOA** *for eccentric stars*
4. **A BARE TORSO** *to drive fans wild*
5. **GLITTER** *to shine*
6. **COLORFUL BELL-BOTTOMS** *because anything goes*
7. **PLATFORM SHOES** *to celebrate androgyny*

**FASHION**
Alessandro Michele for Gucci
Hedi Slimane
Jeremy Scott F/W 2017

**INFLUENCED**
Kate Moss

**MUSIC**
David Bowie
Elton John
Freddie Mercury
in the early days of Queen
T. Rex
Roxie Music
Runaways

**PHOTOGRAPHY**
Mick Rock

**CINEMA**
*The Rocky Horror Picture Show*
*Ziggy Stardust*
*Velvet Goldmine*

# DECONSTRUCTIVISM
## ANTI-FASHION

| BIRTHPLACE | JAPAN |
| --- | --- |
| PEAK | 1980s AND 1990s |

The philosopher Jacques Derrida first evokes deconstruction in the 1960s to define the reversal of the norms and traditions of the decade. Still, it isn't until a 1989 article by Bill Cunningham that the word deconstructivism is applied to fashion, and particularly to the work of Martin Margiela.

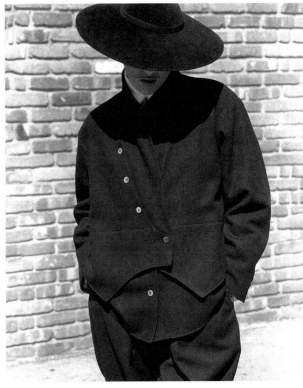

↑ **Yohji Yamamoto** Fall/Winter 1981 prêt-à-porter collection

### A PHILOSOPHY

The deconstructivist aesthetic is launched by Japanese designers Issey Miyake, Yohji Yamamoto, and Rei Kawakubo in the late 1970s. They are influenced by their culture, particularly the notions of wabi-sabi, which celebrates wear-and-tear and impermanence, and kintsugi, which sublimates imperfection. They defy stylistic conventions and offer a new vocabulary that alters the Western criteria of beauty in place since the Renaissance.

### LONG LIVE THE BRIDE AND GROOM

**October 1998:**
Yohji Yamamoto presents his collection to the tune of Mendelssohn's wedding march. The designer, fascinated by the rituals associated with marriage in the West, offers black-and-white looks that question and deconstruct fashion. The models walk down the catwalk and remove elements, transforming their silhouette to evoke the « layers » that constitute tradition and history but also to make space for modernity.

### AN APPEARANCE

Proponents of deconstructivism wear asymmetrical cuts, dark colors, and even dare to expose rips, holes, unraveled hems… everything that Western fashion scorns. This deconstructed look appeals to those who intellectualize their appearance and reject the ostentatious spirit of the 1980s, especially by wearing black. Above all, from deconstructivism flows the whole language of contemporary fashion, or rather, anti-fashion.

« I THINK PERFECTION IS UGLY. SOMEWHERE IN THE THINGS HUMANS MAKE, I WANT TO SEE SCARS, FAILURE, DISORDER, DISTORTION. »

YOHJI YAMAMOTO

### ART

Echoing counterculture movements, the fashion of the 1990s continues the deconstructivist aesthetic of the Japanese designers, particularly among the Antwerp Six, but self-taught Austrian designer Helmut Lang also offers a sensual and brutalist vision of the style.

### STRONGER TOGETHER

The Antwerp Six is the name given to six Belgian designers who graduated from Antwerp's Royal Academy of Fine Arts: Dirk Van Saene, Ann Demeulemeester, Walter Van Beirendonck, Dries Van Noten, Dirk Bikkembergs, and Marina Yee. These young graduates stand out at London Fashion Week in 1986. They are fueled by a desire to deconstruct elitist and flashy fashion norms, much like the Japanese designers.

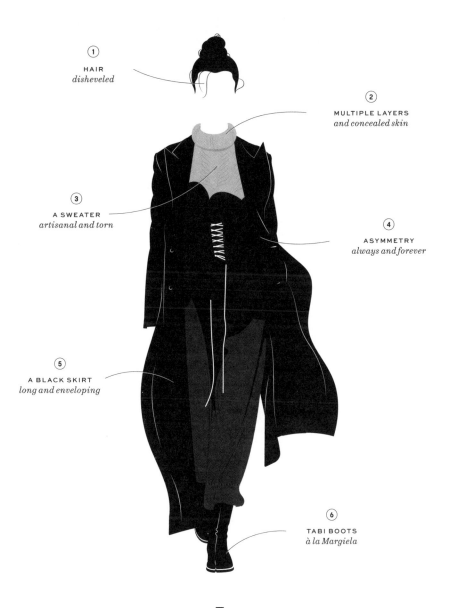

## DECONSTRUCTIVIST ATTRIBUTES AND REFERENCES

1. **HAIR** *disheveled*
2. **MULTIPLE LAYERS** *and concealed skin*
3. **A SWEATER** *artisanal and torn*
4. **ASYMMETRY** *always and forever*
5. **A BLACK SKIRT** *long and enveloping*
6. **TABI BOOTS** *à la Margiela*

---

**CINEMA**
Tilda Swinton
*Mad Max*
*Dune*

**ICONS**
Vivienne Westwood
Jean-Michel Basquiat

**FASHION**
Yohji Yamamoto
Rick Owens
Comme des Garçons
Issey Miyake
Martin Margiela
Ann Demeulemeester
Helmut Lang
Demna for Balenciaga

**ARCHITECTURE**
Zaha Hadid

**MUSIC**
David Bowie
in the 1990s
Lady Gaga

# FUNK
## SOUNDTRACK

| BIRTHPLACE | NEW ORLEANS |
| --- | --- |
| PEAK | 1970s |

The 1970s are an era of individual and collective emancipation. Ideas, sexual orientation, culture, and intimate battles are affirmed. The body accompanies this liberation with outfits and accessories that reflect desires and demands. Popular culture plays a decisive role in establishing a rich visual culture.

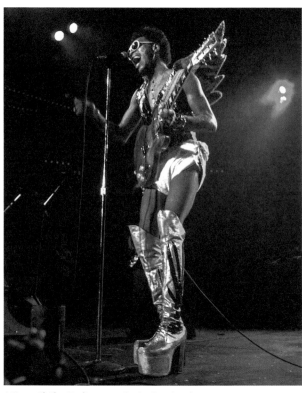

↑ **Garry Shider**, Parliament guitarist, Los Angeles, 1977

### A PHENOMENON

Funk music is a descendant of soul and jazz and synthesizes Black American music of the 1950s and beyond. It builds on the syncopated, raw, and fierce expression of improvisational jazz before becoming a major cultural phenomenon in the 1970s. Funk accompanies the soundtracks of Blaxploitation, a film genre that principally addresses a Black, urban audience.

### A CLICHÉ

The genre's movies depict stereotypical characters (pimps, gangsters, dealers), especially among the men (even if the actress Pam Grier distinguishes herself in this category). Funk asserts a virile masculinity that's eroticized to excess. When these movies exaggerate the realities of violence, crude language, and sexuality, they use clichés to denounce those formed by the White community.

### AN EMANCIPATION

Funk singers and groups then borrow from Blaxploitation film characters and wear platform shoes (p. 131), bell-bottom pants, leather, and chains, but also traditional African garments like the dashiki (p. 114) and the kufi (p. 111) in order to highlight origins previously stigmatized and ignored. Funk sexualizes the body to assert its emancipation more effectively. It shows that the Black community isn't reduced to servitude and pain; it also exults, thrives, and rejoices.

> « GET ON UP,
> STAY ON THE SCENE,
> GET ON UP,
> LIKE A SEX MACHINE. »
>
> JAMES BROWN

### MASCULINITIES

Since 2019, the British designer Grace Wales Bonner has been exploring clothing styles cultivated by the global African diaspora. Even if she designs for women as well as for men, questions surrounding Black masculinity intrigue her and push her to analyze and interpret its cultural and intimate representations.

### TV SHOW

In the U.S. in 1971, a new musical show called *Soul Train* appears on national TV. A rare program made by the Black community for the Black community, it lasts until the 2000s and meets with considerable success. Michael Jackson and Stevie Wonder both appear on the show. All of America discovers soul and funk music. To be able to dance on the show, style matters; it is the most extravagantly dressed that are selected.

## FUNK ATTRIBUTES AND REFERENCES

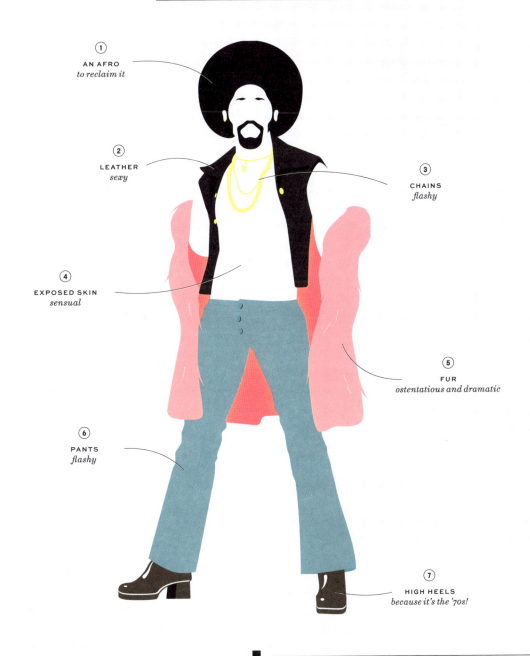

1. AN AFRO — *to reclaim it*
2. LEATHER — *sexy*
3. CHAINS — *flashy*
4. EXPOSED SKIN — *sensual*
5. FUR — *ostentatious and dramatic*
6. PANTS — *flashy*
7. HIGH HEELS — *because it's the '70s!*

**INFLUENCED**
Prince
Lenny Kravitz

**CINEMA**
*Superfly*

**MUSIC VIDEOS**
*Uptown Funk*, by
Mark Ronson
and Bruno Mars

**FASHION**
Gucci

**MUSIC**
James Brown
Sly and the Family Stone
Nile Rodgers
George Clinton
Rick James

# NORMCORE
## A NEW NORMAL

| BIRTHPLACE | NEW YORK |
| --- | --- |
| PEAK | 2010s |

What if fashion wasn't a social issue but simply a routine? That's what normcore style is all about – leaning into the mundane, blending in with the masses, and ignoring the notion of style.

↑ **Sofia Coppola**, Armory Show, New York, 2009

### DAILY LIFE

Normcore hides its cards well because nothing is more arduous than trying to seem natural. The origin of this term, pronounced ironically in New York during a contemporary art fair in 2013, signifies this ambivalence since it's a contraction of « normal » and « hardcore » : radical banality. The problem with normcore lies in the very question of normality.

### ON THE MOVE

In the fashion photography of the 1990s, the prevailing aesthetic is raw, more like everyday life. British photographer Corinne Day specializes in realistic images that eschew posing or staging. Her models exhibit a relaxed look, undone hair, and little makeup. She discovers a very young Kate Moss, whose career she launches.

### CHIC...

One designer anticipated normcore: Phoebe Philo. Named creative director of Celine in 2008, she refreshes the image of the house and its allure with elegant, severe, sometimes ascetic looks. She links deconstructivist and minimalist references to create classic, essential fashion that generates a veritable cult following.

### ... AND SHOCK

Normality is also banality, even triviality. In 2014, Celine revisits the plaid pattern of the "sac Barbes," a plastic tote bag created by the French discount store Tati, located in the Barbès neighborhood of Paris. The bag quickly becomes a symbol of immigration and diaspora after its creation in 1962. More surprisingly, the brand Vetements offers a yellow T-shirt with the DHL logo in 2015, and Balenciaga offers reinterpretations of Crocs in 2017.

« I WOULDN'T WANT TO EVEN TRY TO BEGIN TO DESCRIBE OUR CUSTOMER, AS I THINK SHE LIKES A CERTAIN AMOUNT OF ANONYMITY. I TRY TO OFFER CLOTHES THAT ALLOW THAT. I MYSELF DO NOT LIKE BEING DEFINED SO READILY, SO I IMAGINE THAT SHE IS SIMILAR. »

PHOEBE PHILO

### PERFECTIONISM

What does normalcy look like in fashion? Is it our teenage cousin in a sweatshirt (p. 55) and jeans (p. 136)? Our grandfather in corduroy pants? A discreet First Lady? A conventional businessperson? Normcore takes inspiration from all these people without ever looking like them and builds a style where nothing is left to chance, from the perfect fit of the pants to the careful choice of trendy sneakers (p. 92). Normal, in the hands of normcore wearers, becomes a perfectly studied look.

## NORMCORE ATTRIBUTES AND REFERENCES

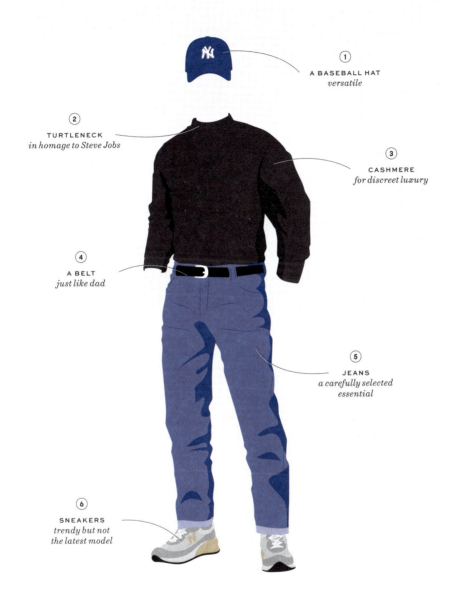

1. **A BASEBALL HAT** — *versatile*
2. **TURTLENECK** — *in homage to Steve Jobs*
3. **CASHMERE** — *for discreet luxury*
4. **A BELT** — *just like dad*
5. **JEANS** — *a carefully selected essential*
6. **SNEAKERS** — *trendy but not the latest model*

**FASHION**
Gap
APC
Phoebe Philo
Gosha Rubchinskiy F/W 2015

**CINEMA**
*The Equalizer*
Ben Affleck
Matt Damon

**TV**
*Seinfeld*
*Friends*

**SEEN ON**
Steve Jobs
Leonardo DiCaprio
Sofia Coppola
Larry David

# SAPEUR
## REFUSING INVISIBILITY

| BIRTHPLACE | CONGO |
|---|---|
| PEAK | SINCE THE 1960s |

Mobutu Sese Seko becomes president of the Democratic Republic of Congo in 1965 following a coup d'état. He rejects Western attire with the abacost movement (« à bas le costume » or « down with the suit »). Suits and ties are banned in favor of a light jacket, often with short sleeves, worn without a shirt underneath.

↑ Congolese sapeurs, Brazzaville, 2008

### POLITICAL

In protest, the Sape (Société des Ambianceurs et des Personnes Élégantes or Society of Ambiance-makers and Elegant People), in the tradition of 19th-century dandies (p. 324), seeks to subvert those codes in Brazzaville and Kinshasa. Sapeurs adopt European behaviors, thus rejecting the authority of the head of state. In the 1970s, members of the Congolese diaspora in Belgium and France appropriate the three-piece suit, accessorize lavishly, and sometimes wear flashy colors.

### INTIMATE

Wearing the colonizers' clothes to emphasize emancipation, the sapeur wants to be noticed and accords great importance to the visibility of a brand or a logo. Sape is about disguising oneself to forget the difficulties of everyday life; it's resilience through fashion. A sapeur conspicuously occupies the public space to shine in the places where he is otherwise excluded. He is always seen as foreign: immigrant on one hand, Parisian on the other. If you're going to stand out, you might as well do it with panache.

### SAPE DICTIONARY

**Diatance :** proud and dramatic gait

**Déka :** to walk with elegance

**Démarrage :** improvised fashion show

**L'œil de l'aigle en suspension :** observing a sapeur whose elegance you appreciate to then reinterpret it

**Ngaya :** non-connoisseurs

**Maintenir la pression :** to remain élégant in all circumstances

> « WHITE MEN INVENTED THE SUIT; WE'VE TURNED IT INTO ART. »
>
> PAPA WEMBA

### SAPEURS IN SONG

In 2012, Solange directs the video for her song « Losing You ». Fascinated by the book *Gentlemen of Bacongo*, she wants to shoot in Brazzaville, surrounded by local sapeurs. For logistical reasons, the video ends up taking place in South Africa, where Solange finds a community of sapeurs to be in her video.

### WHERE FASHION HAPPENS

Reducing the fashion industry to the Paris-Milan-London-New York quartet is completely obsolete. In France, the idea of fashion in service to power and cultural influence develops under Louis XIV. The 20th century sees the emergence of centers such as Milan, Florence, London, and New York. Now, there are centers in Japan, China, India, and Brazil. Young designers also reinvent fashion in Nigeria, Ghana, South Africa, Mexico, and South Korea.

## SAPEUR ATTRIBUTES AND REFERENCES

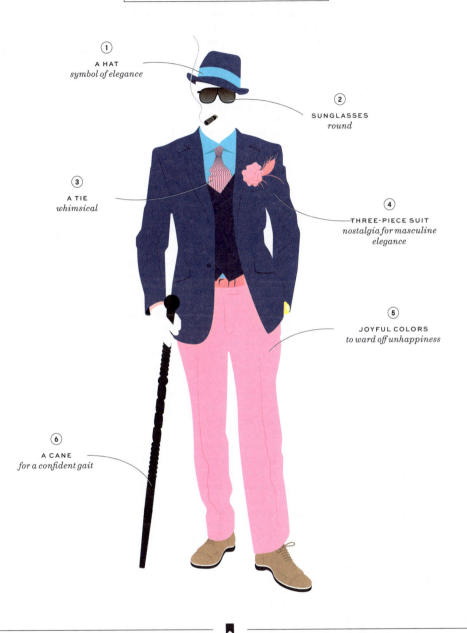

1. **A HAT** — *symbol of elegance*
2. **SUNGLASSES** — *round*
3. **A TIE** — *whimsical*
4. **THREE-PIECE SUIT** — *nostalgia for masculine elegance*
5. **JOYFUL COLORS** — *to ward off unhappiness*
6. **A CANE** — *for a confident gait*

**CINEMA**
*Black Mic Mac*

**MUSIC**
The song « Sapés comme jamais »
(« Dressed up Like Never Before »)
by Maître Gims

**MODELS**
Stervos Niarcos
Christian Loubaki
Papa Wemba
General Firenze

**VIDEOS AND ADS**
*Losing You* music video by Solange
Guinness commercial - 2014

**FASHION**
Paul Smith

**PLACES**
Rex Club

# HIP-HOP
## « I SAID A HIP-HOP »

| BIRTHPLACE | BRONX |
| --- | --- |
| PEAK | SINCE THE 1970s |

In 1979, hip-hop enters popular culture with the first rap hit, « Rapper's Delight » by The Sugarhill Gang. The movement is an escape for many young people in neglected neighborhoods and low-income housing. A veritable urban culture develops and exerts significant influence on the evolution and very identity of fashion.

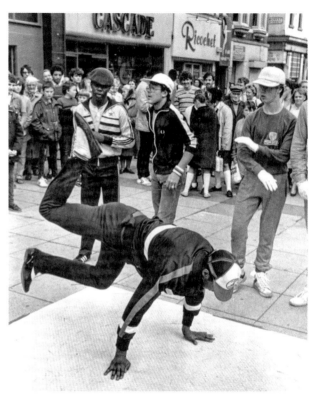

↑ **Breakdancers**, Broken Glass Crew, Liverpool, 1983

### A PARTY

On August 11, 1973, a brother and sister organize a party in the recreation room of their Bronx building. He is DJ Kool Herc, and he officiates at the turntables, mixing rhythmic repetitions of his records: he calls them breaks. On this day, he is playing James Brown, and he raps while calling to the crowd; hip-hop is born. The emergence of a new musical genre follows, along with an artistic culture based on graffiti, which allows young people neglected by mainstream American society to express themselves. Breakdancers (b-boys) establish the hip-hop look of the 1980s with their Adidas tracksuits (p. 144), Kangol bucket hats (p. 35), and sneakers (p. 92).

### BACK AND FORTH

1970s breakdancers need comfortable shoes to perform their moves on the asphalt. It begins with Adidas Superstar and Puma Suede. In the 1990s, it's Nike Jordan and Air Max. Fashion feeds off street influences, and sneakers soon move beyond the countercultural wardrobes of the young when they are transformed into a luxury item. Sneakers have become commonplace while also becoming highly desirable at the same time.

### LUXURY FOR ALL

In 1982, Dapper Dan (from his full name Daniel Day) opens his boutique in Harlem. His specialty is to reinterpret logos and monograms of the biggest luxury brands on pieces from the hip-hop wardrobe, mixing fur and leather. Dapper Dan launches a style that will become very popular at the end of the 1990s and into the 2000s: logomania. In 1992, he is sued, and his store is shut down. The luxury industry doesn't appreciate his use of their logos – though afterward, the industry doesn't hesitate to appropriate his creative techniques.

> « THAT'S WHY THIS GENERATION IS THE LEAST RACIST GENERATION EVER. YOU SEE IT ALL THE TIME. GO TO ANY CLUB. PEOPLE ARE INTERMINGLING, HANGING OUT, HAVING FUN, ENJOYING THE SAME MUSIC. HIP-HOP IS NOT JUST IN THE BRONX ANYMORE. IT'S WORLDWIDE. EVERYWHERE YOU GO, PEOPLE ARE LISTENING TO HIP-HOP AND PARTYING TOGETHER. HIP-HOP HAS DONE THAT. »
>
> JAY-Z

### A MOVEMENT

The movement establishes itself on the music scene, and the style diversifies – from baggy jeans in the 1990s that evoke zoot suits (p. 322) to the ostentation of the 2000s. Hip-hop takes over luxury brands, and fashion feeds off hip-hop. Women are more and more visible and generate a sexier aesthetic. In 1981, MTV's culture of astonishment is born, and artists rival each other in videos and looks, prescribed by groups like Run-D.M.C., creating a link between the street and popular culture.

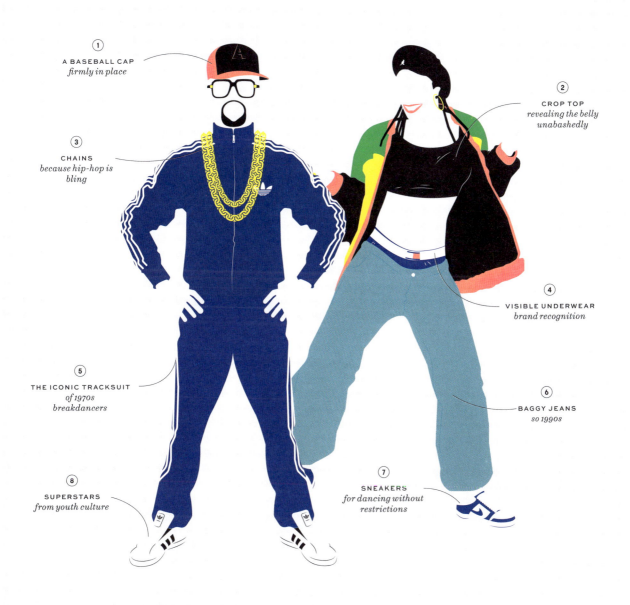

# GOTH
## DEATH BECOMES YOU

| | |
|---|---|
| BIRTHPLACE | ENGLAND |
| PEAK | 1980s AND 1990s |

Goth music develops in England in the late 1970s as an extension of the punk movement. With a more melancholic sound and poetic lyrics evoking the romanticism and symbolism of the 19th century, groups like Siouxsie and the Banshees, Joy Division, and The Cure establish themselves.

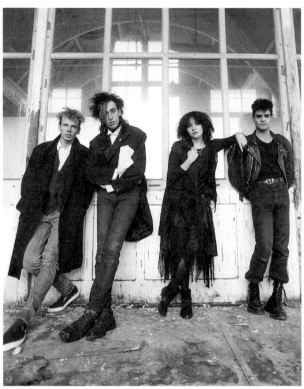

↑ *Blood and Roses*, metal band, London, 1982

### MELANCHOLIA

In 1979, English band Bauhaus releases the single « Bela Lugosi's Dead », a nine-minute tribute to the actor who played Count Dracula in the 1930s. The song is considered to be the first sound of gothic rock. The four members of the band line their eyes with black and red, exhibit sunken cheekbones, and wear black clothing. The subsequent goth movement defines a dark, dreamlike iconography. Fans imitate the style of those who play with a tragic allure. The look is sometimes historicizing; women wear corsets (p. 263) and crinolines (p. 223) adapted from punk, fetishism, and gloom, even borrowing the dark makeup and fascination with the supernatural. Death is not to be feared.

### FANTASY

Black dominates, but so does purple, in a nod to the Victorian era and its taste for the neomedieval aesthetic and the occult. Disciples of goth style exhibit silhouettes with an air of mystery that is exaggerated in 1980s and 1990s movies like *The Addams Family* and those of Tim Burton, while designers like Yohji Yamamoto, Alexander McQueen, and Rick Owens reinterpret the style. What distinguishes the goth movement is the way it links men and women in an androgynous space where masculinity and femininity dialogue without embarrassment and with an uninhibited acceptance of taboos.

> « WHEN I WAS GROWING UP, WOMEN WERE SUPPOSED TO BE ALL BLONDE HAIR, GOLD SUNTAN, AND PINK LIPS. »
>
> SIOUXSIE SIOUX

### ESOTERISM

Under Queen Victoria's reign in England, the supernatural is very present in literature. A fascination for the esoteric is born, and spiritualism develops. The living even photograph themselves near their dear departed. The queen, herself a widow in 1861, wears dark colors that become popular in society.

### NEOGOTHIC

Beginning in the 1820s, romantic movements, encouraged by works such as *Frankenstein* by Mary Shelley and the poems of Edgar Allan Poe, renew the neomedieval and neo-Renaissance aesthetic. Women wear styles with faded tones and puffy gigot sleeves.

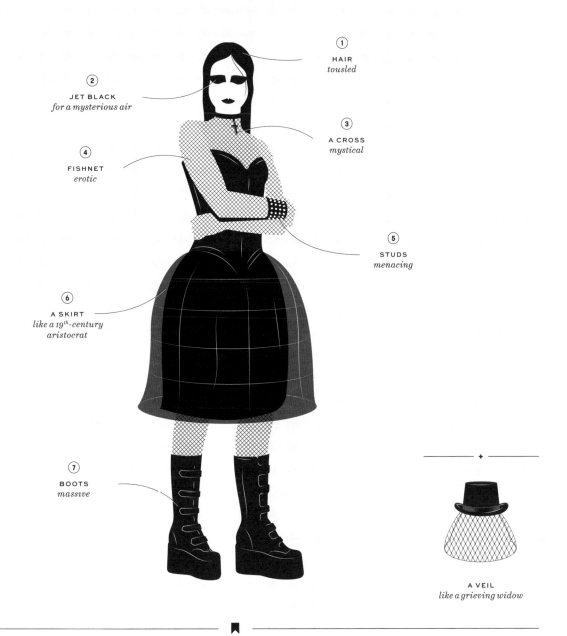

## GOTH ATTRIBUTES AND REFERENCES

1. **HAIR** *tousled*
2. **JET BLACK** *for a mysterious air*
3. **A CROSS** *mystical*
4. **FISHNET** *erotic*
5. **STUDS** *menacing*
6. **A SKIRT** *like a 19th-century aristocrat*
7. **BOOTS** *massive*

**A VEIL** *like a grieving widow*

**MUSIC**
Siouxsie Sioux
The Cure
Marilyn Manson
Nina Hagen

**MEDIA**
Diane Pernet

**CINEMA**
*The Addams Family*
*Edward Scissorhands*
Tim Burton
Helena Bonham Carter
*Beetlejuice*
Eva Green
Ed Wood

**FASHION**
Alexander McQueen
Gareth Pugh
Riccardo Tisci

**ICONS**
Dracula
Musidora

# FLAPPER
## DANCING THE CHARLESTON

| | |
|---|---|
| BIRTHPLACE | PARIS, LONDON, NEW YORK, HOLLYWOOD |
| PEAK | 1920s |

As the First World War ends and a new decade begins, it's time for parties and fun. « The Roaring Twenties » sweep away memories of the ravages of war. Art, music, and society evolve and bloom. New lifestyles take shape that transform society but also become a source of clichés.

↑ Young women on a beach, circa 1920

**FROM SHORT DRESSES TO PANTS**

For a long time, it is a risk for a woman to wear pants; she exposes herself to a fine or even imprisonment. But in the 1920s, women's pants emerge as « beach pajamas », though they still cannot be worn anywhere else. World War II increases their popularity, particularly in the United States, where women are working in factories. In the 1950s and 1960s, pants make a timid appearance as chic, summery cropped pants, but it's during the 1970s that they finally become a staple.

**A BOOK**

In 1922, French author Victor Margueritte writes *La Garçonne (The Flapper)*, a novel about a young, liberated woman who has multiple bisexual experiences. The work is a success but also a scandal. Above all, it mythologizes a whole category of women who take advantage of the Roaring Twenties to free themselves from the shackles that society has locked them into for centuries. 1920s fashion offers a straighter, lighter silhouette with shorter hemlines and a preference for hair cut into a short bob. The androgynous flapper intensifies these trends.

**A FANTASY**

The decade wishes to forget the horrors of the war and establish the image of a period devoted to celebration, jazz, and emancipation. It's a fantasy, more than anything else, that only concerns a few privileged insurgents. Because the figure of the flapper, rapidly recuperated by Hollywood with the actress Louise Brooks, is not as present in society as we would like to believe. Flappers represent a fragment of urban life, and the style is adopted by only the most audacious feminists and lesbians. The world is not yet ready to liberate these women. And most women don't yet feel authorized to claim those freedoms.

**« WE SHOULD ALL BE FEMINISTS »**

Borrowed from the writer Chimamanda Ngozi Adichie, these words appear on a Dior T-shirt in 2017. The piece is sold for more than 600 dollars. Opportunistic? Certainly. Because feminism has become a fashionable phenomenon and a marketing tool. But the T-shirt is also part of Maria Grizia Chiuri's first collection for Dior. She is the first woman to be named creative director of the brand – perhaps it deserved a little special attention.

**FEMINISTS**

Not all flappers are feminists, but these liberated and unsubmissive women open the way to social emancipation. Starting at the end of the 19th century, women who want to manifest their feminism openly do it with the uniform of the suffragettes or by borrowing from men's wardrobes. In the 1960s and 1970s, feminism is claimed by wearing T-shirts with messages, like the famous « The Future is Female » T-shirt created by the feminist bookstore Labrys Books, which opened in New York in 1972.

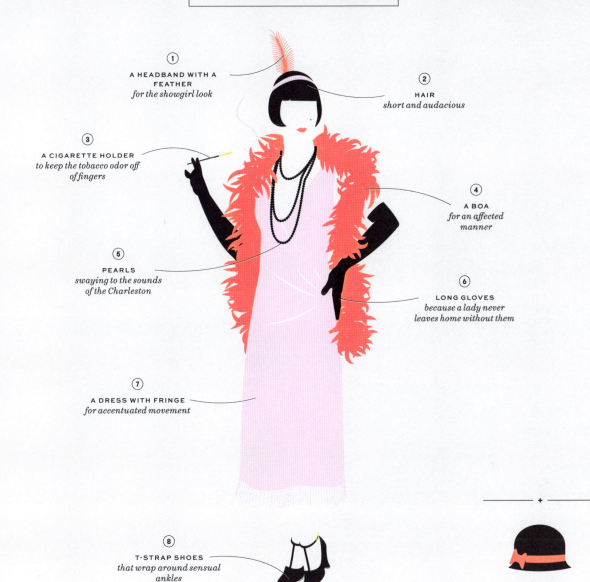

## FLAPPER ATTRIBUTES AND REFERENCES

1. **A HEADBAND WITH A FEATHER** *for the showgirl look*
2. **HAIR** *short and audacious*
3. **A CIGARETTE HOLDER** *to keep the tobacco odor off of fingers*
4. **A BOA** *for an affected manner*
5. **PEARLS** *swaying to the sounds of the Charleston*
6. **LONG GLOVES** *because a lady never leaves home without them*
7. **A DRESS WITH FRINGE** *for accentuated movement*
8. **T-STRAP SHOES** *that wrap around sensual ankles*

**CLOCHE HAT** *bell-shaped*

**SEEN ON**
Louise Brooks
Clara Bow
Kiki de Montparnasse

**FASHION**
Gabrielle Chanel
Jean Patou
Emporio Armani F/W 2013

**CINEMA**
*The Great Gatsby*
*Cabaret*
Betty Boop

**MUSIC**
Mistinguett
Joséphine Baker

**ART**
Tamara de Lempicka
Romaine Brooks
*Portrait of the Journalist Sylvia von Harden*, Otto Dix

# ZOOT SUIT
## DISSENTING DANCERS

| BIRTHPLACE | HARLEM |
|---|---|
| PEAK | 1940s |

The 1929 stock market crash devastates the American economy and leads to the Great Depression. The social situation is dramatic for many: unemployment is at an all-time high, food banks multiply, and shantytowns sprout up everywhere. To counter the ambient morosity, some choose to dance.

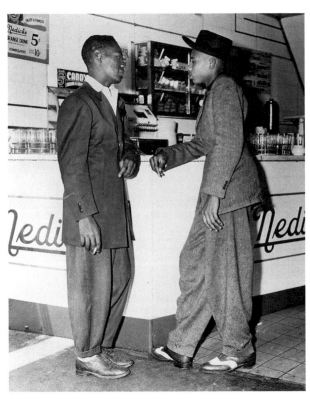

↑ Two young men in zoot suits, 1943

### « TO ME, IT DON'T MEAN A THING BUT IT'S GOT A VERY PECULIAR SWING! ZAA-ZUH-ZAZ-ZUH-ZAZ »

CAB CALLOWAY

**AN ESCAPE**

In Harlem, men wear loose garments for more ease. The typical uniform is composed of wide-legged pants tapered at the ankle, a long jacket with square shoulders, chains hanging from the pants, and a hat (p. 153), sometimes decorated with a feather: the zoot suit is born. The movement spreads in the 1940s among the Latinx community in Los Angeles and the Black American community in New York, as much among men as women.

**FAMILY**

In 1989, Janet Jackson releases the video for her song *Alright*. It's a tribute to the 1930s, 1940s, and 1950s, and to zoot style. Cab Calloway appears in it (as does Cyd Charisse). Meanwhile, Michael Jackson offers a hybrid take on the zoot suit, flirting with 1930s gangster style and the French zazou look in the 1987 video *Smooth Criminal*.

**INVISIBLE FASHION**

Zoot suiters are subjected to harassment under the guise of fashion, but in reality, it is latent racism that is being expressed. Civil rights movements are gaining momentum, and yet fashion ignores them. Ann Lowe is a Black American designer and seamstress who works for the wealthy. In 1946, the actress Olivia de Havilland wears one of her dresses when she receives her Oscar. Is her name mentioned? No. Not even on the label. In 1953, Jackie Bouvier marries John Kennedy. Ann Lowe makes her wedding dress, which is destined to become iconic. The dress is heavily detailed in the media; there is no mention of the designer's name.

**A MARGIN**

It becomes a synonym of delinquency and rebellion because it is associated with clashes between gangs, and the extravagant proportions of the outfits go against textile restrictions imposed by the war. But ultimately, because zoot suiters are from communities of color, it is more about skin color than style. Even the jazz singer Cab Calloway, otherwise appreciated by the general public, is criticized for his zoot suit in the movie *Stormy Weather*, released in 1943. But the zoot movement is an outlet, a form of expression for a repressed youth. It doesn't matter if they're frowned upon; zoot suiters want to individualize themselves since society has already marginalized them.

**FRENCH ZAZOUS**

On the other side of the Atlantic, zazous dance the swing and listen to jazz. Their name comes from the Cab Calloway song *Zah Zuh Zah*. They wear slimmer-fitting suits than their American counterparts and shorten their pants to reveal their white socks. They adopt a thin mustache and gaudy ties. Women opt for long hair, sometimes platinum, sweaters with square shoulders, and pleated skirts.

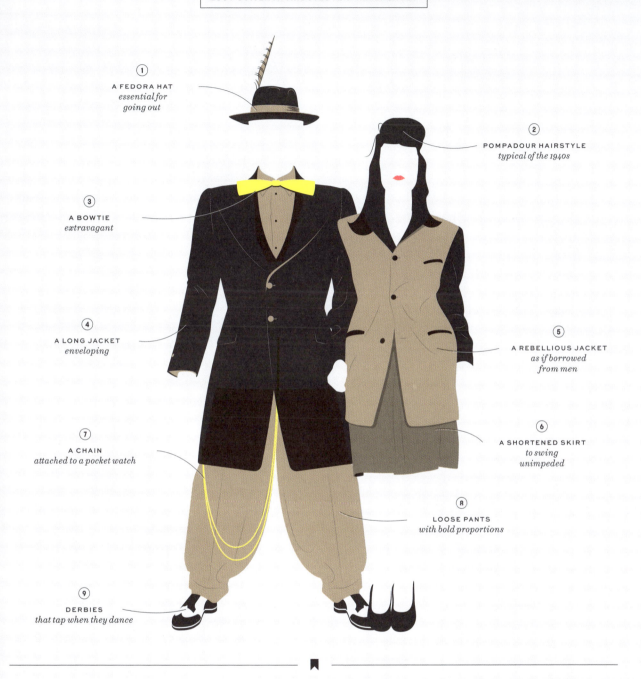

# DANDY
## SELF-EXPRESSION

BIRTHPLACE .................... ENGLAND
PEAK .................... 19ᵀᴴ CENTURY TO TODAY

In reaction to the excesses and frills of European aristocratic fashion, the English, led by George Bryan « Beau » Brummel, encourage a more sober look in the early 19th century. However, this sobriety does not preclude singular details, refinement, and individuality as the look finds followers across Europe.

↑ Thomas Baignières, Paris, 2011

« INDEED, I LOVED MY MOTHER FOR HER ELEGANCE. I WAS A PRECOCIOUS DANDY. »

CHARLES BAUDELAIRE

### SNOBBERY

The dandy's moderation is, paradoxically, considered eccentric. He aims to develop a personal style rather than passively succumb to trends. In the 19th century, men of the European bohemian class, especially writers and artists, assimilate dandyism and celebrate finery with impertinence. Beyond his appearance, the dandy also cultivates his intellectual posture and his lifestyle tinted with snobbery, even if he isn't well-born. Dandyism allows a « new aristocracy » to emerge.

### A LIFESTYLE

The irony is that at the same moment when dandyism is taking hold, men are invited to slim down their silhouettes. The early dandy is both a forerunner of simplification and an opponent of a form of renunciation of finery. The modern and contemporary dandy, on the other hand, claims an alternative existence: elitist, literary, and a touch fanciful. Dandyism isn't summarized by a look; it's a state of mind. There are as many dandies as there are men eager to express their essence.

### THE NEEDLE AND THE PEN

From Barbey d'Aurevilly, who writes an essay about George Brummel, to Charles Baudelaire, who evokes dandyism in his *Peintre de la vie moderne (The Painter of Modern Life)*, many writers advocate the art of appearance. Even Honoré de Balzac takes an interest in fashion with his *Traité de la vie élégante (Treatise on Elegant Living)*. In the late 19th century, Joris-Karl Huysmans, Robert de Montesquiou, and Oscar Wilde perpetuate literature's fascination with men's style.

### WRITING STYLE

Oscar Wilde wears carefully considered ensembles and writes prolifically about fashion. After writing articles for the *Pall Mall Gazette* in London and an 1885 essay, « The Philosophy of Dress », he becomes the editor-in-chief of the fashion magazine *Lady's World: A Magazine of Fashion and Society*, in which he lambasts trends that subjugate women's bodies and advocates for a more rational style.

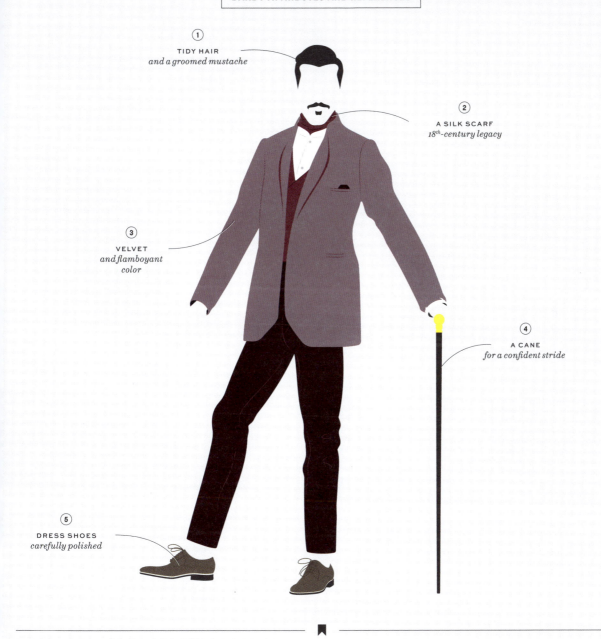

## DANDY ATTRIBUTES AND REFERENCES

1. **TIDY HAIR** *and a groomed mustache*
2. **A SILK SCARF** *18th-century legacy*
3. **VELVET** *and flamboyant color*
4. **A CANE** *for a confident stride*
5. **DRESS SHOES** *carefully polished*

**SEEN ON**
Beau Brummel
Lord Byron

**LITERATURE**
Oscar Wilde
Robert de Montesquiou
Charles Baudelaire
Francis Scott Fitzgerald

**ART**
Salvador Dalí

**MUSIC**
Serge Gainsbourg
Bryan Ferry
Pete Doherty

**THEATER**
Noel Coward

**TV**
*Jason King*

**CINEMA**
*La Collectionneuse*
Edouard Baer
David Niven

# HIPPIE
## FLOWER POWER

| | |
|---|---|
| BIRTHPLACE | SAN FRANCISCO |
| PEAK | 1960s |

Many young Americans born after the war promote an alternative lifestyle that rejects materialism and consumerism. Though mainly rooted in California's San Francisco Bay Area, hippie communities expand in the early 1960s against the tense backdrop of the Vietnam War and the civil rights movement.

↑ Summer Jam festival, Watkins Glen, 1973

### UTOPIA

Successors of the Beatnik movement, many hippies are young and White and come from the middle or upper classes, whose norms they reject. They advocate an ecological ideal and a liberal utopia centered on Eastern philosophy, free love, and psychedelic drugs and music. After the plastic fascination of the 1960s (p. 267), it's time to make room for nature.

### TIE-DYE

Dying garments tied in knots is a technique that has existed since prehistoric times. Yet it's the hippies that we most associate with tie-dye. It allows for creating patterns that evoke the psychedelic aesthetic and valorizes handmade crafts.

### A LOOK

Their clothing expresses their beliefs: multicultural borrowings, such as the caftan (p. 46) or the poncho, supporting the myth of a unified world; jeans (p. 136) in homage to the working class; long hair for all, to blur gender; variegated colors and patterns; long, loose dresses for women who have abandoned the miniskirt (p. 160); and above all, handmade and secondhand clothes. In 1969, Woodstock and the assassination of Sharon Tate, Roman Polanski's wife, by members of Charles Manson's cult, mark the movement's swan song. But hippie style nonetheless inspires designers of the 1970s, who adopt its bohemian allure. Anti-fashion becomes fashion.

« BUY LESS. CHOOSE WELL. MAKE IT LAST. »

VIVIENNE WESTWOOD

### HIPPIE CHIC

In the 1960s and 1970s, photographer Henry Clarke garners attention after collaborating with Diana Vreeland for *Vogue* magazine. His images, shot all over the world, thrill readers at a time when tourism is booming. His aesthetic is full of folkloric clichés, and the photographs feature White models disconnected from the local population. The models wear gorgeous caftans, mysterious veils, and warm tones. Henry Clarke represents a new trend: hippie chic.

### ECO-FRIENDLY

Fashion is one of the most polluting industries in the world, with an ecological and human impact during production, but also because of the wasteful disposal of unsold garments and pieces that fast fashion consumers throw away as rapidly as they buy them. Thanks to those seeking to counter the damage, vintage has never been so popular. Others endorse an alternative mode of fabrication that is more respectful of the planet. Ecology has become a marketing tool for brands that sometimes abuse the concept.

## HIPPIE ATTRIBUTES AND REFERENCES

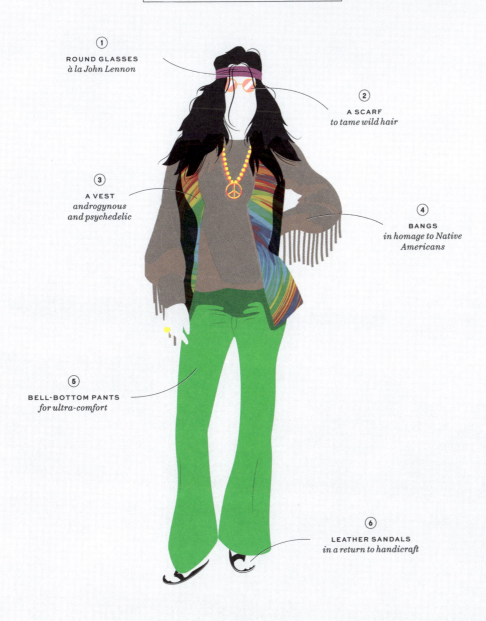

1. **ROUND GLASSES** *à la John Lennon*
2. **A SCARF** *to tame wild hair*
3. **A VEST** *androgynous and psychedelic*
4. **BANGS** *in homage to Native Americans*
5. **BELL-BOTTOM PANTS** *for ultra-comfort*
6. **LEATHER SANDALS** *in a return to handicraft*

**MUSIC**
Janis Joplin
Jim Morrison
The Grateful Dead
Joan Baez

**ICONS**
Beat Generation

**FASHION**
Bill Gibb
Zandra Rhodes
Robert Cavalli S/S 2017
Etro S/S 2020
Chloé S/S 2019

**LITERATURE**
Jack Kerouac, *On the Road*

**CINEMA**
*Hair*
*Easy Rider*
*Once Upon a Time in Hollywood*

**PLACES**
Woodstock
Isle of Wight
San Francisco

# PUNK
## « ANARCHY IN THE UK »

| | |
|---|---|
| BIRTHPLACE | LONDON AND NEW YORK |
| PEAK | LATE 1970s |

In 1971, the word punk describes a musical genre for the first time. It's a provocative, violent, raw rock, and it's the opposite of the flamboyant glam rock it supplants. The Ramones play it in New York and the Sex Pistols in England, where they promote an anti-everything approach: anti-capitalism, anti-conservatism, and anti-establishment.

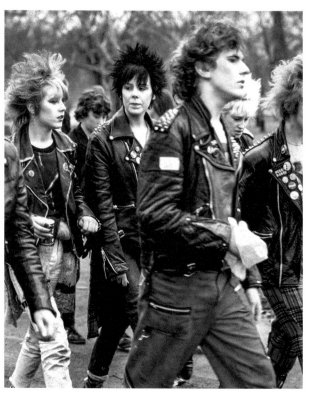

↑ British punks, London, 1970s

### « PUNK WAS DEFINED BY AN ATTITUDE RATHER THAN A MUSICAL STYLE. »

DAVID BYRNE

**ANGER**

The controversial question is whether the punk movement is born in New York or London. In the mid-1970s, in the United States, the music scene renews itself at the underground club CBGB. Meanwhile, in a worn-out England, some young people want to shake things up, shock, and disturb through music, but also style, much more so than in America. Punks don't like much: aristocracy, consumerism, politics, the middle class… everyone is taken to task.

**SHOCKING IMAGES**

In the 1970s, sex and violence aren't only exposed via the punk movement. 1970s fashion photography intentionally employs taboos. The man who pushes the boundaries the furthest is Chris von Wangenheim, with his erotic, macabre, and aggressive photographs. As destabilizing as his style can seem, it is appreciated by luxury brands like Christian Dior. Helmut Newton also joins this aesthetic vein. The German photographer uses sexuality as a manifestation of women's strength and authority: they lead the dance with the grandeur of their bodies and the power of their desire.

**PROVOCATION**

Punk takes on that which disturbs – like violence, sex, and political incorrectness – and manifests it with torn clothes, holes, and safety pins piercing fabric and sometimes skin. It borrows to transform: the tartan (p. 178) of the elite meets fetishistic leather. This is especially true of women, who don't hesitate to adopt the codes of BDSM and provocative eroticism, materialized with fishnet tights and latex. Vivienne Westwood (p. 294) gives the style a commercial identity (major contradiction!), while her companion Malcolm McLaren launches the Sex Pistols. Punk is seen and heard.

**MUSE**

Belgian designer Ann Demeulemeester, one of the Antwerp Six, founds her brand in 1985. A fan of black and of androgynous silhouettes for women, music informs her creative process, especially rock – profound and powerful. Patti Smith captivates her the most: she invites her to provide the music of her shows, places her words on her clothes, and has her walk the runway and pose for some of her campaigns.

# PUNK ATTRIBUTES AND REFERENCES

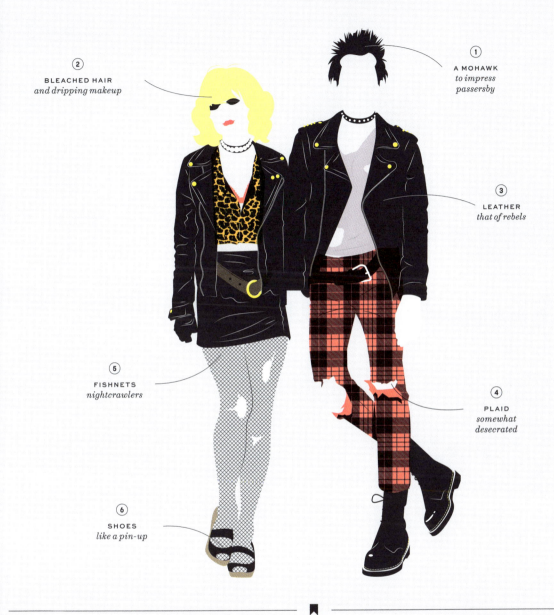

1. **A MOHAWK** *to impress passersby*
2. **BLEACHED HAIR** *and dripping makeup*
3. **LEATHER** *that of rebels*
4. **PLAID** *somewhat desecrated*
5. **FISHNETS** *nightcrawlers*
6. **SHOES** *like a pin-up*

**FASHION**
Vivienne Westwood
Comme des Garçons men's collection F/W 2019
Junya Watanabe F/W 2017
Jean-Paul Gaultier F/W 2014

**MUSIC**
Sex Pistols
Ramones
The Clash
The Runaways
The Stooges

**SEEN ON**
Patti Smith
PJ Harvey

**CINEMA**
*My Beautiful Laundrette*
*A Clockwork Orange*

**PLACES**
CBGB in New York
King's Road in London

# LOLITA
## WOMAN CHILD

| BIRTHPLACE | TOKYO |
| --- | --- |
| PEAK | 1970s-TODAY |

In Japan, young people don't hesitate to transgress norms, especially sartorial ones, by wearing extravagant silhouettes, sometimes as dramatic as stage costumes. In the streets of the Tokyo neighborhood Harajuku, many looks compete. Among them is the style of the woman-child, half doll, half historical creature.

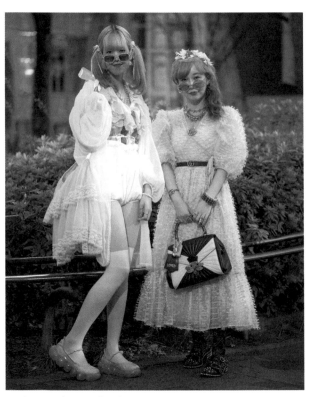

↑ Rakuten Fashion Week, Tokyo, 2022

### « LO-LEE-TA: THE TIP OF THE TONGUE TAKING A TRIP OF THREE STEPS DOWN THE PALATE TO TAP, AT THREE, ON THE TEETH. LO. LEE. TA. »

VLADIMIR NABOKOV

**DRESS-UP**

Lolita style is born in the streets of Japan during the 1970s as an extension of a pronounced appreciation for the charming and childlike. Lolitas have a penchant for drama and historicism, with outfits inspired by heroines of British children's literature, like *Alice in Wonderland*, Japanese manga, and Hello Kitty characters, as well as Rococo and Victorian costumes. Pastel tones (for the sweet Lolita, the most popular), frilly details, fluffy petticoats, lace, ringlets, and playful bows all participate in expressing the naïve and cutesy look. This penchant for performative style is influenced by Visual Kei, a movement that pushes for ostentation, transformation, and cross-dressing.

**IT'S A DREAM**

British photographer Tim Walker is known for his dreamy universe, borrowing from fairy tales, Victorian literature, and children's dreams. His blockbuster-like sets are created by hand. In 2018, he invites the world of *Alice in Wonderland* into the Pirelli calendar's box of fantasies. With exclusively Black models, he shows that within the artifice of fashion, we can transmit essential messages.

**ANTI-AGING**

With her historical references, the Lolita conveys an undeniable gothic air (p. 318) despite her sweet twist. It's not a coincidence that one of the branches of the style is gothic Lolita. Nonetheless, contrary to what Western culture might imagine due to the misunderstood book of the same name by Vladimir Nabokov, the Japanese Lolita has no intention of manifesting sexual ambivalence. To be a Lolita is not about using childish allure to disturb; it's simply a way to bring out the inner child who doesn't want to grow up.

**MODELS...**

The Western world doesn't shine for its diversity. Some models open the way for change. Hiroko Matsumoto is the first Japanese model to establish herself in the world of Parisian couture after being scouted by Pierre Cardin. Sayoko Yamaguchi, 1970s muse, will work as much with her compatriots Kenzo Takada and Issey Miyake as with Yves Saint Laurent and Chanel.

**... OF DIVERSITY**

By signing a contract with the cosmetics brand Shiseido in 1973, the model Sayoko Yamaguchi reaffirms the necessity of diversity. Yet her natural features are regularly dramatized in response to the West's habit of orientalizing.

## LOLITA ATTRIBUTES AND REFERENCES

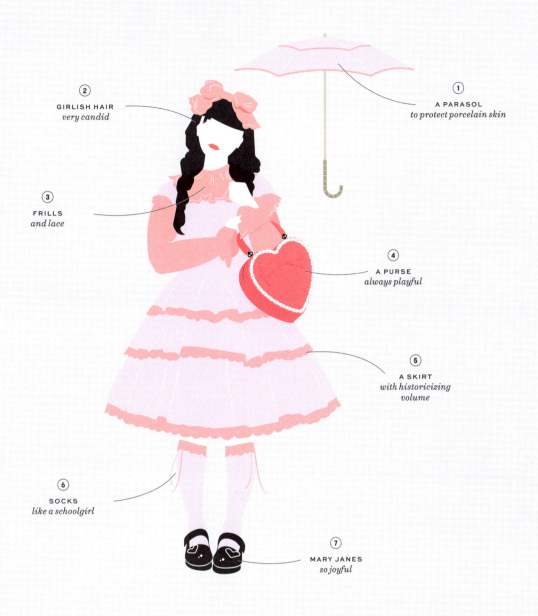

1. **A PARASOL** *to protect porcelain skin*
2. **GIRLISH HAIR** *very candid*
3. **FRILLS** *and lace*
4. **A PURSE** *always playful*
5. **A SKIRT** *with historicizing volume*
6. **SOCKS** *like a schoolgirl*
7. **MARY JANES** *so joyful*

---

**CINEMA**
*Kamikaze Girls*

**ICONIC**
*Alice in Wonderland* by Lewis Carroll

**SEEN ON**
Misako Aoki

**ICONS**
Marie-Antoinette
Shirley Temple

**BRAND**
Hello Kitty

**FASHION**
Betsey Johnson
Jeremy Scott

**MUSIC**
Gwen Stefani and the Harajuku Girls for her album *Love.Angel.Music.Baby*

# BLITZ KIDS
## NOCTURNAL AVANT-GARDE

| BIRTHPLACE | LONDON |
| PEAK | 1980s |

On the eve of the 1980s, in the eyes of some avant-gardists and creatives, punk has become banal and too popular. These eccentrics want to express their radical identities, unique and theatrical. They do so during Blitz parties that influence fashion, music, art, and media.

↑ Blitz Club party, *Covent Garden*, London, 1980

> « I'D FIND PEOPLE AT THE BLITZ WHO WERE POSSIBLE ONLY IN MY IMAGINATION. BUT THEY WERE REAL. »
>
> STEPHEN JONES

**A NIGHTCLUB**

Young and fascinated by David Bowie and his song « Heroes », Rusty Egan and Steve Strange organize the first party in the fall of 1978. Their parties become well known, and an eccentric crowd gathers regularly at the minuscule Blitz bar. Entry conditions are extravagance and insouciance. It's necessary to put on a show, without holding back, by borrowing from the past, from multiculturalism, and from theater, all with an androgynous flair. The goal is flamboyance and individuality. Vivienne Westwood captures the aesthetic with her collection « Pirate » in 1981.

**A MAGAZINE**

In this context, in May 1980, the first issue of the British magazine *The Face* is published. The editorial line explores music and counterculture. Pioneer in the domain, the publication quickly becomes one of the most influential of its era; the magazine will reveal Kate Moss and become a reference for creatives of the London underground in the 1980s and 1990s. *The Face* and the Blitz generation participate in constructing creative British culture.

**AN INFLUENCE**

The Blitz Kids, also known as the New Romantics, are bored of the archaic demands of punks (p. 328) and integrate new electronic sounds, pop, funk (p. 310), reggae, and rock. By the end of the 1980s, the movement slows, but it influences Boy George and groups like Culture Club, who soon invade MTV, and designers like John Galliano (p. 206), destined for prodigious success. In the 1990s, New York's Club Kids revive the Blitz spirit. With them comes a world where identity takes precedence, a universe mixing drag queens and punks, voguers, and students.

**ICONIC**

In May 1980, the first issue of the British magazine *The Face* is published. It quickly becomes one of the most influential of its time: it reveals Kate Moss. It's a reference for London underground creatives of the 1980s and 1990s. *The Face* develops a unique style with its sharp, Bauhaus-inspired graphics, acerbic text, and spare photographs. It will inspire magazines like *i-D* and *Dazed*.

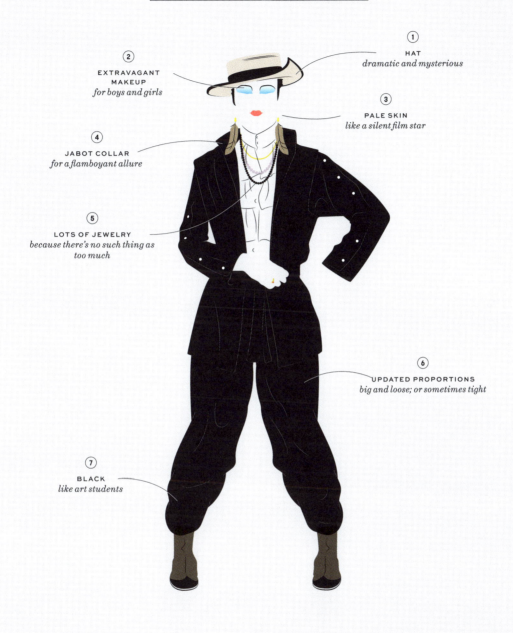

## BLITZ KIDS ATTRIBUTES AND REFERENCES

1. **HAT** — *dramatic and mysterious*
2. **EXTRAVAGANT MAKEUP** — *for boys and girls*
3. **PALE SKIN** — *like a silent film star*
4. **JABOT COLLAR** — *for a flamboyant allure*
5. **LOTS OF JEWELRY** — *because there's no such thing as too much*
6. **UPDATED PROPORTIONS** — *big and loose; or sometimes tight*
7. **BLACK** — *like art students*

**MUSIC**
Boy George
Lady Gaga
Bananarama

**CULTURE**
Leigh Bowery
Central Saint Martins

**FASHION**
Stephen Jones
Zandra Rhodes
Vivienne Westwood
Judy Blame
John Galliano

**ICONS**
David Bowie
Marylin Monroe

**MEDIA**
The video for *Ashes to Ashes*, by David Bowie
*Blitz* Magazine

# IVY LEAGUE
## ALL-AMERICAN

| BIRTHPLACE | IVY LEAGUE |
|---|---|
| PEAK | 1950s |

In the mid-1940s, a style borrowing from 1920s sportswear develops on the campuses of prestigious American schools associated with the Ivy League (a university sports association), such as Harvard, Yale, and Princeton. The style aims to create an allure that is distinguished and falsely nonchalant, chic but without emphasis.

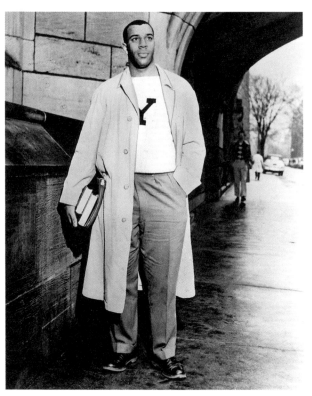

↑ Yale student, New Haven, 1952

**JAPANESE VERSION**

In 1964, young Tokyoites adopt the ivy style; they are the Miyuki-zoku. They change clothes in the cafés of the Ginza neighborhood, trading their school uniforms for the trendy style. The magazine *Heibon Punch* expands the popularity of the American style, imported by Kensuke Ishizu in the 1950s with his brand Vans. The style displeases the older generation, who aren't keen on Western styles, which they associate with delinquency and memories of the war.

**THE GAP**

In the 1980s, the brand concentrates on basics like jeans, polo shirts, sweaters, and khakis. Gap asserts the idea that anyone can dress like an American college student. In the mid-1990s, Gap relaunches the popularity of a look drawn from the Ivy aesthetic with ads featuring legendary celebrities.

**MODEL STUDENTS**

During the interwar period, students at these prestigious schools wear the sack suit invented by the brand Brooks Brothers in 1901 for a more natural and informal fit. They popularize sportswear outside the playing field, blazers, tweed (p. 42), Oxford shirts, and moccasins (p. 174). After the war, young veterans enroll in Ivy League schools, supported by the G.I. Bill, a law that financed their studies. There, they introduce khaki pants (p. 54).

**REBELLIOUS SPIRIT**

However, reducing the style to the White elite would be erroneous. Above all, these young students seek to differentiate themselves from their fathers, and their hobby is jazz. Some Black American musicians who embody the essence of cool, like John Coltrane and Miles Davis, wear Ivy League style, which will inspire many young Black Americans and the activists of the 1960s. By the middle of the decade, the look reaches the middle class and becomes the archetype of American style.

« I HAVE ALWAYS BEEN INSPIRED BY THE DREAM OF AMERICA – FAMILIES IN THE COUNTRY, WEATHERED TRUCKS AND FARMHOUSES; SAILING OFF THE COAST OF MAINE; FOLLOWING DIRT ROADS IN AN OLD WOOD-PANELED STATION WAGON; A CONVERTIBLE FILLED WITH YOUNG COLLEGE KIDS SPORTING CREW CUTS AND SWEATSHIRTS AND FRAYED SNEAKERS. »

RALPH LAUREN

**FROM WEST TO EAST**

Since then, the style has inspired the preppy look, the work of Ralph Lauren in the 1970s, and contemporary Japanese youth. The Ivy look is less exclusive than it seems.

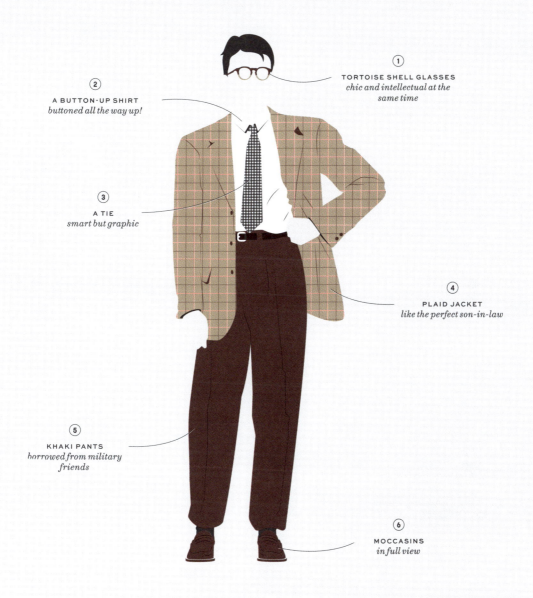

## IVY LEAGUE ATTRIBUTES AND REFERENCES

1. **TORTOISE SHELL GLASSES** *chic and intellectual at the same time*
2. **A BUTTON-UP SHIRT** *buttoned all the way up!*
3. **A TIE** *smart but graphic*
4. **PLAID JACKET** *like the perfect son-in-law*
5. **KHAKI PANTS** *borrowed from military friends*
6. **MOCCASINS** *in full view*

**CINEMA**
Paul Newman
Sidney Poitier
Dustin Hoffman in *The Graduate*
The wholesome students in *Grease*
*The Talented Mr. Ripley*
*Love Story*

**POLITICS**
John F. Kennedy

**SPORTS**
Muhammad Ali
Tommie Smith

**PHOTOGRAPHY**
Gordon Parks

**MUSIC**
Miles Davis
Bill Evans

**FASHION**
Brooks Brothers
Ralph Lauren
Tommy Hilfiger

# EMO
## « HELLO, SADNESS »

| BIRTHPLACE | WASHINGTON |
|---|---|
| PEAK | 2000s |

Derived from the term « emotive hardcore », the musical genre emo, considered the last big teen countercultural movement, evolves from post-punk to a popular mainstream identity during its peak in the 2000s. Emotional catharsis, it brings together a tormented youth who feels out of place.

↑ Teenager, Ukraine, 2000s

> « MELANCHOLY CHARACTERIZES THOSE WITH A SUPERB SENSE OF THE SUBLIME. »
>
> EMMANUEL KANT

### THE MUSIC

In Washington, in the middle of the 1980s, punk rock groups like the Rites of Spring – thought of as the initiators of the genre – feel the need to explore sensitivity, introspection, and emotions, as well as broader musical structures. Initially described as hardcore, they find themselves labeled emo as an insult by audiences and critics alike. In the 2000s, the genre emerges from the underground and lands on the international stage.

### THE LOOK

A community of young people follows. They imitate their idols via the internet, particularly on MySpace, adopting the signature straight dark hairstyle with bangs, skinny jeans (p. 136), tight T-shirts (p. 10), studded belts, and Converse sneakers (p. 92), everything accompanied by heavily lined eyes, black nail polish, and sometimes piercings and tattoos. Emo style, which seems to have been launched by the Swedish group Refused in 1998, refuses trends and accentuates its divergence with banal pieces that carry no stylistic connotations.

### A VIRTUAL LINK

Popularized by the social media platform MySpace, the emo genre is the first counterculture movement to develop via new technologies. It participates in the rise of e-commerce and online creation, with sites like Etsy, on which teens sell merchandise from their favorite groups.

### THE SENSITIVITY

Androgynous, romantic, and timid young emos are often stigmatized by a society that rejects reserve. The movement is accused of glamorizing suicide. But its controversies and its stereotypes are reductive. Adolescence is unquestioningly melancholic. It would be unreasonable to ignore that reality. Through sartorial expression, young emos are simply revealing an inner world that most people hide.

### SWEET MELANCHOLY

The photographer Sarah Moon stands out thanks to her work with the French brand Cacharel. Her melancholic images are tinted with romanticism, fantasy, and mysticism. Playing with the fictional aspect of photography, she accentuates its illusory aesthetic using blurring and accidents. A fan of black-and-white, she introduces color to render it even more evanescent and strange.

## EMO ATTRIBUTES AND REFERENCES

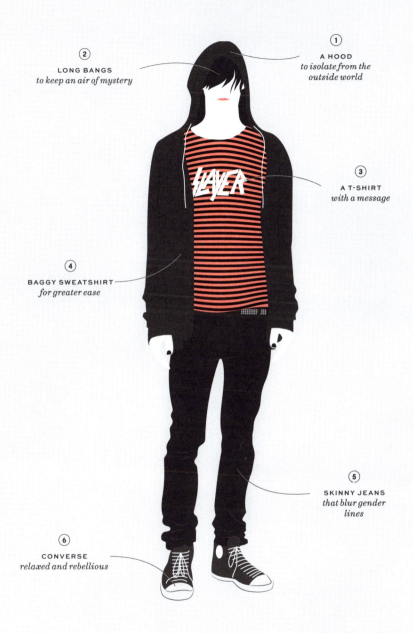

1. **A HOOD** *to isolate from the outside world*
2. **LONG BANGS** *to keep an air of mystery*
3. **A T-SHIRT** *with a message*
4. **BAGGY SWEATSHIRT** *for greater ease*
5. **SKINNY JEANS** *that blur gender lines*
6. **CONVERSE** *relaxed and rebellious*

**MEDIA**
Kid Cudi at the 2021 Met Gala
*Daria*

**MODE**
Vetements F/W 2017
R13 S/S 2017

**MUSIC**
My Chemical Romance
Avril Lavigne
Weezer
Panic ! At the Disco

**CINEMA**
*Donnie Darko*
*Eternal Sunshine of the Spotless Mind*

**ICONS**
The Smiths
Winona Ryder

# GRUNGE
## « SMELLS LIKE TEEN SPIRIT »

| BIRTHPLACE | SEATTLE |
|---|---|
| PEAK | 1990s |

In the 1980s, low rents in Seattle attract musicians who dynamize the rock scene of a previously sleepy provincial town. The new sound is called grunge. Along with the clothing style that imitates the penniless musicians, it will become an international phenomenon in the 1990s.

↑ Nirvana, backstage, Tokyo, 1992

**BAD INTERPRETATION...**

In 1993, Marc Jacobs is inspired by the grunge movement for the Spring/Summer collection of Perry Ellis. It's the first time the style is so explicitly incarnated on the runways, and it's a flop. The style lends itself with difficulty to the Perry Ellis aesthetic, and the transcription of grunge is hazardous; to try to render grunge trendy and commercial is to strip it of its essence. Perry Ellis fires Marc Jacobs.

**THRIFT STORES**

In the late 1980s, grunge music, a blend of punk (p. 328), heavy metal, and rock, is born in Seattle. Very soon, the music is accompanied by a recognizable silhouette composed of used clothing, but also, surprisingly, of standards of the male wardrobe. Indeed, in the region, flannel shirts (p. 29), characteristic of loggers, and wool Pendleton coats abound. Young people of the movement pick up these essentials in thrift stores, where they also unearth military jackets, old graphic T-shirts (p. 10), and worn-out jeans (p. 136). As for the girls, they wear floral vintage dresses and oversized cardigans (p. 15). The hair is greasy, and the complexion pale.

**... AND BAD AMBASSADORS**

Marc Jacobs sends pieces from the same collection to Courtney Love and Kurt Cobain. They burn them. Too fashionable!

**NOT VERY CHIC**

Davide Sorrenti, one of the most renowned photographers of his generation, dies at age 21 of a heroin overdose. At his funeral, the editor of *Interview* magazine declares: « This is heroin, this isn't chic. This has got to stop, this heroin chic ». The drug is devastating for Kurt Cobain, River Phoenix, and many others. The journalist points her finger at an accomplice: the photography style of the 1990s, which aestheticizes taking drugs with bodies too thin, faces too pale, and eyes too tired. The combat soon becomes political. Bill Clinton gets involved and condemns the images. After the disappearance of Sorrenti, heroin isn't chic anymore at all.

**THE CRISIS**

An economic recession sweeps the world, and the grunge look echoes the crisis. The ostentatiousness of the 1980s is over. So are parties and materialism. Young people are confronted with a harsh reality, and they show it. A band participates in the dissemination of this anti-fashion style that rejects norms: Nirvana. Young people around the world discover Kurt Cobain and his cohorts on MTV. Fashion tries to grab ahold of grunge, but it escapes: too messy, too grimy, too personal.

**GRUNGE ATTRIBUTES AND REFERENCES**

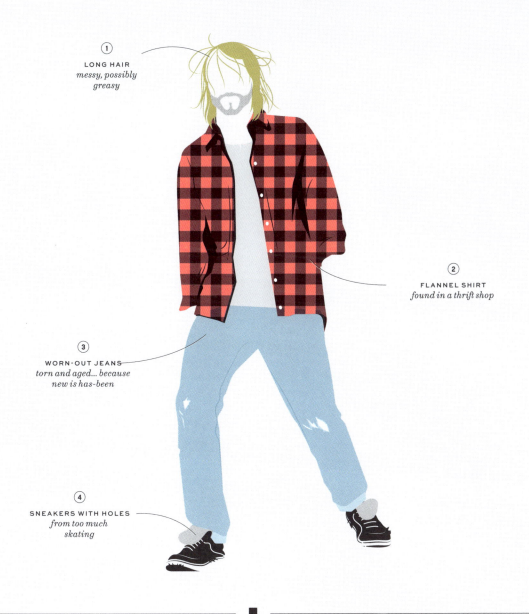

① **LONG HAIR**
*messy, possibly greasy*

② **FLANNEL SHIRT**
*found in a thrift shop*

③ **WORN-OUT JEANS**
*torn and aged... because new is has-been*

④ **SNEAKERS WITH HOLES**
*from too much skating*

---

**MUSIC**
Kurt Cobain
Courtney Love
Kim Gordon
Riot Grrrls
Pearl Jam

**CINEMA**
*Wayne's World*
*Kids*
*Singles*

**FASHION**
Perry Ellis S/S 1993
Ann Demeulemeester S/S 1997
Saint Laurent F/W 2003

**PHOTOGRAPHY**
Corinne Day
Wolfgang Tillmans

**TV**
The series *My So-Called Life*

# BLACK PANTHER
## BLACK POWER

| | |
|---|---|
| BIRTHPLACE | CALIFORNIA |
| PEAK | 1960s |

In the U.S., despite the 1964 Civil Rights Act that ends segregation, the Black American population is still subjected to injustice and discrimination. In the context of this decade of protest, the Black Panther Party is founded in 1966 by Huey Newton and Bobby Seale in Oakland, California.

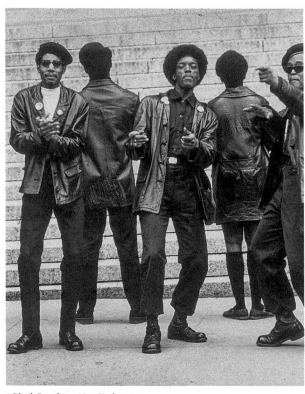

↑ Black Panthers, New York, 1969

### DEMANDS

The Black Panthers fight to obtain the rights they are denied while proudly claiming their Black identity. With this affirmation, their bodies occupy space in the public sphere that has so long been denied. From invisible, the members of the group and their supporters metamorphize into powerful, even intimidating individuals. The Black Panthers don a uniform that links them and distinguishes them. The group knows the power of media and image.

### AN ARMY

Like soldiers, men and women of the movement take on an imposing military allure, as evidenced by their beret (p. 119). They are all dressed in symbolic black; the same color that stigmatizes them is now their strength. The photographer Kwame Brathwaite popularizes the phrase « Black is Beautiful » in the early 1960s when he founds a modeling agency for Black models, Grandassa Models. He reclaims African pride in cultural, artistic, and stylistic circles in order to counter the injunctions of Western beauty standards. The Black Panthers adopt the slogan as a political weapon.

### « BLACK IS BEAUTIFUL »

*Vogue* magazine reigns supreme. To be on the cover is the Holy Grail. But diversity is lacking. In 1966, Donyale Luna becomes the first Black woman to be on the cover of the British version. For *Vogue* U.S., it won't be until 1974, with Beverly Johnson, while *Vogue Paris* waits until 1988 to put Naomi Campbell on the cover.

« WE'VE GOT TO DO SOMETHING TO MAKE THE WOMEN FEEL PROUD OF THEIR HAIR, PROUD OF THEIR BLACKNESS. »

KWAME BRATHWAITE

### POLITICAL FASHION

Ever since its birth in the 14th century, fashion never stops serving a social, societal, and political discourse.

**French Revolution** : tricolor ribbons and sans-culottes

**Circa 1900** : in England and the United States, suffragettes wear white.

**2018** : « gilets jaunes » (yellow jackets) invade France.

### PERFORMANCE

In 2016, during her Super Bowl performance, the singer Beyoncé, along with her dancers, pays homage to the Black Panthers by wearing a leather suit and black beret and by lifting her fist. A way for her to denounce the violence still encountered today by the Black American community in the United States.

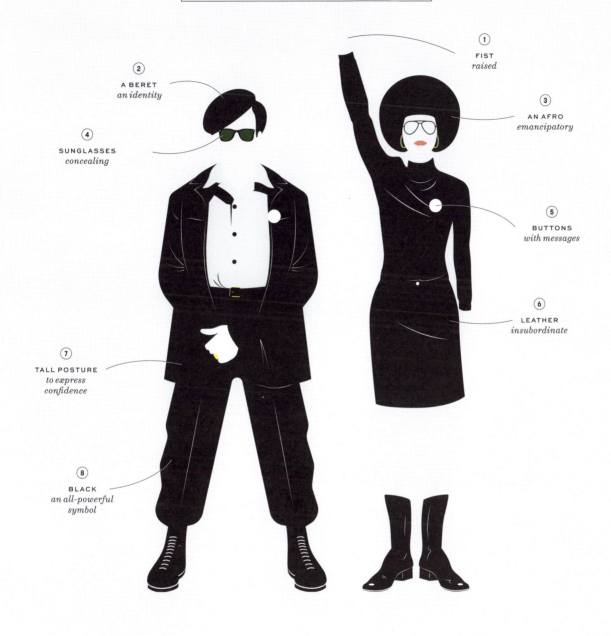

# TECHNO
## PETER PAN SYNDROME

| BIRTHPLACE | MANCHESTER |
| --- | --- |
| PEAK | 1990s |

The electro movement develops in the 1990s, merging the dance scene born in Manchester and London in the early 1980s and techno, which emerges in Detroit at the end of the 1970s before reaching its peak in Berlin. Popular, carefree, and festive, it instills a new, playful aesthetic.

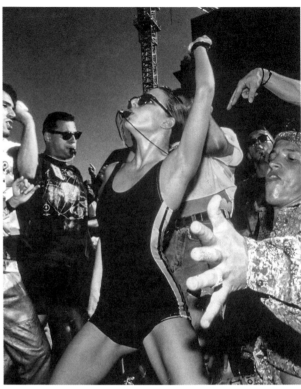

↑ Love Parade, Berlin, 1991

### UTOPIA

In England, it is nicknamed « Second Summer of Love », in a nod to the summer of 1967, the peak of the hippie movement. The techno phenomenon takes hold internationally among young people. Carried on by values of peace, love, and liberty, it is often compared to the hippie movement (p. 326). At the same time, technology is developing, becoming more and more accessible and fascinating, as portrayed in films like *The Matrix*, which offer a futuristic vision of the digital era. Young people gather at outdoor raves or urban events like the Techno Parade in Paris and the legendary Love Parade in Berlin.

### « I'M MORE TECHNO »

Raf Simons founds his menswear brand in 1995 and acknowledges the influence of electro music. From the outset, the Belgian designer infuses men's silhouettes with a penchant for youth culture. He renews the masculine vocabulary in fashion with a spirit that is both futuristic and nostalgic for past countercultures. Raf Simons explores women's fashion at Jil Sander and Dior. In 2020, he and Miuccia Prada announce a surprise four-hand collaboration as creative directors of the Prada house – because the future is also about transforming the systems in place through unification.

### PARTIES

Comfort matters; it's about dancing to percussive rhythms while standing out in the darkness of the clubs. Thus, smiley T-shirts (a cheeky nod to ecstasy), baggy pants borrowed from hip-hop (p. 316), and fluorescent colors abound. Girls and boys blend together, androgynous, with falsely childish looks, as if to refuse the adult world during this decade of political and economic crisis. Techno style extends to the streets, and pop groups like the Spice Girls adopt an attenuated version as if there were a global desire to never grow up.

> « THE WORLD IS CHANGING. MUSIC IS CHANGING. DRUGS ARE CHANGING. »
>
> *TRAINSPOTTING*

### HOLLOW LAUGH

In 1963, graphic designer Harvey Ball is chosen by an insurance company to design an illustration that lifts spirits. He imagines a yellow and black smiley face. The unregistered design is soon recuperated. It becomes a symbol of optimism in an America haunted by the Vietnam War. In the late 1980s, the smiley face is associated with acid house music and ecstasy. After becoming representative of techno and raves in the 1990s, it is boycotted by British companies following overdose deaths.

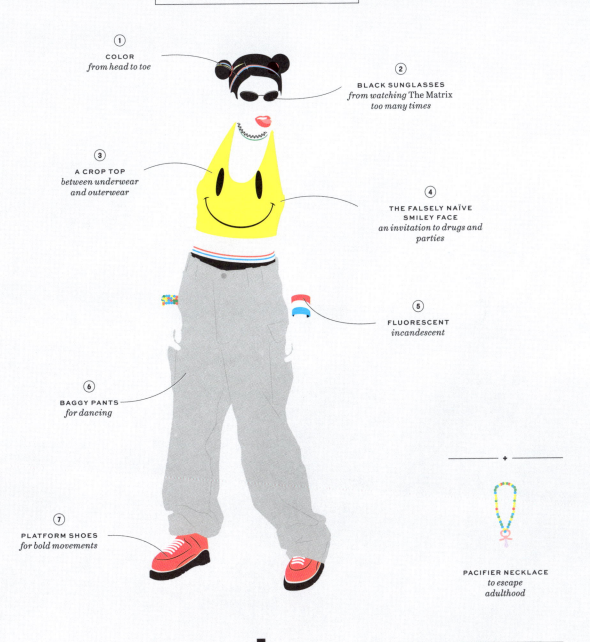

# PEACOCKS
## SHOWING YOUR FEATHERS

| | |
|---|---|
| BIRTHPLACE | LONDON |
| PEAK | LATE 1960s |

In the 1960s, men distance themselves more and more from the conservative shackles that have confined their style since the 19$^{th}$ century. Whether it's English mods, bohemian Parisians, or California hippies, they seek to deconstruct rigid norms of masculinity and allow space for whimsy.

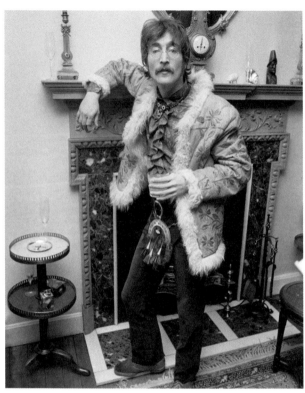

↑ John Lennon, London, 1967

### « VANITY IS THE DOMINANT PASSION OF MAN. »

HENRY DE MONTHERLANT

### A FANTASY

Those referred to as « peacocks » emerge in London, where they marry flamboyant velvet suits with Liberty shirts (p. 194) and graphic ties (p. 182). They are found on Carnaby Street, where they go to visit the movement's chief designer, John Stephen, who dresses the Rolling Stones, The Who, and The Kinks. They also visit certain refined tailors on Savile Row who redefine their silhouette with audacious collarless jackets.

### STREET SHOW

The peacocks of the 1960s should brace themselves: with social media, everyone is now a peacock. Ever since Bill Cunningham invented the concept of street style photography, style shines in the streets. In the late 2000s, personalities such as Garance Doré, the Sartorialist, and Tommy Ton photograph those whose looks deserve to be immortalized. The rendezvous point is the fashion show exit. Guests focus on their looks, while feigning indifference.

### A RENAISSANCE

Even if the movement seems to be born out of spite for English postwar bourgeois traditions, there is also an air of nostalgia at its heart. These 20$^{th}$-century dandies (p. 324) reinterpret the historic silhouette of the *habit à la française* worn at the French court, the pussy bow, and the Victorian redingote, thus reminding those who qualify their posture as feminine that before the 19$^{th}$ century, men wore silk, lace, and color; the norms of the day were precisely what 20$^{th}$-century society rejects for men. And above all, the references demonstrate that there is nothing wrong with a man caring about his appearance.

### THE CULT OF SELF

October 2010: the birth of Instagram. The selfie now dominates. We stage ourselves, alone or with friends. With the development of smartphones, everyone becomes a narcissistic and egocentric photographer. We exhibit our outfits with pretension while anxiously checking for likes. The selfie gives rise to an almost pathological quest for validation. Even those who feign detachment present themselves with false modesty. In the secure, intimate space, the gaze of the other has never been so valued.

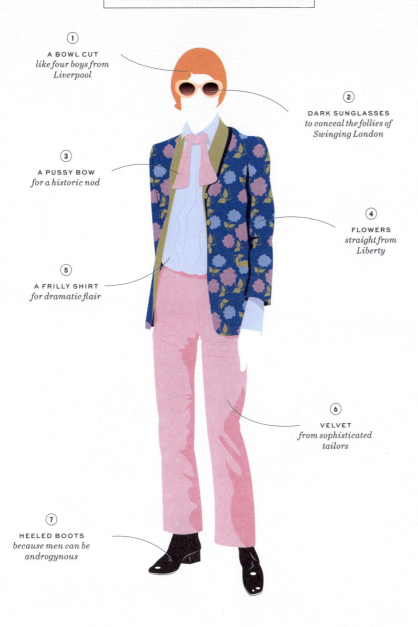

## PEACOCK ATTRIBUTES AND REFERENCES

1. **A BOWL CUT** *like four boys from Liverpool*
2. **DARK SUNGLASSES** *to conceal the follies of Swinging London*
3. **A PUSSY BOW** *for a historic nod*
4. **FLOWERS** *straight from Liberty*
5. **A FRILLY SHIRT** *for dramatic flair*
6. **VELVET** *from sophisticated tailors*
7. **HEELED BOOTS** *because men can be androgynous*

**FASHION**
John Stephen
Mr. Fish
Granny takes a trip
Alessandro Michele for Gucci
Liberty & Co
Miuccia Prada for Miu Miu et Prada

**SEEN ON**
Christopher Gibbs

**MUSIC**
The Beatles – *Sgt. Pepper's Lonely Hearts Club Band*
Jimi Hendrix
Prince
Brian Jones

**CINEMA**
The character of Austin Powers
*Modesty Blaise*

**TV**
Mick Jagger on the show *Ready Steady Go!* in 1966

# TEDDY BOYS & GIRLS
## ELEGANT DELINQUENCY

| BIRTHPLACE | LONDON |
| --- | --- |
| PEAK | 1950s |

After the war, the tailors of wealthy London neighborhoods, concerned with relaunching their business, try to popularize baggier fits that were popular under the early 1900s reign of Edward VII. The jackets are too long, the pants too cigarette, and the style too evocative of the much-maligned American zoot suit. It is not a success among the elite.

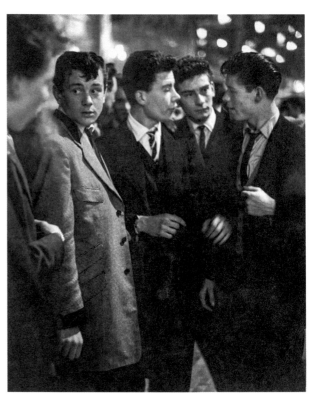

↑ Teddy boys *in front of the Mecca Dance Hall in Tottenham*, London, 1954

### PROVOCATION
Ever since aristocrats established the dominant fashion in the Middle Ages, anyone who doesn't adhere to its codes is denigrated as scandalous. In the 20th century, scandal seems to have become a marketing tool, as with Benetton's ad campaigns during the 1980s and 1990s: Photographer Oliviero Toscani tackles subjects as difficult as AIDS, capital punishment, and worldwide hunger and advocates for multiculturalism and tolerance.

### SECOND LIFE
The garments end up in shops in non-affluent neighborhoods, offered at a discount, and working-class teenagers snap them up. The resulting Teddy style (the name is from the diminutive of Edwardian) takes over London and its suburbs in 1952. The somewhat marginal movement is composed of boys, often affiliated with gangs, sometimes with racist overtones, who reject conventions and austerity. The few girls in the movement must borrow from the male wardrobe because nothing in women's fashion expresses sufficient transgression.

### YOUTH CULTURE
Teddy Boys and Girls are seething with anger and become one of the first movements of youth culture. They don't want to resemble their parents, even if they adopt traditional Edwardian forms. They also cherish American culture, especially rockabilly, which explains their look's proximity to that of the zoot suiters. Perceived as criminals, Teddy Boys are also mocked for their affectation. They represent a clothing style but also a veritable counterculture movement. Although the movement barely lasts six years, it influences the mods (p. 304) and the punks (p. 328).

« THESE WERE WORKING CLASS KIDS WHO WERE GOING TO BE BUTCHERS AND BAKERS AND SO ON, AND THEY WANTED TO BE TAKEN MORE SERIOUSLY. »

CHRIS STEELE-PERKINS

### GENDERLESS
The androgynous style of the Teddy Girls aligns with the preference for gender neutrality in today's fashion, designed for a generation that does not wish to be identified by sex. Designers sometimes offer gender-neutral collections or eliminate the distinction between men's and women's garments. In 2020, London Fashion Week announces there will no longer be a week dedicated to menswear. Unisex collections will be presented instead.

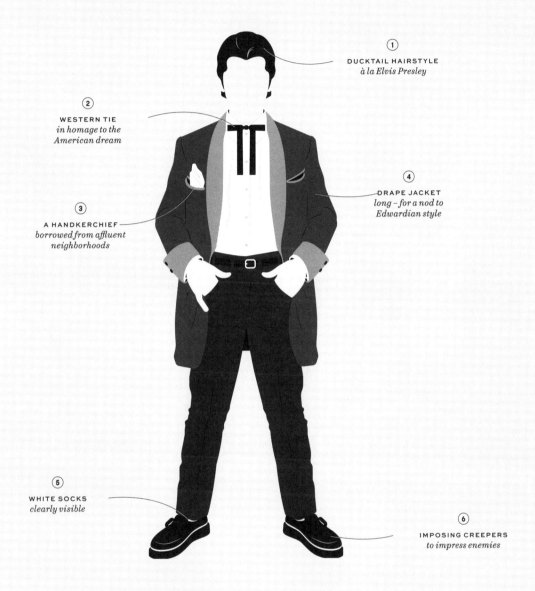

## TEDDY BOYS & GIRLS ATTRIBUTES AND REFERENCES

1. **DUCKTAIL HAIRSTYLE** *à la Elvis Presley*
2. **WESTERN TIE** *in homage to the American dream*
3. **A HANDKERCHIEF** *borrowed from affluent neighborhoods*
4. **DRAPE JACKET** *long – for a nod to Edwardian style*
5. **WHITE SOCKS** *clearly visible*
6. **IMPOSING CREEPERS** *to impress enemies*

**ICONS**
Bill Haley & His Comets
Billy Eckstine
Eddie Cochran

**MUSIC**
« Rock Around the Clock »
*Blackboard Jungle*

**PHOTOGRAPHY**
Ken Russell

**MOVIES**
*Teddy Boy*
*A Clockwork Orange*

**MUSIC**
Arctic Monkeys
Beatles

**FASHION**
Dior F/W 2019
Vivienne Westwood
Saint Laurent S/S 2014

**PART 4**

# PORTRAITS

## 52 DESIGNERS

| | |
|---|---|
| Virgil Abloh ............................................. p. 350 | Calvin Klein ........................................... p. 356 |
| Azzedine Alaïa ...................................... p. 350 | Christian Lacroix ................................. p. 356 |
| Giorgio Armani ..................................... p. 350 | Karl Lagerfeld ....................................... p. 357 |
| Cristóbal Balenciaga ........................... p. 350 | Guy Laroche ........................................... p. 357 |
| Pierre Cardin ........................................ p. 351 | Jeanne Lanvin ....................................... p. 357 |
| Jean-Charles de Castelbajac ............ p. 351 | Christian Louboutin ........................... p. 357 |
| Hussein Chalayan ............................... p. 351 | Martin Margiela ................................... p. 358 |
| Gabrielle Chanel ................................. p. 351 | Alexander McQueen ........................... p. 358 |
| Coperni .................................................. p. 352 | Issey Miyake .......................................... p. 358 |
| André Courrèges .................................. p. 352 | Thierry Mugler ..................................... p. 358 |
| Christian Dior ...................................... p. 352 | Rick Owens ............................................ p. 359 |
| Dolce & Gabbana ................................ p. 352 | Miuccia Prada ....................................... p. 359 |
| Tom Ford ............................................... p. 353 | Emilio Pucci .......................................... p. 359 |
| Mariano Fortuny ................................. p. 353 | Paco Rabanne ....................................... p. 359 |
| Diane Von Fürstenberg ..................... p. 353 | Olivier Rousteing ................................ p. 360 |
| John Galliano ....................................... p. 353 | Sonia Rykiel .......................................... p. 360 |
| Valentino Garavani ............................ p. 354 | Yves Saint Laurent ............................. p. 360 |
| Jean-Paul Gaultier ............................. p. 354 | Elsa Schiaparelli .................................. p. 360 |
| Rudi Gernreich .................................... p. 354 | Jeremy Scott ......................................... p. 361 |
| Alix Grès ................................................ p. 354 | Marine Serre ......................................... p. 361 |
| Demna Gvasalia .................................. p. 355 | Hedi Slimane ........................................ p. 361 |
| Roy Halston .......................................... p. 355 | Paul Smith ............................................. p. 361 |
| Iris Van Herpen ................................... p. 355 | Kenzo Takada ....................................... p. 362 |
| Simon Porte Jacquemus .................... p. 355 | Gianni Versace ..................................... p. 362 |
| Rei Kawakubo ...................................... p. 356 | Viktor & Rolf ........................................ p. 362 |
| Patrick Kelly ......................................... p. 356 | Vivienne Westwood ........................... p. 362 |

# DESIGNERS
## THE IDEA AND THE EXECUTION

**VIRGIL ABLOH**
(1980-2021)

**AZZEDINE ALAÏA**
(1935-2017)

**GIORGIO ARMANI**
(BORN IN 1934)

**CRISTÓBAL BALENCIAGA**
(1895-1972)

**URBAN LUXE**
P. 282

**BANDAGE DRESS**
P. 232

**ARMANI SUIT**
P. 290

**SCULPTURAL DRESS**
P. 222

Virgil Abloh first attracts attention in Chicago in 2009 with a concept store that blends art and design. His collaboration with Kanye West, as the artistic director of his albums and concerts, propels him into the spotlight. In 2013, he founds Off-White, a sportswear brand that appeals to young people and the counterculture. In 2018, Louis Vuitton names him head of their men's collections. He breathes new life into the luxury brand while pursuing his musical and artistic projects.

Arriving in France from Tunisia in the 1950s, Azzedine Alaïa perfects his couture skills while working with elegant Parisian women before founding his brand in 1980. His patience pays off. The couturier is an expert in women's bodies, which he enhances or transforms with sculptural designs that are like a second skin. Stretch fabric, impertinent zippers, and corseted waists are his signature. Alaïa is an artisan of fashion: durability rather than temporality.

First a window dresser, then a stylist for Nino Cerruti in the 1960s, Giorgio Armani founds his own brand in 1975. His international career is launched when he dresses Richard Gere for the movie *American Gigolo* in 1980. He participates in the 1980s power-dressing vocabulary while relaxing the codes of masculinity and affirming those of femininity. The designer establishes a veritable empire by multiplying his lines and activities, demonstrating a modern spirit without altering his timeless aesthetic.

Initiated by his mother into sewing, the couturier opens his first shops in Spain before coming to Paris in 1937. While Christian Dior imposes his « Corolle » line, Cristóbal Balenciaga works with asymmetrical volumes and borrows from Spanish folklore, represented in his preference for black, and from 19th-century fashion. His deconstructed silhouettes are like sculptures, heralding the curves of 1960s fashion. Despite his modern touch, Cristóbal Balenciaga prefers to end his career in 1968, feeling overwhelmed by a world rushing towards change.

**PIERRE CARDIN**
(1922-2020)

**JEAN-CHARLES DE CASTELBAJAC**
(BORN IN 1949)

**HUSSEIN CHALAYAN**
(BORN IN 1970)

**GABRIELLE CHANEL**
(1883-1971)

**SPACE AGE**
P. 266

**TEDDY BEAR JACKET**
P. 226

**TABLE SKIRT**
P. 227

**WOMEN'S SUIT**
P. 203

After honing his technique alongside couturiers like Elsa Schiaparelli and Christian Dior, Pierre Cardin founds his brand in 1950. A trailblazer, he develops his prêt-à-porter lines imbued with a Space Age style as much as his haute couture lines. The designer is interested in innovation, aesthetics, and commercial success. His brand thrives in the Asian market, and he multiplies his licenses, tarnishing the brand's reputation while also securing its prominence in the international wardrobe.

In 1968, Jean-Charles de Castelbajac creates his first women's clothing line for his mother's clothing company. Called Ko & Co, the brand plays with the misappropriation of objects and re-creations, reflecting his fondness for surrealist art and the Dada movement. Adept at color-blocking, Castelbajac formulates a playful and joyful aesthetic that refutes the solemnity of fashion. With humor and poetry, the multidisciplinary designer introduces contemporary art and pop culture into his designs and celebrates the permeability of the imagination.

His childhood emigration from Cyprus has a considerable impact on the designer, who, as a teenager, studies at Central Saint Martins in London. When he establishes his brand in 1995, Hussein Chalayan intellectualizes his stylistic work by infusing social and political reflections translated into impactful conceptual runway shows and astonishing technological and experimental designs. As a multidisciplinary visionary, the designer uses the performative nature of fashion to challenge and tell stories, both beautiful and cruel.

Sometimes Gabrielle, often Coco; the Chanel legend begins in her childhood in an orphanage. In 1909, all grown up, she founds a milliner workshop in Paris. In 1913, she opens a boutique in Deauville, where she offers jersey ensembles with fluid lines that participate in the modern style vocabulary. She reigns supreme in the 1920s with her little black dresses embracing an elegance that passes through restraint. For her remarkable return to fashion after the war, she creates timeless tweed suits. Chanel is both a woman and a brand with a well-established history.

**COPERNI**
(BORN IN 1972 AND 1973)

**ANDRÉ COURRÈGES**
(1923-2016)

**CHRISTIAN DIOR**
(1905-1957)

**DOLCE & GABBANA**
(BORN IN 1958 AND 1962)

**ANTIBACTERIAL FABRIC**
P. 282

**VINYL JACKET**
P. 267

**BAR SUIT**
P. 213

**ITALIAN FASHION**
P. 216

Sébastien Meyer and Arnaud Vaillant meet at Modart International fashion school. In 2013, they launch their brand, Coperni, offering a modern and sober style. Between 2015 and 2019, they put the brand on pause and revive the success of Courrèges, where they link archives with novelty, before moving back to Coperni, where they experiment more than ever with forms and materials that marry technology and artisanry with modesty and virtuosity.

André Courrèges perfects his technique for ten years alongside Cristóbal Balenciaga before founding his house in 1961. Passionate about architecture, the designer constructs a modern and graphic style and redraws an emancipatory and feminine silhouette. Protagonist of a futuristic utopia, he shakes up the spirit of the times: he is responsible for the popularity of the miniskirt. Long afterward confined to a cliché of 1960s fashion, his style is revived in the 2010s, supported by increasingly vintage-oriented young people.

Christian Dior first makes a name for himself in the art world as a gallerist before selling his fashion sketches in the 1930s. Assistant to couturier Lucien Lelong during the war, he founds his house, backed by industrialist Marcel Boussac, in 1946. His first runway show is an upheaval. Or rather, a renaissance. Christian Dior revives haute couture, which was dormant after the Occupation, and brings back sumptuous styles and exaggerated femininity. Modernity is not a consideration. He prefers to dream. During the 1950s and until his sudden death, the couturier defines the fashion of his time, imposing his style and his « Corolle », « Muguet », and « Fuseau » lines.

Domenico Dolce and Stefano Gabbana establish a styling consultancy in 1982 before presenting their first collection under the name Dolce & Gabbana in 1985. The duo offers a nostalgic aesthetic with their designs that evoke Southern Italy and 1960s movies. The brand's popularity grows in the 1990s, largely thanks to the more accessible D&G line. The brand promotes a sensual, glamorous aesthetic that tells the story of Italy and adopts its iconography.

**TOM FORD**
(BORN IN 1961)

**MARIANO FORTUNY**
(1871-1949)

**DIANE VON FÜRSTENBERG**
(BORN IN 1946)

**JOHN GALLIANO**
(BORN IN 1960)

**PORNO CHIC**
P. 243

**DELPHOS GOWN**
P. 228

**WRAP DRESS**
P. 278

**HOMELESS CHIC**
P. 206

In 1990, Tom Ford joins Gucci and is promoted to creative director in 1994. His first collections are a hit. He partners with Carine Roitfeld and photographer Mario Testino and redefines the brand's entire identity by popularizing porno chic. Gucci, which was stagnant at the time, sees its sales explode. Tom Ford leaves the house in 2004, and in 2006, he creates the brand that wears his name. He then turns to film directing with critically and commercially successful movies like *A Single Man*.

Mariano Fortuny, a multi-disciplinary artist, founds a textile company in Venice in 1899, where he creates fabrics and patterns with his wife, Henriette. Inspired by the ancient world and Eastern cultures, he specializes in velvet and his signature pleats. He participates in a new vocabulary of women's fashion that abandons corsets and volumes for straight, supple lines. He dresses artists and avant-gardists who dare to liberate their bodies and their sensuality under veils and silks.

Newly divorced young mom Diane von Fürstenberg gets her start in the early 1970s while living in New York, where she popularizes the wrap dress. Emblematic of a new generation of active women, the versatile dress also represents its designer – an inveterate party girl, socialite, and muse to Andy Warhol, but also a businesswoman who rapidly builds an empire. In 1997, after a decade of absence, the designer relaunches the brand DVF and her signature dress. She meets with new success while providing an inspiring example of a successful woman.

As a student at Central Saint Martins in London, John Galliano's 1984 graduation collection garners attention. He then launches his brand, nourished by theatricality, historicism, and sensuality. In 1996, he is named creative director of Dior. Despite initial reticence, the media and the public are soon won over as he revives the luxury house with his spectacular runway shows, stunning designs, and his taste for singularity. Following an anti-Semitic scandal in 2011, the designer is fired, before a discreet but masterful return to fashion at Maison Margiela in 2014.

**VALENTINO GARAVANI**
(BORN IN 1932)

**JEAN-PAUL GAULTIER**
(BORN IN 1952)

**RUDI GERNREICH**
(1922-1985)

**ALIX GRÈS**
(1903-1993)

**RED COUTURE**
P. 286

**CONE BRA CORSET**
P. 263

**MONOKINI**
P. 291

**NEOCLASSICISM**
P. 218

The Italian designer learns his trade in Paris at the Chambre Syndicale and alongside Guy Laroche. In 1959, back in Rome, he opens his couture house. After his all-white collection in 1968 draws attention, he establishes himself in the 1970s among prestigious clients who appreciate his timeless sophistication. An aesthete, the designer offers clothes that suggest luxury without ostentation. He leaves the house in 2008 but remains a leading figure in Italian fashion.

Initially self-taught, then apprentice at Pierre Cardin, Jean-Paul Gaultier presents his first collection in 1976 before founding his brand. In the 1980s, he plays with deconstructing the imperatives of gender and style, daring to blend inspiration from his modest childhood with eminently urban multiculturalism. The wild child of fashion, he establishes a leading brand that shakes up haute couture and enchants prêt-à-porter, all while dialoguing with pop culture as a costume designer for movies and musicians.

Rudi Gernreich flees Austria's Nazi regime and settles in Los Angeles in 1938. In 1942, he becomes a professional dancer for a modern dance company while experimenting with clothing design. He establishes himself as a freelance stylist and designs avant-gardist silhouettes that rehabilitate the body while blurring gender lines. Soft bras, monokinis, and one-piece bathing suits promote a liberty of movement that is dear to him. In 1970, he launches a unisex line, a pretext for an innovative dialogue on fashion and society.

In 1935, Germaine Krebs, known under the name Alix, founds her brand, Madame Grès. She immediately stands out for her timeless neoclassical jersey looks, with elegant pleats that highlight the body while infusing it with lightness and sensuality. As a trained sculptor, she drapes her designs on the bodies of her models, establishing a straight line between the flesh and the fabric. As popular in the 1930s as in the 1970s, she becomes the president of the Chambre Syndicale de la Haute Couture in 1972.

**DEMNA GVASALIA**
(BORN IN 1981)

**ROY HALSTON**
(1932-1990)

**IRIS VAN HERPEN**
(BORN IN 1984)

**SIMON PORTE JACQUEMUS**
(BORN IN 1990)

**CRINOLINE**
P. 223

**DISCO**
P. 219

**ETHEREAL TECHNOLOGY**
P. 297

**SANTON**
P. 252

Graduate of the Royal Academy of Fine Arts in Antwerp, Demna Gvasalia trains alongside other alums, such as Walter Van Bereindonck and Martin Margiela. In 2014, he launches the brand Vetements with his brother Guram. They quickly gain a cult following for their subversion of traditional fashion norms. In 2015, the designer enters Balenciaga, where his nonconformism pairs surprisingly well with the sophistication of the historic house. Because behind the originality, Demna Gvasalia understands the intimate and collective language of fashion.

First known as a milliner, Roy Halston sees his career take off when he designs the hat worn by Jackie Kennedy on the day of her husband's presidential inauguration in 1961. In the early 1970s, he launches his prêt-à-porter line with its minimalist, sophisticated, and sometimes even masculine aesthetic for a prestigious clientele. He is also appreciated for his designs destined to be worn at night, like his disco dresses that are part of the festive and fantastical atmosphere of 1970s New York. Poorly chosen licensing deals lead to the brand's aura waning in the 1980s.

Trained by Alexander McQueen, Iris van Herpen establishes her brand of the same name in 2007, where she develops all of her poetic reflections, inspired by dance, architecture, technology, experimentation, and especially by materials and the way they cohabitate with the body. A prodigy, Iris van Herpen pushes the boundaries of clothing design, bringing it closer to an organic and sculptural future that is already taking shape.

Self-taught Provençal Simon Porte Jacquemus is not yet 20 years old when he sets up his brand in Paris. He is noticed thanks to his audacity and levity. He integrates the official Parisian runway calendar in 2012, but it's in 2017 that his popularity intensifies. The public is charmed by his designs that evoke the South of France without clichés or snobbery. Remaining close to his clients thanks to social media, his innovative commercial operations refute luxury codes in favor of greater accessibility.

**REI KAWAKUBO**
(BORN IN 1942)

**PATRICK KELLY**
(1954-1990)

**CALVIN KLEIN**
(BORN IN 1942)

**CHRISTIAN LACROIX**
(BORN IN 1951)

**DRESS MEETS BODY**
P. 256

**BUTTONS AND HEARTS**
P. 237

**SLIP DRESS**
P. 127

**POUF SKIRT**
P. 253

Rei Kawakubo begins her career in fashion as a self-taught artist before founding her brand, Comme des Garçons, in Tokyo in 1969. In 1980, she presents her first Parisian collection. The critics are ferocious: her deconstructed style that redefines the norms of beauty and fashion offends Western sensibilities. Despite this, the Japanese designer succeeds by offering a new vocabulary appreciated by those who refuse conventions. Playing with body shapes, the abstract, and textile craft, Rei Kawakubo continues to establish herself as a visionary of contemporary design.

Patrick Kelly moves to New York in the late 1970s where he designs his first garments before settling in Paris. In 1985, he founds his immediately successful brand. Behind the exuberant joy of his designs, he never ceases to interrogate racism and his Black American heritage. In 1988, he enters the Chambre Syndicale de la Couture Parisienne, but his career is brought to an abrupt end when he dies of AIDS in 1990.

In 1968, Calvin Klein founds the brand that carries his name. Initially, he only offers coats before moving into sportswear. But it's an emblem of American fashion that will propel him into the spotlight when, in 1979, he designs a pair of jeans. Inaugurating a commercial identity with provocative advertising and underwear lines, the designer establishes an aesthetic that relies on minimalism, a vital component of the DNA of American style. He typifies the 1990s with his spectacularly successful perfumes and ad campaigns that exalt teen idols.

While dreaming of becoming a museum curator, Christian Lacroix turns to fashion, joining Jean Patou before founding his own house in 1987. However, he doesn't ignore his affection for art history; it feeds his collections, whose silhouettes emerge like paintings on dresses. Sometimes, he even dares a literal wink to his influences, with costumes that the past wouldn't deny. His native South, with its Arlesian and Provençal nuances, also informs his stylistic work, which pays tribute to his personal passions.

**KARL LAGERFELD**
(1933-2019)

**JEANNE LANVIN**
(1867-1946)

**GUY LAROCHE**
(1921-1989)

**CHRISTIAN LOUBOUTIN**
(BORN IN 1964)

**ANGKOR DRESS**
P. 247

**ROBE DE STYLE**
P. 287

**BACKLESS DRESS**
P. 274

**PIGALLE PUMPS**
P. 209

It isn't easy to summarize the designer's career because his work is so prolific. Initially an assistant, at Pierre Balmain and Jean Patou, Karl Lagerfeld becomes an independent stylist in the 1960s. He is the creative director at Chloé (from 1964 to 1983) and at Fendi (beginning in 1965). After joining Chanel in 1983, his fame is enhanced when he revives the house by revisiting its classics with an aesthetic that combines pop, luxury, erudition, and impertinence. He creates his own brand in 1984. Also, an accomplished photographer, the versatile designer will go down in posterity as a true Renaissance man.

What distinguishes Jeanne Lanvin is her talent and versatility. Originally a stylist, she is first noticed for her designs for women and children at the turn of the 20$^{th}$ century. The link between mother and child becomes a strong marketing signature of the house; the relationship is even depicted on the brand's logo. She is the first designer to create couture for men in 1926, while also experimenting with decoration and cosmetics. Inspired by the arts and the Art Deco movement, she designs sober and modern silhouettes with refined embroideries, and with a sharp sense of color.

Guy Laroche founds his brand in 1957. Mastering the codes of couture, he nonetheless never forgets the comfort of his clients with sober and innovative silhouettes. His style is characterized by vivid colors and a playful sensuality, as seen in the dresses with vertiginous décolletés actress Mireille Darc wears at the peak of his popularity in 1972. Ambitious, he expands his activities in the 1970s, turning his brand into an influential business.

In the early 1980s, Christian Louboutin interns with the shoemaker Charles Jourdan. He gains enough experience to sell his shoe designs on a freelance basis before launching his brand in 1991. Noticed by the fashion press and by the wealthy, he soon creates a name for himself. His shoes are worn in runway shows, and an international clientele is attracted to his distinctive red soles. His universe navigates between burlesque, fetishism, conceptual art, and playful fantasy. Christian Louboutin has established a signature style that is endlessly revisited.

**MARTIN MARGIELA**
(BORN IN 1957)

**ALEXANDER MCQUEEN**
(1969-2010)

**ISSEY MIYAKE**
(1938- 2022)

**THIERRY MUGLER**
(1948-2022)

**STOCKMAN JACKET**
P. 257

**BUMSTER**
P. 275

**BUSTIER**
P. 262

**BIRTH OF VENUS DRESS**
P. 233

After graduating from the prestigious Royal Academy of Fine Arts in Antwerp, Martin Margiela is Jean-Paul Gaultier's assistant until 1988, when he founds his own house. Atypical, the designer refuses interviews and photographs, using his anonymity to highlight the collective work of fashion and the garments themselves. His originality is evident in his runway shows, which are like artistic performances, and in his designs that blend craft, couture, and secondhand. From 1997 to 2003, Margiela is the creative director of Hermès, where he successfully links luxury with nonconformity.

Discovered thanks to his graduation collection at Central Saint Martins College of Art and Design, Alexander McQueen founds his brand in 1992. The tortured and political designer uses his collections to interrogate troubling subjects like violence, death, mental health, sexuality, and identity. His runway shows are performances that are often provocative and sometimes disturbing. He defines unprecedented silhouettes between historicism, artisanal prowess, and organic feeling. Devastated by the death of loved ones and struggling with depression, the English designer ends his own life in 2010.

An art student fascinated by textiles, Issey Miyake designs his first Japanese fashion show, « A Poem of Cloth and Stone », in 1963. Shortly afterwards, he moves to Paris, where he works for Givenchy and Guy Laroche, before returning to Tokyo to set up his design studio. In 1971, he presents his first collection in New York before being invited to show in Paris beginning in 1972. He distinguishes himself through his poetic designs that blend inspirations from the Far East and the West. Above all, he stands out for his textile experimentation, which reinvents forms and materials, blending technology with craft.

Independent stylist trained in classical dance and interior design, Thierry Mugler sells his designs to the major prêt-à-porter brands before founding his own house in 1973. In stark contrast to the hippie style of the era, he privileges a glamorous aesthetic that idolizes femininity, and that rapidly becomes his signature. In the 1980s, he exalts the theatrical side of his collection, bringing in pop culture inspiration while playing with representations of women's bodies, sculpted and remodeled.

**RICK OWENS**
(BORN IN 1962)

**MIUCCIA PRADA**
(BORN IN 1949)

**EMILIO PUCCI**
(1914-1992)

**PACO RABANNE**
(1934-2023)

**EXPOSED GENITALIA**
P. 296

**ATHLEISURE**
P. 208

**PSYCHEDELIC PRINTS**
P. 199

**METAL DRESS**
P. 270

Rick Owens opens his first boutique in Los Angeles in 1994. In 2003, he sets up his Paris atelier where, with his companion, Michèle Lamy, he dreams up a style highlighting deconstructivist codes such as asymmetry, ennobled flaws, and somber colors. Gothic, punk, anti-fashion: qualifiers abound to attempt to describe the designer's style, which progresses from minimalist and sportswear-inspired to futuristic and theatrical, always aiming to interrogate society and the world we live in.

In the mid-1970s, Miuccia Prada joins her family's handbag and accessory company founded by her grandfather in 1913. Initially responsible for accessories, she signs her first prêt-à-porter collection in 1988. She accompanies the minimalist aesthetic of the 1990s and founds Miu Miu, Prada's brazen little sister, in 1993. Her feminine, impertinent, and artistic style is heavily influenced by 1940s and 1960s references. Passionate about contemporary art, she creates la Fondazione Prada with her husband in 1995.

Emilio Pucci first enters fashion through his love of skiing. In 1949, he opens his first boutique in Capri. He sells the ideal wardrobe for an international jet set, seeking lightweight, elegant garments for sunny vacations. In the 1950s, he develops his colorful patterns with a psychedelic aesthetic, expanding his success into the hippie chic 1960s. Emilio Pucci has established a playful, timeless, and recognizable identity.

In 1965, the stylistic story of Paco Rabanne begins. Former art student, he presents a collection that he calls « Twelve Unwearable Dresses in Contemporary Materials ». It's the manifesto of a designer who applies jewelry-making and metalworking techniques to garments. Riveted, welded, assembled, and inlaid metals or perforated leathers form futuristic silhouettes that shake up the ancestral gesture of sewing. The couturier participates in the redefinition of fashion and its language.

**OLIVIER ROUSTEING**
(BORN IN 1985)

**SONIA RYKIEL**
(1930-2016)

**YVES SAINT LAURENT**
(1936-2008)

**ELSA SCHIAPARELLI**
(1890-1973)

**EDGY EMBROIDERY**
P. 246

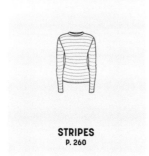

**STRIPES**
P. 260

**MONDRIAN DRESS**
P. 271

**OPTICAL ILLUSION HAT**
P. 236

After working for the Italian band Roberto Cavalli, Olivier Rousteing enters Balmain in 2009 and is named creative director of the house in 2011. Blending sportswear, glamour, and pop culture, the young designer shakes up the conventions of luxury and appropriates the codes of the star system and social media. He is thus able to establish himself internationally and to surround himself with influential muses such as Beyoncé, Kim Kardashian, and Jennifer Lopez. Olivier Rousteing knows the power of image and celebrity and is not ashamed to use it.

Sonia Rykiel creates her first garment while pregnant during the 1950s. It's a sweater, like those worn by men, but more closely fitted, almost as if too small. Her « poor boy sweater » becomes a classic and launches her career as a stylist. In the 1970s, she designs a playful and sensual wardrobe that responds to the needs of women who are more and more active. Sonia Rykiel plays with the different faces of femininity throughout her career, exploring the intellectual as much as the erotic.

When Christian Dior suddenly dies in 1957, his assistant takes over as creative director of the house. The young and shy designer garners attention before establishing his brand in 1962, associated with his companion Pierre Bergé. He speaks to emancipated women, offering them tuxedoes, safari jackets, and graphic dresses. An avid collector, he subverts artistic motifs and explores the aesthetics of other cultures in sometimes insolent, often dazzling creations. He remains, throughout the decades, faithful to women's wishes.

It's almost by accident that the Italian aristocrat becomes involved in fashion in 1927. She begins by creating sweaters with optical illusions that appeal to *Vogue* readers. Her career launched, she establishes herself at Place Vendôme in Paris and becomes one of the most visible designers of the 1930s. She shines thanks to her artistic collaborations and her surrealist inspirations that nourish her explosive creations – haute couture and mischievous at the same time. Avant-garde and influential, Elsa Schiaparelli closes her house in 1954.

**JEREMY SCOTT**
(BORN IN 1975)

**MARINE SERRE**
(BORN IN 1991)

**HEDI SLIMANE**
(BORN IN 1968)

**PAUL SMITH**
(BORN IN 1946)

**POP CULTURE**
P. 207

**MOON PRINT**
P. 195

**SLIM SILHOUETTE**
P. 242

**FLORAL SHIRT**
P. 194

Penniless and escaping his native Missouri, Jeremy Scott launches his brand using secondhand clothing, fabric scraps, and garbage bags in Paris in 1997. The boutique Colette notices his work and begins selling his garments, establishing his designs in the fashion landscape. In 2013, he is named creative director of Moschino. The association between the Italian brand's exuberant universe and the whimsical designer is successful. Endlessly influenced by pop culture, Jeremy Scott becomes part of it when he collaborates with the biggest stars of the day.

After several internships with designers like Martin Margiela and Alexander McQueen, Marine Serre earns the LVMH prize for young designers in 2017. She develops her brand, incarnated by her crescent moon motif that rapidly becomes the emblem of those who follow her. Loyal to her principles of eco-responsibility, the designer favors upcycling and limits her collections, showing that it's possible to succeed in fashion while changing its codes.

In 1996, Hedi Slimane is named creative director of the menswear collections at Yves Saint Laurent. He brings an appreciation for fitted silhouettes and androgynous virility. In 2000, he begins working at Dior Homme, where his archetypal silhouette is so popular that the brand experiences exceptional growth. Hedi Slimane also makes his mark with edgy photographs. He returns to Saint Laurent in 2012, where he also works on women's fashion, before arriving at Celine in 2018.

Self-taught, Paul Smith discovers fashion in the textile workshop where he works as a teenager. In 1970, he opens his first boutique, a tiny den where he sells both his own creations and brands he unearths. He quickly makes a name for himself and develops a style firmly based on British inspiration, which comes as much from pop culture as from his childhood memories. In 1993, he launches his line for women and continues to develop a brand that is more than fashion; it is a state of mind.

**KENZO TAKADA**
(1939-2020)

**GIANNI VERSACE**
(1946-1997)

**VIKTOR & ROLF**
(BORN IN 1969)

**VIVIENNE WESTWOOD**
(1941-2022)

**JOYFUL FASHION**
P. 238

**BAROQUE**
P. 198

**MEME DRESS**
P. 229

**GHILLIE SHOES**
P. 295

At 19 years old, Kenzo Takada becomes the first male student at Bunka Fashion College in Tokyo. In 1965, he arrives in Paris, where he lives off the sales of his design sketches before opening his first boutique, Jungle Jap, in 1970. The Japanese designer is then noticed by the press, who highlight his multiculturalism and joyful forms that blend East and West, as well as his playful and informal approach to runway shows. Kenzo Takada develops his brand's lines before selling it in 1993 to LVMH. He loses the use of Kenzo, but not his whole name.

After a precocious apprenticeship alongside his seamstress mother, a few Parisian internships, and some freelance stylist jobs, Gianni Versace founds the Milan fashion house that carries his name in 1978. He instills his love for the arts, especially Italian baroque, and celebrates opulence and sensuality, as much for women as for men. Passionate about theater, he creates extravagant runway shows that are spectacular and sometimes provocative. He surrounds himself with the greatest supermodels of the era and is fully in tune with the 1990s, decadent despite the prevailing minimalism. He is murdered in front of his Miami home in 1997, at the height of his glory.

Viktor Horsting and Rolf Snoeren meet while they are students at the Academy of Art & Design in Arnhem, Netherlands, in 1989. In 1998, they present their first haute couture collection in Paris, with pieces that are a hybrid of conceptual art and fashion. Museums acquire their collections as much as the boutiques. Viktor & Rolf deploys commercial lines but remains a brand with experimental creativity, exhibited during spectacular runway shows similar to artistic installations.

In 1971, Vivienne Westwood opens her first London boutique, Let it Rock, with her companion Malcolm McLaren. McLaren becomes manager of the punk group Sex Pistols, and she creates a style that will crystallize the provocative codes of the punk movement. In 1981, the pair emerges from the fringe and presents their first official collections. The designer becomes a mainstay of London fashion shows, where she changes history, art, culture, and British tradition, spurning conventions and supporting her political and social convictions.

# BRANDS AND DESIGNERS
## INDEX

**A**

Abloh (Virgil) p. 85, 123, 283, 350
Adidas p. 35, 92, 93, 94, 144, 145, 316, 317
Afrohemien p. 113
Aghion p. 247
agnès b. p. 15, 85
Alaïa p. 232, 350
Alexander Mcqueen p. 61, 122, 131, 156, 170, 178, 196, 275, 297, 318, 319, 355, 358, 361
Alpha Industrie p. 60, 122, 123
Ann Demeulemeester p. 308, 309, 328, 339
Armani p. 10, 186, 187, 290, 350

**B**

Balenciaga p. 43, 50, 64, 76, 86, 123, 126, 144, 171, 192, 222, 223, 232, 248, 267, 286, 308, 312, 350, 352, 355
Balibaris p. 71
Balmain p. 246, 357, 360
Barbour p. 77, 164
Batsheva p. 79
Bikkembergs (Dirk) p. 308
Birkenstock p. 50
Bohan p. 206
Brioni p. 155
Buffalo p. 29, 131
Burberry p. 171, 173, 196

**C**

Camplin p. 128
Capezio (Salvatore) p. 14
Carioca p. 74
Castaner p. 130
Castelbajac (Jean-Charles de) p. 226, 272, 351
Celine p. 248, 272, 312, 361
Chalayan p. 227, 351
Champion p. 55, 147
Chanel p. 15, 16, 42, 106, 107, 130, 156, 160, 192, 193, 202, 203, 207, 212, 226, 247, 267, 321, 330, 351, 357
Charles Jourdan p. 96, 357
Chevignon p. 76
Chiuri (Maria Grazia) p. 286, 320
Chloé p. 247, 260, 272, 294, 327, 357
Christian Lacroix p. 64, 252, 253, 356
Clarks p. 175
Comme des garçons p. 61, 256, 272, 309, 323, 329, 356
Converse p. 92, 93, 94, 336, 337

Coperni p. 282, 352
Coq Sportif p. 144, 145
Courrèges p. 76, 160, 266, 267, 282, 352
Crocs p. 50, 312

**D**

Dapper Dan p. 316, 317
Dickies p. 49
Dior p. 11, 50, 76, 92, 96, 97, 106, 192, 203, 206, 213, 222, 242, 260, 286, 317, 320, 328, 342, 347, 350, 351, 352, 353, 361
Dirk Van Saene p. 308
Dockers p. 54
Dolce & Gabbana p. 216, 352
Doursoux p. 54
Dr. Martens p. 18, 20
Drake's p. 42
Dries Van Noten p. 253, 308, 323

**E**

Eres p. 72

**F**

Ferragamo p. 14, 97, 130, 131, 295
Ford (Tom) p. 67, 68, 122, 243, 353
Fortuny p. 228, 353
Fred Perry p. 24, 25
Fruit of the Loom p. 11
Diane Von Furstenberg p. 278, 353

**G**

G. H. Bass p. 174
John Galliano p. 206, 275, 332, 333, 353
Gap p. 54, 313, 334
Gérard Darel p. 248
Givenchy p. 107, 108, 222, 358
Gloverall p. 126
Grès (Alix) p. 218, 229, 354
Gucci p. 174, 186, 243, 248, 272, 294, 307, 311, 317, 345, 353
Gunne Saxe p. 80
Guy Laroche p. 274, 286, 354, 357, 358

**H**

Halston p. 21, 46, 219, 355
Hanae Mori p. 32, 193
Hanes p. 11
Havaianas p. 37
Hedi Slimane p. 187, 242, 305, 307, 361
Helmut Lang p. 102, 123, 242, 308, 309
Henriette H p. 99

Hermès p. 43, 248, 249, 358
Iris Van Herpen p. 297, 355
Herschel p. 52
Huishan Zhang p. 84

**I**

Indigo union p. 86
Indira de Paris p. 162
Issey Miyake p. 21, 152, 219, 228, 262, 272

**J**

Jacquemus p. 252, 355
Jean-Paul Gaultier p. 123, 261, 263, 329, 354, 358
Jérôme Dreyfus p. 248
Jil Sander p. 50, 166, 342
Johnstons of Elgin p. 165
Juicy Couture p. 145

**K**

Karl Lagerfeld p. 37, 77, 115, 202, 203, 207, 242, 247, 357
Kawakubo (Rei) p. 86, 232, 256, 308, 353
Kelly (Patrick) p. 237, 356
Kenzo p. 32, 77, 194, 238, 260, 330, 362
Calvin Klein p. 14, 38, 55, 102, 103, 104, 137, 140, 198, 217, 356

**L**

La Botte Gardiane p. 43
Lacoste p. 24, 25, 27
Lafont p. 47, 85
Lanvin p. 272, 286, 287, 357
Laulhère p. 119, 121
Laura Ashley p. 79, 80
Le Minor p. 16
Lee p. 136, 140, 143
Lelong (Lucien) p. 15, 193, 352
Levis p. 64, 136, 137, 138
Longchamp p. 248
Louboutin p. 97, 209, 357
Louis Vuitton p. 123, 196, 248, 272, 279, 283, 317, 350

**M**

Maison Beaurepaire p. 134
Manolo Blahnik p. 28, 96, 97
Marc Jacobs p. 29, 272, 279, 317, 338
Marine Serre p. 195, 196, 361
Margiela p. 32, 223, 257, 286, 308, 309, 353, 355, 358, 361
Marina Yee p. 308
Marithé + François Girbaud p. 85, 137
Max Mara p. 152
Mc Cardell (Claire) p. 14, 127, 137

Meyer (Sébastien) p. 282, 352
Mirto p. 118
Miu Miu p. 158, 160, 359
Moncler p. 76, 283
Moschino p. 28, 72, 179, 207, 272, 317, 360
Mugler p. 233, 358

**N**

Neighborhood p. 65
New Balance p. 92, 93, 94
New Breed p. 114
New Era p. 87, 89
Next p. 135
Nike p. 92, 93, 94, 283, 316
Nodaleto p. 133

**O**

Olivier Rousteing p. 246, 360
Omear p. 101

**P**

Patagonia p. 76
Patou p. 15, 253, 321, 356, 357
Paul Smith p. 194, 196, 315, 361
Petit Bateau p. 99, 103
Piccioli (Pierpaolo) p. 286
Pierre Cardin p. 213, 248, 266, 330, 351, 354
Poiret (Paul) p. 46, 193, 228, 272
Prada p. 51, 208, 342, 343, 345, 359
Pucci p. 76, 196, 199, 359
Puma p. 92, 93, 316
Pyer Moss p. 192

**Q**

Quant (Mary) p. 160, 305

**R**

Paco Rabanne p. 270, 343, 359
Raf Simons p. 123, 242, 272, 342
Ralph Lauren p. 14, 24, 25, 54, 55, 168, 170, 334, 335
Reebok p. 92, 94
Repetto p. 14
Rick Owens p. 50, 261, 296, 309, 318, 359
Roger Vivier p. 96, 97, 131, 271
Ron Dorff p. 104
Row Mango p. 58
Rudi Gernreich p. 291, 354

**S**

Saint James p. 16

Saint Laurent p. 46, 107,127, 130, 136, 137, 156,166, 170, 187, 193, 208, 212, 239, 242, 260, 271, 272, 296, 330,339, 347, 360, 361
Schiaparelli (Elsa) p. 131, 156, 206, 236,237, 272, 286, 351, 360
Schott p. 115
Scott (Jeremy) p. 207, 272, 307, 331, 361
Sebago p. 174
Sebti (Zhor) p. 46
Sonia Rykiel p. 196, 260, 360
Strauss p. 47, 54, 136, 140
Supreme p. 77, 317

**T**

Tazi (Tami) p. 46
Ted Baker p. 188
The Nines p. 185
Timberland p. 28
Tod's p. 174
Tricot p. 24

**V**

Vaillant (Arnaud) p. 282, 352
Valentino p. 50, 286, 354
Van Bereindonck (Walter) p. 308, 355
Vanessa Bruno p. 248
Vans p. 93, 94, 334
Velva Sheen p. 13
Versace p. 115, 196, 198, 208, 242, 272, 287, 362
Viktor & Rolf p. 76, 229, 362
Vionnet (Madeleine) p. 218, 232

**W**

Vivienne Westwood p. 42, 178, 263, 272, 294, 295, 309,326, 328, 329, 332, 333, 347, 362
Wrangler p. 62, 136, 140, 143, 145, 170

**Y**

Yasmine Eslami p. 98
Yohji Yamamoto p. 65, 86, 93, 145, 187, 232, 308, 309, 318

**&**

& Daughter p. 156

# GARMENTS AND ACCESSORIES
## INDEX

**A**

*Angkor dress* – Chloé *p. 247*
*Antibacterial fabric* – Coperni *p. 282*
*Armani suit* – Giorgio Armani *p. 290*
*Athleisure* – Prada *p. 208*
Aviator jacket *p. 122*

**B**

*Backless dress* – Guy Lacroche *p. 274*
Backpack *p. 51*
Bag (2.55) – Chanel *p. 202*
Ballet flats *p. 14*
*Bandana dress* – Azzedine Alaïa *p. 232*
Bandana *p. 38*
*Bar suit* – Dior *p. 198*
*Barbour jacket p. 164*
*Baroque* – Versace *p. 198*
Beanie *p. 165*
Beret *p. 119*
Bikini *p. 73*
Biker jacket *p. 115*
Birkenstocks *p. 50*
*Birth of Venus dress* – Thierry Mugler *p. 233*
Bomber jacket *p. 123*
Boots *p. 43*
Boubou *p. 134*
Bowtie *p. 68*
Bra *p. 98*
*Bumster* – Alexander Mcqueen *p. 275*
*Bustier* – Issey Miyake *p. 262*
*Buttons and hearts* – Patrick Kelly *p. 237*

**C**

Caftan *p. 46*
Cap *p. 87*
Cardigan *p. 15*
Chore jacket *p. 85*
*Cone bra corset* – Jean-Paul Gaultier *p. 263*
*Crinoline* – Balenciaga *p. 223*

**D**

Dashiki *p. 114*
*Delphos gown* – Mariano Fortuny *p. 228*
Desert boots *p. 61*
*Disco* – Halston *p. 219*
Djellaba *p. 110*
Dr. Martens *p. 20*
*Dress Meets Body* – Rei Kawabuko *p. 256*
Duffle coat *p. 126*

**E**

*Edgy embroidery* – Balmain *p. 246*
Espadrille *p. 130*
*Ethereal technology* – Iris van Herpen *p. 297*

**F**

Fédora *p. 156*
Flip flops *p. 37*
*Floral shirt* – Paul Smith *p. 194*

**G**

Geta *p. 32*
*Ghillie Shoes* – Vivienne Westwood *p. 295*
Guayabera *p. 118*

**H**

*Homeless chic* – Dior *p. 206*
Huipil *p. 181*

**I**

*Italian fashion* – Dolce & Gabbana *p. 216*

**J**

Jeans *p. 136*
Jean jacket *p. 64*
Jean shirt *p. 170*
*Joyful fashion* – Kenzo Takada *p. 238*

**K**

*Kelly bag* – Hermès *p. 248*
Khakis *p. 54*
Kilt *p. 178*
Kimono *p. 148*
Kufi *p. 105*

**L**

Little black dress *p. 106*
Lumberjack shirt *p. 29*

**M**

Marinière *p. 16*
*Meme dress* – Viktor & Rolf *p. 229*
Men's briefs *p. 103*
*Men's skirt* – Jean-Paul Gaultier *p. 261*
*Metal dress* – Paco Rabanne *p. 270*
Military jacket *p. 60*
*Mini-crini* – Vivienne Westwood *p. 294*
Miniskirt *p. 160*
Moccasin *p. 174*
Modern suit *p. 186*
*Moon print* – Marine Serre *p. 195*
*Mondrian dress* – Yves Saint Laurent *p. 271*
*Monokini* – Rudi Gernreich *p. 291*

**N**

*Neoclassicism* – Alix Grès *p. 218*

**O**

One-piece bathing suit *p. 72*
*Optical illusion hat* – Elsa Schiaparelli *p. 236*
Overalls *p. 47*
Overcoat *p. 152*

**P**

Panties *p. 99*
Peacoat *p. 127*
*Pigalle pumps* – Louboutin *p. 209*
Platform shoes *p. 131*
Polo *p. 24*
*Pop culture* – Moschino *p. 207*
*Porno chic* – Gucci *p. 243*
*Pouf skirt* – Christian Lacroix *p. 256*
Prairie dress *p. 80*
*Psychedelic prints* – Pucci *p. 199*
Puffer jacket *p. 76*
Pumps *p. 96*

**Q**

Qamis *p. 135*
Qipao *p. 84*

**R**

*Robe de style* – Jeanne Lanvin *p. 287*
*Red couture* – Valentino *p. 286*

**S**

*Safari jacket* – Yves Saint Laurent *p. 239*
Samue *p. 86*
*Santon* – Jacquemus *p. 252*
Sari *p. 56*
Sarong *p. 33*
*Sculptural dress* – Balenciaga *p. 222*
*Silk square* – Hermès *p. 249*
*Silhouette slim* – Hedi Slimane *p. 242*
*Slip dress* – Calvin Klein *p. 127*
Sneakers *p. 92*
*Space age* – Pierre Cardin *p. 266*
*Speedy bag* – Louis Vuitton *p. 279*
*Stockman jacket* – Margiela *p. 257*
Straw hat *p. 81*
*Stripes* – Sonia Rykiel *p. 260*
Sweater *p. 156*
Sweatpants *p. 144*
Sweatshirt *p. 55*

**T**

*Table skirt* – Hussein Chalayan *p. 227*
Tang jacket *p. 65*
Tank top *p. 102*
*Teddy bear jacket* – Jean-Charles de Castelbajac *p. 226*
Tie *p. 182*
Trench coat *p. 171*
Turban *p. 161*
Turtleneck *p. 21*
*Tuxedo* – Yves Saint Laurent *p. 212*
Tweed jacket *p. 42*

**U**

*Urban luxe* – Louis Vuitton *p. 283*

**V**

*Vinyl jacket* – Courrèges *p. 267*

**W**

Waist bag *p. 77*
White button-up *p. 166*
White T-shirt *p. 10*
*Women's suit* – Chanel *p. 203*
*Wrap dress* – Diane von Furstenberg *p. 278*

**Y**

Yellow boots *p. 18*

# PHOTO CREDITS

© GettyImages :
ABC Photo archives : 133, 141
AfrikImages gency : 314
Alain Dejean : 211, 268
Alex Dellow : 346
Anwar Hussein : 47
Archive photo : 137
Barbara Alper : 124
Bettmann : 179, 322
Bob Thomas : 176
Catwalking : 214
Columbia TriStar : 186
Daniel Simon : 234
David Montgomery : 169
Dirck Halstead : 220
Edward Berthelot : 197
Erica Echenberg : 318
Ernst Haas : 200
Estrop : 224
Fairchild : 170, 231, 308
Foc Kan : 324
FPG : 26
Gareth Cattermole-MTV : 111
Gene Lester : 53
Genevieve Naylor : 163
Gutchie Kojima-Shinko Music : 338
H. Armstrong Roberts-ClassicStock : 95
Harry Langdon : 154
Historical picture archive : 51
Howard Sochurek : 250
Image press : 254
IWM : 129
Jack Manning : 340
Jack Robinson : 182
Jean-Louis Atlan : 44
Jean-Louis Urli : 69
John Downing : 344
John Kobal Fondation : 139
John Metson Scott : 293
Kammerman/Gamma-Rapho : 215
Kirn Vintage Stock : 320
Larry Ellis : 159
Lee Lockwood : 119
Lynn Goldsmith : 131
Manchester Daily Express : 19
Mandadori portfolio : 146
Masha Raymers : 336
Matthew Sperzel : 330
Michael Ochs Archives : 12, 144, 172, 306, 310
Mirrorpix : 100, 241, 304, 316, 332
New York Daily Archive : 326
Paramount pictures : 48
Patrick Mc Mullan : 312
Penske Media : 255, 289
Peter Turnley : 116
Photo File : 88
Popperfoto : 82
Reporters associés : 269
Ron Gallela : 38
Rose Hartman : 259
Santi Visalli : 277
Science & Society Picture Library : 36
Slim Aarons : 75
Stephane Cardinale - Corbis : 184
Sunset boulevard : 73, 160
Sydney O'meara : 201
Ullstein bild : 334, 342
Victor Boyko : 230
Victor Virgile : 223, 225
Virginia Turbett : 328
Weegee (Arthur Fellig)- International Center of Photography : 66
WWD : 22, 34, 204, 229, 240, 244, 276

© Gamma Rapho :
Anthea Simms-Camerapress : 273
API : 10
Giancarlo Botti : 64, 120
Graham Wiltshire-Camerapress : 20
Jean-Philippe Charbonnier : 81
Keystone France : 24
Lebon : 171
Victor Virgile : 205, 296, 297, 298

© [2023] Museum Associates/LACMA. Licenciée par Dist. RMN-Grand Palais/image LACMA : 218
© & Daughter : 156
© Alamy : 245 (dpa picture alliance archive), 251 (Pictorial Press), 80 (United Archives GmbH), 136 (Granger-Historical Pictures archive)
© Alpha Industrie : 60, 122
© Artcurial : 206
© Balibaris : 71
© Batsheva : 79
© Birdman (Alejandro González Iñárritu), 2014 : 103
© Birkenstock : 50
© Bougainvillea London : 78
© Bridgeman Images : 127, 153, 210
© Brioni : 155
© Bruce Weber : 104
© Burberry : 173
© Calvin Klein : 217
© Charles Michalet : 92
© Chloé Archives : 24
© Collection particulière : 77, 84, 115, 123, 158, 199, 219, 238, 239, 243, 252, 253, 256, 257, 261, 266, 270, 275, 294
© Coperni : 282
© Courrèges : 267
© Cristóbal Balenciaga Museoa : 222
© Diane Von Furstenberg : 278
© Dolce & Gabbana : 216
© Drake's : 42
© Emil Larsson : 263
© Eve Arnold/Magnum Photos : 63
© Evening standard archives : 56
© Frida Kahlo/Nickolas Muray Photo Archives : 181
© G.H. Bass : 174
© Giorgio Armani : 290
© Hermès : 249
© Hiro, 1967/courtesy of Victoria and Albert Museum, London : 221
© Hugh Holland : 90
© Indigo Union : 86
© Jil Sander : 166
© La Botte Gardiane : 43
© Le Grand Blond avec une chaussure noire (Yves Robert, 1972) : 274
© Library of Congress : 41
© Life Photo Collection : 68
© Louboutin : 209
© Louis Vuitton : 279, 285
© Maas Museum : 150, 198, 228, 242
© Marine Serre : 195
© Max Mara : 152
© Mirto : 118
© Mudam : 227
© Musée départemental Albert Kahn : 32, 148
© Musée du quai Branly - Jacques Chirac, Dist. RMN-Grand Palais/Claude Germain : 180
© Museo del Traje, Madrid : 213
© National Archives at College Park/colorisation Sebastien de Oliveira : 102
© National Gallery of Victoria, Melbourne : 262
© Neighborhood : 65
© Next : 135
© Norman Parkinson : 112
© Paris Match/Walter Carone : 106
© Paris Musées, Palais Galliera, Dist. RMN-Grand Palais/image ville de Paris : 70, 233
© Paul Smith : 194
© Peter Knapp : 265
© Peter Lindbergh (courtesy Peter Lindbergh Foundation, Paris) : 264
© Prada : 208
© Roger-Viollet : 109 (Georges Kelaïditès), 87 (Jack Nisberg), 151 (Janine Niepce), 258 (Jean-Régis Roustan), 288 (Laure Albin Guillot), 292 (TopFoto), 235 (Ullstein Bild)
© Ron Dorff : 105
© Row Mango : 59
© Sotheby's : 283
© Stephen Shore : 189
© Ted Baker : 188
© Kyoto Costume Institute : 291
© The Metropolitan Museum of Art, Dist. RMN-Grand Palais/image of the MMA : 226, 287, 207, 232, 236, 237, 246, 271
© Tom Ford : 67
© Tricot : 23
© Umrao Singh Sher-Gil : 161
© Unsplash : 31 (Romeo-a), 21 (Unseen Histories/Library of Congress)
© Valentino : 286
© Vivienne Westwood : 178, 295
© Vogue : 284

The publisher has made every effort to obtain the rights to the photographs reproduced in this book. If, however, the present book should infringe the rights of third parties, they are invited to contact Éditions du Chêne.

## ABOUT HAYLEY EDWARDS-DUJARDIN

A graduate of the École du Louvre in Paris and the London College of Fashion, Hayley Edwards-Dujardin is an independent art and fashion historian. She teaches the history and sociology of fashion and explores the links between visual culture and fashion theory. Her publications and research cover the relationship between art and fashion, art history, photography, questions of the body and identity, contemporary fashion, and the decentralization of fashion theory. She is the author of several books published by Éditions du Chêne in the collection, « Ça c'est de l'art » (« This is Art »).

## ACKNOWLEDGMENTS

I would like to thank my loved ones for their support and enthusiasm during the long months of research and writing that have shaped this book. I would also like to thank those who have undoubtedly influenced my work: my family, my friends, my students, and strangers in the street... Thank you for endlessly sharpening my curiosity!

I would also like to extend my warmest thanks to everyone who contributed to the production of this book: my editors, of course, Emmanuel Le Vallois and Hélène Sevin, who accompanied me with unwavering enthusiasm and motivation, Sabine Houplain and her sharp eye, the Bureau Berger, in charge of art direction, Timothy Durand and The Shelf Studio for their illustrations, Arpiné Movsisyan assisted by Ambrine Haddadi and Joséphat Mboma for styling, as well as Violaine Carrère who created the still lifes that compose the book.

I would also like to thank the brands who have placed their trust in us.

And finally, thank you to all those who have made and still make fashion. Those who create the fantasy, the controversy, the everyday garments, and the political statements. Fashion will never cease to fascinate me, and I will never tire of challenging it.

First published in 2023 by Éditions du Chêne – Hachette Livre

This edition published in 2024 by Hardie Grant North America, an imprint of Hardie Grant Publishing.

All rights reserved. No part of this book may be reproduced in any form without written permission from the publisher.

**Hardie Grant**
NORTH AMERICA

**Hardie Grant North America**
2912 Telegraph Ave
Berkeley, CA 94705

hardiegrantusa.com

Art direction: Sabine Houplain

Graphic design:
Bureau Berger and NWB Studio

Cover design:
Lizzie Allen

Layout:
Nathalie Kapagiannidi, Noémie Deslot, Sophie Della Corte

Illustrations: Timothy Durand, The Shelf Studio for the silhouettes on pages 305-347

Pages 13, 14, 15, 16, 18, 27, 28, 29, 30, 33, 35, 37, 40, 45, 46, 49, 52, 54, 55, 58, 61, 62, 72, 74, 76, 83, 85, 89, 94, 96, 98, 99, 101, 108, 110, 113, 114, 121, 126, 128, 130, 132, 134, 138, 147, 162, 164, 165, 168, 177, 185, 202, 203, 212, 248, 260
Photographs: Violaine Carrère
Styling: Arpiné Movsisyan assisted by Ambrine Haddadi and Joséphat Mboma

Printed in 2024 by C&C

Copyright: 2024
ISBN : 9781958417683